Half in Shadow

Half in Shadow

The Life and Legacy of Nellie Y. McKay

Shanna Greene Benjamin

The University of North Carolina Press CHAPEL HILL

This book was published with the assistance of the Greensboro Women's Fund of the University of North Carolina Press.

Founding Contributors: Linda Arnold Carlisle, Sally Schindel Cone, Anne Faircloth, Bonnie McElveen Hunter, Linda Bullard Jennings, Janice J. Kerley (in honor of Margaret Supplee Smith), Nancy Rouzer May, and Betty Hughes Nichols.

Set in Merope Basic by Westchester Publishing Services
Manufactured in the United States of America

The University of North Carolina Press has been a member of the Green Press Initiative since 2003.

Library of Congress Cataloging-in-Publication Data
Names: Benjamin, Shanna Greene, author.
Title: Half in shadow : the life and legacy of Nellie Y. McKay /
 Shanna Greene Benjamin.
Description: Chapel Hill : University of North Carolina Press, 2021. |
 Includes bibliographical references and index.
Identifiers: LCCN 2020042509 | ISBN 9781469661889 (cloth ; alk. paper) |
 ISBN 9781469662534 (pbk. ; alk. paper) | ISBN 9781469661896 (ebook)
Subjects: LCSH: McKay, Nellie Y. | African American women college
 Teachers—Biography. | African American women scholars—Biography. |
 Women's studies—United States—History.
Classification: LCC LC2781.5 .B46 2021 | DDC 378.1/2092 [B]—dc23
LC record available at https://lccn.loc.gov/2020042509

Cover illustration: Photo of Nellie Y. McKay (detail). Courtesy of University Wisconsin–Madison Archives, #2020s00029.

"kitchenette building" by Gwendolyn Brooks reprinted by consent of Brooks Permissions.

For Edwin

Contents

A photo gallery begins on p. 105

Prologue

Growing up, summertime meant family reunions, when extended family scattered across the country, and sometimes around the globe, reconnected over card games in the hospitality suite, under a shade tree at the cookout, or across the table at the banquet. Through porch talk, laughter, games, and food, we ritualized our connection to family, those living and those deceased. Over time, our numbers grew. What began in the yard I raked became highly coordinated affairs with hotel stays and buffet dinners celebrating superlatives: the youngest and oldest in attendance, the person who traveled the farthest. There were small variances in execution from year to year, but one thing remained consistent: the reading of the family history.

Cousin Johnny, an impressive man who stood over six feet and spoke in a rumbling bass, would read this history aloud, tracing the roots of our family tree as he lifted up the names of relatives long gone. By remembering our history, we claimed our inheritance, affirmed our interconnectedness, and highlighted our shared legacy. The family history began as little more than a paragraph or two sandwiched inside a simple cardstock program. Later, it swelled into an extended narrative, accompanied by a multi-page computer-generated diagram of our family tree, bound together as a booklet. As a child, I marveled at the expansiveness of our tree and lingered on the pages with my name. I followed genogram symbols—solid and dotted lines, triangles and circles—defining my place within my immediate family and among my extended relations. As I grew older, I became curious about the stories hidden behind the names or inside the lines delineating marriages and partnerships, siblings and cousins, deaths and births. How did my people come together? Why did they break apart? What did they endure? How did they triumph?

One afternoon, I acted upon my curiosity while visiting my paternal grandmother, Mary Elizabeth Griffin Greene. With college, graduate school, and jobs taking me from the South to the Midwest and back again, I visited Grandma Greene in the "Oranges" whenever I happened to land near New Jersey. She and her sisters, Alberta and Pauline, lived together in separate apartments within the same senior living facility, a building that was the former site of the YMCA where their mother, who I called Nana, had worked as

a domestic. As I got older, I grew more appreciative of their knowledge, their wit, and their outlook, and looked forward to the times when it was just us. My academic training had introduced me to broad narratives about Black women's intellectual and social work, so as I listened to their stories, I grafted them onto a larger context and before long, saw how my academic training supplied new vocabularies to animate my personal history. Their stories fascinated me, and I looked forward to hearing multiple versions of the most colorful ones over and over again. I especially enjoyed one-on-one time with Grandma Greene because she never tired of telling me stories about my father when he was a boy. Then, one day, I decided to ask her about herself, instead of asking her about Daddy.

"How did you and PopPop meet?"

The question seemed simple enough. Grandma Greene was born in Chatham, Virginia, on 19 December 1922. When she was not quite ten, she moved with her parents and nine brothers and sisters to Orange, New Jersey—a town in the northern part of what is now known as the Garden State. In 1931, my great-grandfather William C. Griffin made the trek of nearly 500 miles north with his family in tow because he yearned for more opportunities than those afforded to him in the South. In Virginia, he worked as a carpenter. Moving to New Jersey, he hoped, would allow him to fulfill his dream of becoming an architect. This would never come to pass. Fed up with "not being able to build the type of dwelling for his family that he was capable of building,"[1] William C. took on work as a janitor. He was still working as a janitor at the time of his death.

In her response to my query, Grandma recounted the days when James C. Greene, the man who would become my PopPop, came courting. Day after day he showed up like clockwork, and they would sit and visit together on the porch, talking for hours. After it became clear that his visits were becoming a habit, Nana pulled Grandma aside and presented her with an ultimatum. If she was serious about this here James C. and marriage was on the horizon, then she had a choice: learn to sew or learn to do hair. As I listened to Grandma's story, my thoughts ran to Nanny, the grandmother in Zora Neale Hurston's classic *Their Eyes Were Watching God* (1937), and the episode when Nanny forces the protagonist to marry someone she thinks is a sure thing after she sees that "shiftless" Johnny Taylor "lacerating her Janie with a kiss."[2] In the novel, Nanny's solution to Janie's flowering womanhood, to the singing bees and creaming blossoms, was marriage and the security Nanny presumed it would afford. Perhaps Nana knew something similar when it came to my grandmother. If marriage was the likely outcome of all

this time young Mary was spending with James C., then she would need a vocation. Doing hair and sewing clothes were respectable forms of employment for Black women because they did not involve cleaning white folks' homes.

For a moment, Grandma stopped talking. But her story hadn't ended.

"But I wanted to be a math teacher."

Her response hovered in the air like smoke. Almost immediately, my mind raced. Was it a coincidence that my father had earned his bachelor's degree in mathematics, which he parlayed into an over-thirty-year career in computer technology, systems engineering, and management? I knew enough of my family history to know that the lack of access my grandmother had to higher education was not entirely a question of money: my great-grandfather did well enough for himself, in spite of his limited vocational options. But only the boys earned college degrees. While my Aunt Georgia, who died before I formed a strong memory of her, attended college briefly, she never finished. What could Mary Elizabeth Griffin Greene have been if Nana had granted her the space to pursue her calling? Grandma became a hairdresser, a salon owner, and eventually skilled in switchboard operation, typing, and keypunch.[3] She was a successful entrepreneur, had a loving family, and maintained an extensive network of friends with whom she played cards and attended church. But hairdressing wasn't her dream. Her ambitions, thwarted. Her place in the genealogy, set. Grandma was wife to James C., mother to James L. and Charles E., grandmother to Shanna, Onaje, and James Jr. But this other part of her story—her yearning for a piece of life where she could cultivate her own abilities and pursue her own joys—was invisible to everyone except me.

Half in Shadow: The Life and Legacy of Nellie Y. McKay is a biography driven by interlocking personal and intellectual commitments. I make visible the hidden story of McKay, the literary scholar who made an indelible mark on the American academy by creating space for Black literature, Black scholars, and Black feminist thought. Simultaneously, I position myself as a link in the chain of Black women's intellectualism. As I recount McKay's beginnings, how she realized her vision of a life beyond the one prescribed for Black women in the first half of the twentieth century, I chart my inheritance through a matrilineal line in which the work of McKay and other Black feminist literary scholars becomes my intellectual birthright. McKay's story is an account of field formation, how African American literature and Black women's studies became codified within the academy. This is a story about McKay's brave pursuit of her ambitions in the face of racism, sexism,

class oppression, and age discrimination; it is also a statement of the inheritance I claim because of her sacrifice.

If my grandmother's story planted the seed for this project, then it broke ground with a conversation. In 2009, I hosted my colleague and Mellon Mays comrade Gene Andrew Jarrett as the Connelly Lecturer in English at Grinnell College. The Connelly Lectures, named for the late Peter Connelly, who taught at Grinnell for over thirty years, feature accomplished literary scholars who are not only experts in their fields but also generous teachers and mentors. After two days of lectures and classroom visits, Jarrett and I met for lunch to reflect on his visit and catch up. We discussed McKay's passing and the secrets revealed after her death. I told Jarrett what I knew: who was told and when, the daughter McKay introduced to colleagues as her sister, the life we knew nothing about, and my questions about her legacy.

"You should write about that," Jarrett offered.

My eyes widened. I shifted in my seat. Smiled a little, maybe.

The conversation continued. We finished our lunch, but I couldn't stop thinking about Jarrett's suggestion and how it raised questions about the writing of McKay's story, my preparedness to undertake it, and the potential risks involved. How would I write a biography faithful to the nuances of her life when so many of the key players were still alive? What stories were McKay's alone, and which stories, particularly those involving persons close to her, were for others to tell? How could I offer revelations about McKay's life without exposing her peers unnecessarily? Then again, how could I *not* take advantage of the opportunity to speak directly to Black scholars who entered the professoriate in the 1970s and 1980s to better understand the climate of the times and how that climate impacted McKay's choices? What would McKay's story tell me about how there came to be a place for me—as a scholar of African American literature—in the English department at a small liberal arts college in the middle of Iowa? I found the prospect of writing McKay's story both exciting and daunting but ultimately decided that my curiosities could not stop with that conversation.

I consulted my graduate advisers and learned that McKay's daughter, Patricia "Pat" Watson, would be key, so I wrote to ask if she would support my efforts to write her mother's biography. I suppose I could have proceeded without her participation, but in truth, the thought never crossed my mind. I knew writing McKay's life story would require that I tap an expansive archive, that I work within and beyond those institutional repositories that house the documents and ephemera that archivists deem "valuable." I knew that institutional archives, those contested sites of knowledge production,

privilege certain materials to the exclusion of others, so to tell the story I wanted to tell, I would need access to resources that might never find their way into the archive's acid-free folders and low-lignin boxes. I knew that when initiating contact with Watson, I needed to lead with a sensitivity that conveyed my seriousness. I mailed my letter then waited. A few weeks later, I received a card from Watson; I found, enclosed therein, an email thread. Watson explained that since she didn't know me personally, she felt lacking "in the knowledge needed to make a good evaluation of [my] request," so she did "the only logical thing: [she] passed the ball to those who did have that knowledge."[4] In the card, she included a copy of the "string of e-mails" exchanged between her and McKay's closest friends and colleagues in the professoriate, then concluded the correspondence by agreeing to support my efforts to write about her mother: "I would be very happy," Watson wrote, "to give my consent and cooperation to your project."[5] With this, the work of learning about McKay's life had officially begun.

Watson's support resulted from the endorsement I received from literary scholars Susan Stanford Friedman and Thadious M. Davis, historian Nell Irvin Painter, and Black women's studies scholar Stanlie M. James. I had already been in touch with Painter about gaining special access to her nearly thirty-year correspondence with McKay, and in the e-mail exchange with Watson, Painter confirmed my interest in going "about this project in a scholarly way" and recognized that my "affection for Nellie will ensure a careful, sensitive job."[6] Friedman concurred but noted that a project like this "grows and grows."[7] It is this unwieldiness, and the shift between literary criticism and biography, that informs Davis's response: "I agree with Nell about Shanna's being the kind of person and scholar to do a biography of Nellie, and I also agree with Susan that Shanna may want to consider that biography as a second book because writing biography is very time consuming and difficult to do—it is and it isn't the same as most of our academic writing."[8] I was so floored by these early endorsements that I completely underestimated Davis's admonition about how long biographies take and how they differ from more traditional forms of literary scholarship. My writing proceeded slowly. Then, with barely two years of preliminary research under my belt, I became a mother of two, and the conditions under which I found myself working completely changed.

My research proceeded in fits and starts. I worked while the babies slept. I kept a notebook handy for brainstorming. In my office, a picture of McKay reminded me of my responsibilities to my project. I chipped away at the research, and even though in some years progress felt slow, I know now that

I had been absorbing and synthesizing the information all along, allowing what I had learned from interviews or in the archives to become a part of me. As I conducted research, I published articles where I reflected on the methodology behind Black women's biography and taught my undergraduates the delicate business of writing Black women's stories. Seeking Watson's support, and witnessing how she consulted her mother's community of friends, led me to write "Intimacy and Ephemera: In Search of Our Mother's Letters," an essay that discusses how I initiated "invisible trust-building work" to build the repository of primary sources I needed to narrate McKay's story.[9] My mentored advanced research with a team of students was the foundation of "Black Women and the Biographical Method: Undergraduate Research and Life Writing," an essay that explains how undergraduates can be trained to assist with research projects about women prone to secrecy.[10] These projects bridged my interests in mentoring, pedagogy, and humanistic inquiry, to be sure, but they also inspired me to keep going with my research on McKay while I negotiated the competing demands of work and family life. There was a story I felt compelled to tell. Some projects you choose. This project chose me.

When I started McKay's biography over ten years ago, I was in the early stages of figuring out how to commit to my work, give love to my children, and take care of myself. My research gave me a glimpse into some of the trade-offs McKay negotiated during her life, but when I became a parent, motherhood opened up an entirely new set of questions relative to the book. Specifically, how do Black women create conditions conducive to creative expression and negotiate trade-offs when pursuing a passion? What are the narratives we tell ourselves to keep going, and where do those stories come from? How frequently do we all engage in some form of self-fashioning in which we make and remake ourselves according to a vision that's out of step with popular portrayals, caricature, or stereotype, and in what way is an academic persona a survival strategy for Black women? Understanding McKay's path by way of the narrative she created to progress allowed me to better understand my personal story and place in the professoriate. Therefore, as much as this book is about McKay, it is also about me and the Black women who inherited a literary tradition reflective of a range of Black women's subjectivities; the working women who burned the midnight oil in order to create; the grandmothers, aunts, and mothers who "passed," in one way or another, to circumvent oppression resulting from race, gender, age, or class bias. McKay spent her life creating space for others. This book creates space for her.

Half in Shadow

Introduction

We are things of dry hours and the involuntary plan,
Grayed in, and gray. "Dream" makes a giddy sound, not strong
Like "rent," "feeding a wife," "satisfying a man."
—GWENDOLYN BROOKS, "kitchenette building"

On 1 April 2006, friends and colleagues, students and guests, gathered in Morgridge Auditorium, a lecture hall nestled inside the University of Wisconsin–Madison's School of Business, to memorialize Nellie Y. McKay, a preeminent scholar in the fields of Black literary and feminist studies. "The cause was cancer," reported the *New York Times*, and those in academic circles grieved the loss of another Black woman scholar who died prematurely, physically impacted by the toxicity of the academy, the stress of anti-racism work, and a range of diseases assaulting "the lives of black women who are artists, teachers, activists, and scholars."[1] At the time, it felt like an epidemic,[2] and McKay's passing, on 22 January 2006, only added to the grief. In the span of a decade, from 1992 to 2002, Black feminist scholars, students, and Black studies practitioners had already lost figures, forces of nature actually, who laid the foundation for Black women's studies with their writing, teaching, and activism: Audre Lorde (1992), Sylvia Ardyn Boone (1993), Toni Cade Bambara (1995), Sherley Anne Williams (1999), Barbara T. Christian (2000), June Jordan (2002), and Claudia Tate (2002). Most were dead by fifty-five. Often, the cause was cancer. Now, Nellie was gone. The symposium gave those impacted by McKay's academic work and professional influence the opportunity to come together and remember a woman who shaped the lives of countless individuals through her scholarship, teaching, and mentoring.

Craig Werner, chair of the Department of Afro-American Studies and McKay's longtime ally, oversaw symposium proceedings. As colleagues, Werner and McKay had advised students and collaborated on a variety of projects, many of them Ford-funded grants to fortify Black studies at UW-Madison. Outfitted in an oversize steel-gray blazer atop a pink-and-white striped shirt and black tie, instead of the baseball caps and hockey jerseys he regularly wore in casual contexts, Werner thanked the event sponsors, faculty, students, and support staff who made the event possible before moving deliberately, sometimes joyfully, at other times somberly, from

1

guest to guest, speaker to speaker, as outlined in the symposium program. After opening remarks came a series of panels: "From Margin to Center: Nellie McKay's Scholarly Achievement," "Nellie McKay and the Art of Mentoring," "Nellie McKay and Black Women's Studies." In the audience, Lani Guinier, the first Black woman tenured professor of Harvard University's law school, sat quietly; former UW-Madison chancellor Donna Shalala, who was unable to attend, sent regrets. Afterward there would be dinner at Baraka, an East African restaurant and a favorite of McKay's. Guests who returned to the lecture hall after dinner would view the video montage "Remembering Nellie McKay," watch a dramatic reading from Lorraine Hansberry's *A Raisin in the Sun*, and hear McKay's friends, colleagues, and former students read literary passages in her honor. While skimming the program, I saw it. In the middle of the day's events was a special presentation to Patricia M. Watson on behalf of congresswoman Tammy Baldwin, the former a woman many had met but none had ever really known.

For her entire career, McKay's students, colleagues, and friends within the profession thought her students were her only children and her work her only lover. However, a man and woman, seated together toward the rear of the auditorium, but noticeably apart from the clusters of colleagues, the groupings of students, and the famous friends peppered throughout the audience, had always known better. The events of the day confirmed the speculation, the truth revealed only after her death, the secret McKay had hidden from even her closest friends in the academy. Not only had McKay once been married, but she was also ten years older than we knew and a mother of two: a son, Harry McKay, and a daughter, Patricia M. Watson or "Pat," whom McKay had always introduced and referred to as her sister. To me, she was Professor McKay. To her colleagues, she was Nellie. To the Madison community, she was Dr. Nellie. But to Pat, she was mother. To the seated young man, Nicholas Henry Watson, McKay was grandmother—his Nell.

By the start of the symposium, most had already heard the news of this family life hidden in McKay's professional shadows. Many responded with good humor to the irony, laughing that their friend had pulled one last trick on them; others saw little humor in this postmortem revelation or were angry with McKay for her withholdings. Susan Stanford Friedman, McKay's English Department friend and women's studies comrade, used her time at the podium to imagine both the humor and the pathos in McKay's concealments. In remarks titled "Nellie's Laughing," Friedman named the deception and imagined the impetus: "She fooled us all. . . . And for so long. Out of what necessity or compul-

sion? And with what devilish glee?"[3] Friedman continued, assessing the other side of the coin: "No, I don't think her fooling us all—friends and acquaintances alike—was simply a matter of fun and rebellion. At times it must have tickled her fancy, at other times perhaps it left her feeling quite alone."[4]

It was this loneliness that led Richard Ralston, McKay's longtime UW-Madison colleague, to feel great sadness over McKay's secret. Ralston had helped to recruit McKay to Madison's Afro-American Studies Department in 1977 and was on hand to witness it all: McKay's early adjustment, the tenure track tensions, struggles with the Jean Toomer manuscript, sadness over colleague Tom W. Shick, pride in a Black *Norton*, love of her students. But in the end, he found nothing funny about a woman who felt the need to live her life half in shadow.[5] McKay was a master of narrative and was particularly adept at interpreting the narratives of Black women writers. The extent to which she had mastered her own narrative, dictating its contours, limiting our access to details, and managing the flow of information, only came to light after her death. I, too, wondered "Why?" and returned to an interview I had conducted with McKay two years prior for clues.

In the October 2006 issue of *PMLA*, the journal of the Modern Language Association, I published "Breaking the Whole Thing Open: An Interview with Nellie Y. McKay," which documented McKay's "undergraduate work at Queens College, her graduate years at Harvard, and her professional life in Madison."[6] I met McKay in the spring of 1994 and became her graduate student in the fall of that same year. I was one of her "daughters," a group of five Black women graduate students who arrived one or two at a time in the early to mid-1990s, most of us earning master's degrees in Afro-American studies at the University of Wisconsin–Madison but all of us earning PhDs in English, just as McKay had done at Harvard decades before. I conducted the interview during the summer of 2004 after feeling an intense and inexplicable pull to Madison, Wisconsin. Something similar had called me to South Carolina to sit at the knee of my maternal grandmother, Magnolia Means, years before. It turned out to be the last summer Grandma Means was alive. So, when I heard that same inside voice telling me to "go talk to Nellie," I knew better than to ignore it. I rerouted a flight and made my way to Madison. The summer of 2004 was the last summer McKay was well enough to sit and answer questions at length. At the time I conducted this interview, I envisioned it as *the* moment to document truths about McKay that were off limits to the general public. I felt as if the intimate conversations about her life were mine alone and that the published version of our interview would reveal something altogether new. Later, I learned that she

had told of the early days so often that the carefully edited version she presented to me had come to sound complete, whole.

"Breaking the Whole Thing Open," an edited, published version of this interview, focused on McKay's recollections of the formative years of Black literary studies. What remained on the cutting room floor, and which I reference throughout this book, are her first-hand accounts of childhood memories, recollections of "my mother," "my parents," "my dad."[7] Later, I found a problem. McKay's version of these events collided with truths found in my research. McKay narrated her childhood as idyllic, governed by memories of her mother's love and care and her father's encouragement. There is no mention of an early shocking and traumatic loss, only the inevitability of an academic career after being shaped by parents who were connoisseurs of Black literature, parents who would read the poetry of Paul Laurence Dunbar to her at night and who would bring home Langston Hughes's Jesse B. Simple stories from the *Post*.[8] The full interview illuminates the disconnect between McKay's public narrative and what I call her secret, what certain colleagues call a lie, what Kevin Young calls "storying,"[9] and what a dear friend calls McKay's business. McKay's letters, personal reflections, and scholarship, then, provide the keys to understanding the meaning behind her machinations and a window into how she narrated an academic self as a Black woman.

McKay acknowledged how she wrote and rewrote her personal narrative to emphasize the elements that play on the public or serve a political purpose in a letter to her friend and colleague Nell Irvin Painter, the highly regarded scholar of African American history and the author, most recently, of *The History of White People* (2010) and *Old in Art School* (2018). In the letter cited here, McKay recalled a talk she had agreed to give but had forgotten to prepare (such slip-ups were not uncommon in McKay's life, as she worked quite regularly to exhaustion).[10] Note her reflection on how she rendered a romanticized and "propagandistic" personal story to manipulate her white audience:

> But flush with victory from my King Day talk, I decided to go the path of my own autobiography and to talk about how I got to be doing the work I do. So out came another romantic version of my growing up years and how the riots at Queens College in 1967 led to my decision to study American Literature (that's absolutely true). Also true was the part of how important my folks thought education was and how all of their daughters lead successful lives (also true).

What I really did however, was to spin a tale that I consciously knew I was trying to weave to show that there were black people, still are, who are not from the slums and ghettoes, whose values are very middle class whether they have money or not, and who, to a large extent are "just like white people." It was all in the casting. The story was basically true but the emphasis pointed to something that was romantic and propagandistic. I found it very interesting.[11]

Later in the letter, McKay—who was noticeably intrigued and, dare I say, tickled by her professional antics—wrote: "Autobiography is a construction (as we've known for sometime) and how one shapes it makes all the difference."[12] Her assessment is as much a commentary on the talk she gave at the last minute as it is a primer for decoding her life story. In describing to Painter how she constructed her personal story for those retired professors, McKay offered hers as a counternarrative to stories about Black folk, stories propagated by a white establishment, stories limited in their representational scope because they equate a Black experience only with "the slums and ghettoes." The stories McKay told—the details she included as well as those she omitted—reinforced her vision for her life, allowing her to eke out a space for herself and her ambitions as an older Black working-class and soon-to-be divorced wife and mother whose opportunities were limited by age, race, and class prejudice. McKay wanted to pursue her dreams. With her race and gender always on display, she manipulated and policed the boundaries of the one thing she could control: her narrative.

Even though "Breaking the Whole Thing Open" repeats some anecdotes documented elsewhere,[13] the interview in its totality is significant because it provided me with an as-told-to version of McKay's life story that I would later examine against the alternate version that emerged after her death. What's more, it taught me my greatest lesson as an ethnographer: how *not* to allow culturally inflected notions of respect and respectability to override my responsibilities as a researcher. Whenever I think back to the afternoon I interviewed McKay, I lament not asking the question ready to leap from my lips: Did you ever regret not having children? I heard it in my head, but I kept my mouth shut, out of fear that I would hurt her feelings or trespass the borders of her personal life. McKay was known as a professor who kept an open door. This open door was a symbol of her accessibility. But accessibility does not equal intimacy. McKay gave her colleagues and her students access on her own terms. And for her Black women students, particularly, boundaries were maintained by rules of engagement dictated by McKay's status as elder.

In reflections published as part of the Nellie Y. McKay memorial issue of the *African American Review*, two of McKay's former Black women graduate students, Lisa Woolfork and Keisha Watson, pondered first names, respect, and Black women. "The ease with which I've been calling her *Nellie* in this remembrance does not reflect my name for her during the entirety of my graduate career," Woolfork explained. "I called her 'Professor McKay.' This gesture was not at her insistence, but at my own. Not out of fear, but out of genuine and heartfelt respect, the boundaries of our relationship were clear."[14] Watson echoed Woolfork's sentiments: "I only called her *Nellie* when outside of her earshot, thinking it impertinent to be that familiar with so wise and accomplished an elder, and a Jamaican one at that. (She never disabused me of this notion either.)"[15] Watson's "eight years in a small, primarily Caribbean, fundamentalist school in Brooklyn" were instructive: "always call people respectfully and by their proper name," she learned, and she applied this lesson to her engagements with McKay.[16] My aversion to potentially insulting my adviser notwithstanding, I don't believe McKay would have admitted anything if I had asked her directly about wanting to be a mother. I imagine she would have laughed and said something like, "But Shanna, you're *all* my children!" Nevertheless, while I use "McKay" throughout my biography, it is not out of fear of trespass; it is out of respect for her as a scholar who has earned the right to be called by her "proper name." I am consistent with my use of quotes and use "Nellie" when my interlocutors do, except when I use "little Nellie" to differentiate between McKay and her mother or to signal intimate exchanges, especially those at the time of her death.

Half in Shadow: The Life and Legacy of Nellie Y. McKay traces twentieth-century Black literary history through McKay's life to reveal her role in field formation. As a scholar, McKay achieved remarkable professional success. From her groundbreaking feminist analysis of the life and work of Jean Toomer, author of the imagistic prose poem *Cane* (1923), to her coeditorship of *The Norton Anthology of African American Literature* (1997) with Henry Louis Gates Jr. and her authorship of introductions, forewords, and afterwords, McKay helped codify Black literary studies, especially at predominately white institutions. Black literary studies were already alive and well at many historically Black colleges and universities (HBCUs) and in Black periodicals such as *Black World*—facts McKay readily acknowledged[17]—but McKay's work is noteworthy because it justified the work to white scholars and insisted on the centrality of Black literary studies in English departments nationwide. "The *Norton Anthology of Afro-American Literature*," McKay wrote, was "the white literary establishment's final endorsement of

this field" and, as such, "was one of the single most significant events in the history of black studies."[18] Where there was once only a smattering of books by Black critics, McKay and her peers created new shelves of knowledge to hold what they created as well as what they imagined would come.

In addition to her field forming work in Black literary studies, McKay was also a foremother of what we now call Black women's studies. By recovering and publishing literature by Black women, writing about the texts, collecting them in anthologies, and teaching them in college and university classes, McKay and a critical mass of Black women literary scholars theorized a tradition of Black feminism. McKay and others woke a sleeping tradition of Black feminist thought reaching back to Victoria Earle Matthews, Frances Ellen Watkins Harper, Anna Julia Cooper, and others dating from the late nineteenth century. McKay published essays, which focused on how to read Black women's literature, how to understand the state of the field, and how Black women experience white universities; she contributed to the efforts of other Black women scholars, Beverly Guy-Sheftall and Barbara Smith, Patricia Bell-Scott and Gloria Hull, for example, and together, as scholars and editors, advanced the study of Black women as writers and intellectuals in books, symposia, and public-facing work. The intellectual genealogies of Black women and their contributions to Black literary studies still remain in the shadow of their male counterparts. *Half in Shadow* highlights McKay's influence to bring Black women's role in African American literary history to the fore.

I am certainly not the first scholar to take an interest in the history of Black literary studies or in McKay's role in it. In 2004, Farah Jasmine Griffin published a review of "Thirty Years of Black American Literature and Literary Studies," which traced key moments in the recovery, teaching, institutionalizing, and publishing of Black literature and identified historical movements, scholars, and particularly formative texts published between 1974 and 2004.[19] Griffin followed "Thirty Years" with her 2007 essay "That the Mothers May Soar and the Daughters May Know Their Names: A Retrospective of Black Feminist Literary Criticism," which maps the contributions of a number of scholars—Barbara Smith, Ann duCille, Toni Cade, Alice Walker, Audre Lorde, Paule Marshall, Mary Helen Washington, Michelle Wallace, Frances Smith Foster, Deborah E. McDowell, Hortense J. Spillers, and Hazel V. Carby, to name a few—by illuminating how their intellectual contributions "influenced their disciplines even if they did so from the margins."[20] Griffin dedicated her essay to McKay, a "pioneering feminist critic, inspiring teacher, and devoted mentor."[21] Lawrence P.

Jackson's *The Indignant Generation: A Narrative History of African American Writers and Critics, 1934–1960* (2011) reaches back to the generation prior to capture what we learn when we look at specific groups of Black writers, such as those who produced during an era when integration, assimilation, and "a myth of liberal America" impacted what they wrote and how they were received, effectively staging the singular story I seek to tell.[22] *Half in Shadow* drills down, adding specificity to the comprehensive analyses offered by Griffin and Jackson, and lifts up the name of one critic—Nellie Y. McKay—to unravel the rich life she lived and name specific sites of institutional impact, so that the daughters, too, may soar.

Half in Shadow also builds upon a body of research on Black women's intellectualism reaching back to the early Black Atlantic and collisions between Africans in the diaspora and white Europeans. Stephanie Y. Evans's *Black Women in the Ivory Tower, 1850–1954* (2007), Kristin Waters and Carol B. Conaway's *Black Women's Intellectual Traditions: Speaking Their Minds* (2007), and *Toward an Intellectual History of Black Women* (2015), edited by Mia E. Bay, Farah J. Griffin, Martha S. Jones, and Barbara D. Savage, are three texts that "challenge narrow assumptions about intellectual history by demonstrating how ideas have been crucial to black women"[23] as they confronted interlocking systems of oppression. As scholars have traced the long arc of "black women's educational attainment"[24] according to "a long history of ideas,"[25] they have also attended to how Black women fared as professors and administrators in institutions of higher learning. The first-person accounts in Lois Benjamin's *Black Women in the Academy: Promises and Perils* (1997) and Deborah Gray White's *Telling Histories: Black Women Historians in the Ivory Tower* (2008) contribute to an archive that documents not only Black women's experiences in the professoriate but also how their "very presence . . . is a testimony of revisionism and change."[26] Motifs repeated throughout these books—how Black women sacrificed to pursue their ambitions and how they responded to racism and sexism while pursuing the PhD and in their professional work—emerge in *Half in Shadow*, too. But in a book-length study that delves deeply into a single life, I can be expansive, free to treat "work that does not lend itself as easily to summary"[27] with nuance and specificity. I eagerly await Barbara D. Savage's intellectual history of Professor Merze Tate, the Oxford- and Harvard-educated Black woman historian who traveled widely, wrote extensively, and named specifically the contours of her own extraordinary life through "something few black women have the power to generate: a historical archive."[28] *Half in Shadow* contributes to this historical record to further prevent Black women scholars like McKay from languishing in obscurity.

Half in Shadow, the title, captures two aspects of McKay's story: a life hidden behind a carefully curated public persona and scholarly contributions obscured by the elision of Black feminist scholars from the fields they formed. Barbara T. Christian, Ann duCille, and Nellie Y. McKay called the profession to task on this and similar topics in their prescient essays "But What Do We Think We're Doing Anyway: The State of Black Feminist Criticism(s) or My Version of a Little Bit of History" (1989), "The Occult of True Black Womanhood: Critical Demeanor and Black Feminist Studies" (1994), and "Naming the Problem That Led to the Question 'Who Shall Teach African American Literature?'; Or, Are We Ready to Disband the Wheatley Court?" (1998). In her "B-side rendition," P. Gabrielle Foreman's "A Riff, a Call, and a Response: Reframing the Problem That Led to Our Being Tokens in Ethnic and Gender Studies; or, Where Are We Going Anyway and with Whom Will We Travel?" (2013) considers the "hidden entitlements" that led to the exclusion of "specialists who are also the subjects" from Black print culture studies and other subfields within Black studies.[29] *Half in Shadow* recounts this history, then restores McKay to her rightful place as a woman whose embodied presence and literary scholarship transformed the academy by making Black writing indispensable to American literature and by rewriting Black literary canons with Black women prominently placed. *Half in Shadow* reads McKay's life story alongside the literature she studied, the essays she penned, the books she wrote, the collections she edited, and the introductions she authored to offer a new assessment of Black literary studies by casting the tradition as a movement of bodies, not simply as a body of texts.

When it comes to Black women and self-writing, autobiography, not biography, has been either the genre of choice or the genre of last resort, since autobiography requires the subject to deem her life important. Biography, in contrast, requires that others both value the life and render it in words. It is more likely, therefore, for Black women to write about themselves than to be written about. The long tradition of African American self-writing through slave narratives, autobiographies, and memoirs evidences this. But then, in the late twentieth century and into the twenty-first century, there was a shift. Black women scholars including, but not limited to, Barbara Ransby, Nell Irvin Painter, Alexis De Veaux, Mia E. Bay, Valerie Boyd, Thadious M. Davis, Cherene Sherrard-Johnson, Sherie M. Randolph, and Imani Perry decided that Black women were worthy subjects and penned biographies of historical figures, writers, and activists. In so doing, they followed in the path forged by Pauline Hopkins, the first editor of the turn-of-the-century periodical the *Colored American Magazine*, who is best known for her serialized novels but who also published "historical and biographical articles of persons and incidents

famous in the history of the race,"[30] most notably, a biography of Harriet Tubman in Hopkins's "Famous Women of the Negro Race" series.[31] Black women scholars trained since the advent of Black power, Black studies, and the women's movement actively recovered archival materials required to write biographies about Black women subjects and availed themselves of the publishing outlets available to them because of their professional work, developing methodologies of Black feminist biography along the way.

For all of McKay's work to illuminate the inner lives and creative work of Black women writers, like most Black women scholars of her generation, McKay's deep influence during the formative moments of Black literary studies remains underrecognized. Hidden, too, is her interior life, the self that informed how she approached her scholarship, managed administrative work, and mentored her students. *Half in Shadow*, the first biography of a Black woman scholar, not a Black woman writer, artist, or activist, historicizes the transformative products of McKay's work and, by naming the institutional inheritance she left behind for students, scholars, colleges, and universities, acknowledges the Black women scholars who laid the intellectual groundwork for twenty-first century Black feminist biography.

This biography is not "traditional," which is to say that it is not, as National Humanities Medal recipient and renowned biographer Arnold Rampersad described, a "full-scale portrait."[32] For Rampersad, literary and intellectual biographies such as mine run the risk of "confessions of partial portraiture, and partial failure" and "should be attempted before full-scale biographies only when there is an acute and most likely permanent shortage of data."[33] I don't know whether the archive at my disposal represents a "shortage," but I believe there's a case to be made for nontraditional biographical approaches to Black women who have not achieved some degree of celebrity or whose personal archive may be sparse by comparison, not because they are any less important but because of what historian Deborah Gray White identified as Black women's traditional "reluctance to donate personal papers" to "manuscript repositories" and the "resultant suspicion of anyone seeking private information."[34] Certainly, the limits of the archive define the contours of biography. *Half in Shadow*, then, is more than a linear accounting of the whys and wherefores of McKay's life. This book honors the interplay between literary history, literary criticism, and memoir not only to tell the story of McKay's life but also to explain who I am because of her, my place in an intellectual genealogy.

Half in Shadow does not presume objectivity; it is self-consciously subjective and embodied, meaning that periodically throughout the book, I foreground my positionality as a scholar in the field McKay pioneered and as a

student she mentored. My positionality is not methodology, however, and the latter is informed by a tradition of Black feminist biography in which biographers must negotiate their Black women subjects' "penchant for secrecy"[35] to construct a life story that is faithful even in the face of missing information. To establish a narrative time line of McKay's life, I relied on primary sources that include, but are not limited to, curricula vitae, letters, transcripts, and personnel and student files as well as government documents; I used birth and death certificates, registrar transcripts, marriage records, naturalization papers, military service records, and social security applications to reconstruct her family history.

McKay left no journal, per se, but from time to time she sent Painter what she called "Notes to a Journal," daily reflections a paragraph or so long listed chronologically; she also referred to her correspondence with Painter as a journal of sorts.[36] When explicit facts were unavailable, I turned to a form of triangulation, such as the one Alexis De Veaux described in *Warrior Poet: A Biography of Audre Lorde* (2004), to reasonably speculate when "competing truths" offer more insight into "complexities rather than absolutes."[37] On questions of objectivity, I cannot change my proximity to my subject. McKay was my adviser. But like Pulitzer Prize–winning essayist Rachel Kaadzi Ghansah, who practices the biographical method in her feature articles, I am "the filter of [McKay's] story,"[38] ever present through vantage point. True to Imani Perry's observation that "all biography is autobiography, at least in part,"[39] I am up-front and self-reflective about my positionality; and like Barbara Ransby, who, in her introduction to *Ella Baker and the Black Freedom Movement* (2003), explained how her affinity for Baker "enhanced rather than lessened [her] desire to be thorough, rigorous, and balanced in [her] treatment of [Baker's] life and ideas,"[40] I write, conscious of and confident in my perspective but faithful to my archive.

As McKay's biographer, I snooped and investigated, constructed, and arranged. I narrated, situated, and postulated. I reasonably concluded, imagined, told, traced, and explained. I read for repetition; I made sense of bits and pieces. This biography is a mosaic, held together by the mortar of leitmotif. But it is not the entire story. Missing, for example, is a rendering of McKay's romantic life. At various points, McKay's letters identify love interests, but I have been unable to corroborate the information. Other letters were given to me redacted to protect a reportedly married former lover who, according to my sources, is still living. The holder of those letters made a choice that I honor. The time may never come when those letters become available in full. But I make note here, lest those who read this biography

think that McKay was interested only in books. She was not. McKay was a woman who experienced desire and heartbreak, who had harsh words for a colleague she thought was trying to bird-dog her man, and who experienced fear when harassment threatened her safety.

Most members of McKay's immediate family are deceased. I tried repeatedly to interview her sister, Constance, but she demurred each time, insisting that the next time she would talk to me. She passed before I ever heard a word about her memories of their time together in Queens, New York. McKay's daughter, Patricia M. Watson, was forthcoming and generous from the start. I visited her several times in St. Louis before her death due to cancer. Her resemblance to McKay was uncanny. They had the same slight build, the same short Afro, and her hands: the very same hands. Watson's slender fingers and raised veins reminded me of the many times I had seen her mother reading in her office. I visualized McKay, glasses on, book open, hands clasped, and palms upward, as if ready to receive the Eucharist. The first time we met, Watson and I talked food, Penzeys, and chili spices. She provided contact information for the family and friends who knew McKay before she entered the academy, those who knew both sides of the story. I do not know the whereabouts of McKay's son, Harry, because Watson was the only person who could put me in contact with him. McKay's grandson Nicholas is aware of the project, but he did not respond to my request for an interview. In chapter 1, I say more about Joyce Scott, McKay's dearest friend from the "old days," whom I was able to interview. She and McKay were like sisters and remained close until McKay's death.

McKay spent her adolescence and early adulthood in Jamaica. I have been unable to reconstruct this history. There may be sources and individuals in Jamaica capable of unlocking details about McKay's adolescence abroad and willing to shed a brighter light on the motivations behind her withholdings. Perhaps this missing information will be included either in a future edition of this book or in someone else's biography of McKay. All told, I am invested in this book doing the job it was meant to do. In other words, I am committed to introducing McKay to a broader public and to mapping her life in relation to the emergence of African American literature as a codified field of study. One day, I hope, there will be multiple biographies of McKay and her contemporaries, since the multiple biographies of Lorraine Hansberry, either published or in progress, by Imani Perry, Margaret Wilkerson, and Soyica Colbert, not to mention Tracy Heather Strain's documentary, are proof that each biography assumes its own perspective, informed by the author's politics, intellectual investments, and archive.

Those who agreed to speak with me about McKay did so in overwhelmingly glowing terms. For most who declined to be interviewed, a pattern emerged: they had a contentious history with McKay. I cannot claim, with absolute certainty, sour grapes as their motivation for not speaking with me. But I raise it here as a limitation because it impacts the book in two ways. The most obvious is that *Half in Shadow* may seem one-sided when, in fact, it reflects the archive, the ephemera, and the ethnographic accounts I have available to me at present. The second is a matter of degree. Moments where I pause to consider McKay's motivations, to critique her choices not from a position of judgment but from a site of curiosity, may read as accusatory because there are only a handful of places in the book where McKay's peers have cause to call her out or enter into conflict. With few instances to offset the contrast, this analysis may prove disconcerting to some readers, especially those invested in a particular view of McKay or rankled by the thought of the student taking on the life of the teacher. With so much harmony, dissonance is deafening. *Half in Shadow*, admittedly, is a product of this day and time. Half a century or so in the future, oral histories complicating McKay's interpersonal relationships—such as those housed in the University of Wisconsin–Madison's archives—will be made available to the next generation of scholars, those who will be here long after I am gone. What is indisputable, even in the face of this missing information, is McKay's impact on African American literary history and American literature writ large. It is this legacy, and her absolutely fascinating manipulations of her personal history, that I amplify in *Half in Shadow*.

McKay rewrote her past to pursue her ambitions. Her story speaks to those whose dreams, like the ruminations of the speaker in the epigraph that opens this introduction, risk never making it past the daily work of "feeding a wife" or "satisfying a man."[41] Gwendolyn Brooks, the Pulitzer Prize–winning United States Poet Laureate who penned "kitchenette building," was known, in part, for the poetry she found in the quotidian experiences of the denizens of Chicago's South Side. Like the dreamer in Brooks's poem, McKay knew that she was more than "things of dry hours and the involuntary plan" and imagined that her life could be technicolor, not "grayed in, and gray." Dreams, rendered in poetry or pursued in life, can dissipate in the rush of the everyday. Instead of the unremarkable shades of grayscale, McKay pursued color, opting for a dream, "white and violet," fluttering like an aria sung "down these rooms," in and out of the walls and ceilings, both literal and symbolic, that delineated her existence. McKay's life is testimony that Black women's dreams and ambitions are worth the

pursuit, worth taking the time to consider the possibility of what might be "if we were willing to let it in, / Had time to warm it, / keep it very clean, / Anticipate a message, let it begin?"[42] There is no "I" in the Brooks poem. Only the "we" forced to suspend the dream when an opportunity to satisfy creature comforts strikes: "We wonder. But not well! not for a minute! / Since Number Five is out of the bathroom now, / We think of lukewarm water, hope to get in it."[43] For the speaker, the everyday supersedes the dream. This was the way McKay lived her life, until she found another way.

Chapter 1, "Strategies, Not Truths," maps the experiences that propelled McKay into higher education. It traces McKay's movement as an adult between Jamaica, West Indies, and Queens, New York; between marriage and divorce; between leaving her children and being reunited with them; and between Queens College and Harvard University. This chapter identifies the social forces that prompted McKay to attend Harvard, contemporaneously with her daughter at Radcliffe, where the two lived as "sisters." I position McKay's narrative in a tradition of uplift facilitated by church communities to reveal how she dissembled as a survival strategy she would practice throughout her career. The late 1960s were a moment of uprising and change, when the reverberations of *Brown v. Board of Education* and the women's movement, Black power, the Vietnam War, and student protests shifted the landscape of higher education. Forever changed by the student protests for racial and social justice at Queens College in 1969, McKay experienced her intellectual flowering alongside the college's open admissions program, a fact that contextualized her lifelong investment in inclusion and access.

Chapter 2, "Some Very Vital Missing Thing," discusses how McKay, a first-generation divorced working-class Black woman who entered Harvard in 1969 at the age of thirty-nine, circumvented the limited professional opportunities race, gender, and class oppression prescribed and prepared herself to marshal the collective enterprise that produced Black literary studies. This chapter considers how McKay policed the borders of her professional life to make space for herself, her colleagues, and her thoughts about Black writing in institutions hostile to her ideas and to her presence. I probe McKay's struggles at Harvard, difficulties with her Jean Toomer book, and anxieties around tenure to show how these early experiences allowed McKay to build a professional profile that would lead her to reject the individualist ethos of the academic "superstar."

Chapter 3, "When and Where I Enter," goes behind the scenes of the making of *The Norton Anthology of African American Literature* (*NAAAL*), the groundbreaking collection that canonized foundational Black texts—an

ongoing project reaching back to *Les Cenelles* (1845) — and made Black literature widely accessible through a premier teaching tool. This chapter traces the ups and downs of an enterprise that extended far beyond the five-year estimate into twelve years total and saw an initial 1,250-page limit more than double to 2,665 pages, to illustrate McKay's role in making African American literature indispensable to American literary studies and a teaching tool for social justice. Using unpublished interviews and an array of primary sources, this chapter explains how McKay managed early editorial board tensions and captures how "gender trouble" impacted the anthology and the canonization of African American literature.

Chapter 4, "Crepuscule with Nellie," recounts McKay's final year, her decline due to cancer, and defines her legacy by highlighting McKay's commitment to adult education, institutional bridge building, and PhD pipelines. From an early interview with Toni Morrison to her provocative *PMLA* article on white scholars of Black literature, McKay introduced little-known Black writers to the world of American letters while maintaining a close eye on the future of Black literary studies. Regularly passed over for named professorships and endowed chairs, McKay is restored in this chapter to her proper place alongside a more publicly renowned Henry Louis Gates Jr. for her often hidden yet indispensable role in field formation. An array of initiatives executed during her lifetime and following her death commemorates her work as a scholar, an institution builder, a community servant, a consultant, and a mentor.

In the autobiographical vignettes that introduce the chapters, I reflect on my origins and origin story, as well as my intellectual genealogy and personal and professional development, as a counterpoint to McKay's life story. These vignettes identify sites of influence in my lived experience and intellectual provenance. As a Black woman scholar who came of age in the 1990s, laying claim to my intellectual inheritance involves learning more about the lives of the Black women scholars and writers who shaped my thinking. What did I know, *really* know, about the scholars whose work I admired? The scholars whose work gave me a vocabulary to understand Black women's literature and culture? I needed biography, not just as a book of many pages but as a constellation of formative stories, so I could better understand the pathways of those who came before me as I set out to chart my own course.

The arcs that precede my first-person vignettes are evocative of Jean Toomer's *Cane*. Toomer was the author McKay studied in her first and only single-authored monograph, *Jean Toomer, Artist: A Study of His Literary Life and Work, 1894–1936* (1984). In *Cane*, the arcs reflect the text's thematic

circularity, the impossibility of closure in some moments and the literal coming full circle in others. The arcs in *Half in Shadow* symbolize the genealogical thrust of the book, which lays claim to my place in a long line of Black feminist and literary scholars. They reflect, as does this book, the process of arranging fragments, what happens when you manipulate parts of a whole and decide, like Sula, "I don't want to make somebody else. I want to make myself."[44]

SCENE 1 | The Site of Memory

> But the authenticity of my presence here lies in the
> fact that a very large part of my own literary heritage
> is the autobiography.
>
> —TONI MORRISON, "The Site of Memory"

Years of researching and writing Nellie Y. McKay's story, where I considered
what she remembered about her early years and the ways those memories
impacted how she fashioned herself, compelled me to reach back to the
memories I conjure as a source of strength and self-definition.

In the hope chest beside my bed is a handmade book made of faded con-
struction paper and held together by rusty staples: "A Book about Shanna
and Things That She Knows." The pages, once vibrant shades of red and or-
ange, perhaps, are now dulled to a nearly uniform muted shade of salmon.
On 7 November 1975, in Mrs. Murphy and Mrs. Blinn's nursery school class
at Temple Emmanuel, a Jewish preschool in Willingboro, New Jersey, I dic-
tated my first autobiography. I know because my mother's script in the lower
right-hand corner says so. A brief treatment, two pages total. Chapter 1:
"Little." I crawled. I fell down and sat down, too. I learned to laugh. I said
DaDa. My Daddy picked me up and put me up in the sky. I played toys and
played in my playroom. I used to pound with my hands on tables. Chapter 2:
"Big." Now that I'm big, I can do the monkey walk. I can jump. I can rock in
a rocker all by myself. I can drink milk by myself. I can reach up to the sky.
I can kiss. I can skip. I can roar like a lion. I can pretend.

My mother saved this and other handmade books for me. When I got
married, she gifted me the gilded chest, reminders inside of the self that was
forming, or had already formed, and was in search of its ideal expressive
mode. I see the little girl in the picture staring back at me, almost recogniz-
able. Same nose, same mouth. But she sits in a surety that comes and goes in
my adulthood. Her eyes say so: so confident, so sure. A knowing. I feel her

whenever Mommy tells the story of how she introduced me to Black writers: we sat near the water at Mill Creek Park, Mommy and me, Langston Hughes's "Mother to Son" read mother to daughter. The crystal stair, translucent and ethereal, juxtaposed with those that are splinter-laden and worn. Hughes's Mother ascending to an unknown destination. The persistence of the climb in spite of its precarity is the message here. Mommy: you read, I listened. Daddy: I read, you inscribed: "Shanna read this book to Daddy on X date." It was a ledger of literacy. My parents' dreams for me as limitless as those magical stories of edible skies and flying people. They were my first teachers along an educational genealogy that included grade-school educators who filled my cup to overflowing. Together, they taught me to believe in myself and gave me stories to rely on when that belief was shaken.

During the school year, Mom packed her '69 robin's egg blue Volkswagen Beetle with my brother and me and our neighbors, the Sheie girls, and drove us to Country Club Ridge—not our neighborhood school, the crosstown school she chose. My mother, a former educator, selected all of my teachers except one. As I think back to the teachers she selected for me, what they had in common was this: I felt loved, cared for, and encouraged. Mrs. Boyer, my Trans Am–driving music teacher, made me a soloist in *H.M.S. Pinafore*; Miss Bertolino, who was wild about the Philadelphia Phillies, made me editor of the school newspaper, the *CCR Critter*. These teachers loved me, put me up front, and left me in charge not in the interest of adultification but as an act of care, because love and encouragement are things children need.

Mrs. Fiarman, my fifth-grade teacher, was in a class all by herself. Success Cards. Always the carrot of the Success Card. Following a job well done, either individually or as part of a team of students, our desks clustered together in groups of four or six, Mrs. Fiarman distributed handwritten cards of congratulations and encouragement. I still have a stack of the yellowing four-by-eight cards somewhere, a reminder of the consistent and persistent ways she built me up, made me feel invincible. She's still living, so during a visit I asked her about the me that was and that is, even when insecurity overwhelms me. I was bright, she said. A leader. "You got that from your mother, you know. She was active in the P.T.A. and all that," she recalled. "But you got along well with the other children and were gentle, so I sat you with students you could influence." Her eyes drifted out the window at Carlucci's Waterfront in Mt. Laurel, New Jersey. "Right there," she said—"I see your desk right there." She was my teacher during the early 1980s; nearly forty years later, miraculously, she still remembers where I sat.

The memories that stand out aren't always mine (as-told-to in the case of my mother's story of reading to me at Mill Creek), and I know they're often unreliable. But I've come to think of memory, experience, and personal narrative in cumulative terms; that is, the accumulated moments of feeling loved and wanted, encouraged and seen, combine to form a feeling, something visceral, where I've been made to feel capable and sure, even though, as a child, I often felt scared and always a little bit on the outside of what was going on around me.

Mine is a narrative of privilege. Of middle-class origins, of boundless love and open access, of 3C-haired, light-skinned, cisgender ability. It is also a narrative that I read through the long history of Black self-writing, where the trauma of the hold and the afterlife of slavery were precursors to forms of Black writing that attempted to decode and transmit the inner workings of a financial system of servitude in which Black bodies were reduced to chattel, used as remuneration for gambling debts, exchanged as payment for bone china, raped to reproduce bodies of labor, experimented on to advance gynecological technique, and bequeathed to sons and daughters. This original break makes me sensitive to genealogy, to my family tree, and to honoring elders and ancestors.

The epigraph that opens this vignette invokes Toni Morrison's "The Site of Memory," an essay included in William Zinsser's *Inventing the Truth: The Art and Craft of Memoir* (1995). Here, Morrison discusses writers of the earliest Black autobiographies, slave narratives by Frederick Douglass, Harriet Jacobs, and Olaudah Equiano for example, explaining how this legacy justifies her "inclusion in a series of talks on autobiography and memoir."[1] It's hard for me to imagine Morrison needing to justify anything, but I include her here to speak to the significance of the vignettes that precede each chapter of *Half in Shadow*, since they illustrate how the chapter themes resonate in my life. McKay invented herself at the same time she helped form a field of Black women's writing. Invented lives such as hers "document," in the words of Mary Helen Washington, "black women as artists, as intellectuals, as symbol makers."[2] I share Washington's investments. I want to be rooted, to understand my place within a literary and cultural genealogy in which Black subjects invent the self through writing—imagining, among other things, a future beyond plunder. Black self-writing asserts the sovereignty of the self and reckons with what it means to be human in a world where antiblackness runs rampant.

My recollections, by themselves, are fragments. What holds them together is the origin story my mother gave me as she read folktales rooted in

resistance and the poetry of deferred dreams. Black writing is my inheritance, education paves the path to freedom, and you don't let white shopkeepers call you "girl." In writing about McKay, I consider how she organized fragments to create her story, with the goal of envisioning "what we are not meant to envision: complex black selves, real and enactable black power, rampant and unfetishized black beauty."[3] This is "black life and creativity behind the public face of stereotype and limited imagination."[4] This is not about who we are supposed to be. This is about who we are.

CHAPTER ONE

Strategies, Not Truths

> Ah was born back due in slavery so it wasn't for me to fulfill my dreams
> of whut a woman oughta be and to do. Dat's one of de hold-backs of
> slavery. But nothing can't stop you from wishin'. . . . Ah wanted to
> preach a great sermon about colored women sittin' on high, but
> they wasn't no pulpit for me.
>
> —Nannie to Janie, in HURSTON, *Their Eyes Were Watching God*

As a young girl of maybe five or six, Nellie Reynolds and her mother left
their East Harlem apartment at 1804 Madison Avenue at 118th Street and
rounded the corner toward the park. What is now known as Marcus Garvey
Park, just up the street at 120th, would have been a likely destination. Years
earlier, this public space (defined by West 120th Street to the south, West
124th Street to the north, and Madison Avenue to the east) was called Mount
Morris Park, so named for its western boundary, Mount Morris Avenue. In
the 1930s, renovations transformed what began as terrain unsuitable for
children into a family-friendly space that included a playground, a commu-
nity center, and a child health station.[1] Renamed in 1973 after Garvey, the
Jamaican founder of the Universal Negro Improvement Association (UNIA)
who promoted repatriation and self-sufficiency for Black Americans, the
park would have been in walking distance from the Reynoldses' four-story
apartment building, close enough for mother and daughter to enjoy time to-
gether, perhaps with baby sister in tow. Then again, they may have visited
Harlem River Park or another playground in closer proximity to a neighbor-
hood school, since it was near a school that little Nellie's earliest memory
impressed itself upon her mind.

One particular day, as young Nellie stood impatiently beside her mother,
who had turned to talk to a neighbor, she spied some children her age across
the street. Immersed in conversation, Mrs. Reynolds missed the little hand
slipping from hers, the feet that took off down the sidewalk and across the
street in the direction of carefree joy and laughter. Little Nellie joined the
others in play, oblivious to the dangers of crossing the street all alone, un-
aware of her mother's panic, her fear. Nellie's playtime was short-lived,
since as soon as mother caught up with daughter, she slapped her across the
face in view of everyone.[2] McKay never forgot this episode, embarrassed by

the public shaming, the overwhelming hurt that her mother "had done this out in the public."[3]

Chances are, this never happened.

McKay recounted the episode when I interviewed her in 2004. In response to my opening question about her earliest memories, McKay recalled playing with friends in the park, roller-skating on the sidewalk, stealing coins from the collection plate, and learning to read.[4] These were among her most vivid childhood memories. McKay's mother, whom she remembered as a strict disciplinarian, a source of instruction, and a model and standard to emulate, played a central role in the recollections she shared. According to McKay, her mother read frequently to her and her sisters.[5] Bright and curious, McKay followed along, memorizing the words on the pages as her mother made her way, book after book, left to right, top to bottom. McKay learned to read, as many children do, by imitating grownups: she would pick up the book and "read," turning the pages at the appropriate moment, reciting memorized text, without anyone ever realizing that she, in fact, "didn't know how to read it, because [she] had memorized it so well."[6] The memory of McKay's mother resonates in new ways when backlit by the truths that emerged following McKay's death. Given what we now know about McKay's family and her early years, these books were not the only fictions McKay had memorized and passed off as the real story.

McKay rewrote a traumatic past by nurturing personal ambitions through professional pursuits. McKay's ambitions, like those of Nannie, the figure whose voice opens this chapter, were housed in what Elizabeth Alexander called "the black interior," a space where "black life and creativity" exist "behind the public face of stereotype and limited imagination."[7] A domain for reflection, introspection, and observation, the interior is a quiet space that, according to Kevin Quashie, encompasses "the full range of one's inner life—one's desires, ambitions, hungers, vulnerabilities, fears."[8] But why differentiate between a Black interior and the privately held beliefs and desires of any human being? The opening epigraph and the latter part of Alexander's definition offer clues. Slavery, a circumstance beyond Nannie's control, aimed to break her spirit and reduce her to a body of labor. To justify the enslavement of stolen Africans, dehumanizing stereotypes painted the enslaved as savages without souls or reason, as simultaneously dangerous and docile, crafty yet naïve. These stereotypes were never meant to faithfully portray Black humanity. In the face of anti-Blackness, the interior becomes necessary for African Americans because it offers a space to live and create, to imagine and dream, to live out a range of creative possibilities beyond

the reach of Black death. McKay's interior afforded her space to imagine. But it also afforded her the space to withhold. McKay understood the slippage between image and interior and manipulated it to her advantage: "No one believes that human beings live only an exterior life," she wrote in a response to Arnold Rampersad's essay "Biography and Afro-American Culture." "The internal life is hidden," she asserted, "and we can never capture it fully, but we now have the tools [in psychological theory] to discover some of what takes place in the reflective inner self."[9] McKay engaged in what Audre Lorde called biomythography,[10] which involves the manipulation of history, self-fashioning, and mythmaking. Instead of focusing solely on the truths McKay withheld, this chapter unravels her motivations to name the strategies she used to get what she wanted out of life.

WHEN MCKAY'S PARENTS, Harry and Nellie Reynolds (née Robertson) made their separate ways to the United States in the 1920s, they were two of 12,243 West Indian immigrants who entered the United States by 1924 and made New York their home.[11] Hailing from Panama and the British West Indies, respectively,[12] Harry and Nellie made their way in "this man country" as grocer and housewife, aiming, perhaps, to "buy house" and raise a family in a place where "you could at least see your way to make a dollar."[13] If Paule Marshall's 1959 novel *Brown Girl, Brownstones* is any indication of the immigrant experience in New York at the time, then Harry and Nellie Reynolds, like Deighton and Silla Boyce, saw the States through hopeful eyes, imagining, perhaps, homeownership, or wrestling, maybe, with a longing for family in the Caribbean. Unfortunately, as with Deighton and Silla, the lives of the Reynolds family would be marred by tragedy.

On 13 May 1925, Harry and Nellie welcomed their first child, Alfreda, into the world. Once mother and child were fit to travel, they made their way uptown from Babies Hospital, a care facility founded in 1887 that would later become "one of the nation's pre-eminent children's hospitals,"[14] to their Harlem walk-up at 207 West 147th Street. Alfreda was born prematurely, and the couple, I'm sure, prayed for the best, hoping that Alfreda would grow stronger, day after day, and live to enjoy the life they imagined for her. But this was not to be. Barely a month later Alfreda died, leaving her parents to grieve the loss of their firstborn child, whose final resting place would be Potter's Field.[15] About a year later, the Reynoldses had already moved over a few blocks, to 241 West 142nd Street, when their next child, an unnamed boy, was born at Harlem Hospital. It was 3 May 1926, and the couple, yet again, were pummeled with more bad news. This time,

they would not be taking a baby home.[16] The boy, who lived only an hour, left Harry and Nellie with what must have been indescribable grief. They waited years before trying again. By 1930, the year of little Nellie's birth, Harry and his wife had suffered the loss of two infants—Alfreda and the baby boy—in less than five years. When Harry Reynolds and his wife, Nellie, brought home their newborn daughter to a modest apartment on Manhattan Avenue, later moving uptown on Madison Avenue, they were bringing home a child hoped for, prayed for. Little Nellie was her mother's namesake. She was wanted. And, I imagine, very much loved.

Born on 12 May 1930,[17] Nellie Yvonne Reynolds entered into a world that held limited life choices for Black women. Jacqueline Jones's award-winning *Labor of Love, Labor of Sorrow: Black Women, Work, and the Family, from Slavery to the Present* (1985) characterizes the era into which McKay was born as one during which the African American unemployment rate reached a staggering 50 percent.[18] As the nation headed toward depression and Southern Blacks pressed their way north as part of a great migration that sent them in search of the "warmth of other suns,"[19] African Americans who remained "at the very bottom of a hierarchical labor force" held out hope that Franklin Delano Roosevelt's Fair Employment Act would ensure equitable access to government work by forbidding discriminatory hiring practices.[20] Though modest advancements were made by a relatively small group of Black people, the Depression placed a stranglehold on the occupational opportunities of African Americans as a group. By 1940, jobs once held by Black women—namely "sharecropping, private household service, and unskilled factory work"[21]— were unavailable. According to the educator and activist Nannie Burroughs, these jobs had "gone to machines, gone to white people or gone out of style."[22] McKay and her sister Constance E., who was born on 23 September 1932 and affectionately known as Connie,[23] were children to parents who held out hope that their daughters would grow into a world where the hindrances that beset Black women in the 1930s would become a thing of the past.

McKay may have been born into an era when it was more likely for Black women to work as beauticians or as domestics than as the mathematicians or physicists portrayed in the popular film *Hidden Figures* (2016) or Duchess Harris's book *Hidden Human Computers* (2016), but it is both unfair and inaccurate to frame Black women's work solely in terms of what they did. Ever present is what Black women wanted to do—what they were capable of— and the rich interior lives they maintained in the face of racism, sexism, and patriarchy. The epigraph for this chapter, a passage from the early pages of *Their Eyes Were Watching God* (1937), captures this disconnect be-

tween Black women's aspirations and their material reality. A now-classic bildungsroman of Black women's fiction, *Their Eyes* recounts a Black woman's coming of age through relationships that test her mettle and shape her voice. In the section cited, Nannie speaks to her granddaughter Janie, the novel's protagonist, imagining a different life from the one slavery's afterlife afforded her. Slavery may have placed a stranglehold on Nannie's ability to "fulfill [her] dreams of whut a woman oughta be and to do," but circumstance could never suffocate the desire, her wish, to "preach a great sermon about colored women sittin' on high."[24] Nannie also admits to a secondary, yet no less present, inner desire to move beyond her station, a desire that did not fade during her life. Nellie Y. McKay stood fast in a similar desire for more. She may not have had slavery to contend with, but she refused to allow obstacles beyond her control to dampen the dreams she held deep within.

While McKay faced barriers based on race, gender, and class prejudice throughout her life, these societal obstacles were compounded by the psychological weight of an early trauma at home. It was her mother. We don't know who found her, but at 10:30 A.M. on 31 May 1936, just three weeks after little Nellie celebrated her sixth birthday—with cake and Grape-Nuts or rum raisin ice cream, perhaps—Nellie Reynolds was unexpectedly found dead in their home on Madison Avenue. She was only thirty years old when she passed, having died alone of "Hypertension and Cardiac Valvular Disease"[25]—an illness that typically strikes down women twice her age. For her husband, Harry, springtime must have brought memories of much heartache: the deaths of two children and the loss of his wife—a yearly reminder of the babies who never realized their full potential and the spouse with whom he'd never grow old. Something fell off the shelf inside of young Nellie, I'm sure, and years later, when she went inside herself in search of her mother, she would find only an inherited history of hypertension. The loss haunted McKay, who could pull no information about her mother from her father. Did he see in his daughter's face the eyes, the mouth, the brow of the woman he had loved and lost? When he called his daughter's name, did it conjure memories of his deceased wife? Years later, an aunt would gift McKay a small, grainy black-and-white family photograph. In it, barely visible, was her mother.[26] Later, extended psychotherapy and a visit to her mother's gravesite would help heal the wound,[27] but until it did, McKay longed for her mother's love and nurturing. On 4 June 1936, Mrs. Nellie Reynolds was buried at the East Ridgelawn Cemetery in Clifton, New Jersey, by Harlem undertaker Ernest A. Reid. The location of the grave is Section 14, Block B, Row H, number 18. It is not marked.[28]

After the death of her mother, young Nellie was sent to Jamaica to live with relatives, most likely her father's parents. For nearly twenty years, she lived life outside of the States and beyond the reach of this biographer. What we know through oral history and official records is this: Nellie Yvonne Reynolds married Joseph McKay,[29] and in 1951 and 1952, respectively, bore children Patricia and Harry. McKay was barely in her twenties when she found herself married and the mother of two children under two. She returned to the States in May 1954 and did so alone,[30] leaving her children to live with her father's family—probably her paternal grandmother—while she made a way for herself in the States. Five years later, in 1959, McKay's children, Pat and Harry, joined their mother and Aunt Connie in their grandfather's house in Queens, New York.[31] Joseph McKay remained in Jamaica. There is scant information about McKay's marriage, and it appears that she gave it little thought once she began her new life in Queens.[32] McKay's father, Harry, purchased a home to accommodate the daughters he expected to stay close, to house the children who would help after he had lived so many years with his wife gone. Though this expectation was communicated quite directly to her and her sister, McKay could not conform.[33] McKay was intent on leaving and pursued a life beyond her father's house. Her sister, Connie, married and stayed close.[34] Years later, after moving to Florida with her husband, Basil J. Prout, Connie relocated their father to the Sunshine State to care for him during his twilight years.[35]

ST. ALBANS, THE NEIGHBORHOOD McKay moved into in 1954 and where her children joined her in 1959, sits just beyond the gentle curve of Farmers Boulevard, a neighborhood of modest single-family homes in Queens, New York. Hers was a two-story house. A brick stoop and symmetrical bay windows face front, watching. McKay called it 111 Road. The full address was 190-28, 111 Road, Hollis, Queens, to be exact. And for twelve years, it was her life. It was the locus of "very happy" and "very sad" years; it was the home she shared with her father, sister, and two children; and it was the place where she decided, as she wrote to her dear friend and confidante Joyce Scott, that "WOMEN NOW WANT SOMETHING out of life."[36] McKay could not define that "something" in specific terms at the time, since her priority was eking out a living for herself and her children, but she had an orientation, a worldview, that allowed work she didn't find fulfilling to aid in her growth and development. It was still the 1960s, and for the time being, McKay held a workaday existence at Bennett Brothers, the place where her thoughts on the rights and roles of women collided with what white men thought she ought to be and do.

To support herself and prepare for the arrival of her children, who were living with family in Jamaica, McKay worked at Bennett Brothers, a company that began as a jewelry business and later became known for the plethora of household goods compiled in its "Blue Book of Quality Merchandise."[37] While there, McKay paid little attention to the warehouse full of food processors and other odds and ends. Instead, what she noticed most about Bennett Brothers was the way it exploited women, mostly "women with children and women who had to work to make a living."[38] She recalled: "It was capitalism at its worst in a certain way. . . . It was very bad and I thought it was such unequal work. Very few women were managers. The managers were men [and] they were white. . . . Women just did the grunt work and they were, essentially, as I saw it, locked in for their lives. Many of them had been married before, or were divorced women struggling to raise children."[39] While there is no evidence McKay ever told her coworkers about her marriage and divorce, a fact that may offer insight into where McKay placed the partnership along a spectrum of personal priorities, it appears that McKay sympathized with these women because it was an experience that she, too, shared as a single mother of two.

Bennett Brothers may have been the place where McKay worked a job, but it was through dinner parties at home that she lived her life. She frequently invited a "coterie of friends"[40] to her father's house in Queens and hosted simple gatherings that allowed them to break bread and share ideas. It was the beginning of a tradition, an expression of what later became a lifelong love of bringing people together around food and talk. Those who attended held forth on a variety of topics—the theater, music, and literature among them—and together maintained an intellectual life that far exceeded anything that was expected of them at Bennett Brothers warehouse. McKay knew how to find people who shared common interests and held strong opinions. In this community of coworkers who joined her for dinner, they would sit and talk, eat and drink, and discuss the intellectual topics that interested them in spite of their relatively "lowly, ho-hum jobs."[41]

The dinner parties were also one place where the lives of McKay and her young daughter, Patricia, began to split from the rest of the family. Even though all members of the household would have been welcome at dinner, only McKay's daughter, Pat, joined in the fun. As Pat recalled, she learned to cook by watching her mother prepare meals for the group. Pat remembered these gatherings fondly for how they instilled in her a love of good friends, great food, and scintillating conversation: "Oh, gosh. I remember a lot her dinner parties. Those were some of the best. I told you she was working at

Bennett Brothers and had a close coterie of friends, about half a dozen of them. She would have these dinner parties all the time, fix meals and invite them over for dinner. . . . That's how I got my taste for French champagne. After a certain point, I'd be allowed to have a sip. I've been spoiled for good champagne ever since."[42] McKay used these dinners to create a space where she could explore her inner thoughts and opinions and voice all that she held inside while on the floor at Bennett Brothers. Her daughter shared in what, between the two, became an exclusive journey. "This was not my mother, my grandfather, my aunt, and these additional people," Pat recalled; "This was my mother, her friends, and generally, me."[43] A special relationship between mother and daughter formed during these events, one in which the two found themselves apart from the other members of the household. Dinner parties at 111 Road would not be the last time their opportunities or experiences diverged.

As intellectually stimulating as McKay found the dinners with her Bennett Brothers coworkers, they were not enough to satisfy her yearning for sustained intellectual engagement and a fulfilling professional life. The job paid the bills, but something inside told her that she wanted something more, something different. Would college be the pathway? Her high school experience had left her feeling less than inspired about higher education. When she earned her diploma, she thought, "Well, this is the last of me in school. I'm never going to go back to school again."[44] Fortunately, an intervention from her church community convinced McKay that she had what it took to pursue higher education and that there was a path for her to get there, if she wanted it.

Soon after Bennett Brothers became McKay's workplace, she found a church home in Hollis Presbyterian Church. The church was founded in 1922; Donald "Don" Scott became the head minister in 1959 and was the pastor who shepherded his flock through the turbulent 1960s and encouraged McKay's educational pursuits. Robert "Bob" Plows, a former attorney and lifelong friend of Pastor Scott and his wife, Joyce, remembered when the exclusively white congregation began to change. It started as a trickle. African Americans and Afro-Caribbeans from Brooklyn and Harlem made their way to Hollis, Queens, in search of "a place where they thought they could have a decent life, raise their children, and achieve some measure of prosperity."[45] Before long, the area experienced "more than a usual degree of white flight."[46] The white people who stayed and the Black people who came, however, shared this in common: a commitment to striving. Hollis was composed of "a community of strivers," Plows recalled, and it was an

"environment of people who, even if they didn't have it, recognized the value of an education."[47] Scott, who joined the congregation after graduating from Princeton Theological Seminary, approached his ministry with the values of the community and the needs of young people in mind.[48]

Pastor Scott's personal history made him inclined to think broadly about what young people were capable of. Princeton's seminary drew him out of the Pacific Northwest, and after benefiting "from a stretch move," he made it his mission to "stretch [young people] to achieve using whatever gifts or capacities they had."[49] Even though McKay was technically an older member of the congregation, Pastor Scott saw her "quiet determination,"[50] her potential for excellence outside the Hollis community, and initiated efforts that would open the doors of higher education to her. Impressed by McKay's thoughtfulness and confidence, Pastor Scott told her about a new program recently initiated at Queens College.[51] The pipeline program instituted to diversify the city college system was called SEEK, and it stood then, as it stands now, for the "search for education, elevation, and knowledge."[52]

While SEEK, initially branded as a tool for educational advancement, transformed McKay's life, its beginnings were complex and contradictory. At the time the program was instituted, white flight, coupled with a boom in the number of New York City residents from Puerto Rico and "the southeastern United States (especially black migrants),"[53] produced a radical shift in the city's population. In an essay titled "Black Feminist Pedagogy and Solidarity," Alexis Pauline Gumbs explained how the city sought to control its "post-civil rights diasporic population."[54] There were two ways the city opted to manage the influx of Black and brown families: by expanding the carceral state and by granting "educational access to people of color."[55] The SEEK Program was the educational arm of the city's broader initiative, which was geared toward managing "the dispersal of white residents and the consolidation of racialized migrants in New York City."[56] Through remedial math, English, and reading courses, and with financial aid through college stipends, SEEK became the on-ramp by which "disadvantaged" Black and Puerto Rican youth could gain access to the city's college system. The system was, of course, inherently flawed. How it addressed the problem of educational access did not take into account the systemic disparities that segregated the most vulnerable populations in substandard public schools. But that didn't keep a cadre of wonderfully radical intellectual troublemakers—mostly Black women hired to teach writing in the SEEK Program—from introducing their students to the imperialist underpinnings of higher education, or from training them to be more than cogs in the university machine.

Launched in 1966 by the New York State Legislature, the Percy Ellis Sutton SEEK Program aimed to "reach qualified high school graduates who might not attend college otherwise."[57] Sutton, the program's founder, was one of the "Gang of Four": a "group of distinguished Harlem politicians" that included "attorney Basil Patterson, former New York Mayor David Dinkins and Congressman Charles B. Rangel."[58] As a politician, Sutton was formidable. He was the "longest-serving Manhattan borough president and, for more than a decade, the highest-ranking black elected official in New York City."[59] After Sutton served as an "intelligence officer"[60] with the renowned all-Black Tuskegee Airmen squadron in World War II, a combination of good college grades and the G.I. Bill enabled him to attend Columbia Law School. However, the intense hours of his two jobs as a postal worker and subway conductor were incompatible with the workload and commute. Sutton transferred to Brooklyn Law School, where juggling work and school expectations was more manageable. The SEEK Program, then, reflected Sutton's commitment to social justice in higher education because it worked to grant Black and Puerto Rican New Yorkers greater access to the city's system of colleges and universities. McKay was an ideal candidate for the program because of her exceptional promise. "She had a hell of a lot of grit and internal discipline," Pastor Scott recalled. "She wasn't going to go back to Bennett Brothers as a secretary. She was going to be something."[61] With emotional and financial support from her church family, McKay took the leap into higher education.

Not everyone at Bennett Brothers encouraged McKay's new vision. During her last year of employment with the company, McKay worked for a man she remembered as Arthur, a "very nice guy" who taught her a great deal about "how things functioned at the company."[62] Even though he tasked McKay with doing *his* work instead of completing it on his own, she gladly acquiesced, finding clerical responsibilities "more interesting"[63] than the work she had been doing in the warehouse. One day, when McKay mentioned that she was leaving Bennett Brothers to go to college, Arthur responded, "You really don't need to go to college. What you need to do is, you need to go to secretarial school, and you would make a bumper secretary."[64] McKay remembered the conversation vividly: "That word has stuck with me ever since, and I said to him, 'But I don't want to be a bumper secretary. It's not how I want to spend my life.'"[65]

With college on the horizon and a continued need to work, McKay struggled to find time for her teenage children, Pat and Harry, who would have been about fifteen and fourteen, respectively, when McKay applied to Queens. A little older and a bit more self-sufficient, Pat was not adversely

affected by her mother's absence due to school and work. They reconnected during dinner parties, and for Pat, focused and bright, success at school came easily. Things were different for Harry. He "didn't really understand"[66] why his mother was always gone. He knew that "she would try her best to take care of us but most of the time she wasn't really around to do it, to me anyway."[67] While she worked and attended school, Harry felt that his mother was not emotionally available or appropriately attentive to his needs. McKay's choices involved trade-offs. She could stay home and risk sacrificing a dream, or attend college and risk fracturing her family. Without more information about life inside 111 Road, it is impossible to imagine how the climate of the home or her relationship with Harry would have impacted her choice. All we have is her decision. Queens College would allow McKay to venture beyond the dining room for intellectual stimulation and embark on a new life in which she could prioritize her ideas and pursue her ambitions. Away from her family, she built an identity that was something other than mother, sister, daughter. Queens offered McKay the space for self-definition in a place that was uniquely hers, but it also set her on a path vastly different from the one her father had laid out for her.

MCKAY ATTENDED QUEENS COLLEGE from 1966 to 1969, during a time of radical transformation in the United States, when the antiwar effort, women's rights, and Black power sparked protests with slogans such as "Make Love, Not War," "ERA Yes," and "All Power to the People." This period, and the campus uprisings that accompanied it, had a profound impact on McKay and how she thought about the usefulness of her education. At Queens College two groups stood at the center of this maelstrom: the Ad Hoc Committee to End Political Suppression (AHCEPS) and the Students for a Democratic Society (SDS). They began their challenge to the academic status quo in 1966 with the publication of two student newspapers that violated college regulations because they had not been authorized by the Queens College Student Governments and the Faculty Committee on Student Activities and Services.[68] The SDS challenged Queens College's authority to regulate and censor student expression by releasing its publications "The Free Press" and "The Activist" on 10 March and 14 April 1966, respectively. The climate at Queens mirrored institutions across the country where students invested in antiwar, prowoman, anticapitalist, and pro-Black causes collided with university administrators willing to admit Black and Puerto Rican students but unwilling to address the toxic practices that disenfranchised these groups once on campus.

What began as seemingly innocuous off-campus publications in 1966 exploded into protests and office takeovers by 1969. On 27 March 1969, "over two hundred students successfully occupied the offices and hallways of the Social Science building" at Queens College.[69] This sit-in was driven by three issues. First, protesters occupied the building "in defense of three members of the Students for a Democratic Society who were arrested and charged for leading a protest for the removal of General Electric [and Dow Chemical] recruiters" from the Queens College campus.[70] The AHCEPS was also upset over the college's failure to reappoint Assistant Professor Sheila Delany, a medievalist who had helped "to negotiate a space for Marxist and gender-conscious investigations in a field that frequently stymied such work."[71] Related to student outrage over the treatment of Delany "was the issue of the Max-Kahn Report, which gave the personnel and Budget Committee the right to withhold the information that resulted in Professor Delany's dismissal."[72] The students presented a "Statement of Demands" to Dean George Pierson. The dean refused to meet their demands and would not override decisions made by the Student Court by lifting suspensions levied against the three students, dropping the charges against them, or rehiring Delany.[73] In response, the students resolved to sit in peaceful protest "until their demands were addressed."[74] After four days, the number of protesters had swelled to six hundred. On 1 April, President Joseph P. McMurray made what he called in a later statement the "most difficult decision . . . to bring police on to the Queens College campus to remove persons illegally occupying the Social Science Building."[75] McMurray's action led to the arrest of thirty-eight students and one professor; all were charged with trespassing.[76] In the end, President McMurray and Dean Pierson agreed to meet only one of the students' demands: "the charges against the three SDS members were dropped. The rest of the demands were never met."[77] While there is no evidence that McKay participated in the protests or race riots, they had a profound impact on her: "It was at that point that I came to understand that there was something that was radically wrong in the country,"[78] she said. Education would be the tool that McKay deployed to address inequities that seemed beyond the scope of her influence.

It had been a long time since McKay, a working mother of two, had set foot inside a classroom. She arrived at Queens without the academic preparation of some of her peers but quickly connected with faculty members who encouraged her and helped her fill the gaps in her formal education. Two professors in particular, "Michelle Cooper" and John J. McDermott, helped McKay grow as a student and modeled high-quality undergraduate

mentoring. During her first year, McKay enrolled in a class with Cooper, a young Jewish professor who, as McKay recalled, notoriously graded her papers with a red pen. After McKay received one of her weekly writing assignments drenched in "blood," she went to Cooper and asked, "Do you think I ought to be in college?"[79] Cooper laughed and reassured McKay that the feedback was not a reflection on her abilities; it was only meant to make her better. The two bonded and went on to work closely together. With Cooper's help, McKay knew which classes to select and which professors to avoid. Cooper helped McKay, as a first-generation college student, negotiate an educational experience McKay and her immediate family knew nothing about. When McKay became a college professor, she mirrored the model set by Cooper. As powerful as Cooper's impact was, McKay either misremembered Cooper's name or created a composite based on professors who influenced her, as there is no record of a Michelle Cooper or a Michael Cooper teaching at Queens during this time.[80] But the impact of Cooper, as an actual person or as a symbolic figure, is undeniable. While McKay never used a red pen to grade papers, she took great care to help enrolled students, especially her Black ones, adapt to college life.

"On the other end of Michelle Cooper"[81] was John J. McDermott, a professor in the philosophy department who played a crucial role in helping McKay navigate Queens and prepare for success at Harvard University. McDermott, who specialized in "the philosophy of culture, of literature, of medicine and classical American philosophy"[82] at Texas A&M University before his death in 2018, taught at Queens from 1956 until 1977.[83] McKay most likely crossed paths with McDermott in History of Ancient Philosophy or in Medieval Renaissance History and Philosophy, courses McKay took during her first two semesters at Queens.[84] McDermott observed that "Nellie started from scratch," adding that it never prevented her from being courageous in her studies.[85] One semester, McKay participated in "a little seminar" that included "Nellie and these four guys, four hard-core parolees. Felons. And Nellie."[86] He could still see McKay in his mind's eye: she "sat in this room with these rough guys" holding her own, and together they "studied Philosophy all semester."[87] McDermott worked closely alongside Joseph Mulholland to help McKay get acclimated to the institution. Mulholland, a "former parole officer,"[88] began as the SEEK director but his office was later ransacked by students who protested SEEK being led by a white man.[89] He was subsequently replaced with an African American program head, Dr. Ralph Hewitt Lee from Morehouse, a historically Black college in Atlanta, Georgia. The contentiousness of his appointment notwithstanding,

Mulholland protected McKay and entrusted McDermott to mentor her when he no longer could. As well-meaning as Mulholland and McDermott were, however, McKay noticed their paternalism. McDermott explained that "without Mulholland there's no Nellie";[90] McKay observed that without paternalism, there was no Queens.[91]

McDermott's philosophy class transformed her, and McKay began to rethink whether majoring in English, as she had originally intended, was the way to go. She earned an A in Shakespeare and thought, for a time, that she would become a Shakespearean. She approached Cooper with her dilemma: "I have a problem. . . . I don't know what to major in next year. . . . I either want to major in English or I want to major in Philosophy, and I can't decide."[92] In McKay's mind, there was this "tremendous problem," but Cooper, "in the blink of an eye," looked at McKay and said, "You don't have a problem, you major in English and you teach philosophy"[93]—the text itself and the belief systems that inform it. The creative problem-solving the "Cooper" figure demonstrated in this moment stayed with McKay and pushed her to look beyond the binary, beyond a zero-sum view of the world, and imagine creative pathways to achieve her goals.

McKay might have initially lacked confidence when she enrolled at Queens, but through hard work, drive, and support from invested professors across disciplines, as well as her Hollis church family, she quickly became a "powerful"[94] figure who began to see graduate school as a possible next step. McKay was awarded English departmental honors, earned a spot on the Dean's List, and graduated cum laude in just three years by loading up on courses between academic terms.[95] Enrolled at Queens in 1966 as a thirty-six-year-old freshman, McKay did not end her day after class: she still had to commute home, where she started her "second shift" as a mother and provider for two. It was taxing, but ultimately, for McKay, college was a joy: "I went to Queens and I loved it. I loved the whole nine yards of that. College was just exactly what I wanted."[96]

The philosophical orientation McKay developed at Queens would become indispensable to her approach to teaching, reading, and writing about Black women's literature. Alongside a collective of Black women dispersed across institutions as early-career professors and graduate students, across geographies in the Northeast, Southeast, Midwest, and West Coast, McKay would find herself theorizing about Black women's writing at the same time she engaged in the groundbreaking work of recovering it. The methodology of these Black women was inherently collaborative and their motivations expressly personal: their observed lack of research on Black women's ways

of knowing, ways of seeing, and ways of being in the world spurred on their work.

MCKAY PARTICIPATED IN THE SEEK Program at the same time as other Black women who worked as SEEK instructors but would later become renowned in their own right as writers and scholars. Toni Cade (who later added Bambara), June Jordan, Barbara T. Christian, and Audre Lorde taught at campuses across the city before they published now-famous texts such as *The Black Woman* (1970), *Soulscript: Afro-American Poetry* (1970), *Black Women Novelists: The Development of a Tradition* (1980), and *Zami: A New Spelling of My Name* (1982), respectively. Even though there's no evidence that any of these women taught McKay while she was a student, she later befriended several of them—certainly Jordan, Christian, and Lorde—as her letters and collaborations confirm. Their trajectories were united, among other things, around the effort to elevate Black women's literature and to practice distinctly inclusive pedagogies informed by their intellectual work as Black feminists. Before "inclusive teaching" became a pedagogical buzzword, Bambara, Jordan, Christian, and Lorde practiced inclusivity through teaching practices that challenged narratives of Black and Puerto Rican students as lacking, as problems to be solved, or as groups whose communicative practices were substandard expressive modes for an academic environment. They challenged rampant paternalism, not by encouraging their Black and brown students to assimilate but by connecting them with literature that animated their experiences and affirmed the value of the literacies they brought to the classroom from their home communities.

In a program that saw an astounding confluence of talent, SEEK's Basic Writing course and the open structure of the program gave instructors—many of them Black women at the beginning of their academic careers—carte blanche in syllabus development. SEEK instructors worked without a "set curriculum or a required reading list" and as a result relied on one another for assignments and book ideas.[97] Feminist poet Adrienne Rich, who also taught in the SEEK Program in the late 1960s and early 1970s, noted how instructors "poached off each others' booklists, methods, essay topics, grammar-teaching exercises, and anything else that we hoped would 'work' for us."[98] Danica Savonick's "Insurgent Knowledge: The Poetics and Pedagogy of Toni Cade Bambara, June Jordan, Audre Lorde, and Adrienne Rich in the Era of Open Admissions," a dissertation based on extensive archival research on Lorde, Jordan, Bambara, and Rich, culled unpublished archival artifacts to document how these scholars "shaped U.S. education."[99] Savonick's

important "genealogy of feminist poet-teachers as leaders of pedagogical, institutional, and social change"[100] helped paint a picture of the radical climate within New York's city college system at the very moment McKay became an undergraduate at Queens.

Through collaboration, student-centered practices, and the rejection of what had hitherto been a "banking"[101] concept of education, Bambara, Jordan, Christian, and Lorde used the classroom as a liberatory space and Black writing as a pedagogical tool to redefine education for Black and Puerto Rican students. In the words of Jordan, their efforts turned "the individual drama of being human into words"[102] so that students who supposedly had been written off by high school guidance counselors and academic gatekeepers could join the college community and, among other things, interrogate the relevance of a college education against the backdrop of anti-Black violence within the city's police state. When McKay joined the SEEK Program in 1966, she felt the energy emanating across City University of New York (CUNY) campuses and, even as an indirect beneficiary of the groundbreaking pedagogies of her Black woman peers, felt inspired to make change through literary studies that inspired social justice.

The work of SEEK instructor Barbara T. Christian captured this feeling. Born on 12 December 1943, in St. Thomas, Virgin Islands, Christian became a preeminent professor of Black women's literature at the University of California, Berkeley, publishing the indispensable *Black Women Novelists: The Development of a Tradition, 1892–1976* in 1980. Christian first joined the SEEK Program when, as a graduate student at Columbia University, she was hired to work as an instructor. Christian was dubious of a program with a mission she sarcastically described as "designed to uplift apparently uneducable black and Puerto Rican youth by giving them the skills to enter city colleges"[103] and fundamentally rejected the deficit model used to describe the students SEEK recruited. Through "a sequence of courses, academic counseling, financial aid counseling, and a Learning Skills Center," SEEK was "designed to help students achieve academic success."[104] Even today, CUNY's Office of Financial Affairs describes the program in the degrading terms Christian decried: "[SEEK] is a program designed to meet the needs of students who are considered to be economically disadvantaged and academically underprepared."[105] The mission of the program was access, but it stood on a premise of inherent inequality that was anathema to the beliefs of teachers such as Lorde, Bambara, Jordan, and Rich.

Christian's first experience in teaching African American literature was transformative, and in "Being the Subject and the Object," an essay that refer-

enced her work as a partner in the SEEK Program, she attributed her early contact with Black writers as foundational to her philosophy of teaching and mentoring. The essay discussed Toni Morrison's *The Bluest Eye* (1970) and Alice Walker's *Third Life of Grange Copeland* (1970), novels penned by Black woman writers who are taught regularly today but whose books at the time were, at best, hard to come by and, at worst, out of print. The literature spoke to Christian, who sought to redefine "misrepresentations as to who a black woman should be."[106] Years later, McKay would do this very same thing in her teaching.

Early in McKay's teaching career, she was already living out the pedagogical ethos of the Black women of SEEK. One example came in the fall of 1982, when she taught Major Black Writers. The syllabus moved from external triggers, namely American society, literary scholarship, and feminist studies, as justification for her class, to an inward focus, concentrating on love as the ultimate motivation for study. She wrote: "1. I love life, I love literature, I see literature as a dynamic expression of life, and I am definitely partial to black women's lives and the literature of black women writers. / 2. I love to share my love of all of these with you. . . . / 6. This course forces me to learn and to grow, intellectually and emotionally, in ways that no other course that I took as a student, or have conducted as a teacher, has done. When it is over we will all be wiser, and perhaps even better people, for having shared this learning experience together."[107] The vulnerability expressed in these sentiments is powerful, for as McKay titled her reasons "Why I Teach This Course" and framed them within a love discourse, she risked exposing herself to rejection from students unwilling to accept what she had to offer. Any fear of potential risks came second to the strength she found within the literature read and the experiences explored within the class. McKay named the source of this strength explicitly in reason 5, where she asserted that "Black women, contrary to anything else you have heard or may think—are at the center of their world. This class will affirm and celebrate that. I hope you do too as you read these writers."[108] As much a moment to set the record straight as it is a reminder to herself of the source of her strength, this statement boldly moved the experiences of Black women from peripheral to primary, or, in the words of bell hooks, from margin to center. There is no supplication here, no begging to be part of American culture, no wish for the academy to bend toward inclusion, no desire for Black and white women to be friends. There is just the clear, unadulterated centrality of the Black woman's experience on McKay's syllabus.

The intellectual and emotional shift resulting from McKay's acknowledgment that Black women are at "the center of their world" allowed her, in the spirit of Christian and other SEEK professors, to move beyond misrecognition. McKay rejected what forces beyond her control told her about herself. American racism, academic paternalism, or feminist elitism would not define her. Moreover, she avoided working from a reactive posture and instead used her imagination to develop a picture of where she wanted to go and with whom she wanted to travel. She centered her experience as a Black woman not just to withstand racism and sexism but also to experience laughter, joy, and pleasure—to live a full and rich human life, to live as if you are at the center of your world. There was a collective impulse, too, suggested through McKay's use of the plural "women," and this gesture toward community was a harbinger of what would become McKay's professional philosophy: to dream creatively, to work collaboratively, and to celebrate collectively.

BY HER SENIOR YEAR OF COLLEGE, McKay knew that she was on her way to graduate school. At first, she thought that she "was going to go to graduate school and become a college professor so [she] could teach Shakespeare."[109] Her vision of professional opportunities expanded the further she went in her studies at Queens. Over time, she began to envision literary study as a tool for social justice. She had fallen in love with literature and was committed "to study the great American writers"[110] so they could provide her with the answers she needed to solve the problems the country faced when she was a student. A New Yorker to her core, McKay never thought about applying anywhere besides New York for graduate study. She had been nominated for, and awarded, a Woodrow Wilson Fellowship by a "dean of the college with whom [she] did an independent study of Shakespeare's tragedies"[111] and was looking forward to spending someone else's money at the graduate school of her choice.

She held news of her Woodrow Wilson award close to the vest. Then, by chance, she ran into an unnamed sociology professor with whom she had taken a class. Even though "his course totally turned [her] off from Sociology all together,"[112] the two had managed to stay in touch. She mentioned the fellowship and, thrilled by the news of her success, he asked where she had applied. McKay offered three schools: Columbia, New York University, and CUNY. He asked, "And where outside of New York did you apply for graduate school?" McKay replied, "Nowhere."[113] He insisted that she apply somewhere else. McKay thought, "Okay. I'll fix his wagon. I'm going to ap-

ply to Harvard, Yale, and Princeton. That'll fix him."[114] Rejected from Columbia but accepted by CUNY and NYU, McKay was also, as we know, accepted to Harvard. "And of course," McKay said, "the rest is history."[115]

In spite of her limited exposure to Black literature as a college student, McKay's experience at Queens propelled her toward Black writing as a vehicle for enacting social change and as a mechanism for inspiring social justice. Her personal statement to Harvard expressed her interest in studying American literature but outlined a particular investment in doing "intensive research in the field of Afro-American Literature"[116] to have an impact on the Black students she might one day teach:

> This choice [to study American Literature] has been reached for two main reasons. First, as a Negro American, I am sensitively aware of the need for more research in this area. I hope my research will uncover more of this rich area of our heritage. Secondly, as a teacher, I will have an opportunity to spend some time with young Negro Americans. Communicating with these young people through the medium of literature, especially that of their own heritage, should stimulate an ethnic pride and help them towards a greater sense of security and stability within the framework of American society.[117]

From the very beginning of her studies, McKay saw herself as someone who would not just research and teach but also inspire and lead. In her statement, she returned to her earlier English-versus-philosophy conundrum, explaining, "It is my feeling that young people, especially those from a minority background, can more easily be reached and will more readily respond to a philosophy of life revealed through literature, especially the literature of their ethnic background, than through a course in Philosophy."[118] In her conclusion, McKay asserted her interest in making "a worthwhile contribution to the field of Afro-American Literature by making it more accessible."[119] McKay knew, from the very beginning, what she wanted to do and why she wanted to do it. With her acceptance to Harvard, she was moving forward, steady on.

AS MCKAY COMPLETED HER BACHELOR'S DEGREE at Queens and looked forward to graduate study, her daughter, Pat, was finishing high school and moving toward a life change all her own. An industrious student and budding poet in her own right, Pat had her eyes set on attending Columbia University—and only Columbia. She was just like her mother in this regard: a die-hard New Yorker who felt no need to venture beyond the city for advanced study.

When she sat down with her high school guidance counselor to discuss her college applications, Columbia was the sole institution on what barely qualified as a list. Questioned on the practicality of investing in only one college, Pat mused, "Why do I need to apply to any other school if Columbia is the only one I want to attend?"[120] With gentle cajoling, the counselor convinced Pat to apply to Harvard as well. In a move that seems made for the movies, Pat submitted her college application for undergraduate admission to Radcliffe College the same year her mother applied to Harvard's graduate program in English. As fate would have it, both McKay and daughter Pat were accepted. The good news should have made it a happy time at 111 Road. But this was not the case. While McKay's and Patricia's Harvard acceptances promised to expand their worlds by taking them to Cambridge, Massachusetts, their bright futures cast a shadow over Harry, the son and brother left in their wake, and exiled him from the world of ideas and expanding possibilities rising to greet his mother and sister.

Harry, who was born about a year after his sister, lived in another world, a separate solar system from the one orbited by mother and daughter, who together were planet and star. While McKay and Pat were entertaining guests during champagne-soaked dinners and discussing the state of the world, life, and art, Harry struggled to make do. So, he did what he could. Living his life in the streets fit him better than living a life of the mind: "Everybody had the brains," he said, "and I wasn't in the line for none."[121] He resented the fact that he was unable to stay in school, let alone succeed there, and instead pursued a revolving door of odd jobs. By his own description he was, at one time or another, a failed mechanic, a gypsy cab driver, a janitor, and a messenger. Even though he "could basically sit down and reason with people about just about anything," by his own account he seemed to live with severe learning deficiencies that prevented him, for quite a while, from even learning to tell time.[122]

The hardest part of measuring himself against his mother's yardstick was that in his mind, Harry was doing his level best. His mother and grandfather, however, thought differently and admonished Harry for not applying himself: "Everybody's supposed to be able to do this,"[123] they told him, and ignored Harry as he insisted that he was trying as hard as he could. "Nobody ever listened to me," Harry complained. "No matter what, nobody ever heard me."[124] Dejected, Harry felt pushed further to the periphery of his immediate family. As the possibilities for McKay and Pat expanded, Harry's world closed in, and he was eventually pushed out of 111 Road (by whom, I don't know) and resorted to living on trains, stealing bikes, and

pilfering from the collection plate to stay afloat. He yearned for a relationship with his father, Joseph, who still lived in Jamaica, and the nurturing hand of a mother who "kept moving" and "was always working."[125] But it never came. Harry was a "lost soul" who tried to find a home in the Navy but was rejected, as I understand it, due to flat feet.[126]

Pursuing the college degree that allowed McKay to look beyond the limits of life at home and dead-end work at Bennett Brothers also marked the beginning of her estrangement from Harry. By all accounts, as a teenager of about thirteen or fourteen, he was often left in the house alone with no one to help care for him. When McKay attended night school at Queens, her friend Joyce Scott frequently cooked for Harry, since neither his aunt nor his grandfather did so. According to Scott, the only thing McKay regretted about moving from Queens to Cambridge was her failed relationship with her son. If Harry was on the periphery of home life when McKay and Pat were in Queens, he disappeared from the picture altogether once they got to Harvard—the place where McKay and her daughter, for all intents and purposes, became sisters. Harry was about seventeen when McKay set off for graduate school, and he struggled with the ultimatum McKay presented. "She told me I had a choice of where I could go. I could either come with her or go to Granny. The only thing I knew at the time was that [Boston] would've been the wrong place for me. . . . All I used to hear is Boston was somewhat of an educational town, colleges and this and that. I knew I didn't fit in there. . . . That day, it was almost like my heart dropped."[127] Both McKay and her son longed for nurturing from their mothers. McKay never received it, so perhaps she didn't have it to give. Years later, whenever Harry needed money, though, McKay sent it to her son through her sister, Connie. Mother and son remained estranged until McKay's death. Harry did not attend his mother's memorial.

Harvard symbolized the realization of a dream for McKay and Pat. It was also the final act that separated McKay's life from her immediate family. Before Cambridge, 111 Road was a house of five: Harry, Nellie, Connie, Pat, and Harry. After Cambridge, Pat never returned home; McKay visited infrequently. Try as she might to leave memories of home firmly rooted in the past, they steadily crept into her present. The ghost of her mother's premature death followed her wherever she went. The unanswered questions and grainy photo left an open wound that might be healed if McKay could be to others what she never had herself.

Joyce Scott was the one other person who McKay carried with her into her new life in Cambridge and beyond. The two first met when McKay

joined Hollis Presbyterian, where Joyce's husband, Don, was pastor. During their over-forty-year friendship, the two "really became as close to being sisters" as they could be and displayed this sisterly spirit by being "mutually supportive" of each other throughout their lives.[128] Scott offered "a sympathetic ear and a quiet voice of support through difficult times,"[129] and McKay relied on Scott's listening way—a skill Scott most likely cultivated in her career as a social worker—as McKay struggled at Queens and navigated the elite world of Harvard. When McKay transitioned from graduate student to faculty member, she left 111 Road behind but carried with her Scott's enduring friendship. Scott was McKay's best friend from "the old days," and she knew all about the family history McKay kept hidden from her friends in academe. She maintained McKay's confidences and provided quiet support away from the intellectual community that McKay formed as she advanced in her educational pursuits.

As McKay planned to venture from Queens to Cambridge, she wrote her friend a letter that reflected on their friendship and the place Scott had played, and would always play, in her life. This letter, notable as the earliest of McKay's correspondences that I have access to, documented "the inner soul" of a woman in the days leading up to a momentous shift in her life. Here, we get a glimpse into early Nellie Y. McKay. Before she earned the degree at Harvard, before she became a notable figure, before her dreams materialized, she was a woman in the midst of a transition, searching for a way to say goodbye without bidding farewell. Of course, there was no way for her to anticipate all that her future would hold, but the letter captures quiet thoughts and ritualizes her break with the past. McKay was leaving 111 Road behind, but she would carry Scott forever in her heart:

My dear Joyce,

As the time draws near for me to leave the place and people who have comprised that part of me that has been the familiar for many years now it seems only fitting to sit down and put my thoughts in some sort of orderly fashion. It has been twelve years on 111 Road, the major part of my adult life. Needless to say I don't suppose that I will ever be out of the influence of many of the experiences I have had while living here. There have been very sad ones and there have been very happy ones and I suppose that it is the combination of both that determine the factors that make a whole life good or bad.

But while it might be possible for me to sit and write a book on my experiences while I lived in Hollis, the purpose of this correspondence

is to be rather specific about how I do feel about having gotten to know you. A long time ago (it seems like a hundred years now) I told you that you were the first person with whom I ever felt comfortable as a friend in talking about the things that were painful to me. I think I have done some growing since the time I first told you that and probably the most important thing I learned from being able to talk with you is that friendship is not a luxury confined to enjoyment when the sun shines. It is warm and lovely and protective when the showers are coming down. Thanks for helping me to see that.

. . . If I were a poet or an artist like my daughter I would express my feelings in a more aesthetic manner. Not being endowed with such gifts I can only say what I feel in this manner, but I hope you will understand and accept the sentiments as coming from the inner soul of

Your friend,

Nellie[130]

McKay's letter to Scott foreshadows how liminality and compartmentalization would allow McKay to keep separate the parts of her life she wanted to remain distinct without forsaking the friendship that was most meaningful to her. Not quite a part of her academic world yet years and miles apart from her past on 111 Road, McKay's friendship with Scott was a safe space between worlds where, in the absence of a unity between past and present, on the horizon of a new life at Harvard, McKay would enact new strategies to conceal personal truths.

IN HER PREWAR APARTMENT AT 274 Brookline Street in Cambridge, Massachusetts, Nellie Y. McKay cooked dinner for expected guests. This building, a brick midrise unit nestled in Cambridgeport, located at the corner of Putnam and a stone's throw away from the Charles River, was her first home as a graduate student at Harvard. Far enough from Harvard Square that few undergraduates peopled the streets, it was a more residential district by comparison, good for graduate students and those embarking on their studies at the law school nearby. For her daughter, Patricia, a first-year student at Radcliffe, Apartment 3 was her sometime home away from home. A place to enjoy her mother and the dining ritual they had begun during their days on 111 Road in Queens. Friends and food, to be sure. But during one visit, a secret, too.

With plenty of pepper on hand, McKay most likely made a family favorite because Pat, her boyfriend, and his roommates were coming over. Ackee

and saltfish, perhaps? It was something Pat recalls her mother "cooking for us when we were growing up, which I liked a lot."[131] Once everyone arrived, it was Pat and "the guys," a crew of undergraduates at her mother's house talking to one another and getting to know their host. Pat and her friends eating, laughing. Dinah Washington playing in the background, maybe. Or Nina Simone's "To Be Young, Gifted and Black," the song McKay listened to every day for her first two years of graduate school: "What took me through those first two years was Nina," who McKay appreciated for her "sense of pride in being black."[132] Then, sometime after her guests' arrival, the din fractured by a voice asking Pat something like "Who's that?" McKay, who overheard, responded cheekily: "Oh, we're sisters!"[133]

This joke became their secret. It was the moment Nellie and Pat went from being mother and daughter to becoming sisters. It was easy to believe, after all—the two as peers. As a graduate student, McKay had been carded at least once, the bartender demanding proof that she was twenty-one.[134] While McKay's Harvard professors and peers knew nothing about the true relationship between the pair, Pat's friends were always well aware. Among Pat's friends, there was never any question about who her mother was: "She acted like my mother when we were alone, and in fact my closest friends always knew she was my mother,"[135] explained daughter-cum-sister. "It's not like everyone who interacted with us didn't know,"[136] she clarified. "In our lives together, there was never any question that this was a mother and daughter relationship, so I didn't feel in any way deprived. But [to] the rest of the world, hey, it was a joke."[137] The joke that became their secret. "Our private joke against the world."[138]

The "joke" marked the beginning of a bifurcation, a separation between McKay's personal life and professional self. The elusive "Why?" of McKay's choices—the reason behind her withholdings—is rooted in her childhood. There's reason to believe that McKay learned how to withhold, to keep quiet about family matters, simply by breathing the air inside 111 Road. Silence was "the absolute atmosphere of the house,"[139] remembered Scott, and the most deafening silence involved McKay's deceased mother. McKay tried to convince her father to open up about her, but no matter how often "Nellie tried to get [her father] to talk to her," explained Scott, "he would not. He slammed that door over and over and he never stopped. He never stopped."[140] As painful as it was to have so many unanswered questions, McKay continued this practice with her own children by keeping them in the dark about their father, Joseph McKay. "Pat and Harry did not know anything about their father or that Nellie and he were divorced," Scott recalled, her mind

drifting back to a conversation between herself and McKay following a church function, and McKay was intent on not telling them.[141] On the one hand, McKay's decision might be chalked up to a generational practice in which "grown-folks'" business was off limits to young people; on the other hand, McKay may have been replicating, either consciously or unconsciously, a parental model for how to deal with personal pain.

In what was, perhaps, a subconscious attempt to heal this early trauma, McKay developed a lasting preoccupation with opening doors for others. Once she became a faculty member, she maintained an open-door policy with her colleagues and students and opened doors for the students and faculty she mentored. These acts of collegiality and availability as a mentor appear to have been an effort to be available to others in ways that members of her family weren't available to her. Earning her graduate degree, then, would place her in a position to open doors for others and possibly heal herself.

When McKay arrived at Harvard, in the fall of 1969, she found another campus erupting with political fervor. At both Harvard and Queens, students took over buildings to demand that administrators be held accountable for their support of the Vietnam War and their disavowal of Black students on campus. On both campuses, the police were called in to forcibly remove protesters who impeded university business. While Harvard students were primarily concerned with the Vietnam War and Black studies, Houghton Professor of Theology[142] Preston N. Williams clarified who sided where: "Generally speaking, the white students were angry about Vietnam and the Black students were angry about the lack of Black Studies."[143] Harvard's hallowed halls could not insulate it from the tensions consuming the nation. Inevitably, protests erupted. Pressure to move forward with an Afro-American studies department and adjacent issues mounted on 9 April 1969, when student protesters "stormed University Hall," ransacked the building, and "forcibly removed all Harvard administrators."[144]

This event, which was later chronicled by former Harvard professor Roger Rosenblatt in *Coming Apart: A Memoir of the Harvard Wars of 1969* (1977), marked an important cultural shift at the institution—a shift not unlike the rise of student protests and the call for Black studies at campuses across the country. "Harvard's upheaval," Rosenblatt claimed, "was not simply a typical war of the late 1960s between radical students and University officials. It was a deeper and more far-reaching conflict between older and younger sensibilities, between those who believed in institutions and those who wanted to tear them down, between those who were driven by sympathy for individual causes, and those who stood with traditional social

structures."[145] According to one article in the *Harvard Crimson*, the university's daily newspaper, "a changing student body in a very traditional college atmosphere" spurred on a "wave of student radicalism" that led to "riots and protests" challenging even the most firmly entrenched Harvard traditions.[146] But conflicts between old and new Harvard were about much more than social movements beyond their walls. These conflicts were also about inclusion and how the institution would make space for those who were marginalized in social, cultural, and, now, academic settings, within an elitist space that perpetually placed white men and their interests atop the educational hierarchy.

By September 1969, the year McKay set foot on campus, the smoke had cleared from student protests, but the divisions had been made clear. Robert Kiely, a professor in the English department who eventually served as the second reader on McKay's dissertation, was a young father and husband at the time. Kiely, whose bright eyes and ready smile bear no trace of the pressures he faced as a young professor, remembered a time "of turmoil in the country and in universities," a time when "protests against the war" and "demands for increases in recruitment of African-Americans and women in student body and faculty" dominated the day.[147] The English department had recently voted to include African American literature in its curriculum, but tensions between faculty, students, and administrators continued to run high.

During this next phase of Harvard's history, defined by *Blacks at Harvard: A Documentary History of African-American Experience at Harvard and Radcliffe* (1993) as the period after 1970, "Harvard hosted more Black students, professors, administrators, and guests than in all of the previous years combined."[148] Change was on the horizon, and this change impacted women at the same time it impacted Black people. Musicologist Eileen Southern, who in 1975 became "the first black woman to be appointed a full professor with tenure at Harvard,"[149] described what it meant to negotiate race and gender at elite, predominately white institutions and between Black studies and women's studies. She was designated as both the "black presence" and the "female presence" on the Arts and Sciences faculty yet occupied a liminal existence between them both: "Neither group paid much attention to my presence as a new member; indeed, the attitude of the black men . . . generally was that of indifference, shifting at times to outright hostility."[150] While one may think that solo members of minority groups would welcome new faces into the fold, that was not Southern's experience: "And to me, as a newcomer, it seemed that the minorities already at Har-

vard did not welcome the idea of being joined by others. It was as if they were reluctant to lose their status of being 'the only one.'"[151] The tensions Southern described were in full swing while McKay was a graduate student at Harvard.

Fortunately for McKay, there was another Black graduate student in English who was happy to help her adjust to life at Harvard. That graduate student was Arnold Rampersad: now professor emeritus at Stanford University and a 2010 recipient of the National Humanities Medal. Rampersad, who would later pen award-winning biographies of W. E. B. Du Bois, Langston Hughes, and Jackie Robinson, arrived in Cambridge in 1968, the year before McKay's arrival. They met in Harvard Yard, a grass courtyard nestled in the heart of Harvard's campus where persons convene and paths cross. McKay recalled their meeting as a defining moment in her life as a graduate student that foreshadowed the synchronicity she and Rampersad would maintain as colleagues throughout their careers:

> The first person I ran into when I walked across the Harvard Yard for the first time was Arnold Rampersad. We were walking in opposite directions and he said, "You look like a new graduate student." I said, "How could you know?" He said, "You just have that look." And we went off and had coffee and he told me a few things. He was an Americanist who had come the year before and he was going to study American literature. And I was going to be an Americanist, so therefore we were going to be in the same camp, and just so on. And we became very fast friends, from that time.[152]

Rampersad, who was born in Trinidad, found his way to Harvard from Bowling Green University in Ohio. By his own admission, he "got into Bowling Green by accident."[153] He had lived for "twenty-one years in Trinidad" and, after taking a job in Barbados, had "given up all hope of going to college."[154] That was until he learned about a partial-scholarship program sponsored by the U.S. Department of State for persons from the Caribbean to study in the United States. Imagining that the State Department would want to cultivate him as a journalist, Rampersad applied to pursue a journalism degree. He had always excelled in English as a high school student at St. Mary's College, a secondary school blocks away from the National Archives of Trinidad and Tobago in Port of Spain.

Sure enough, the State Department sent Rampersad to Bowling Green. But journalism, per se, would not be his future. Soon after his arrival he enrolled in a course with a professor who altered his academic trajectory.

Professor Alma J. Payne taught Rampersad's course on nineteenth-century American literature and enamored the budding scholar with the study of literature. The experience with Payne clarified, for Rampersad, what he wanted to do with the rest of his career: "to study American literature and perhaps, who knows, teach it."[155] With courses from his education back in Trinidad and summer school classes contributing to his total college credit count, Rampersad earned his degree at Bowling Green in just two years. While completing a master's degree there, he applied to graduate programs at several institutions, including Stanford and Harvard. He was accepted to both. He received a full ride to Stanford and had no guarantee for funding at Harvard, but he nevertheless set out for Harvard in the fall of 1968.

McKay's circle of Black graduate school friends expanded further to include the woman with whom she would correspond for nearly thirty years: Nell Irvin Painter. McKay met Painter, a Princeton University historian emerita and the author of definitive histories of Hosea Hudson, Sojourner Truth, and white people, "in the fall of 1969,"[156] while McKay was a first-year graduate student in English and Painter a graduate student in history. They entered Harvard the same year, but their backgrounds and academic trajectories were vastly different. Painter's parents, Frank E. and Dona L. Irvin, had met at Houston College for Negroes (now Texas Southern University).[157] Her father worked "for many years" for the Chemistry Department at the University of California, Berkeley, while Painter's mother, a public-school teacher, taught in the Oakland public schools.[158] Married for over seventy years, the Irvins were shaken by the death of their five-year-old son, who would have been Painter's older brother, during a botched tonsillectomy.[159] His passing influenced their approach to parenting their only other child, Painter, born Nell Elizabeth Irvin.

Grief-stricken by the unexpected death of their young son, they "focused on" their daughter and took efforts to make "life easy and welcome for her."[160] As college graduates themselves, Painter's parents understood the value of higher education and encouraged her to explore freely. They nurtured Painter by providing her with familial love, encouragement, and financial resources to launch her into a world where she could develop the intellectual gifts and work ethic that would lead to her becoming one of the most prolific and recognizable American historians. While McKay came to Harvard unsure of her abilities and lacking in the cultural and social capital she thought her peers possessed in spades, Rampersad was self-assured and dignified; Painter was poised and privileged. Their attributes contrasted sharply with McKay's insecurity and working-class upbringing, but,

collectively, Rampersad's and Painter's self-confident and sophisticated worldviews were key to helping McKay manage some of her most difficult periods at Harvard. Rampersad and Painter were central to McKay's thinking about her education at Harvard and her ability to be successful there.

McKay experienced Harvard as an elitist institution steeped in and committed to maintaining its superiority. McKay was eager to attend at first, but her excitement faded little by little as she came to feel "out of place within the vast sea of whiteness and New England culture. It was alienating. There was this feeling that if you didn't come from there, you didn't belong there."[161] Harvard may not have necessarily gone "out of its way to make people feel miserable,"[162] but it did not cultivate a climate of belongingness either. So as a Black woman in a place that didn't know "what to do with women or with African Americans," McKay found herself in a "double bind."[163] She was not alone in her feelings about Harvard's climate. Cheryl A. Wall, who arrived at Harvard for graduate study a short time after McKay and became a scholar, professor, and specialist in Black women's literature at Rutgers University in New Jersey before passing in 2020, came prepared for Harvard's academic rigors but not for the shock of affluence and excess that colored her classroom experience.

Born in New York City and raised in South Jamaica, Queens, Wall was the daughter of a Baptist minister and came of age in a household where "education was highly valued."[164] An English major at the historically Black Howard University, Wall was "more interested in American Studies" than English for graduate study and enrolled in the History of American Civilization program at Harvard following her participation in an intensive summer study program for "Negro students" sponsored by the Ford Foundation.[165] The summer program opened up a world of possibilities for Wall: "It was that program that really made me think, 'Oh well, this is something that you would really enjoy and that you would be good at.' It was important."[166]

Once at Harvard, Wall realized that her summer preparation was only part of the lesson she would learn about how to be successful there. For example, one day, after taking time to carefully prepare for class, she entered the room and, after discussion commenced, found herself completely outside of the conversation, unable to mimic the academic moves of her peers. Paralyzed, she kept quiet. When she learned, later, that there were students who had not read but instead had "bullshitted" their way through the discussion, she experienced a new degree of alienation. She learned that "it was not substance, it was style, it was performance, and it was a performance that was enabled by lives of great privilege."[167] That moment in the

classroom was, for Wall, a very "prototypical Harvard experience"; navigating the institution's extreme "material wealth" and the privilege that accompanied it, she bemoaned, "was a constant challenge."[168] Given the paucity of Black graduate students at Harvard before 1970, no wonder McKay struggled to acclimate.

McKay's difficulties turned acute when it became clear that the nurturing she had received as a student at Queens would not be found at Harvard. She worked hard to maintain a veneer of strength in the face of her difficulties, but her efforts were futile. She could not keep her problems hidden from two of her dissertation advisers, Robert Kiely and Warner Berthoff. They knew she was having trouble, even if she kept her difficulties to herself. Kiely, an assistant professor at the time, imagined that she "must have felt pretty lonely in the crowd of white students," even though "she never once complained to [him]."[169] Kiely was a rarity within Harvard's otherwise conservative English department. An Americanist, Kiely was open to McKay's interest in Toomer and supported her study of his life and work even though he knew nothing about the author who had penned the imagistic prose poem *Cane* in 1923 and about whom McKay had chosen to write her dissertation. Harvard Divinity School professor Preston N. Williams remembered Kiely as "one of the greatest gifts of Harvard to the literature community and to its movement and the direction of diversity. If she had Kiely as her dissertation adviser, she would have gotten support. But if she would have been working with some of the other folks in the department at that time, she would not have gotten support."[170]

The late Warner Berthoff, another faculty member in the English department and a member of her dissertation committee, learned of McKay's difficulties and encouraged her when he could. He recalled "one particular instance when, reading a chapter draft, I came across one sentence that seemed to me extraordinarily good: both substantial in content and quite elegantly phrased; it was a pleasure for both of us when I read it back to her and complimented her."[171] Their support stuck with McKay, who subsequently dedicated her compilation *Critical Essays on Toni Morrison* (1988) to Kiely and Berthoff, among others, clearly grateful for their encouragement. As appreciative as she was for their words of support, intermittent praise was not enough. Sporadic wouldn't suffice. Just two years after enrolling at Harvard, riddled with self-doubt and ambivalent about her path, McKay considered withdrawing.

McKay needed sage advice, so she sought the counsel of the ever-sensible Arnold Rampersad to help her come to grips with the fact that she was look-

ing for a way out of the institution she had worked so hard to get into. "I wasn't sure what I wanted to do," McKay recalled. "I just knew I had to get out of there. And I remember telling Rampersad."[172] Even though she counted Rampersad as a friend, she did not look forward to admitting that Harvard had gotten the better of her. Perhaps McKay thought her friend would be disappointed when she forewarned, "I have something to tell you and I know you're not going to like it."[173] To her surprise, Rampersad was not the least bit fazed by her admission. Instead of responding with disappointment, as she had anticipated, he responded with compassion. "Oh, you don't have to feel badly about that," he reassured her. "A lot of people do that."[174] He reminded McKay that "Boston is full of schools" and encouraged her to cast a wide net in her search for employment.[175] McKay promptly shared her plans with her network of friends in the area. When Andrea B. Rushing, another Queens College graduate and, later, professor emerita of English at Amherst College, learned that McKay was in the market for academic employment, she offered fortuitous news: Rushing was leaving her teaching position at nearby Simmons College. Hopeful about her prospects, McKay applied.

Unlike Harvard, which conferred PhDs, Simmons was a women's college grounded in the liberal arts that prioritized teaching and building the capacity of its students. McKay landed the position, hoping that Simmons students, faculty, and campus culture would be the "antidote" to what ailed her about Harvard.[176] There was much about the history and culture at Simmons that would have appealed to McKay. Founded in the late nineteenth century by a Boston clothier who revolutionized prêt-à-porter suit making, Simmons College, now Simmons University,[177] aimed to educate women and prepare them to be economically self-sufficient by pursuing vocations outside the home. The "cult of domesticity" was a dominant ideology of the nineteenth century, governing white women's roles and life choices according to a set of principles that dictated what they should value; this "cult" also fashioned a set of spheres that demarcated the boundaries of their work. Women were to be pious, pure, submissive, and domestic. Their work, then, was limited to the home and hearth, where child-rearing and other household duties held prominence.

While the category seems gender-specific, as Harriet Jacobs reminded us in *Incidents in the Life of a Slave Girl* (1861), it was also racially inflected. When Linda Brent, the narrative's protagonist, intoned, "Reader, my story ends with freedom; not in the usual way, with marriage,"[178] she invoked the marriage trope of nineteenth-century Victorian novels and recast it according to enslaved Black women's ultimate goal: freedom. White women could

be pious, pure, submissive, and domestic. Enslaved Black women could not. Simmons College considered this history and not only provided women of the day—notably those who could afford a college degree—access to higher education but also made inclusive strides earlier than most. In 1914, the institution "produced the first African-American Simmons graduate"; it was also "one of the only private colleges that did not impose admission quotas on Jewish students during the first half of the 1900s."[179] McKay would be joining a faculty that valued teaching and promoted inclusive social justice for women.

On 22 September 1971, McKay submitted a notice of withdrawal to Harvard, indicating that she had "accepted a teaching position at [sic] local college for one year."[180] By her own description, McKay, who would go on to win teaching awards at the University of Wisconsin–Madison, extended the social justice–driven focus of her SEEK experience and developed what would become her signature pedagogy at Simmons. She enjoyed being part of a close-knit department committed to developing the potential of young women. Simmons boasts several notable Black women graduates, among them journalist and late "Washington Week" coanchor Gwen Ifill, chief executive and former Rockefeller Foundation trustee Ann Fudge, and Grammy-nominated jazz vocalist Nnenna Freelon, and McKay happily served as one of a handful of faces on the faculty and staff side that Black women students could encounter during their time at Simmons.[181] At Harvard, McKay had struggled to find her place; but at Simmons, and as part of a broad-based Boston community of Black women, McKay was able to make a space for herself, and eventually for other Black women, by cultivating ideas and developing relationships that would serve as a lifetime lifeline of support.

In contrast with all that had alienated McKay from Harvard, she felt welcomed within a coterie of Black women in Boston, many of whom had descended upon the city for academic jobs or graduate study. Together, they taught themselves what their formal education was unable to teach them about Black women and the products of their intellectual and creative labor. Boston was ground zero for what eventually became the renowned Combahee River Collective (CRC). The CRC, composed of a group of Black women thinkers, began as the Boston chapter of the National Black Feminist Organization, or NBFO, an organization that Duchess Harris cited as central to the history of "Black women's involvement in formal American politics."[182] In short order, this once formally political group transformed into a transgressive, "anti-capitalist, socialist, and revolutionary" organization that rejected

the white-feminist leanings of feminism in the United States and splintered from the "bourgeois-feminist stance" of the NBFO.[183] When the CRC severed its ties with the NBFO, they set as a goal to take a more intersectional approach to Black feminist organizing. Specifically, they chose to "focus more exclusively on issues of sexuality and economic development"[184] so that Black women would be empowered to resist the stereotypical portrayals from the Moynihan Report, seize control of their reproductive rights, resist heterosexual oppression, include Black lesbian issues, and systematically combat the emerging and demoralizing figure of the welfare queen.

The Boston-based CRC, led by Barbara Smith, Demita Frazier, and Beverly Smith, produced what would become a seminal text in Black feminist theory: *The Combahee River Collective Statement: Black Feminist Organizing in the Seventies and Eighties* (1986), originally published in 1977. It is a slim volume, approximately twenty pages total. But what it lacks in length, it more than makes up for as a radical statement of Black lesbian feminism and for what its grassroots method of dissemination teaches about early Black feminist organizing. The statement was named for a river in the South Carolina Low Country, the Combahee River, since it was on this site in 1863 that Harriet Tubman masterminded and, with help from 150 Black Union troops, executed the Combahee Ferry Raid. The raid itself "freed 750 enslaved people";[185] but it was Tubman's leadership as "the first woman to lead a major military operation in the United States" that inspired the authors to name the *Statement* in her honor.[186]

The *Statement* was one of several foundational texts penned by Black women in the 1970s that helped form the field of Black feminist thought, shaping the vocabulary Black cultural critics use even now to reckon with current events. Keeanga-Yamahtta Taylor elaborated: "It is difficult to quantify the enormity of the political contribution made by the women of the Combahee River Collective . . . because so much of their analysis is taken for granted in feminist politics today."[187] While "intersectionality" is typically attributed to Kimberlé Crenshaw's 1989 article "Demarginalizing the Intersection of Race and Sex," Taylor continued, the CRC introduced this concept when they identified "interlocking" forms of oppression that created "*new* measures of oppression and inequality."[188] The collaborative nature of their work was reflective of strategies that introduced McKay to a burgeoning framework of twentieth-century Black feminist thought and methodologies of Black feminist organizing.

Codifying Black feminist politics required a visionary outlook, so Smith, Frazier, and Smith proposed collecting, publishing, and disseminating Black

feminist writing as a way to archive the work of Black feminists laboring in isolation across the country. At first, the Combahee River Collective's *Statement* was published in the anthology *Capitalist Patriarchy and the Case for Socialist Feminism* (1978). Later, the authors duplicated the *Statement* and distributed it "hand-to-hand."[189] After finding its way into several anthologies "by feminists of color,"[190] in 1985 the *Statement* was published by Kitchen Table, a press that began as a publishing outlet that would give "disenfranchised women of color . . . autonomy" when determining "the content and conditions of our work" and "the words and images that were produced about us."[191] The CRC, unified by a common interest in elevating the voices, thoughts, and politics of Black women, developed a statement of Black women's contributions to intellectual enterprises from which they were otherwise excluded. The *Statement* documented and defined the foundational elements of Black feminist politics and was organized in four sections: "(1) the genesis of contemporary Black feminism; (2) what we believe, i.e., the specific province of our politics; (3) the problems in organizing Black feminists, including a brief herstory of our collective; and (4) Black feminist issues and practice."[192] It was within a study group not unlike those described in the *Combahee River Collective Statement* that McKay was launched into the study of Black women's literature.

Black women graduate students in the Boston area formed a "women's study group"[193] committed to the recovery and dissemination of Black women's literature. Sometime after joining the Simmons faculty, McKay was invited to a dinner at the home of Andrea B. Rushing, who was "then an instructor in the Afro-American Studies Department at Harvard."[194] In McKay's memory of the gathering, it was a "nice warm spring night" when a group of Black women graduate students gathered at Rushing's to discuss Zora Neale Hurston's *Their Eyes Were Watching God*.[195] McKay took the train to Roxbury, climbed the hill to Rushing's, and joined a who's who of Black feminist graduate students and early-career faculty to discuss the book. As mentioned in Mary Helen Washington's foreword to *Their Eyes*, Rushing remembered McKay, Combahee cofounder Barbara Smith, and Wesleyan University professor emerita Gayle Pemberton in attendance.[196] McKay recalled Hortense J. Spillers and Thadious M. Davis, too.[197] Mostly, these women were either teaching at local colleges (Amherst hired Rushing to teach English and Black studies in 1974) or on their way to earning degrees at institutions that included Harvard (McKay and Pemberton), Brandeis University (Spillers), and Boston University (Davis). Smith, who had earned her BA from Mount Holyoke College in South Hadley, Massachusetts, re-

turned to the Boston area after earning her MA in literature from the University of Pittsburgh. Boston brought them together, but Black women's literature bonded many of them for life.

Once everyone had assembled, Rushing posed a question to the group. McKay recalled: "And Andrea said, 'Well, I brought you here because I want us to talk about something that is really serious.' And she said, 'Have you thought about the question, Where are the women?'"[198] After that, according to McKay, it was pure bedlam. The room exploded. Until that time, the women in attendance had primarily been reading the men. James Baldwin, Ralph Ellison, and Langston Hughes were ever present, but the women, by and large, were absent. McKay only "had any real sense"[199] of one woman: Gwendolyn Brooks, the first African American to win the Pulitzer Prize, for *Annie Allen* in 1950. The women present were "all in fact teaching by then," so they took advantage of that fact and began teaching texts by Black women: "So we started copying everything and sharing" because, at the time, many of the books they wanted to teach were out of print.[200]

Even though McKay was unclear about the first text they circulated, she remembered Zora Neale Hurston's *Their Eyes Were Watching God* being one of the first. They shared titles and taught the texts. Then they used "these little three-by-five cards,"[201] the ones once clustered together in card catalogs, now relics of the research library, to search for other sources and reclaim more of the literature. In the end, "it wasn't like we reinvented it. We didn't invent it. It was just there, sleeping."[202] This experience informed McKay's teaching at Simmons by putting her on the cutting edge of a field that was being formed by Black women who created intellectual communities geared toward elevating the literature of their sister writers. This, along with Alice Walker's teaching of the first class dedicated to Black women writers at Wellesley College during the 1971–1972 school year,[203] moved Black women's literature a step closer to becoming a field unto itself.

Teaching at Simmons gave McKay classroom experience, but interacting with the handful of Black women in her classes connected her to teaching and mentoring as a calling, and a gift. She admitted that teaching validated her: "I had grown up with a father who had not been able to do what he wanted to do in his life and he was angry and bitter. But he used to tell us that we needed to find work that we could love because having work that you didn't like was not a good thing. . . . So I had essentially discovered, actually found, yes, this is the thing I want to do."[204] Before long, the chair of Simmons's English department, F. Wylie Sypher, took notice of McKay's disciplinary expertise, developed in collaboration with her Black women

colleagues in Boston, and her skills as a teacher and mentor, fostered in her experimental teaching at Simmons. Sypher, in turn, initiated a process to keep McKay at Simmons College for the long term.

Sypher, a Harvard-educated literary scholar and professor who developed an exceptional and widely known research profile while maintaining a stellar reputation as a teacher, took a shine to McKay. He would later credit McKay for making "invaluable" contributions to Black studies and for doing "an inspiring and inspired job in our experimental freshman curriculum."[205] Sypher taught Renaissance literature at Simmons for over fifty years and was a resident elder statesman known for his kindness and generosity and, to some extent, his chauvinism. Sypher elected to hire McKay even though it was not standard practice for him to hire women. McKay's Simmons colleague Lawrence L. Langer recalled Sypher saying that the women "get married and have children. The children get sick and they call in and say 'My baby is sick. I can't come to class today.'"[206] Because McKay had said nothing about her former husband or her undergraduate daughter, Langer noted, too, that "Nellie was not married and had no children, so that wasn't a problem."[207] McKay had the requisite experience and, as far as her Simmons colleagues were concerned, was unattached, so in Sypher's eyes, she was a good fit for the position.

Sypher's thinking was unfortunately standard fare in the society at large and common among male academics and professionals at the time. When asked about the climate that may have contributed to McKay's decision to keep details of her personal life private, Pamela Bromberg, another former Simmons colleague, imagined "that [McKay's] motivations are complex, and they had to do with race, but also gender. I'm quite sure that Nellie really calculated that she would not be taken seriously as an older woman, not to mention an older black woman."[208] Having experienced at least one incident stemming from discriminatory decision-making practices at work, Bromberg understood the climate for professional women at the time. Once, while competing with another woman for a full-time position, Bromberg was given part-time work because she "was married and had a working lawyer husband."[209] There was no talk of qualifications. "This is how decisions were made back then,"[210] said Bromberg, who, in spite of seeing women leaders at her alma mater, Wellesley College, failed to see women in higher education reap the same professional benefits as their male colleagues.[211] Under most circumstances, the interlocking influence of race, gender bias, and age discrimination would have made McKay especially vulnerable as an early-career faculty member; as a single woman without

young children, she became more attractive to her department head. In spite of how women were typically treated in the workplace, McKay gained the trust and support of white men very early on in her career. Her collegial relationships with Sypher and others put McKay in close proximity to the power and social currency white men either wielded or freely accessed. In spite of the social climate, but without her degree in hand, McKay was promoted to assistant professor after only a two-year stint at Simmons.

Before she could join the Simmons faculty on a long-term basis, McKay had one last hurdle to cross: the Harvard PhD. Strengthened by her friendships with Black women and empowered by her success in the classroom, McKay initiated the process to return to Harvard. At Simmons, she had taught in the experimental freshman curriculum and had contributed graduate courses in Black literature and a graduate seminar in modern American drama.[212] Sypher, who appreciated how McKay had made herself indispensable to the English department, wrote in support of McKay's readmission to Harvard. In his letter, Sypher noted that McKay was "admired and valued" by "students and faculty" for her "intellectual vigor, her strong sense of commitment, and her good will and congeniality."[213] With Sypher's support and ongoing encouragement from friends Constance W. and Preston N. Williams and from Gwynne Evans, Harvard's director of graduate studies at the time, McKay returned to Harvard after being readmitted to its PhD program in English on 8 January 1975.

As a graduate student at Harvard and as a professor at Simmons, McKay decided that she would not tell her professors, classmates, and peers that she was a divorced wife and mother of two, or that Pat was her daughter, so that she would be defined by the quality of her work, not the theater of her personal life. McKay wanted to fit in among her peers even if, as a Black woman, she could not belong. In the privacy of her graduate school application, she mitigated one personal detail that she thought might raise eyebrows: her age. In the section that required her name, date of birth, and marital status, McKay shaved two years off her age and identified herself as a divorced mother of two.[214] The latter was true. The former was not. Two years isn't much, but perhaps McKay imagined that if she positioned herself closer to thirty-five than to forty, the selection committee would be more likely to support the institution's investment of time and resources in the burgeoning scholar and admit her. In all other parts of the application, however, McKay was faithful to the facts. A Harvard degree would help McKay achieve an "independent black female selfhood,"[215] a topic she would later explore in essays about Harriet Jacobs, Mary Church Terrell,

and Anne Moody. Furthermore, her study with other Black women in the Boston area taught her the value of group ascent, so she couched her achievements within a broader narrative of Black women's intellectualism instead of sharing her successes as a story of inspiration. She would not be known as "an older woman who had raised a family and was going back to school."[216] She wanted to be commended for the fruits of her labor, not congratulated for overcoming personal obstacles.

By the time McKay resumed her studies at Harvard, she was a different person. At Simmons, she had been nurtured into confidence by colleagues who valued her contributions and by students who trusted her guidance. She reenrolled, more secure in her abilities and confident in her capacity to see the PhD through to completion. "I stayed away for two years and then I reenrolled," McKay recalled, "but I had a very different sense of myself when I went back. I had done something on my own and I had a different life and I was no longer intimidated."[217] Alongside Simmons colleagues Langer, Bromberg, and David Gullette, McKay had fashioned a life that existed beyond the reach of her Harvard professors. She saw herself with new eyes. Department chair F. Wylie Sypher encouraged McKay by reminding her that Simmons "shouldn't be the end of the street."[218] Earning her doctorate, then, was nonnegotiable both in McKay's mind and in the minds of those around her. Her ambition reignited, she knew that it was all part of a bigger plan: "There was a life that I said I was going to have; that required that I finish my graduate degree."[219] She returned to Harvard ready to complete her doctorate and pursue the life she wanted. Possibilities awaited on the other side.

| She May Very Well Have
Invented Herself

> And she had nothing to fall back on:
> not maleness, not whiteness, not ladyhood,
> not anything. And out of the profound
> desolation of her reality she may very
> well have invented herself.
>
> —TONI MORRISON, "What the Black Woman Thinks
> about Women's Lib"

I was drawn to Nellie Y. McKay's story because I know what it's like to want something more, to know and believe that you have the tools to achieve more, even if you don't know what "more" is.

In my freshman year of high school, my family moved from Willingboro to Cherry Hill, New Jersey. I received an outstanding education in Willingboro, but it is clear to me now, and was perhaps clear to my parents then, that the town's halcyon days were drawing to a close. Between the recession that spanned 1980–1982, Ronald Reagan's "war on drugs," tax cuts for the wealthy, deployment of the "welfare queen" as stereotype and political dog whistle,[1] and an unemployment rate for Blacks that was twice that of whites leading into the 1980s,[2] African American communities such as those in my hometown were particularly vulnerable. Only seven exits along I-295 separate Willingboro from Cherry Hill, and, at the time, the differences between them could be measured in degrees: on the whole, Cherry Hill was whiter and wealthier, was in closer proximity to Philadelphia, and boasted one of the state's top public high schools. In the long run, my family's move facilitated greater educational access and deeper financial gains, another rung on Langston Hughes's crystal stair. I made friends easily through choir, student government, and soccer, but the move came at a cost. I went from

being one of many Black students to being one of only a few, and this made it hard for me to feel that I belonged.

Soccer turned out to be a space of belonging where I would reinvent myself. Soccer taught me the power of teamwork, which involves acknowledging your role, playing your position, and pursuing excellence in the interest of advancing the whole. I learned to see my teammates' weaknesses better than they did. Not as a source of judgment but to be able to seamlessly support and accommodate. As team captain and sweeper, I led the team from the back, my perspective enhanced by my ability to see the entire pitch. I experienced the sensation of flight when my physicality matched the flow of the game, intuitive movement made possible by practice, repetition, or what Daddy calls "impressions on the muscles." When I played, I felt perfect, capable, and strong. I could be aggressive, shrewd, and competitive, all of the things stereotyped portrayals of Black women and girls said I should not be. But in my mind, I was pitch-perfect. Soccer met a deep need; during the span of my high school years, I went from defining myself by my academic achievements to prioritizing my athletic ability. So much so that when the time came to apply to college, I focused more on the athletic programs and recruitment than on graduation rates and majors offered. I made my decision. In the late summer of 1990, I was off to New Brunswick, New Jersey, and the Rutgers University women's soccer team.

Rutgers was hard. Training camp and three-a-days—practice in the morning, practice in the afternoon, and a scrimmage under the lights at night—strained my capacity physically and mentally. Training camp was the first thing I ever wanted to quit. Every day, I said as much to my roommate and women's soccer teammate Sandy Dickson; and every single day, she refused to let me. For all that I learned during training camp—the power of one person to make a difference and finishing what you start—I still sought validation from Coach, imagining that even if I barely made it off the bench, I could work hard enough to win his approval. The season progressed. The validation I sought never came. I had a choice. Wait, perhaps in vain, for Coach's validation or validate myself. I chose the latter, and once I learned to play for myself, a new world opened up. I would shine on the inside with every well-placed pass, every expertly defended attack. In the process, I confronted a hard truth: I had no future in the sport. I had nothing to fall back on. Not soccer, and after a poor showing my first semester, certainly not academics. And out of this unmooring, I reinvented myself. I remembered Mill Creek and the crystal stair, Success Cards, love, and the belief others had in my ability to succeed. These stories provided

the confidence I needed to change course. And so, I transferred to my parents' alma mater: Johnson C. Smith University (JCSU), a small historically Black college miles away in Charlotte, North Carolina.

At Johnson C. Smith, I met Nellie Y. McKay on the page before I ever saw her face. As a UNCF/Mellon Mays fellow, I researched the uses of folklore in Toni Morrison's novels and came across her work while compiling an annotated bibliography for my research project. When Sandy Adell, a faculty member at the University of Wisconsin–Madison who attended a graduate school fair sponsored by JCSU's Honors College, showed me a list of UW-Madison's Afro-American Studies faculty, I pointed: "I know that name." I knew *your* name. I was headed to graduate school because I wanted to be a college professor. I wanted to teach at an HBCU because I wanted students to see themselves reflected in the faculty. I was headed to UW-Madison because I sought a vocabulary to describe what I knew about myself and my people, Black people, but could not fully express. "My hand," in the words of Gwendolyn Brooks, was "stuffed with mode, design, device. / But I lack access to my proper stone."[3] I was ready to reinvent myself and conjured memories of my younger days to fuel my pursuit of a life of the mind.

The desire to stretch and reach for something more is certainly not unique, but McKay's approach to achieving against the odds is what makes her both singular and representative of women like me who imagine futures beyond their present-day circumstances, and who step out in search of some very vital missing thing.

CHAPTER TWO

Some Very Vital Missing Thing

Not all of my life is painful—most of it is not. And certainly the
professional life has far exceeded anything I could have dreamed up
during the fall of 1966 when I made my way to those first evening
classes at Queens, feeling afraid. The M.I.T. thing is going to pay
me more money than anyone else has ever paid me to do anything!

But it is not enough. There is something very vital which is missing.

—NELLIE Y. MCKAY, memorandum to Joyce Scott, May 1977

In 1980, three years into a tenure-track position at the University of
Wisconsin–Madison, Nellie Y. McKay had a decision to make. The chair of
McKay's tenure review committee had informed her that she needed more
than her Jean Toomer book, recently contracted by the University of North
Carolina Press, to fulfill the research requirement for tenure. McKay's man-
uscript revisions were already slow going, so the thought of adding new
projects to an already teeming list of writing tasks filled her with dread.
Strategically, McKay turned her attention to shorter pieces: an essay on be-
ing a Black woman at a white university, reviews of books by William L. An-
drews and Barbara T. Christian, and a third project her review chair deemed
unwise—an interview with Toni Morrison.

McKay's review chair insisted that an interview with Morrison was "not
real scholarship."[1] But for McKay, it was the key to a new way of knowing:
"We've been trained to read and criticize Faulkner and Shakespeare," she
observed in a letter to longtime friend and historian Nell Irvin Painter, "but
none of us were told how to look at Toni Morrison or Sarah Wright."[2] This
interview with Morrison—who at that time had been nominated for a Na-
tional Book Award for *Sula* (1973) but had not yet penned *Beloved* (1987) nor
won the Nobel Prize—would help McKay define a Black feminist pedagogy.
McKay professed an epistemology articulated by Black women writers, art-
ists, and thinkers as they hastened against what Christian would call "the race
for theory,"[3] the privileging of esoteric analyses over criticism grounded in
tropes endemic to the text itself. McKay's decision to conduct the interview
confirmed the sovereign value of Black women's literature, asserted the im-
portance of Black women defining for themselves the writers, the topics,

and the texts that warranted their intellectual attention, and set McKay on a path toward reshaping American literary history.

This was risky business. McKay was defying her review chair, who, no matter how solipsistic, ventriloquized institutional values reinforced by an academic elitism that privileged high theory. He insisted that the Morrison interview was nothing more than McKay "evading the 'real' work that [she needed] to do"[4] to earn tenure. He committed to that position.

Until, at least, the interview was published.

The stakes were high for Black women such as McKay who worked to establish Black feminist thought and Black literary studies in the late 1970s and early 1980s. They risked their careers and reputations, jeopardized their health and well-being, and had their literature and criticism dismissed by the mainstream academy. Note the players in the anecdote above: McKay, a Black woman with limited power; her review chair, a white man with institutional authority; and the work, literature and scholarship that centered Black women's texts and perspectives. It was an ongoing battle between the three that pitted McKay's vision for her life and work against the low ceilings white men, Black men, and white women tried to place on her aspirations. McKay risked her professional future to pursue work that men, that white people, snubbed until it became popular. McKay bet on herself when she challenged institutions, pried them open, and demanded a seat at the table. McKay found allies and fostered collaborations that redefined what counted as scholarly contributions to the field. In this next phase of her career, and with the PhD in hand, McKay defined the scope of what she called her "project," which involved her "turn toward black women's writings" as an area of critical inquiry.[5] McKay wanted recognition. Not for herself or for individual gain, but in the interest of collective impact. Black women—their recognition in leadership and literature, their camaraderie and collaborative labor, and their embodied existence in the American academy—were the very vital missing things McKay sought, and she was willing to take the risks required to build the foundation they deserved.

AS A GRADUATE STUDENT AT HARVARD UNIVERSITY, McKay reinvented herself by presenting as a single woman, childless and fully prepared to focus exclusively on her studies. She gained inspiration from Jean Toomer, the subject of her dissertation who was also the focus of her first book, as a writer who lived "a divided life."[6] Writing about Toomer moved McKay to think imaginatively about how and why she would remake herself. McKay was drawn to Toomer because he was an enigma, and she was invested in

uncovering "some of the elements in his personal life in order to determine how his life and literary output affected each other."[7] Toomer's life was forever changed by his three-month immersion into Black life in Sparta, Georgia, his time there forming the basis of his masterpiece, *Cane* (1923), and marking the moment when he decided that choosing his place in the world meant choosing "to live his own life as a white man."[8]

The idea of choosing a life instead of being fated into a particular future appealed to McKay, whose research on two of Toomer's plays, *Balo* and *Natalie Mann*, both from "the early 1920s,"[9] led her to conclude that Black women's interiors, the unseen experiences and desires suppressed by domestic duties, were more than sites of angst. These interiors held desires safe, and by attending to Toomer's women in her analysis, McKay could draw them from the shadows and grant them the grand stage they deserved. For example, in her study of *Balo*, "a documentary account of one day in the life of protagonist "Will Lee, a black peasant farmer, and his family,"[10] McKay considered his wife, Susan: "a yellow-complexioned woman with large, deep-set eyes that are sad and weary, a cracked voice, and a frail body."[11] McKay made the effort to see Susan beyond her appearance or her condition and found something in Susan she recognized: "Susan is the voice of the growing number of those who want more from life. She knows there are things other than what she has, and while she is unable to define them concretely, she wants to have some of them."[12] Susan's search for what was missing was not hers alone. McKay embarked on a similar search, and with each academic position, with each new leadership opportunity, she made choices that supported her quest for intellectual and personal freedom.

In late August 1977, following her readmission to Harvard, McKay was awash in the optimism brought by the good news of multiple job prospects. William J. Holmes, the fourth president of Simmons College, who in his 1970 inauguration speech acknowledged the need for the college to "expand programs that train women for executive-level careers,"[13] an observation that led to Simmons creating the first "MBA program designed for women in the country," informed McKay of the college's decision to grant her "the presumption of tenure . . . after the satisfactory completion of the 1977–1978 academic year."[14] The administrative process that put McKay on the path to tenure at Simmons certainly differed from twenty-first-century review processes—processes that typically involve a series of intermediate reviews in which institutions determine whether a tenure-track candidate is meeting the mark in the areas of research, teaching, and service—but Simmons's

message was clear: McKay's impressive work had made her the candidate department chair F. Wylie Sypher would move mountains for.

About a month after receiving the Simmons offer, McKay was invited by the Massachusetts Institute of Technology (MIT) to serve as a 1978 visiting assistant professor in literature "for the spring semester, to teach a course in Black Autobiography."[15] The head of the Department of Humanities, historian Bruce Mazlish, offered to pay McKay $3,500 to teach the course. By even today's standards, where adjunct professors at baccalaureate institutions earn anywhere from about $2,000 to $4,500 per course,[16] MIT's offer was generous. Indeed, the amount astonished McKay, who admitted to Joyce Scott that "the M.I.T. thing is going to pay me more money than anyone else has ever paid me to do anything!"[17] However, for a woman whose admission to Harvard was followed by a handwritten letter in which she outlined her financial hardships and requested a loan to fill the gap between a Harvard fellowship and a Woodrow Wilson Foundation grant,[18] McKay needed more than the promise of good pay to feel satisfied. There was another possibility on the horizon. This opportunity would turn McKay's attention away from the prestige of tenure at Simmons and the financial rewards of academic life in New England toward new possibilities in the Midwest.

Richard Ralston, on behalf of a search committee affiliated with the University of Wisconsin–Madison's Afro-American Studies Department, had contacted McKay to find out whether she would be interested in a job teaching Afro-American literature at the flagship campus of Wisconsin's state university system.[19] Ralston, a Fisk University–educated "Africanist with a special interest in the relationship between the U.S. and Africa,"[20] had learned about McKay as a prospective candidate from Samuel Allen, a fellow alumnus of the historically Black Fisk University who had earned a law degree from Harvard, studied at the Sorbonne, and who, in 1977, was teaching at Boston University.[21] It is clear from the letter inviting McKay to apply for the position that Ralston understood that Madison might be a hard sell for her. He confessed, "You may not have thought of making such a move at the present time."[22] He was right.

McKay responded positively to Ralston's initial request for information but, in a private letter to Joyce Scott, her longtime friend from Hollis, Queens, expressed ambivalence about "the Black Studies thing."[23] McKay felt great affinity for the W. E. B. Du Bois Institute, which, while relatively unknown to anyone outside of Harvard at the time, was slowly but surely building a reputation all its own. It was a space that had emerged out of "long years when Black Studies was still only a wish on our part,"[24] and

McKay, who appears to have been a Du Bois Institute fellow from 1977 to 1978,[25] was eager to expand its profile. But Black studies at the University of Wisconsin–Madison gave her pause: the isolation of the Midwest and the prospect of a life far away from her familiar haunts in the Northeast were certainly not appealing. McKay respected the fact that Wisconsin was the kind of place where people go "to become more attractive for places like Harvard etc.," but she also believed that "one does not go to Wisconsin to remain forever."[26] Or so she thought.

Faced with the biggest decision of her professional career thus far, McKay solicited advice from Preston N. and Constance W. Williams (better known as Connie), Harvard friends who knew her, understood the profession, and were well respected in the Harvard community. Preston, the first director of Harvard's Du Bois Institute,[27] earned his bachelor's degree in divinity from Johnson C. Smith University. He mentored McKay and, at this particular moment, helped her to weigh her professional options. McKay frequented Preston and Connie's home on Martha's Vineyard, a secluded residence in Chilmark that was twists and turns away from the historic Black enclave of Oak Bluffs, which was home to Dorothy West, author of *The Living Is Easy* (1948). As the first tenured Black faculty member of Harvard's Divinity School, Williams knew plenty about the climate and politics of the place and was a generous sounding board for McKay during her time at Harvard. Politically astute and well connected, Preston provided McKay with invaluable insight into life in the professoriate. When it came to making a decision about Madison, however, he was not the only member of the Williams family who had an opinion about McKay's next steps.

Connie was staunchly against McKay pursuing the Madison position. When McKay shared news of Madison's interest with Preston, he responded with his trademark candor and confidence: "You should go to Madison."[28] Plain and simple. For Preston, Simmons College, in spite of its strong reputation in the Boston area, was a "small pond" that would limit McKay's ability to "develop and express her own scholarship and interests."[29] What she needed was a "bigger arena,"[30] the larger platform that Madison could provide. Connie, on the other hand, admittedly "risk averse,"[31] was hesitant about McKay making such a big step. In her mind, why leave Simmons *and* tenure? Preston envisioned Madison as just the sort of launching pad McKay needed. In his mind, Madison was a "premier university,"[32] the place institutions such as Harvard and Stanford University went to recruit. He was confident she would get tenure, and "if she didn't really fit in then she knew that with her background some bigger institution would come

calling. That was where she ought to go."[33] After consulting her friends, McKay promptly followed Preston's advice and, to Richard Ralston, relayed her interest in being considered for an assistant professor position at the University of Wisconsin–Madison.

IN 1977, BY THE TIME McKay looked west to teach, almost a decade had passed since Black student protests first pressured administrators to fulfill their promise to students and establish a Black studies program at UW-Madison.[34] Conversations about Black studies at the institution had been in the works since around 1968, when the Committee on Studies and Instruction in Race Relations initially began "researching the issue."[35] But progress was slow, and the students wanted Black control of the program. It wasn't enough that artist and UW-Madison Afro-American Studies professor Freida High W. Tesfagiorgis, then a master's student, joined the committee along with other African American nonvoting student members; the fact that the committee was composed of "all white males" during a time when the students wanted Black faculty, a Black department, and more Black students[36] was enough to launch those who were already skeptical about the university's commitment to their issues into protest.

Then, for two weeks in early February 1969, Black students inspired by Black power, supported by mostly white Vietnam War protesters and spurred by residual grief and anger over the assassination of Martin Luther King Jr. on 4 April of the previous year, staged a series of protests at UW-Madison. The list of thirteen demands they presented to the chancellor on 7 February 1969 led with a call for an "autonomous Black Studies department controlled and organized by black students and faculty, which would enable students to receive a B.A. in Black Studies."[37] Three other related demands—such as those about a Black chair of Black studies, the hiring of twenty teachers to teach in Black studies, and the transfer of "existing Black courses . . . into the Black Studies Department"[38]—supported their primary purpose: the establishment of Black studies as a center for the study of Black life and as a disciplinary home for Black faculty and Black students.

At first, Chancellor Edwin Young pointed to individual ad hoc courses as evidence of the institution moving in the right direction.[39] There were "courses in Afro-American Studies; a seminar on black history, [and] a black literature course"[40] already being offered. Chicago native and Pulitzer Prize winner Gwendolyn Brooks also taught creative writing. The protesters were not impressed. When students proceeded with their peaceful protest,

the chancellor called in the National Guard to quell their march. In *The Black Campus Movement: Black Students and the Radical Reconstruction of Higher Education, 1965-1972* (2012), Ibram H. Rogers, now Ibram X. Kendi, captured the events on 13 February 1969, as follows:

> Nine hundred National Guardsmen strolled onto the UW Madison campus with fixed bayonets that Thursday. Some rode on jeeps decked with machine guns. Helicopters surveyed the thousands of protesters. If the presence of city police had stirred campus activism a few days earlier when black students kicked off their strike, then the National Guard whipped students into a frenzy. After picketing and obstructing traffic during the day, about ten thousand students, with African American torch bearers leading the way, walked in the cold from the university to the capitol in the largest student march of the Black Campus Movement (BCM).[41]

"Their bodies may have been freezing that night," Rogers continued, "but their mouths were on fire" as they shouted, "'On strike, shut it down! Support black demands!'"[42] The organizers pressed on, leading a nonviolent march of anywhere between 6,000 and 10,000 that evening—"the largest crowd of the strike"[43]—up State Street to the capitol to draw national attention to their cause.

Decried for his decision to bring in the National Guard and termed the "War Maker, Strike Breaker" because of it, Chancellor Young defended his decision, stating that he did so "to protect the students from untrained sheriff's deputies who may have wanted to 'teach these young people a lesson.'"[44] He certainly deemed students' desire to "close the university down" as "anti-intellectual,"[45] but there's no arguing with the fact that without student resistance, which was highly organized and sustained over many years, Black studies at UW-Madison might never have come into being.[46] Student effort paid off. On 3 March 1969, faculty at the University of Wisconsin-Madison approved the "establishment of a Black Studies Department."[47] It was ratified by the board of regents in 1970.

In 1977, McKay made her way to UW-Madison as a prospective hire, fully aware that what Black studies protests had afforded her as a student at Queens and Harvard also opened doors for her as a job candidate in the heartland. She envisioned a direct link between protest and access and was grateful for the opportunities forged from sacrifice: "I still think that I went to Harvard because some people were willing to riot in the streets," she explained. "I don't have any doubt about that. I got there because there were

some Black folks who got their heads battered in. Those doors would not have opened had not some people been willing to die. I probably would never have gotten in those doors."[48] McKay lived through the race riots at Queens and experienced Harvard in the wake of the storming of University Hall, so she was familiar with the strife leading to the creation of UW-Madison's Afro-American Studies Department. This history shaped her personal mission at the same time it informed departmental pedagogy, which cited relevancy as a core value. McKay understood that the path to Black studies at the University of Wisconsin–Madison had been won through great physical violence and sacrifice. She was interviewing with a department that believed that it was responsible for delivering a relevant education to its students and responsible for serving as a positive influence to the community beyond its walls. This was the history, climate, and culture of the department McKay sought to join.

McKay's campus visit was folded into an experimental course that featured prominent Black male writers and Black male critics. Ralston asked her to prepare a lecture as part of a course coordinated by Africanist Edris Makward called Trends and Ideas in Contemporary Black Writing. McKay's proposed talk, "Jean Toomer and his Generation," was one of "a series of guest lectures" that featured the likes of satirist Ishmael Reed, poet Robert Hayden, and literary critic Addison Gayle, among others.[49] McKay was excited to see these luminaries on the roster and, while honored to be among such esteemed writers, appears not to have been threatened by their relative celebrity. A few weeks after McKay's trip to Madison and her Toomer presentation, she received a letter from Richard Ralston about the "enthusiastic"[50] responses to her visit. Shortly thereafter, McKay was hired as an assistant professor in the Department of Afro-American Studies at the University of Wisconsin–Madison; she started her first semester as a tenure-track faculty member in the fall of 1978.

McKay joined Afro-American Studies during a moment of transition. In the wake of a student strike that led to Black studies at UW-Madison, the department faced a new challenge: how would it balance its commitment to relevancy as a curricular value while becoming "academically respectable"[51] in the eyes of white institutional tastemakers? The distinction is specious but important to acknowledge, since this would not be the last time Black studies practitioners would face pressure to shape the products of their intellectual labor into forms palatable to a white institutional elite. McKay was brought on as part of a cohort of new faculty—hired within a year or so of one another—who would take an integrative approach to the dual desire

for culturally relevant teaching and scholarship legible to the white male faculty members who overwhelmingly comprised the institution's tenure and promotion committee. In addition to labor historian Herbert Hill and Tom W. Shick, who in 1976 had earned a PhD in history from the University of Wisconsin–Madison,[52] the department also hired poet-scholar Sarah Webster Fabio to join its faculty ranks.[53]

Hiring Fabio to teach at UW-Madison was a masterstroke. She had taught "some of the earliest Black studies courses at Merritt College and the University of California, Berkeley" and, in her teaching and poetry, represented a "generational bridge" between "Black Power and Black Arts."[54] She was known as "Panther teacher" among "Huey Newton and other young activists"[55] and brought expertise as a teacher-practitioner to UW-Madison, especially through her powerful and innovative performances of spoken-word poetry. Fabio was guided by an investment in making legible Black women's sensibilities—namely, the unknown Black woman, the Rosa Parks figure, and the Black mother—and her careful attention to craft distinguished her as one of "several leading poets" of the Black Arts Movement.[56] Pioneering the cultivation of "black aesthetics" and altering previously accepted conventions of how scholarship was supposed to sound, Fabio dared to experiment with poetry and prose through a "blend of poetic rhythms and critical delineation," to reveal how the poet might "jazz up" archaic, arthritic academic prose.[57] Fabio was committed to working within a Black aesthetic that could "create a power force which will interpret, support, and validate the reality of 'black experience.'"[58] Fabio came to UW-Madison ready to shake up students' conceptions of the technical foundations of spoken-word poetry.

One of Fabio's students recalled a firsthand experience of the poet's influence. Student Fabu Mogaka came to UW-Madison as a practicing poet but wanted to develop her understanding of the literary traditions that informed creative production. At first, Mogaka mistook Fabio's poetry as the product of pure spontaneity. Poets with a strong performative bent are sometimes mistaken as producing out of raw emotion. Not theorists. Not scholars. A tough teacher, Fabio disabused Mogaka of this notion. While she performed live, Fabio's poetry paid careful attention to craft. She embodied Howard Rambsy's claim in *The Black Arts Enterprise and the Production of African American Poetry* (2013) that the "poets, critics, and theorists are one."[59] By demonstrating the interplay between the "artistic use of poetry" and "the study of poetry," Fabio transformed Mogaka's sense of herself as a writer.[60] The study of the formal elements of African and African American literature "added a depth" to Mogaka's writing, and she credited Fabio for influence that lasted a lifetime.[61]

The differences between Fabio and McKay encapsulate an early debate around the mission of Black studies programs as they negotiated their activist origins and elite academic futures. Fabio's community connections made her more reflective of the activist leanings of Madison's Afro-American Studies Department; McKay, a Harvard-educated scholar who would similarly focus on Black women's literary and cultural production, reflected the institutionalization of Black studies even if she often bristled at the way the field was ghettoized by her white peers. Together, perhaps, Fabio and McKay would reconcile that which seemed irreconcilable at the time: the activist tradition of Black studies and the codification of Black studies as a "reputable" area of academic inquiry. Fabio and McKay were different yet complementary, and the possibilities for innovation between them were vast. Unfortunately, members of the department would never see how these two women might have come together to steer the early years of Black literary studies at UW-Madison. Just as McKay was being hired, Fabio was quietly battling cancer. When Fabio left the university, sometime between 1977 and 1978, she never returned. Sarah Webster Fabio died on 7 November 1979, "after a courageous two-year battle with cancer."[62] McKay served as a member of Fabio's memorial committee.

Sadly, Fabio would not be the only loss suffered by the department as it expanded its faculty in the late 1970s and early 1980s. As a new faculty member at UW-Madison, McKay no longer had Fabio to build with, but a friendship formed at Harvard and fostered through correspondence would help her combat the isolation that overwhelmed her in her new home town.

IN THE QUIET OF THE early morning, the rich darkness yielding to daybreak as the sun ascended over Lake Monona, Nellie Y. McKay moved her lithe fingers across the keyboard of her IBM typewriter. As the motor hummed and vibrated, massaging her fingers as they rested on the springy keys between sentiments, between thoughts, between sentences, McKay practiced the writing ritual that had begun the day she left Cambridge, Massachusetts, for Madison, Wisconsin, and that lasted until shortly before her death. For nearly thirty years McKay maintained a correspondence with Nell Irvin Painter, a graduate peer turned colleague she first met in 1969 while studying at Harvard but became close to several years later. Like clockwork, McKay placed her morning letter in the outgoing mail bin kept beside the administrative assistant. It was the first piece of outgoing post nearly every day. As her colleagues arrived to the office and daily work commenced, McKay's letter became buried beneath department memoranda, recommendation let-

ters, and the like, all eventually collected by mail carriers and sorted by postal workers who routed each piece to its appropriate destination.

In the 1970s, letter writing, for both McKay and Painter, was part of a larger effort to make space for themselves through peer-to-peer systems of support in an academy that, for Black women faculty teaching at predominately white colleges and universities especially, was overwhelmingly white and male. They maintained at least two kinds of space. One was disciplinary and institutional space, where Black women broadened the scope of their fields of study and integrated academic departments made up of mostly white men. The other was a private space, the Black interior, a site of quiet creativity, where Black women communicated with one another out of "silences. Loopholes. Interstices. Allegory. Dissemblance"[63] to oppose the pressure to "present highly censored 'positive' images [of themselves] to an often hostile public."[64] The letters between McKay and Painter offered, as Farah Jasmine Griffin explained in Beloved Sisters and Loving Friends (1999), "proof of the importance of sister-friendships in life as well as in fiction."[65] Their correspondence was initiated self-consciously with the intention of becoming part of the historical record and, when read in its entirety, offers a "social history of late 20th-century black women scholars."[66] Certainly, the correspondence is useful for the insight it offers into the experiences of two Black women as they navigated careers in the professoriate at a particular moment in time. It also pulls back the veil on how Black women sustained academic friendships to offset the isolation they felt as Black faculty at predominately white institutions. Their relationship—specifically, how they found each other, how they supported each other, how they disagreed with each other, and how they identified opportunities for each other—promoted a peer-as-mentor model in which subterranean sentiments crucial to the intellectual space-making of Black women of this generation were conveyed through letters.

McKay and Painter met at Harvard "in the fall of 1969,"[67] but based on the first letter included in their archived correspondence, it wasn't until 1977, shortly before McKay filed her dissertation, that the two began corresponding regularly. Painter was teaching at the University of Pennsylvania by then, conducting research for what was to become her second book, The Narrative of Hosea Hudson: His Life as a Negro Communist in the South (1979). In 1976, while in Philadelphia to "interview the second wife of the subject of her dissertation" on Jean Toomer, McKay stayed with Painter at her house on Pine Street in what is now the Society Hill section of Philadelphia.[68] They came together again a year later during a cross-country road

trip, solidifying the bonds that would last for decades to come.[69] These early meetings reflect a truism about the relationship between McKay and Painter: supporting each other's intellectual interests was just one facet of their friendship. They also supported each other emotionally and in quotidian contexts: they shared recipes and gossip and discussed exercise regimens, fashion, and romance. These topics were as much a part of their letters as the sharing of essay or talk drafts, news clippings, or reader's reports. Like all interpersonal contact, their friendship was complex and at times characterized by conflict. Without any professional models of academic mentorship for them to follow—especially as it related to the status of Black women in predominately white spaces—they bushwhacked together to clear a space for disciplinary interests that challenged the intellectual status quo. The correspondence afforded them an intellectually rigorous yet microaggression-free space to pose questions and connect, to refine both ideas and craft.

Painter supported McKay as she struggled to revise her dissertation and transform it into a book. Making the turn from dissertation to book as a new faculty member was hard for McKay, who considered herself a slow, if deliberate, worker, reader, and writer. McKay's insecurities as a writer, dare I say as a creative, resulted from how she viewed her productivity when compared with her peer group. Whether stated explicitly or conveyed implicitly, academic circles value work that is both quick and prolific. The tenure track, which requires new faculty members to reach a particular threshold of research, teaching, and service work within a six-year window, favors those who work fast and who produce much. Never mind the scope of the project or the process of the scholar. "Quite a few factors, including socioeconomics, gender, institutional support, and the properties and expectations of specific domains," explained Howard Rambsy, "affect pace and amount of output."[70] Rambsy studied "African American literary studies and creativity research" in *Bad Men: Creative Touchstones of Black Writers* (2020) and suggested that instead of privileging productivity, or the amount of work produced, we need also consider creativity in a broad sense so that work that moves imaginatively between multiple "creative domains" is praised as a product as well as for the complexity of the process.[71]

McKay's *Jean Toomer, Artist: A Study of His Literary Life and Work, 1894–1936* (1984) was one such creative undertaking. McKay's book, as University of Kansas Distinguished Professor and director of the Project on the History of Black Writing Maryemma Graham wrote in her 1985 review, bore "a double burden."[72] Not only was McKay "confronting one of the most widely dis-

cussed literary texts in the Afro-American literary canon," but she was also, as Toomer's biographer, "attempting to solve the largest puzzle about Toomer's life."[73] *Jean Toomer*, as a biography, involved the analysis of source material from different creative domains: manuscript sources from archives in Nashville, Tennessee, and New Orleans, Louisiana; published books, stories, poems, plays, autobiographies, and essays; unpublished novels, plays, and stories by Jean Toomer; secondary sources on Toomer; and other works to facilitate McKay's immersion into, among other things, Gurdjieff philosophy.[74] McKay imagined that her research was slow going because of a personal deficit, when in fact it was more likely that the work was slow going because such is the nature of biographical research.

The response McKay received from University of North Carolina Press editor Malcolm L. Call following an inquiry about publishing her Toomer book did little to assuage her self-doubt. Call, who also worked as an editor at Massachusetts and Pennsylvania university presses during his career, expressed interest; but following an external review of her manuscript, he could not commit to publishing it. Call yielded to the recommendation of the external reader, who offered a lively and insightful assessment of the merits of McKay's manuscript (it had "provocativeness, insight, and a readable style"), and encouraged McKay to undertake a "period of reflection and synthesis" to better contextualize the "array of forces" that "give resonance" to her claim of Toomer as an "artist with words."[75] The reader did not, however, offer an unequivocal recommendation for publication, which of course was the outcome McKay desired most.

McKay, "dismayed" by the prospect of undertaking revisions for two years as recommended by the reader, solicited feedback from Painter to help her process Call's letter and the reader's report.[76] Painter—already a tenured associate professor of history at the University of Pennsylvania—admitted to reading Nellie's letter "as I would feel if what happened to you happened to me, so be warned that I might be right on target, but I might be way off."[77] With critical distance, Painter let McKay know that she had actually received a "wonderful"[78] reader's report—one that refused, in the words of the reviewer, "to make the type of concise judgment here that editors so dearly love"[79] but that provided McKay with a solid road map to guide her manuscript revisions. Painter's empathic response was informed by the fact that she had already faced three rejections for the Hosea Hudson book and was still awaiting word from Harvard University Press.[80] As Painter helped McKay see the good in even a conditional response, she reckoned with the thought that hers might be conditional as well, "because the manuscript, as I submitted it,

had neither introduction nor completed footnotes."[81] While revising sans contract is not ideal, the manuscript feedback McKay received from the external reader prepared her to fulfill the publishing requirements for tenure[82] at the University of Wisconsin–Madison. With all the effort she was putting into the book, she needed it to meet the mark.

McKay's book revisions were intermittent, due in large part to the teaching demands that accompanied her faculty position. By the time McKay arrived at UW-Madison, she had already been teaching for seven years—at Simmons and between visiting positions at Northeastern University, Boston University, and MIT from 1971 to 1978—and was nearing burnout. She wondered when she would ever find the time to work or the mental space to process reviewer feedback. McKay's dreams of a summer vacation and an opportunity to rest vanished abruptly once she concluded that given her workload, a vacation was a luxury she could not afford. She instead spent the summer of 1980 writing about Toomer's *Cane*, the imagistic prose poem that chronicles Black life in the South, Black life in the North, and the complexities of reconciling Black identity that became Toomer's most important and best-known work.[83] Initially, McKay planned to complete five chapters "or almost all of that"[84] over the summer and imagined securing a research leave so she would be positioned to complete the book and have it accepted for publication in time for her fall 1981 tenure review. Would a spring leave work? If so, how would that leave be financed? Sublet and move into a spare room? A friend's basement? A couple's attic? Stay and borrow money to cover essentials? To make matters worse, McKay began experiencing dizziness around midsummer, likely the result of a nonstop summer work plan. The doctors could not identify a source, which left McKay to wonder whether the dizziness was "stress related."[85] As the physical costs of McKay's summer of "sitting at [her] desk and typewriter" and "throwing lots of sheets of paper into the waste basket" mounted—she was both dizzy and "dead tired"—and was left to wonder how, in a day with only twenty-four hours, twenty-six hours of work would ever get done.[86] In spite of the overwhelming circumstances, she pressed on. "If you stick me with a pin," she once told Painter, "you won't find blood—just black coffee and *Cane*."[87]

ON-CAMPUS CAMARADERIE WAS A VERY VITAL missing thing, so during McKay's early days in Madison, and to combat the isolation she felt as a new professor, she befriended the white women who were part of UW-Madison's newly formed Women's Studies Program, which became the Department of Gender and Women's Studies in 2008. When McKay faced difficulties at

Harvard, she had dealt with them by expanding her network of friends and collaborators and by engaging in work that affirmed her capacity as a teacher and a scholar of Black literature. In Madison, to ease her rough transition and soothe intense feelings of isolation, she found that she would need to enact the same strategies she deployed when she brought coworkers together through dinner parties at 111 Road in Queens or when she collaborated with Black feminists in the Boston area. McKay initially struggled to cultivate similar networks in Madison, which made acclimating to the institution and life on the isthmus tough. There were a limited number of Black women faculty for her to connect with, and without any of the natural relationships that form between mothers of young children or members of a Black sorority, McKay's community roots were shallow. For many Black women faculty members, taking a faculty position without a network was, in the words of sociologist Lori Walkington, to navigate alone the "chilly reception, negative department climate, norms and expectations, and the assumption by their peers that blacks are incapable of theorizing."[88] Luckily, McKay was expansive in her thinking when she imagined the connections she could make, the relationships she would need to form to do the work she wanted to do, so she used gender as an organizing feature of her outreach and befriended white women, particularly those affiliated with Madison's burgeoning women's studies program, to help make the place feel more like home.

Much like the social justice movement for Black civil rights, the second wave of the feminist movement had a profound disciplinary impact on the academy and those who entered the ivory tower at this time. As they had in the fight for Black studies, students played an integral part in forcing mainstream institutions to first acknowledge and then address the absence of the voices of the marginalized and oppressed in classrooms. As feminist writers such as Betty Friedan and Kate Millett captivated the popular imagination, women students and faculty were actively pushing institutions of higher education to make space for women's voices and ways of knowing. Students led their own reading groups and circulated the work of feminist theorists and the manifestos of feminist organizations; they also began valorizing the forgotten work of women in history, philosophy, and literature. In cases where institutions were slow to either designate new resources or reallocate existing resources, students and faculty designed their own classes beyond the confines of the existing curriculum.

Scholars of women's literature played a crucial role in excavating and valuing the work of relatively unknown or unheralded women writers, which contributed significantly to foundational theoretical and methodological

approaches in the field of women's, gender, and queer studies. The persistence of supporters within and outside the academy, as well as the reality that many traditional disciplines in the humanities and social sciences were changing in part because of this and other mass social movements, made possible the slow yet steady incorporation of these spaces of feminist teaching and learning into the curriculum. The first women's studies program in the United States was founded at San Diego State College and was followed by the proliferation of similar programs nationwide. At many institutions, feminist scholarship and teaching has become one of many respected interdisciplinary fields that exist in the academy where one can find whole courses dedicated to the intellectual work of Black women. By joining with a group of women's studies scholars, McKay connected to a broader women's movement that promoted the study of gender, and the presence of women, in the American academy. This collaboration reflects McKay's openness about cultivating diverse friend groups and her commitment to community building with white feminists even as she actively critiqued the reinforcement of white supremacy and the tokenization of Black women.

As an assistant professor, McKay walked a tightrope between maintaining her sense of self and cultivating friendships with white women when she was befriended by Gerda Lerner, the feminist historian and author of *Black Women in White America: A Documentary History* (1972), a collection of primary materials related to Black women's history. Lerner took an immediate interest in McKay and met regularly with the new professor to talk about personal and professional matters. The two had a complicated relationship. The greatest tension between the pair involved Lerner's condescension, constant supply of unsolicited advice, and absolute belief that her way was the right way.[89] This, at least, was how McKay portrayed matters in her letters to Painter. When McKay wrote to Lerner directly, the tone was markedly different. Whether writing to Lerner to wish her well during one of her West Coast trips to visit her grandchildren,[90] express gratitude for their friendship,[91] or rib Lerner for hassling her over one thing or another ("After all, nobody fusses with me the way you do!!!!"),[92] McKay seemed much less impatient with Lerner's meddling when she corresponded with her directly.

There was a power play at hand, and McKay understood the stakes. McKay was keen in her ability to assess people, evaluate situations and systems of power, and make decisions with her ultimate goal in mind, and her deft handling of Lerner reflects strategies that facilitated her later success. Lerner's interference in McKay's life, especially when it came to relation-

ship advice, may have chafed the new professor (Lerner thought McKay's relationship issues would be solved if she'd only consider working class Black men) but the payoff of having Lerner in her corner outweighed McKay's annoyance over Lerner's ways. To that end, even though McKay experienced ambivalence around what she sometimes felt was her token status as a member of the women's studies group at UW-Madison, she ultimately developed close friendships with several colleagues, namely Susan Friedman, a faculty member in the English department, and Linda Gordon of Madison's history department. One of the burdens McKay bore as a faculty member, especially in the early years, involved maintaining her integrity without sacrificing community or assimilating. In certain contexts, the interracial relationships McKay cultivated with her white peers seem politically motivated and driven by a desire to keep her access to powerful networks close. In other contexts, McKay seemed invested in the gift of friendship and the possibility for collaboration with the white women of women's studies. Ever "sober"[93] in her outlook, McKay calculated the risks and rewards associated with the friendships she formed in white academic spaces.

During her early days in Madison, McKay often felt alone, a byproduct of her experience as a Black woman at a white school that did not necessarily reflect the experience of all Black women in the professoriate, particularly those at historically Black colleges and universities (HBCUs).[94] Black women's experiences in the academy have existed along a spectrum ranging from hostile to hospitable, from isolated to included. For some, the placement of their offices in closets—some with windows, others without—or some other ancillary space speaks to their marginalization on campus or in their departments.[95] For others, as McKay's experiences illustrate, Black studies departments or women's studies programs helped Black women find community at white schools before there was a critical mass of Black women to break bread together. But what risks getting lost in discussions about institutional climate are the assumptions made about who we're talking about when we talk about Black women in the professoriate.

Conversations about climate in higher education presume the presence of Black women in inherently white spaces. Exclusionary practices and isolation may characterize the experiences of Black women at predominately white institutions, especially elite ones, but these same terms don't necessarily describe the experiences of Black women PhDs who taught at HBCUs. Beverly Guy-Sheftall, who spent her entire career at the historically Black all-women's Spelman College, observed: "I think we really have to unpack what we mean when we say Black women in the academy, and this notion

that we don't belong there, you know it's not isolated, and it's not isolating to be a Black woman who teaches at an HBCU. Isolating? In fact, I would say what you experience is overwork. You're not isolated."[96] Differentiating between experiences acknowledges the particulars of McKay's experiences without painting the experiences of all Black women in the professoriate with too broad a brush.

The support McKay received from her women's studies friends and, for the most part, her Afro-American Studies colleagues, was only part of what buoyed her spirits in the early years. Her success in the classroom helped her to combat the feelings of isolation and the depressive episodes she battled early on.[97] In one instance, positive student evaluations (provided verbally after class) were confirmed by a formal university assessment in which students reported that McKay's class (she didn't identify which in her letter to Painter) was "the 'best' course they had ever taken."[98] Riding high on this good news following a stressful first semester, she was ready to exhale and take some time to celebrate. Nothing fancy, she thought, just a drink. But the only person available to drink with was Herbert Hill, a former labor director for the NAACP who had recently joined Madison's Afro-American Studies Department and had been tasked with oversight of McKay's tenure process.

The two had a contentious relationship. But McKay, as a junior faculty member with minimal institutional power, opted to temper her displeasure with Hill's paternalism and focus instead on her performance, the one thing she could control. She met Hill for that drink and, suffice it to say that her celebratory cocktail didn't go as planned. "I wanted a drink, felt I deserved it, and I wanted to talk about me and Madison,"[99] she explained to Painter. "Well, Herbert either does not drink, or does not drink at lunch, or something of the kind—so I had no drink. But the worse [sic] of the lunch was that I spent the time listening to Herbert Hill lecture on Herbert Hill."[100] Annoyed but intent on finding an upside of all her hard work that Hill seemed to ignore, she leaned into kudos from her colleague Bill Van Deburg, summarized in a letter from department chair Richard Ralston, who expressed appreciation for her "splendid and selfless chores . . . undertaken in the building up of our [Afro-American Studies'] literature curriculum."[101] Brick by brick, McKay was building the profile that would lead to tenure and the bona fides she would need to clear a space for others at the University of Wisconsin–Madison and for African American literature nationwide.

McKay was immediately successful as a teacher, but she took longer to find success in her research. As she worked on the Toomer book, the project on which the bulk of her research dossier hung, McKay found that the dif-

ficulties she faced as a dissertator at Harvard followed her to UW-Madison. She struggled to move the monograph forward, her slow pace magnifying her self-doubt. The harder it was to write, the faster her tenure clock seemed to move. It was becoming clear to McKay that the two years recommended for revisions, an overhaul of the book really, would take longer, especially because her teaching responsibilities prevented her from making substantive progress.[102] No matter her teaching load, McKay repeatedly said that she could not "teach and write" because "teaching takes that much from me."[103] She needed time. And for scholars on the tenure track, time is always in short supply.

To secure herself some breathing room, McKay began applying for fellowships that would free her from teaching and service responsibilities and allow her to focus solely on writing. She won a research leave at Michigan State University for both the spring and summer of 1981, which was topped off by additional funds from a summer research service grant sponsored by UW-Madison.[104] In addition to affording her dedicated time to write, these research leaves paused her tenure clock, pulling out of thin air the time she desperately needed to remain in good standing with the department and complete her Toomer manuscript in time for her tenure review. Beyond tenure, the Toomer book would lay the foundation for future feminist studies of his work; but there were also institutional changes that needed to take place before McKay could embark on a systematic overhaul of literary studies. To institute the structures that would provide a professional platform for Black women literary critics, McKay pursued leadership within the Modern Language Association (MLA) and supported broader efforts to secure a place for Black literary scholars within an organization open to Black literature but hostile to Black critics.

MCKAY WAS PART OF a group of younger Black literary critics frustrated by the MLA's marginalization of Black literary scholars and committed to taking up greater institutional space within the organization. Without Black pushback, the MLA might have continued with the exclusionary practices that prompted Black faculty and teachers from HBCUs to form the College Language Association (CLA) in 1937. The CLA, as an alternative to the MLA, welcomed Black critics, elevating their research through conference presentations and publishing their scholarship in the association's journal, *CLAJ*. As Black literary critics integrated historically white institutions, however, they sought visibility within the mainstream MLA, the governing body of English literature and language departments worldwide. Chester J.

Fontenot, who would become one of the founding members of the journal *Black American Literature Forum (BALF)*, recalled a core group of newly minted PhDs that included McKay, Thadious M. Davis, Ann duCille, himself, Trudier Harris, Deborah E. McDowell, R. Baxter Miller, and Hortense J. Spillers. They and others engaged in different types of grassroots work to improve the climate for Black scholars at the MLA's Annual Meeting, to ensure the visibility of Black literary studies, and to influence policy within the association's governance structure.

The issue was never whether Black literature was of interest to members of the MLA. According to Fontenot, quite the opposite was true. Panels on Black literature and culture were often "packed" even before there was an MLA division dedicated to supporting them.[105] Interest was not the issue; parity, climate, and organizational culture were. When McKay began teaching African American literature in the 1970s, the MLA was actively "ghettoizing" Black literary studies by presenting book displays with no books by Black people and scheduling Black literature panels at the tail end of the conference. Fontenot remembers how "people would show up to the session with their bags packed in the back of the room, would give a paper, and then couldn't stay for the Q&A" because panels scheduled late in the conference conflicted with the travel plans of the participants who had limited flights to choose from. Conference organizers further aggravated the issue by assigning panelists to rooms with locked doors or no heat.[106] Following a spontaneous walkout during an annual meeting, Fontenot recalled sitting down with the president and MLA board to discuss the treatment of the members who were part of what was then called the Black American Literature and Culture discussion group. Favorable placement on the agenda, unlocked doors, and heat were a start, but they were only part of the group's collective effort to become a known quantity within the association.

For Black American literature and culture, as a specialty area, to have autonomy and agency within the MLA, they needed to be designated as a division, not just as a discussion group. Darwin T. Turner, the stalwart Toomer scholar who became chair of the University of Iowa's Afro-American Studies Program in 1972, was a "lone voice"[107] who maintained his MLA membership well before a critical mass of Black scholars peopled its conventions. Turner was instrumental in helping newer faculty find their way in the organization. Turner, as Richard A. Yarborough explained, "was a real bridge between MLA and CLA . . . he was also a bridge between the black aesthetic movement and black cultural nationalism and the mainstream academy."[108] Turner, who Yarborough described as a "really crucial

figure who did not get a lot of attention and hasn't gotten his due,"[109] established the African American literature discussion group well before there was a critical mass of Black scholars who shared an interest in this burgeoning field. Turner's early work and Fontenot's subsequent provocations set the stage for R. Baxter Miller, a North Carolina Central University graduate and Brown University PhD who authored the application to move African American Literature and Culture from a discussion group to a division and who worked alongside Fontenot and others to formalize Black literary studies within the Modern Language Association.[110]

While, as of 2020, the MLA had subsumed what were once discussion groups and divisions into forums, scholars of Black literature undertook the administrative labor and vision casting that took Black literary studies from being "written in pencil" as a discussion group and perennial favorite to being "written in ink" as a division and permanent fixture.[111] The benefits were significant. In addition to providing access to much-needed funding as a division, scholars of Black literature also assumed editorship of a division-sponsored journal that, beginning in 1983, benefited from the prestige of being indexed with *PMLA*, the association's flagship journal. Black literary scholars had another organ—edited by specialists in the field—in which to publish the peer-reviewed essays that would help them earn tenure and expand the critical base established by *CLAJ*. Joe Weixlmann became de facto editor of the division's journal after he took a job in American and African American literature at Indiana State University,[112] and he served as the journal's intrepid editor for over forty years, transforming, alongside leading scholars in the field, what was then the *Negro American Literature Forum*, a publication "for School and University Teachers,"[113] into the *BALF* and, later, the *African American Review* (*AAR*). McKay was a member of the *AAR*'s advisory board, which allowed her to advance the work of other scholars by reviewing and recommending essays for publication.

Black scholars in this core group published field-forming work out of their respective areas of interest and disparate domains of expertise, so it is important to acknowledge the range of ways they contributed to the larger project of Black literary studies. At the time, one could count "the number of black people on two hands,"[114] recalled Trudier Harris—the University Distinguished Research Professor at the University of Alabama—so scholars contributed where they could to have the most impact. Their numbers were small, but as a group they were mighty. These scholars wrote their books, earned tenure, and helped establish the next generation of tenured faculty in African American literature by reviewing book manuscripts,

writing tenure letters, and advising graduate students. "I think people work with what they're most comfortable doing,"[115] explained Harris. Some were interested in leadership; "[I helped] to create the scholarship and get the work out there."[116]

McKay demonstrated her interest in MLA leadership in her bid for a position on the executive committee of the MLA's Division on Women's Studies. Since another part of McKay's intellectual project involved leveraging the gains of the women's movement to secure Black women's access to leadership, she planned to use her status as an executive committee member to increase the presence of panels on Black women's literature at the MLA's Annual Meeting and to facilitate the entry of more Black women into MLA leadership. Individual leadership, for McKay, then, was a means to an end, and hers was inspired by the collective needs of an ever-expanding network of Black women literary scholars spread across the country, isolated in their respective departments but soon bound together by a common interest in collectively advancing Black literature in general and the writings of Black women in particular. Recognition within the MLA was vital to McKay, who imagined that she could have a positive influence on literary studies by building from within.

If Black scholars, as a group, faced challenges circumscribed by race, then McKay confronted an MLA governance structure that also held a "history of . . . indifference to women."[117] By the time McKay pursued leadership in 1979, it had been about a decade since pressure from the women's movement prompted the MLA to create the Commission on the Status of Women in the Profession. At the time, "women ma[de] up one-third of MLA membership," but they "rarely exercised administrative or executive power."[118] The late Florence Howe, who was then at Goucher College and later became founding editor of the Feminist Press, led the commission, which set as an early goal executive representation commensurate with membership numbers.

The gains of white women did not extend to Black women, who struggled to secure a seat at the table well into the 1970s. In a telling and painful letter to McKay, Gloria T. Hull captured this disconnect between the organizational achievements of white women and the ongoing disenfranchisement of Black women within MLA governance. Hull, who coedited the seminal *All the Women Are White, All the Blacks Are Men, but Some of Us Are Brave: Black Women's Studies* (1982), was appointed as cochair of the MLA's Commission on the Status of Women in the Profession in 1976. She followed Barbara Smith, her close friend and *Brave* coeditor, who became the first woman of color appointed to the commission in 1975.[119] Their presence

on the commission broke new ground. In pursuit of MLA leadership, however, Black women paid a high emotional tax.

In a confidential memorandum from Hull to "CSW Members and Cheryl" regarding the "May 18 [1979] meeting with Executive Council and attendant matters," Hull called the Executive Council to task for creating a "hostile and condescending" environment that prevented Hull and her colleague "Margo"[120] from being received respectfully as "colleagues in the profession."[121] The treatment, according to Hull, reflected the council's "elitism, sexism, and racism—and their ignorance and underlying contempt for the Commission and our work as women."[122] Among their most egregious acts was the failure to appoint Nellie Y. McKay to the commission as the "Black woman replacement."[123] Even though such a designation may read like a quota to our twenty-first-century sensibilities, this move was part of an affirmative step to guarantee participation from an otherwise marginalized constituency. It was the second year McKay had expressed interest in the commission,[124] and while she was not appointed her first time around, she held out hope that, in this case, the second time would be a charm.

In Hull's memo to the group, which she sent to McKay with the presumption that she would later place it in "File 13" (the wastebasket), Hull historicized the practice of having "at least two Black women"[125] serve on the commission to justify her disappointment in McKay being passed over for the position. The practice began "after [a] traumatic confrontation between Barbara Smith and the rest of the then all-white Commission."[126] Smith was not only the coeditor of But Some of Us Are Brave alongside Hull but also a cofounder of the Combahee River Collective, a group of Black feminists who later published a statement arguing against separatism from "progressive Black men"[127] while demanding that the concerns of Black lesbians be woven into any discussion of Black feminism. Hull framed the inclusion of at least two Black women on the commission as an "indispensable principle," but it fell on the deaf ears of a council that "as a whole just did not see race as a compelling issue."[128] Hull's memo explored a few alternate pathways; a handwritten letter to McKay accompanying the memo reads, "In the end, nothing could be done about the choices which had been made."[129] Hull, "disappointed, angry and alienated," sent McKay a copy of the memo as an expression of her sadness over "any inconvenience or disappointment" this may have caused.[130] Hull's correspondence depicts the climate of the MLA for women and Black people and demonstrates how, for Black women whose tenure dossiers required evidence of service to the profession, which included committee service, it wasn't enough just to throw your hat in the

ring. Structures, even those with supposedly feminist foundations, needed to be overhauled to prevent the reinforcement of hierarchical racial structures in their selection of new members.

The outcome was not ideal, but Hull's powerful advocacy, while draining, seems to have prompted allies to respond creatively to McKay's predicament. In February 1980, Erlene Stetson, former professor of English at Indiana University and author of *Black Sister: Poetry by Black American Women, 1746–1980* (1981), invited McKay to chair a session on Black women in the academy. Stetson planned to use the fact that the commission was responsible for a "certain amount of in-house programming" to guarantee that this proposed project was a "shoo-in,"[131] thereby avoiding any obstructionist moves by the more conservative elements within the MLA. Two months later, in April 1980, McKay received a second invitation.[132] This time, the invitation came from the late Helene Moglen on behalf of another group: the Women's Caucus for the Modern Languages (WCML). Moglen, a feminist scholar and former professor emerita of literature and women's studies at the University of California, Santa Cruz, invited McKay to participate in the forum "Literary Influence: Gender to Gender."[133] McKay accepted. While McKay's papers include no invitation to join the panel "The Second Sex in Academia," where she would present "Black Professor: White University,"[134] the fact that the panel was organized by the WCML is notable, since even though the "MLA never officially sanctioned WCML,"[135] the group was influential enough to get women on the program.

The WCML organized itself and members proceeded with their work independent of MLA oversight because of their fear that the MLA's "indifference to women" would translate into a women's commission that was little more than a paper-pushing "study group."[136] Fortunately, under Howe's leadership, the women's commission successfully initiated several progressive actions, one of which included, in 1971, having "proportional [gender] representation"[137] on the first Delegate Assembly. The Delegate Assembly brought together representatives from specific areas of study, regions, and professional concerns to meet during the MLA's Annual Meeting to, among other things, determine dues, recommend actions, and approve amendments.[138] Undeterred, McKay pursued a seat on the Delegate Assembly at around the same time she was unsuccessful in her bid for a seat on the Women's Commission and was selected "to serve on the Assembly for a three-year term, from 1 January 1979 through 31 December 1981."[139] The push for representational parity on the Delegate Assembly was another move that made McKay's eventual place in women's leadership possible.

In the wake of strong feminist leadership, McKay's persistence paid. By 1980, the MLA-based Division on Women's Studies in Language and Literature had elected McKay to a five-year term (1981–1985) on its executive committee.[140] In this role, McKay furthered the work started by Hull and Smith in their years as commission cochairs, and the three remained in contact even after their terms on the commission ended. McKay also became a close friend and colleague of Florence Howe, who later became McKay's publisher. In addition to publishing "three essays—in 1990, 1995, and 2000—about [McKay's] intellectual movement into feminism and particularly into Black women's studies," Howe also asked her to edit a twentieth-anniversary edition of *But Some of Us Are Brave*.[141] McKay agreed, but on the condition that, among other things, Hull, Smith, and Patricia Bell Scott supported her in doing so.[142] Unfortunately, McKay did not live long enough to see *Still Brave: The Evolution of Black Women's Studies* published. Coeditors Stanlie M. James, Frances Smith Foster, and Beverly Guy-Sheftall steered the 2009 anniversary edition to completion. They dedicated the collection to McKay.

McKay's MLA committee appointment did not ease her annoyance with the snubbing of Black women's literature panels at the MLA Annual Meeting. She stayed the course to earn her place within the MLA. And in the face of the MLA's failure to grant her Black women colleagues a platform for their ideas, McKay asserted herself, using her particular brand of quiet yet firm pressure, to get what she wanted. Part of McKay's methodology as a scholar and institutional bridge builder involved the deployment of her extraordinary interpersonal and administrative skills. Specifically, she located domains of influence—organizations such as the MLA that could help increase the notoriety of Black women critics and expand the reach of Black women's literature—and, once inside, mobilized a web of relationships to ensure that the emerging voices of Black women literary scholars would have a home on the conference program. The bumpy road to a panel on Black women's autobiography offers a case in point.

On the heels of the roaring success of the 1979 panel "Black Women Writers and Their Contributions to American Literature: The Quest for an Affirming Self," which featured McKay, Thadious M. Davis, Trudier Harris, Marilyn Truesdell, and Andrea B. Rushing, McKay drafted a new proposal to present on Black women's autobiography alongside Valerie Smith, then a new faculty member at Princeton University and currently the president of Swarthmore College, and Frances Smith Foster: a San Diego State College (SDSC) faculty member who would become McKay's lifelong friend and collaborator. Almost as soon as Foster and Smith confirmed their participation

on the panel,[143] McKay received disheartening news: her special session had been rejected. In identical letters to Foster and Smith, she wrote: "I am sorry to inform you that my proposal for a special session on Black Women's Autobiography for the MLA convention next December has not been approved."[144] Her letter to her colleagues offered a standard-fare diplomatic assessment of the situation and well-wishes to all: "The program committee has to make choices," "I will probably submit [this proposal] again next year," "Thank you for your willingness to prepare a paper."[145]

Then, nary a week later, McKay wrote to Ann Hull, the MLA's convention manager, as follow-up to a phone call that took place after McKay received their rejection. This letter began with an acknowledgment of the competing demands of the selection process before moving into language more assertive and measured, especially when McKay name-dropped Wisconsin colleague Elaine Marks, a prominent professor of French literature and pioneering women's studies scholar, to apply pressure that might prompt a different result. The letter is worth quoting at length:

> This is a follow-up to our phone conversation of May 15 re the non-acceptance of my proposal for a special session at the MLA in Houston in December. In the meantime I have spoken of this matter with Elaine Marks of the Women's Studies Program here at Madison, and she has also registered distress at the possibility of no session on the writings of black women on the MLA Convention program this year.
>
> As I told you on the phone, what upsets me in this is indeed that there may be no session on black women writers. I had a proposal accepted for the 1979 convention and can understand if other black women who submitted proposals this year are given preference. Nor is it a matter of black women not being on the program, because I am aware of a number of black women participating on other panels. However, I am concerned that there be at least one session devoted to the analysis of the writings of black women, and this is to register that concern, which I hope the program committee will look into before the final convention program has been adopted.[146]

This episode illustrates just one of the challenges Black women faced in getting their ideas in circulation: presence on the program. McKay's diplomacy and assertiveness shine through in this letter, in which she made a specific ask (requesting that the program committee look into the issue), provided sound reasoning (explaining the importance of panels on Black women's writing), and leveraged her social capital (name-dropping Elaine Marks, a

highly regarded figure within the organization). McKay was always happy to "get to meet all the black women in the field"[147] during the MLA convention, but it was vital, too, that she claim disciplinary presence and take up intellectual space instead of just occupying embodied real estate as a prototypical "Miss Ebony First" or "Black Woman at the Podium."[148]

The 1980 MLA conference program confirms several papers on Black literature, but there appears to have been only one entire panel devoted to the topic. Individual papers such as Vivian I. Davis's "Selected Black American Literature: A Cultural Interpretation," Sonia Sanchez's paper "Like Bigger Thomas I Didn't Want to Love, but What I Loved for I Am: The Feminine Version of Bigger Thomas in Black American Literature," and Barbara T. Christian's "The Black Woman Writer: Vortex of Sexism and Racism" are worthy of note; the Discussion Group on Afro-American Literature arranged the panel "Black Drama: A Revaluation of the New Aesthetic (1960–80)," with Frances Smith Foster presiding and Marian E. Musgrave and Trudier Harris as panelists.[149] It is unclear whether McKay's letter and phone call precipitated Foster's panel, but one thing is clear: McKay knew that her success as a faculty member depended as much upon her ability to instigate curricular change at UW-Madison as it did on her ability to hold professional organizations accountable for inequities that perpetuated the marginalization of Black women and Black literature when it was vital that they move from margin to center.

IN ADDITION TO THE BARRIERS she faced in her pursuit of leadership, McKay faced resistance to her very intellectual project, Black women's literature. Earning tenure at UW-Madison would be about more than demonstrating excellence in the areas of teaching, research, and service. McKay would also need to take the extra step to justify the value of her intellectual interests. Asserting the sovereignty of Black women's literature was a risk, and the Black women scholars of McKay's generation faced professional precarity while producing field-forming scholarship. McKay's professional gains as an individual would increase the potency of Black women's collective impact.

As McKay acclimated to campus life and to her responsibilities as a faculty member, she felt better about her performance, each success adding to her dossier, the evidence of excellence. McKay's extensive teaching experience at Simmons and MIT allowed her to hit the ground running as a faculty member at the University of Wisconsin–Madison; her MLA leadership within the Division on Women's Studies in Language and Literature demonstrated excellence in service to the profession; and she even felt good about

the progress she was making on her Jean Toomer book. When Herbert Hill, the chair of McKay's review committee, let her know that her Toomer monograph would not be enough to demonstrate excellence in research,[150] she reached out to Toni Morrison about the possibility of an interview. Hill advised McKay against it. McKay proceeded nonetheless.

McKay's willingness to proceed in spite of the risks was standard practice among Black women who believed in their work even when those around them did not. Cherríe Moraga's comment on Erlene Stetson's review of *Conditions: Five, The Black Women's Issue* (1979) captured "the huge personal risk involved in overcoming political and material obstacles in order to put together *in print* feminism, Blackness, and Lesbianism."[151] A Chicana feminist who coedited the pioneering *This Bridge Called My Back: Writings by Radical Women of Color* (1981) alongside Gloria Anzaldúa, Moraga highlighted in her commentary the risks associated with making intellectual interventions that might incite homophobic or racist backlash. She rejected Stetson's characterization of *Conditions: Five, The Black Women's Issue* as a "small beginning" and lauded the editors and contributors to the issue for their willingness to proceed in spite of the inherent risks.[152] Similarly spirited, McKay would pursue the Morrison interview in spite of pressure from her review chair not to.

McKay first initiated contact with Morrison shortly after 13 July 1980, the date Morrison published "Jean Toomer's Art of Darkness," a review of Darwin Turner's *The Wayward and the Seeking: A Collection of Writings by Jean Toomer* (1980) in the *Washington Post*. McKay, impressed by Morrison's review, sent her a letter of thanks for her "wonderful" assessment of Toomer's work, shared an abstract of her book manuscript, and invited Morrison to engage in any "dialogue . . . connected to Toomer."[153] Morrison responded to McKay's letter with a note of her own: "She'd like to see the ms. when it's done,"[154] McKay informed Painter. So McKay sent Morrison, who was at Random House at the time, her Jean Toomer manuscript in October of the following year.[155] January passed.[156] March became a memory.[157] Still no word from Random House on the status of her Toomer manuscript.

Instead of ruminating over whether she would ever hear from Morrison, McKay shifted her focus. Without documented frameworks to decode the artistry of Black women writers and unpack the cultural tropes they deployed, Black women literary critics were recovering texts and developing critical methodologies simultaneously. McKay, as a result, knew that she and others were "inventing that [interpretive] wheel as we go along."[158] McKay decided that an interview with Morrison would move her closer to getting "all the help

I can in the process"[159] of developing distinctly Black feminist interpretive frameworks. McKay shared her plans for a Morrison interview with Painter and ultimately decided to shape it after the best of the genre published in *Contemporary Literature*, a journal that "publishes scholarly essays on contemporary writing in English, interviews with established and emerging authors, and reviews of recent critical books in the field" and, fortunately for McKay, was also housed at the University of Wisconsin–Madison.[160]

With the venue confirmed, McKay moved on to identifying a model: a Nadine Gordimer interview published in *Contemporary Literature* (most likely conducted by Stephen Gray in 1981).[161] McKay included, with her request, a copy of the interview in the hope that it would help Morrison "to get an idea of what is to be expected."[162] Less than a month later, on Random House stationery, Morrison responded:

> Dear Nellie McKay,
> I would be happy to be interviewed by you for *Contemporary Literature*.
> Some time in the fall, perhaps, when I have time and can concentrate.
> I hope we can come up with anything better than that awful "Intimate Things in Place." At least I am sure your questions will be better.
> Regards,
> Toni Morrison[163]

McKay interviewed Morrison, corrected the transcription, edited the interview, and submitted it to *Contemporary Literature* for publication. Then, the wait. Personally, McKay understood the value of her interview to the field. It represented a new direction, one in which Black women's voices were at the center of their creative work and critical theorizing. Her review chair disagreed.[164] He changed his tune, however, once the interview was published.

In the winter edition of *Contemporary Literature*, McKay published "A Literary Conversation with Toni Morrison," and soon thereafter she received a note from Peter Givler, the editor of the University of Wisconsin Press (UW Press). Impressed by McKay's Morrison interview, he wanted to meet with McKay about her Toomer book.[165] When they met later that month, McKay shared with Givler her plans for a collection of "literary interviews with a select group of eight contemporary black women writers" that would include an introductory essay to frame how the interviews "give a critical perspective on the published works of these women."[166] Even though the University of North Carolina Press had the right of first refusal for McKay's next project, Givler, undaunted, hoped to convince McKay to submit her interview manuscript to the UW Press. The interest from the UW Press coincided with the

influx of external tenure letters that testified to McKay's strength as a scholar, the combination of which shifted Herbert Hill's treatment of McKay from chilly antagonism to paternal pride. In addition to enjoying McKay's Morrison interview, Hill, McKay's tenure review chair, found her "Black Woman Professor—White University" essay "very good."[167] He became more "civil" to McKay as the tenure letters he read in support of her candidacy shifted his thinking about the value of her scholarship.[168] With these successes, McKay committed herself ever more firmly to proclaiming the sovereign value of Black women's literature in her research, teaching, and service. Deepening her knowledge of Toni Morrison's oeuvre was a key part of McKay's intellectual project, but maintaining her commitment to elevating Black women's literature in spite of the professional risks was part of her mission.

The publication of McKay's 1983 Morrison interview never resulted in a published collection of interviews on Black women. In the end, Claudia Tate's *Black Women Writers at Work* (1983) and Mari Evans's *Black Women Writers, 1950–1980: A Critical Evaluation* (1984) would achieve the goals that McKay proposed in her tentatively titled "Conversations with Black Women Writers." McKay's Morrison interview and related publications that followed— *Approaches to Teaching the Novels of Toni Morrison* (1997) with Kathryn Earle and *Beloved: A Casebook* (1999) with William L. Andrews—positioned her as an early Morrison expert and a scholar who had direct access to, and held sway with, the writer, whose remarkable skill made her a literary giant. Morrison was at the beginning of the long arc of her career, and at the time McKay's "A Literary Conversation with Toni Morrison" was published, Morrison had won only one of the numerous prizes for which she would be nominated. In 1978, however, before her interview with McKay, before the accolades, professorships, and celebrity, Morrison delivered the commencement address at Spelman, a historically Black women's college in Atlanta, Georgia.

In her address Morrison marveled at the magic and the power of the graduates, the community of Black women they had been nurtured in, and the danger they faced yet held within. Morrison stressed that these Black women graduates were dangerous because they possessed power—the power to change the world. In her final lines, Morrison rejected the conflicts, the dichotomies that typically accompany womanhood by naming their status as Black women as the source of immeasurable strength: "You are not only the ship that will travel difficult waters, you are also the harbor. You are not only the traveler who will break open new paths, you are also the inn where you will offer rest. There is no conflict in that; there is no dichotomy in that: You are *women*. You don't have to choose between mar-

riage *or* work; a career *or* children. What is the history of black women in this country? We did it all."[169]

McKay, like the women of Spelman, recognized Morrison's light well before a wider public acknowledged her shine. McKay, like Morrison, would not be limited by others' sense of what she could be and do. Morrison would write the books she wanted to read, and McKay would produce the scholarship she needed to understand. Together, as writer and critic, they would speak to Black women who saw their worlds represented in their words.

AS VITAL AS IT WAS for Black women's intellectualism to be recognized within the academy, it was equally vital that their embodied experiences be named and known. In addition to contributing to her tenure dossier and serving a practical purpose, McKay's Morrison interview and other shorter pieces helped McKay develop her identity as a scholar. Her professional identity involved solidifying her claims to, and assertion of, a self—an autonomous, sovereign, and "affirming self,"[170] as she once wrote in an MLA conference proposal—that was strong enough to withstand oppression and disenfranchisement. Three early essays—"Black Woman Professor—White University," "The Girls Who Became the Women," and "W. E. B. Du Bois: The Black Women in His Writings"—foreshadowed McKay's particular skill as an essayist and investment in understanding Black women's interiors. These pieces clarified how Black women expressed their subjectivity, responded to trauma, and negotiated domestic concerns such as marriage and motherhood. They also framed McKay's trajectories as a feminist scholar of literature. Often focused on autobiography as a genre, these essays also allowed McKay to explore facets of her personal life hidden from view.

In her 1983 essay "Black Woman Professor—White University," the essay praised by McKay's tenure review committee chair, Herbert Hill, McKay theorized about her faculty experience in a way that set the stage for subsequent essays and compilations that documented the firsthand accounts of those who experienced the American academy from the margins. The straightforward title belied the complexity of the piece. There is physical space, denoted by the em dash, between McKay, our Black woman professor, and her place of work, the white university. Her story takes place against the backdrop of American history and its legacy of Black disenfranchisement, where white men mostly, white women, too, and Black men more invested in upholding patriarchy than in eradicating sexism continued to oppress Black women. But a new era was afoot, and Black women in particular had pursued a "revolutionary political stance"[171] driven by a shift in racial politics and the

emergence of the women's movement. McKay began by tracing the path to the PhD for scholars such as herself who benefited from the social and political pressures that led to the admission of more Black students to historically white colleges and universities. From there, she identified the challenges facing Black women in higher education: isolation within the department, disrespect from students, and the burden of being the primary figure charged with attending to the personal, professional, and even emotional needs of Black women students.

McKay's essay represented an early effort by Black women to speak for themselves through personal accounts that demonstrated how structural inequality and white supremacy collide when Black women enter the classroom at predominately white colleges and universities. Her essay carved out important pedagogical and epistemological territory because it spoke to the experience of many—or, at least, a rising number of—Black women hungry for a genre of scholarship that made space for women of color to reflect on their experiences in academe in the first person. The edited collections *Black Women in the Academy: Promises and Perils* (1997), which opens with McKay's chapter "Black Women in the Halls of the White Academy"; *Presumed Incompetent: The Intersections of Race and Class for Women in Academia* (2012); and *Beyond Retention: Cultivating Spaces of Equity, Justice, and Fairness for Women of Color in U.S. Higher Education* (2016) evidence the role such early testimony played in creating a space for subsequent compilations.

"Black Woman Professor—White University," as autobiography, details McKay's investment in how Black women tell their own stories, a concern that emerges again in her early work on Black women's self-writing. McKay worked most intimately with the narrative of Harriet Jacobs, the author of *Incidents in the Life of a Slave Girl* (1861), who penned the "first full-length narrative written by a former slave woman in America."[172] Through the pseudonym Linda Brent, Jacobs recounted her enslavement and escape from the clutches of her oppressive master, Dr. James Norcom, who appears in the text as the licentious Dr. Flint. In "The Girls Who Became the Women: Childhood Memories in the Autobiographies of Harriet Jacobs, Mary Church Terrell, and Anne Moody," McKay analyzed how the strategies used by these authors to render childhood remembrances reflect how Jacobs, Terrell, and Moody "understood their own development."[173] McKay returned, throughout her career, to coming-of-age stories—with Jean Toomer and Zora Neale Hurston, for example—and "The Girls" allowed her to explore issues she faced in her own life, namely, how Black women overcome patriarchy's oppressive reach by "rejecting the status quo and opposing the

values that demean their humanity."[174] McKay, like Jacobs, Terrell, and Moody, understood firsthand how telling stories could help construct a self and resist a life of "self-rejection."[175] At the same time McKay was finding her voice as a scholar, she was being recognized on campus as a rising star.

WITH MULTIPLE ESSAYS IN PROGRESS and with her essay on Toni Morrison gaining traction, McKay was a star on the rise. The University of Wisconsin knew it. McKay received a glimpse into how faculty beyond her department viewed her when she ran into her dean at a "reception for new minority students."[176] In confidence, or at least until his announcement was made, he told McKay that she had been selected as one of the university's "star" faculty. More prestige than pay, the program, backed by the Star Fund—a pool of money wrangled from the state legislature—provided raises to senior faculty at risk of being lured away and to early career faculty the university sought to retain. Even a modest raise was important because, for the general university population, UW-Madison was not doling out salary increases. When McKay finally received institutional recognition of her star status with the Dean's official announcement, it softened the demoralizing nature of her tenure process. To Painter, she confessed, "senior professors now see me as a person."[177]

Given the timing of this recognition, McKay's tenure seemed assured. But she remained on guard nevertheless. The dean was only one person, and one moment of recognition could not prevent her from being seen as an affirmative action case, as the beneficiary of rewards she had not earned. In a postscript to one of her letters to Painter that captures the disconnect between Black women's experience on the tenure track and how members of the dominant group viewed their path to tenure, McKay mentioned: "P.S. A young white untenured woman in the English Dept. saw me yesterday & asked if I am anxious about tenure. I told her I was anxious because of the University Committee, none of the members of whom I know, & whom I suspect don't care 2 copper pennies for what I do. With wide-eyed innocence she asked: 'But they wouldn't turn down a black woman, would they?'"[178] McKay knew full well that she could be turned down, and that the diversity she embodied may have been a boon to the institution's profile but would not guarantee tenure. So, even after earning a Ford Fellowship, which entitled her to time away from campus, McKay stayed in Madison to keep an eye on her tenure case. Within an institutional culture and academic climate that required McKay to repeatedly justify her work, her presence, and her worth, she knew she could leave nothing to chance.

It turned out to be a wise decision. McKay received notice of her tenure review hearing (which she thought sounded like a "death warrant") and gathered "materials to be considered by the executive committee" in advance of the 3 October deadline.[179] But before she could turn to revising her curriculum vitae, creating a "Chronology of Teaching," and detailing her service to the institution and to the profession,[180] McKay had to first clean up a mess of somebody else's making. The problem had to do with her tenure dossier, and it began when the "wrong materials" were sent "to the wrong people" and McKay became responsible for locating the source of someone else's mistake and personally fixing it.[181] As if that wasn't enough, there was also the matter of lost letters from external reviewers and a committee chair who claimed to need someone other than himself to manage the details. Deeming the talk of tenure "old hat and not of much importance" anymore, McKay had a final thought: "I bet I'm the first person who's ever come up for tenure who actually did most of the work that the Chair of his/her committee was supposed to do. But it is over, and it all went well, so that's all that counts."[182] McKay's first book, *Jean Toomer, Artist: A Study of His Literary Life and Work, 1894–1936*, was in production in time for her tenure review. By December 1983, it was official: Nellie Y. McKay was a tenured member of the University of Wisconsin–Madison's Department of Afro-American Studies.

Jean Toomer, Artist was the first book to offer a uniquely gendered, feminist reading of *Cane* that grounded Toomer as an African American writer in spite of his ambivalences about race; with this book, McKay also became one of the first African Americanists to pen a single-author study of a Black writer. Books such as this were crucial during the days when African American literature was a burgeoning academic discipline because they provided the biographical and cultural context required to read and understand the literary works of key figures in Black literature. Natural analogues for McKay's Toomer monograph include Arnold Rampersad's *The Art and Imagination of W. E. B. Du Bois* (1976) and Robert G. O'Meally's *The Craft of Ralph Ellison* (1980), but juxtaposing McKay's monograph with Thadious M. Davis's *Faulkner's "Negro": Art and the Southern Context* (1983) enables us to see how in reading the men, McKay and Davis also investigated the intersection of gender and race. Black feminists wrote about gender in works by newly discovered Black women writers, of course, but by considering representations of Black women in literature by Black men, white men, and white women, they also revealed the mutable meaning behind the deployment of Black women as sign and symbol.

The publication of *Jean Toomer, Artist*, McKay's positive tenure review, and her successful adjustment to Madison were due in no small part to Tom W. Shick, McKay's department colleague whose vast knowledge of institutional culture helped McKay through a few rough patches at the beginning of her career. When McKay joined the Afro-American Studies Department, McKay, Shick, and his wife, Chris, became fast friends. Shick had earned his PhD at UW-Madison in 1976,[183] joined the department in 1977,[184] and published *Behold the Promised Land: A History of Afro-American Settler Society in Nineteenth-Century Liberia* in 1980. Together, he and McKay formed an informal cohort, with McKay especially benefiting from the camaraderie of working alongside another new faculty member who had the place-based knowledge Shick had developed as both a graduate student and a faculty member at UW-Madison. They broke bread together even though, early on, McKay was unsure whether the Shicks cared for her cooking.[185] The Shicks helped McKay feel at home in a new town that, initially, didn't feel like home at all.

Personally and professionally, Tom W. Shick served as McKay's sounding board, helping her to navigate the politics of the department. From the beginning of her time in Madison, McKay made sure she established a professional presence in Afro-American studies and was both acknowledged and respected. Simply stated, she would not be overlooked by her male colleagues. For example, once, when it looked as if Shick had laid claim to the floating department typewriter soon after McKay's arrival, she took advantage of a moment when Shick, a historian, was busy looking at microfilm, and promptly moved the typewriter to her office. McKay's goal was to put Shick on notice. She wanted him to know that "from now on . . . he has to share it with me."[186] Unoffended, Shick demonstrated his care for McKay by serving as her ally and interceding on her behalf with her prickly review chair, Herbert Hill.

Shick was unafraid to speak candidly with McKay about Hill and submitted that Hill was inclined to take on the work of serving as her review chair even though he "never does any work for the dept.," because "he will have the glory of having brought the first lit. person the dept. has ever brought up for tenure to a successful conclusion."[187] McKay loved and trusted Shick, and the two communicated freely about the department, its personalities, and conflict resolution. A much-beloved member of the campus community and a rising star, McKay recounted enjoying "a real party" (DJ and all!) at the Shicks'[188] and celebrating Tom's thirty-sixth birthday over chocolate cake and ice cream.[189] McKay enjoyed the company of her friends. As she

moved along the tenure track, possibilities expanded before her. She made worthwhile contributions to the Modern Language Association, advocated on behalf of Black women scholars, taught Black women's literature, published her book, and strengthened her profile as an interviewer and essayist. Madison, as a place, expanded before her. For Tom W. Shick, Madison was closing in.

McKay relayed the ups and downs of Shick's emotional state in her letters to Painter. In the spring of 1983, Shick suffered "an emotional crisis" that she wrote might "keep him out of the classroom for the rest of the semester" and prevent him from teaching summer school.[190] Following a leave in 1984,[191] however, things started looking up. Shick had landed a job in Washington, D.C., and Madison was negotiating an increase in salary to get him to return.[192] By August 1985, Shick, "the person [McKay] cared about the most," "the person [she] understood best" and could always depend on,[193] had returned to the isthmus and was "working very hard" to further his scholarship and deepen his community engagement "to make up for his year away."[194] So, when McKay first heard that Shick was missing, through either department scuttlebutt or a notice in the *Wisconsin State Journal* that read "Professor reported missing,"[195] she fancied it "romantic" — thinking that he had taken off in the middle of the semester without a care in the world.[196] Days passed. Then weeks. All along, McKay welcomed updates, imagining that Shick's disappearance had nothing to do with his personal life or his professional work. She anticipated affirmation that Shick was safe and sound. It never came.

Instead, McKay learned the worst: after Shick's car was found in a UW Arboretum parking lot in late November,[197] and following the thaw of Lake Wingra, "two girls walking a dog"[198] came across the body of a man later identified as Tom W. Shick. Immediately following the discovery of his body, McKay referred to Shick in fleeting terms in a letter to Painter: a single paragraph, mention of his professional success, and the tragedy of such a loss.[199] Then, about a week later, waves of grief washed over McKay and she released, finally, the depths of her sadness. Vacillating "between anger, pain, and guilt for Tom," McKay wondered: "What gave him the right to leave the rest of us to feel as we do? Why did he think his pain was any greater than that of the rest of us? How could he not have known that his was an act of selfishness that would cause a great many other people great pain?"[200] She pondered whether prevention would have been possible and considered the rhetorical nature of her queries: "All questions have no answers, and we will never know just what pulled the trigger at the final mo-

ment."[201] Confused and heartbroken, McKay struggled to process the news and accept the reality of Shick's death.

Shick would never be replaced. Nor could he be. But he would be remembered. In the years following his death, McKay—either consciously or unconsciously—adopted an approach to her teaching and mentoring that reflected Shick's values. Shick was "a sensitive and loving man" who was well known "as a man who gave readily of himself."[202] He never said no, kept his door open, and helped his friend McKay negotiate the politics of a new place and find a life in a town she was initially determined never to call home. In the years since Shick's death, Madison's Department of Afro-American Studies and the Kappa Alpha Psi Fraternity, Inc. came together to celebrate his life with an award that honors "students who have 'maintained a high academic standing and . . . demonstrated the intellectual vigor and concern for racial equality that epitomized the life of Tom W. Shick.'"[203] Shick "had been the heart and soul of the department,"[204] recalled Craig Werner, McKay's former colleague who has since retired from his faculty position in Afro-American Studies. He was the person students went to when they had a problem. When he died, "somebody had to step up and fill that role."[205] With his passing, the "spiritual center of the department," explained Werner, "passed from Tom to Nellie."[206] In the next phase of her career McKay would become, for her students, her colleagues, and the profession, their very vital missing thing.

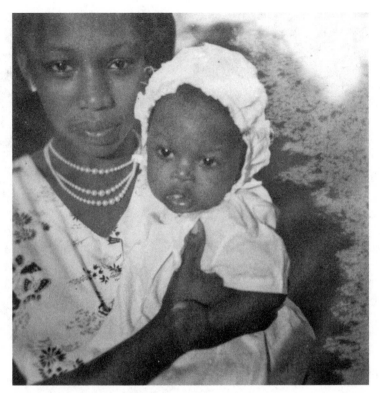

Nellie Y. McKay holds her daughter, Patricia, circa 1951. Inscription reads "To: Dear Grandpa / With love / From Pat." Photograph courtesy of Patricia M. Watson.

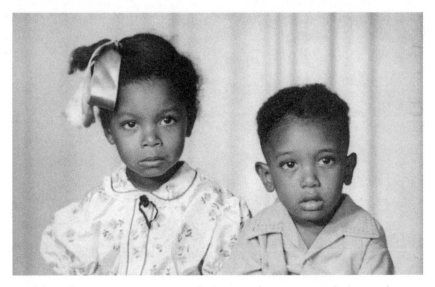

Patricia and Harry McKay pose together, December 1954. Inscription reads "With Love and Wishes." Photograph courtesy of Patricia M. Watson.

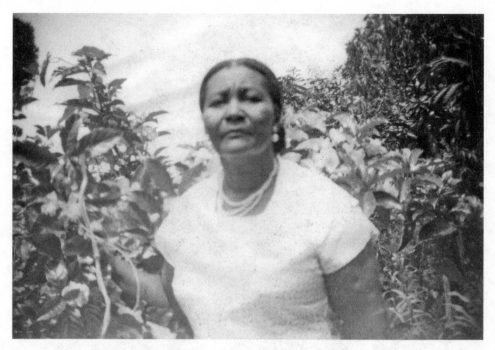

Nellie Y. McKay's mother-in-law, undated. Most likely in Jamaica.
Photograph courtesy of Patricia M. Watson.

Nellie Y. McKay, undated. Note the similar pose with her mother-in-law.
Picture possibly taken in Jamaica. Photograph courtesy of Patricia M. Watson.

Nellie Y. McKay and Joyce Scott at a dissertation party for McKay at the Scotts' home in Philadelphia, Pennsylvania. Photograph courtesy of Patricia M. Watson.

Nellie Y. McKay in her St. Albans kitchen at 111 Road in Queens, New York, sometime between 1964 and 1969. Note the generous use of black pepper! Photograph courtesy of Joyce Scott.

Nellie Y. McKay with Hollis Presbyterian Church congregants. Pastor Donald Scott, McKay, and Mary Morgan in foreground; unnamed church member in background. Picture taken in the Sunday school area of the church. McKay was a Sunday school superintendent. Photograph courtesy of Patricia M. Watson.

Nellie Y. McKay and an unidentified guest during one of her signature dinner parties at 111 Road in Queens, New York, undated. Photograph courtesy of Patricia M. Watson.

Nellie Y. McKay's sister, Constance "Connie" Prout, and her husband, Basil, December 1993. Inscription reads "To Nellie: Hope you like this recent photo. Love, Connie & Basil." Photograph courtesy of Patricia M. Watson.

Nellie Y. McKay's headshot, included in her Harvard University application, circa 1969. Photograph courtesy of Patricia M. Watson.

Nellie Y. McKay and Nell Irvin Painter at McKay's PhD party, 1977.
Photograph courtesy of Patricia M. Watson.

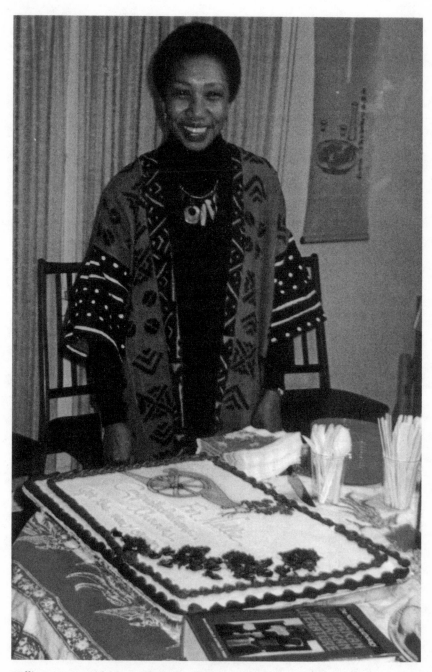

Nellie Y. McKay celebrates *The Norton Anthology of African American Literature*
at a party hosted by Susan and Ed Friedman, Madison, Wisconsin, circa 1997.
Photograph courtesy of Susan Stanford Friedman.

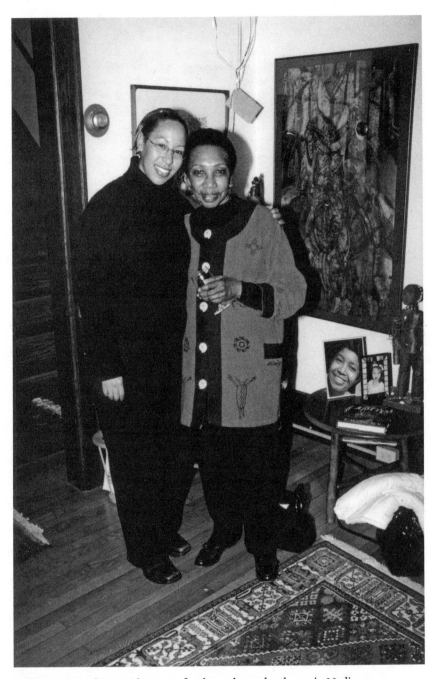

Nellie Y. McKay hosts a PhD party for the author at her home in Madison, Wisconsin, 2002. Note the picture of Pat on the table on the right side of the photograph. Photograph courtesy of James L. Greene.

SCENE III | Rootedness

> There is a conflict between public and private life,
> and it's a conflict that I think ought to remain a
> conflict. . . .
> So I just do the obvious, which is to keep my life as
> private as possible;
> not because it is all that interesting, it's just
> important that it be private.
> And then, whatever I do that is public can be done
> seriously.
>
> —TONI MORRISON, "Rootedness"

While writing about Nellie Y. McKay's early struggles, I relived moments past, such as the time I learned how default whiteness pervades the professoriate and experienced how classrooms become hostile spaces for Black students. When I reflect, I understand anew how McKay's wisdom has rooted me in ways I notice when I feel most vulnerable.

When I arrived at the University of Wisconsin–Madison in 1994, I was one of a handful of Black women graduate students studying African American literature. It didn't take me long to appreciate the value of keeping the personal private. To protect myself from exposure and the limiting beliefs of those who didn't understand the power of a historically Black education, I focused on what I was there to do and not on where I had been.

That was, at least, until my first graduate class with Richard Ralston. It was a history class of some sort, and our day-one icebreaker included simple introductions. When my turn came, I said my name and my undergraduate institution: Johnson C. Smith. "In Charlotte?," he asked. Other times, with similar icebreakers, the response had not been so affirming. Usually, I was met with blank stares. I typically heard, "Smith College? In Massachusetts?" Most of my classmates knew nothing about HBCUs, let

alone a school that wasn't Spelman or Morehouse or Hampton or Howard. No, Ralston knew exactly what I was talking about. That feeling remains palpable: I was safe and seen. "Yes," I responded, my leg, back, and neck muscles softening with relief.

At the time, I didn't appreciate the indispensable role historically Black colleges and their graduates have played in the development of Black literary studies. Writing this book taught me something altogether new. Richard K. Barksdale, the second African American to earn a PhD in English from Harvard University, taught at several HBCUs before moving to the University of Illinois at Urbana-Champaign and coediting, with Keneth "Ken" Kinnamon, *Black Writers of America: A Comprehensive Anthology* (1972). Darwin T. Turner, who taught at the University of Iowa until his death at fifty-nine, began his career at Florida A&M University before taking a position at North Carolina A&T State University. Blyden Jackson, the first African American to earn tenure and, later, the rank of full professor at the University of North Carolina at Chapel Hill, graduated from Wilberforce University. Learning about these scholars revealed my roots in a tradition of Black literary excellence grounded in the Black college experience. I know this is a list of men. I know the white academy limited their professional choices. But I also know that there are many more—the Jerry W. Wards, the Eleanor W. Traylors, the Inez Moore Parkers—whose legacy makes me legible, even if it's to no one but myself.

I was legible in Ralston's history class, both seen and understood; I was illegible in Cold War Fiction, unseen and unknowable. In Cold War Fiction, I learned the physicality of marginalization, the visceral effects of microaggressions. How it *feels* to be invisible, hypervisible, and misrecognized. Ralph Ellison's *Invisible Man* (1952) was our text, and it was my turn to facilitate discussion. Class opened and I introduced my goals: together, we would unpack Ellison's use of folk culture to differentiate between caricature and trickster. This, I thought, would help prepare us to discuss race when teaching the text. It seemed straightforward enough. Then, crickets. Not a word. I sat and waited. No one made eye contact. Our professor—uncomfortable, perhaps, with the silence—broke it with this query: "So? What about the universality of the novel?" The class erupted and the discussion went on without me. I sank inside, the knot in my throat choking back the tears. Class ended. I lumbered downstairs to McKay's office, my shoulders stooped with shame, my eyes downcast in disbelief. I sat down, closed the door behind me, and explained what happened. I didn't cry. She was having none of that. I recounted my experience and waited. She was sitting

behind a midcentury steel Tanker desk in an office overrun with books on the fourth floor of Helen C. White Hall. Behind her was a window—practically the size of the wall, as I recall—and on the side of the desk closest to me, as usual, a small candy dish. She lowered her chin, looked at me from over her glasses, and with eyes that conveyed the seriousness of her words peered directly into mine and said, "Shanna, you have no power. Get your A and get out." As I rose to leave, she added, "And don't write about Ellison in your final paper."

I got my A, got out, and wrote about Ellison anyway. My Cold War Fiction paper focused on Mary Rambo: a minor figure in the novel who played a major role in Ellison's drafts. Rambo got short shrift in the published book, not because Ellison thought she was unimportant—her "section of the novel underwent more revision than any other and is the sole portion of the drafts to be published as a narrative unto itself"[1]—but perhaps she was too grand, too bold, a scene-stealer and changemaker, so was written into a narratively small, yet conceptually large, role as a result. "Imagine, indeed, what the American Negro would be without the Marys of our ever-expanding Harlems," Ellison intoned.[2] Imagine, indeed, what the American academy would be without Black women who, if not here, "would have to be invented."[3]

It is uncomfortable for me to revisit that moment in Cold War Fiction because my body remembers, too. I am there then, even as I write now. And yet, writing McKay's story and bringing together the strands of what she taught me, well before I was ready to receive the lesson, lifts me up and fills me with gratitude. Exposed and vulnerable, McKay and the Black women of her generation poured themselves into their writing for themselves and for me. They bore the condemnation of colleagues, tenure review committees, journal editors, and book publishers who dismissed their work only to turn around and co-opt their theories and pass them off, uncited, as their own. The history of Black women's place in Black literary studies, as told in *Half in Shadow*, reminds me that the price has been paid. Justification is a distraction. My job is to continue the work and to take care of myself—not only because longevity matters, but also because I deserve it.

The opening epigraph, in which Morrison delineates the space between public and private lives, has helped me to think of McKay as a scholar who made choices about her private life that allowed her to maintain a laser-sharp focus on her professional work. But if we mine the ellipsis separating the first part of this quote from the second, we find Morrison teasing out the role of individual work done with a "tribal or racial sensibility,"[4] a facet

of McKay's scholarship and institution building that was never far from her mind. *Half in Shadow* has given me a new way to understand Cold War Fiction, the shame, and the burden to keep personal stories private. I tell here, now, to honor the elders and ancestors, McKay among them, whose sacrifices and secrets afforded me opportunities they never could have imagined. Their concealments bought me the freedom to reveal. I am rooted in the work of a long line of Black women who taught me the value of race literature and to see value in myself.

When and Where I Enter

The department of English at the University of Wisconsin–Madison is housed on the upper floors of Helen C. White Hall, a building named in honor of an English professor who was the first woman full faculty member in the College of Letters and Science. On the north side of the building, there are spectacular views of Lake Mendota, one of the two lakes that form Madison's isthmus, a strip of land that separates the university to the west and communities to the northeast. The English Department sits high and looks low. Nellie Y. McKay experienced its loftiness while on the tenure track, avoiding faculty in the English Department who reminded her too much of the isolation she had felt at Harvard University. "I didn't have anything to do with English, actually,"[1] recalled McKay, when asked about her early relationship with Madison's English Department. "It was like doing Harvard all over again,"[2] she continued. "It wasn't that they were trying to be nasty or anything like that. It was just that they'd never had to live up close with a woman, a single Black woman who had come to the community, what do you do with her?"[3]

In the 1980s, UW-Madison's English Department was in the wake of a series of battles that divided the department along political and philosophical lines. On one side were conservative scholars who upheld the canon as it was constructed at the time; on the other side were those who were "insisting on shaking up the canon." The women and the Black people, especially, argued against Black writers as syllabus appendages and advocated for a literary "tradition" reimagined with the interplay between history, literature, and culture firmly in place.[4] Toward the beginning of her career at UW-Madison, the upper floors of Helen C. White Hall buzzed with gossip about McKay's worthiness, the climate proving hostile toward both McKay and her area of study. "In the earlier years," recalled colleague Deborah "Deb" Brandt, "there would be remarks made all the time by faculty, sometimes by staff. The climate was not good. . . . I'm not going to name names, but I heard snide remarks about Nellie in the English department by some people about her . . . I don't know, her education, her trying to make it, ridiculous stuff."[5] English at UW-Madison was a "very, very canonical, conservative department" at "a rather white university"[6] and, as such, was rigid about the literatures it deemed worthy of study.

Instead of becoming concerned about a climate she couldn't control, McKay looked inside for inspiration. From her apartment on Bluff Street, a quiet two-lane drive that bordered Hoyt Park—its massive stone fireplaces and sturdy picnic enclosures reminding visitors of its former days as a quarry[7]—she imagined worlds beyond the margins. McKay had just earned tenure and was embarking on what she called her "project," an exciting and new endeavor that involved focusing on "black women's writings"[8] as an area of critical inquiry. At the same time, she turned toward another vision: formalizing the relationship between African American literary studies and English at the University of Wisconsin–Madison. "I've never felt that African-American Literature can survive without that other body,"[9] she offered during our interview. "It has to be inside of that body. It's central to the body and can't leave the body alone any more than the body can leave it."[10] McKay's efforts to integrate literary studies were about more than institutional hierarchies or a belief that American literature superseded Black literary traditions. McKay wanted American literature to open wide, to bend toward her, and she was willing to do what was necessary to impress upon her colleagues this simple fact: without Black literature, American literature doesn't exist.

McKay's hard-won battles at her home institution prepared her to ignite change in later years, when she took on the masculinist impulse in Black literary studies at large. Drawing from a position of embodied power, and with the full weight of her experience and expertise behind her, McKay avowed to Americanists and African Americanists alike that when and where she entered, Black women's literature entered with her.

THE TITLE OF THIS CHAPTER evokes Anna Julia Cooper's *A Voice from the South* (1892), the "first book-length Black feminist text"[11] written by the fourth Black woman to earn a PhD. Cooper argued for the educational empowerment of Black women, since their economic independence and self-sufficiency would produce a new class of citizens poised to uplift not just African Americans but the whole human race. Cooper's project was the product of her Blackness and her womanness, so her reclamation of the Black female body in *A Voice from the South*, as Brittney C. Cooper explained, "reminds us that intellectual work is not a disembodied project."[12] McKay and her cohort of Black feminist thinkers invoked similar analytical frameworks in their criticism. Who they were was as important as what they did, and with Cooper's epistemology as both conscious and unconscious backdrop, McKay and others justified the sovereign value of Black women's texts and perspectives in their criticism.

Anna Julia Cooper included the first-person and oft-cited "when and where I enter" in the chapter "Womanhood: A Vital Element in the Regeneration and Progress of a Race." The title of this chapter falls under the subheading "SOPRANO OBLIGATO," a musical descriptor signaling an obligatory female singing voice, to indicate the indispensability of Cooper's claims, which sound from the highest moral and intellectual registers. In "Womanhood," Cooper made it plain: "Only the BLACK WOMAN can say 'when and where I enter, in the quiet, undisputed dignity of my womanhood, without violence and without suing or special patronage, then and there the whole *Negro race enters with me.*'"

In this not-so-subtle dig at abolitionist and Black Nationalist Martin Delany, who "used to say when honors fell upon him, that when he entered the council of kings the Black race entered with him,"[13] Cooper rejected the belief that maleness and so-called pure Black blood were the primary mechanisms by which authentic and representative blackness could be measured.[14] Cooper's nineteenth-century response to Delany anticipated twentieth-century gender tensions that emerged in Black literary studies. McKay mirrored Cooper's rebuke of Delany in her fervent rejection of the masculinist impulse in Black literary studies. And out of her desire to center Black women as theorists, teachers, and students, McKay wrote them into her criticism, pedagogy, and leadership. McKay's intellectual project was also embodied work that, when read through a Cooperian lens, "reminds us that we cannot study Black women's theoretical production or tell Black women's intellectual history without knowing something of their lives."[15] McKay lived her life and produced her work within a profession that was as resistant to her intellectual contributions as it was unsettled by her physical presence.

In his 1992 presidential address, "Local Pedagogy; or, How I Redeemed My Spring Semester," Houston A. Baker Jr., the first Black president of the Modern Language Association (MLA), who is now Distinguished University Professor at Vanderbilt University, described his early complicity in the erasure of Black women's voices in Black literary studies. Baker's class was Black Women's Writing, and during a discussion of Phillis Wheatley's poetry, as the students "were energetically holding forth on neoclassical literary conventions,"[16] a voice came from the back corner of the room. A Black woman, who had been listening quietly to the conversation, had a question: "You know, we have been going on and on about conventions and how Wheatley subverted them and everything. But I'm not so much interested in conventions as in what Phillis means to the black community per se. I'd like to see us

talk about Wheatley in more direct ways."[17] "'Well,'" Baker responded, "'in this class we are going to deal with conventions. You and I can discuss the black community during office hours.'"[18] With the goal of improving students' "reading skills," he returned to the discussion in progress, intent on maintaining the critical legitimacy, not the political relevancy, of his class.

But Baker was undone by the event and couldn't shake the feeling that in "suppress[ing] her individual black 'womanist' voice," in denying "an actual black woman's voice rife with narrative potential," what he deemed "pedagogical entrée," he missed the opportunity to invite into his class—on Black women writers, at that—a consideration of how situated, local, and embodied pedagogies inform critical reading.[19] He came around and, by the end of the address, expounded on how this lone Black woman "redeemed" his pedagogy. Baker's pedagogy may have been free, liberated by his Black woman student, but the Black women responsible for providing the critical vocabulary he used to characterize her voice as womanist—Alice Walker, for example—were noticeably absent. Baker's address marked a moment in time. As Black women's ideas became indispensable within the mainstream academy, the women who produced them became disposable. Like Baker's student, Black women scholars found themselves calling out from the proverbial back corner of the classroom and demanding, with their research and teaching, that white men abandon their supremacist practices, that white feminists abandon their racist behavior, and that Black men abandon their masculinist ways.

It was the climate of the times, the culture out of which McKay did her work, and literary theorist Hortense J. Spillers, who now serves as Gertrude Conaway Vanderbilt Professor of English at Vanderbilt University, remembered how Black women were excluded not just from American and African American literary studies but from feminist studies as well. In "'Whatcha Gonna Do?': Revisiting 'Mama's Baby, Papa's Maybe: An American Grammar Book': A Conversation with Hortense Spillers, Saidiya Hartman, Farah Jasmine Griffin, Shelly Eversley, & Jennifer L. Morgan," Spillers explained how, from the late 1970s through the mid-1980s, Black women struggled to be recognized for their contributions to feminist discourse. Instead of their being invited to collaborate around critical conversations, Black people were used as "raw material" that served "as a note of inspiration" for the scholarly pursuits of others.[20] Black women's recovery work and intellectual interventions were changing higher education, but Black women themselves were consistently marginalized, their ideas invoked without reference to the Black women responsible, to the battles Black women fought, or to the price Black

women paid to document Black women's literature and to elevate and challenge the relevancy of literary theory.

Black women's literature was becoming the next hot thing, an "occult," according to Ann duCille, and its popularity threatened to displace Black women from the field they had toiled to form. duCille pondered how the marginalization of "the black women critics and scholars who excavated" African American literature and Black feminist studies would impact the face of these fields when she asked, "What does it mean for the future of black feminist studies that a large portion of the growing body of scholarship on black women is now being written by white feminists and by men whose work frequently achieves greater critical and commercial success than that of the black female scholars who carved out a field in which few 'others' were then interested?"[21] If we look again to the incident recounted by Baker, the Black women scholars who knew Baker's student without ever having met her, those who occupied a similar position when they asserted the value of Black women's literature and criticism or demanded acknowledgment of their contributions to literary and feminist studies writ large, came to understand that their salvific wish, their redemption through representation, would be fulfilled only from within. There would be no cavalry coming to the rescue, no affirmation from on high. McKay, Spillers, duCille, and others would be responsible for doing the work of remembering Black women writers and critics in the face of forces that would rather forget.[22]

To understand what McKay and her counterparts were up against as they forged the Black literary origins of Black feminist thought, it is useful to rewind to June 1986, when Mel Watkins, the first African American editor of the *New York Times Book Review*, published "Sexism, Racism and Black Women Writers," a review of Steven Spielberg's film version of Alice Walker's *The Color Purple* (1982) that masqueraded as a review of the novel. The review lambasted Walker and a litany of other "notable writers"—Toni Morrison, Gayl Jones, Toni Cade Bambara, Gloria Naylor, Ntozake Shange, and Michele Wallace especially—for "exposing aspects of inner-community life that might reinforce damaging racial stereotypes already proffered by racist antagonists."[23] Incensed, Black women literary critics Deborah E. McDowell[24] and Gayle Pemberton[25] penned letters to the editor castigating Watkins for suggesting that Black women keep the unspeakable unspoken especially in the presence of white people.

Watkins appears to have established his "qualifications" as a critic of Black women's texts in his coedited 1971 collection, *To Be a Black Woman: Portraits in Fact and Fiction*. *To Be a Black Woman* received a scathing review

from then-Random House editor Toni Morrison, who skewered Watkins for confirming the myths about Black women he supposedly sought to dispel. "With the kindest words, the sweetest euphemisms, the commonest sociological jargon," Morrison wrote, "'Portraits in Fact and Fiction' manages to remain fiction. We are left at the end with the same labels provided in the beginning: 'laborer,' 'breadwinner,' 'sexual myth incarnate—plaything,' 'protector,' 'provider,' 'cushion.' In spite of the inclusion of a few splendid pieces, no recognizable human being emerges. What does emerge is an oppressed but sexy, sexy but emasculating bitch."[26]

Literary scholar Candice M. Jenkins drilled down into the meaning behind this moment in her essay "Queering Black Patriarchy: The Salvific Wish and Masculine Possibility in Alice Walker's 'The Color Purple,'" which paid particular attention to the story behind the overwhelmingly negative criticism Walker received from Black men. In this essay, the precursor to her full-length study *Private Lives, Proper Relations: Regulating Black Intimacy* (2007), Jenkins analyzed criticism of Alice Walker's novel-turned-movie as a case study in what happens to the Black woman writer who has been written out of the Black community, marginalized "as a kind of racial turncoat," and "scripted by a black (male) critical establishment as a delinquent daughter who has strayed from the black family fold."[27] After the release of the film adaptation of her novel, which introduced her epistolary fiction to a broad audience, Walker became a target for detractors who readily admitted that they had not read the novel but were willing to criticize its representation of Black men nonetheless.

By refusing to adhere to narrow scripts about Black womanhood or cloak the truths of their material realities behind a veneer of respectability, the Black women writers McKay and others wrote about became easy prey for critics with an axe to grind because these very same Black women writers were brave enough to confront taboo topics in their texts. In the face of outright hostility toward Black women writers—their choice of subject, their treatment of sexual violence, their portrayals of Black men—McKay and her peers collected a body of literature and created modes of critical analysis to write their own version of Black women's literary and cultural history and to trace the contours of what would become known as Black feminist thought.

In their scholarship and publishing, Black women writers and critics culled the archive to allow Black women readers to see themselves in the literature; with the primary source material they compiled, they supported one another's teaching of, and research on, Black women writers. These twentieth-century Black feminist texts established an intellectual geneal-

ogy that launched future studies of the tradition. The clarion call was issued by Toni Cade, whose *The Black Woman* (1970) was an act of self-definition and healing for Black women that, according to Eleanor W. Traylor, would liberate "a future of ever new audiences," and here Traylor invokes Bambara's words, "'to think better than they've been trained.'"[28] Black women's studies were institutionalized in the twentieth century but rooted, as Beverly Guy-Sheftall's *Words of Fire* shows, in the nineteenth-century Black feminist beginnings offered by the likes of Maria Stewart, Anna Julia Cooper, and, I would add, Victoria Earle Matthews.[29] Pat Crutchfield Exum's *Keeping the Faith: Writings by Contemporary Black Women* (1974); Roseann P. Bell, Bettye J. Parker, and Beverly Guy-Sheftall's *Sturdy Black Bridges: Visions of Black Women in Literature* (1979); *Home Girls: A Black Feminist Anthology* (1983) by Barbara Smith; *Double Stitch: Black Women Write about Mothers and Daughters* (1991), edited by Patricia Bell-Scott, Beverly Guy-Sheftall, Jacqueline Jones Royster, Janet Sims-Wood, Miriam DeCosta-Willis, and Lucie Fultz; and Guy-Sheftall's *Words of Fire: An Anthology of African-American Feminist Thought* (1995) are books of note. Mary Helen Washington is particularly significant for her collections *Black Eyed Susans: Classic Stories by and about Black Women* (1975) and *Invented Lives: Narratives of Black Women, 1860–1960* (1987) as well as for two articles of early Black feminist criticism in *Black World*: "The Black Woman's Search for Identity" (1972) and "Their Fiction Becomes Our Reality: Black Women Image Makers" (1974). Washington's early essays introduced thematic concerns and methodological tools Black women critics would take up, expound on, and riff off of in the following scholarly tracts.

Thematically driven critical studies of Black women's literature defined disciplinary subfields and critical vocabularies essential to the study of Black women's texts across time and genre. I list these texts here, together and as catalog, to demonstrate, even visually, the titles that collectively formed the cornerstone of Black feminist literary futures. These books include Barbara T. Christian's *Black Women Novelists: The Development of a Tradition, 1892–1976* (1980); Trudier Harris's *From Mammies to Militants: Domestics in Black American Literature* (1982); Hazel V. Carby's *Reconstructing Womanhood: The Emergence of the Afro-American Woman Novelist* (1987); Joanne M. Braxton's *Black Women Writing Autobiography: A Tradition within a Tradition* (1989); Claudia Tate's *Domestic Allegories of Political Desire: The Black Heroine's Text at the Turn of the Century* (1992); Karla F. C. Holloway's *Moorings and Metaphors: Figures of Culture and Gender in Black Women's Literature* (1992); Frances Smith Foster's *Written by Herself: Literary Production by African American Women*

(1746–1892) (1993); Ann duCille's *The Coupling Convention: Sex, Text and Tradition in Black Women's Fiction* (1993); and Deborah E. McDowell's *"The Changing Same": Black Women's Literature, Criticism, and Theory* (1995). Atop this foundational work in Black feminist recovery and theorizing, Black women critics and the students they trained would build new worlds.

Books that compiled interviews or essays accompanied by critical introductions, such as Claudia Tate's *Black Women Writers at Work* (1983) and Mari Evans's *Black Women Writers (1950–1980): A Critical Evaluation* (1984), Hortense J. Spillers and Marjorie Pryse's *Conjuring: Black Women, Fiction, and Literary Tradition* (1985), and Cheryl A. Wall's *Changing Our Own Words: Essays on Criticism, Theory, and Writing by Black Women* (1989), were especially useful classroom tools that kept the theorizing of Black women accessible and in circulation. The journal *Conditions: Five, The Black Women's Issue* (1979), edited by Lorraine Bethel and Barbara Smith, compiled poetry and prose by both established authors and women who never thought they'd see their work published in a journal to "disprov[e] the 'non-existence' of Black feminist and Black lesbian writers."[30] *All the Women Are White, All the Blacks Are Men, but Some of Us Are Brave: Black Women's Studies* (1982) by Gloria T. Hull, Patricia Bell Scott, and Barbara Smith is indispensable for how it named the work and established the stakes of Black feminism, providing extensive resources for those who wished to learn, as well as those who needed to teach. bell hooks's *Feminist Theory: From Margin to Center* (1984) rejected separatism as mainstream feminism's organizing framework and reevaluated the role of Black women's everyday experience of sexism, patriarchy, and white supremacy in the feminist imagination. These collections answered the implicit call issued by Morrison in the final lines of her negative appraisal of Mel Watkins's collection: "Somewhere there is, or will be, an in-depth portrait of the black woman."[31] With these texts, together a gallery of early Black feminist theorizing, Black women created a rich palette and painted themselves with luminous strokes, to create anew the colors of us.

AFFIRMED BY THE impactful work of her Black feminist peers, protected by the acquisition of tenure, and justified by the publication of her Jean Toomer book, McKay took advantage of the power she possessed and the relationships she had formed and set her sights on ways to impact the profession through sustained institutional change. She began with UW-Madison's department of English and focused on integrating African American literature into American literary studies and giving it pride of place within English departments nationwide. A savvy academician, McKay strategized on two fronts: first, she had to

place herself in a position of power within an English Department that was conservative, hostile, and isolating; second, she had to convince faculty in the Afro-American Studies Department to release their hold on the teaching of Black literature at the University of Wisconsin–Madison. An offer of a joint appointment at precisely the right time gave her the opportunity she needed to initiate the institutional change she envisioned.

While McKay's home department was Afro-American Studies, for the length of her time at UW-Madison she had worked closely with English faculty associated with women's studies, most notably Susan Stanford Friedman, the former Hilldale Professor and Virginia Woolf Professor of English and Women's Studies.[32] During a period after McKay earned tenure, she remembered an unnamed representative from English saying, "Well, you know, you do a lot of work for us," to which McKay responded, "Yes, I do a lot of work for you, and maybe it would be nicer if we had some sort of legal attachment."[33] The details of the exchange are vague, but we know that before long the sides came to an agreement. And so it would be: beginning in the fall of 1984, McKay's first semester as an associate professor, she officially held a joint appointment in the departments of English and Afro-American Studies.[34] McKay used her joint appointment as a tool. While later she would work alongside an English Department ad hoc diversity group on a pipeline program between Afro-American Studies and English, her first order of business following approval of her joint appointment was to make courses on Black literature taught in the department of English.

To advance her initiative, McKay finessed negotiations between English and Afro-American Studies on the issue of which department would "own" Black literary studies. At the time, Black literature was the purview of Madison's Afro-American Studies Department, so to weave it into English, to cross-list Black literature courses, McKay first needed to convince her home department to share this part of their curriculum. McKay's friend William L. Andrews, "Bill" to McKay and colleagues, had entered UW-Madison's English Department in 1977, just a year before McKay joined Afro-American Studies. He remembered a disciplinary terrain where the lines were strictly drawn. Even though he identified as an African Americanist, incorporated Black writers and Black texts into his courses on American literature, and gave a job talk that focused on "late nineteenth-century American and African American novel[s]," it was clear, he said, that "African American literature was taught in the Afro-studies department," not in English.[35]

When Richard Ralston became chair of Afro-American Studies, remembered Susan Friedman, things loosened up, and McKay "managed to get

Afro-American Studies to agree to have their courses cross-listed out."[36] As a faculty member, the Department of Afro-American Studies grounded McKay within a space that presupposed the value of Black subjectivity and the relevancy of Black methodological frameworks. McKay ardently believed that students in English needed these frameworks, too. To her mind, the health of Black literary studies depended on it. It is impossible to know for sure to what extent broadening access to African American literature in this way contributed to the issues of identity politics McKay would raise later in her essay "Naming the Problem That Led to the Question 'Who Shall Teach African American Literature?,'" but for the time being, McKay envisioned the integration of Black literary studies as a move in the right direction. By asserting a vision, soliciting buy-in, and managing personalities, McKay placed herself on the path toward institutionalizing Black literary studies on a grand scale.

On the heels of McKay's work to expand Black literary studies within the English Department, she secured support for Afro-American Studies programming through a series of Ford Foundation grants. These grants were written using the same collaborative approach McKay took to integrating the English Department's curriculum, but they developed her individual skills in grant management and program development as well. Black literary studies was still in its infancy, so McKay pursued grants that would protect the nascent field. Through grants to UW-Madison's Afro-American Studies Department and similar programs nationwide, the Ford Foundation deployed its massive financial resources to remake Black studies according to priorities that included "racial integration and diversification of college campuses and curricula."[37] Over a span of fifteen years and especially where support for graduate students was concerned, the foundation funded numerous grants to strengthen programming and amplify the impact of Afro-American Studies at UW-Madison and within the Midwest Consortium for Black Studies, a group that included the University of Michigan, Michigan State University, the University of Wisconsin–Madison, and Carnegie Mellon University. For example: between 1989 and 1993, McKay and her colleagues at UW-Madison sought and received funding to support "programs in the Afro-American Studies department in the areas of research, materials, development & dissemination,"[38] resources that buttressed the quality of instruction and the support for collaboration between programs in the region. McKay's grant writing and partnership with the Consortium was good for Black studies in the Midwest and good for her professionally, since it was here that she solidified her gift for leading from behind.

At the University of Wisconsin–Madison and in her work with the Consortium, McKay built her capacity as a leader by understanding her strengths and weaknesses and by surrounding herself with colleagues she trusted and whose strengths complemented her own. McKay developed an especially productive working relationship with one Afro-American Studies colleague in particular: Craig Werner. Werner, who joined Afro-American Studies in 1984 as another Black literature specialist, graduated from Colorado College and attended the University of Illinois for graduate study, where he earned his master's in American literature and his PhD in English. Werner was trained by Keneth "Ken" Kinnamon, a Richard Wright expert and scholar of African American literature who coedited *Black Writers of America: A Comprehensive Anthology* (1972) with senior Illinois colleague Richard K. Barksdale. Barksdale, who, in 1951, became the second African American to earn his PhD in English from Harvard, emerged as a "dean of African American letters"[39] and took steps to codify Black literature in his coedited compilation. Werner's knowledge of the broad sweep of Black literature and his speed as a writer operationalized McKay's personal vision and professional connections, and the two enjoyed a close partnership over the years. Stanlie M. James, another member of the department, described McKay's approach to collaboration: "Well, Nellie thinks up these ideas about what we should do. Then I wrote the proposal. Then she calls up all her friends and invites them. That's how we would do it."[40] Between 1995 and 2004, with support from the Ford Foundation, Consortium members such as UW-Madison's Afro-American Studies Department were able to make Black studies a viable and respected part of their institutions through grants that supported "a series of seminars on Black women and on urban communities"[41] and "projects to institutionalize the Midwest Consortium for Black Studies."[42]

Funding from the Ford Foundation, however, was not without strings. A university's institutional philosophy was crucial in determining eligibility, and the Ford Foundation privileged programs that veered away from the Black power foundations of Black studies. Under the leadership of McGeorge Bundy, explained Noliwe M. Rooks, author of *White Money/Black Power: The Surprising History of African American Studies and the Crisis of Race in Higher Education* (2006), the Ford Foundation took an integrationist approach to funding and supported only Black studies programs that reinforced its vision. The Foundation "refused to fund programs and groups that couched their requests for assistance within the rhetoric of Black Power,"[43] leaving programs that took so-called militant approaches to Black self-efficacy without support. The Foundation's focus on desegregation[44]

pitted "those who believed in racial cooperation"[45] against those who envisioned Black studies "as an independent field capable of delivering institutional power into Black hands, free from the interference of white faculty and administration."[46] Ford money, then, came at a cost. Instead of promoting self-reliance, relevancy, and Black liberation as foundational concepts, funded programs ensured their longevity by professionalizing their departments and replicating the norms of academic elites.

The "ideological divide" within Black studies had long-lasting effects on the types of literature, modes of criticism, and pedagogical practices that Black literary scholars valued and that mainstream colleges and universities affirmed. In her rich and comprehensive essay "Black Is Gold: African American Literature, Critical Literacy, and Twenty-First Century Pedagogies," Maryemma Graham traced contemporary African American "theory and pedagogy" through the civil rights, Black power, and Black arts movements to consider the trade-offs associated with institutionalizing Black literary studies.[47] For the purpose of this biography, Graham's observations regarding how scholars of Black literature established "professional legitimacy within the academy" are instructive, since they detailed how, as early as Dexter Fisher and Robert Stepto's *Afro-American Literature: The Reconstruction of Instruction* (1978), Black scholars were "drawing boundaries for the field" and "redefining for its practitioners the meaning of social relevance and community engagement."[48] There would be no "black radical politics" or a preponderance of "writers associated with such activity."[49] Instead, the "path to mainstream acceptance" would be paved with high theory, "intellectual hierarchies," and Ivy League degrees.[50] McKay straddled the space between Black power and this new Black intellectual elite. McKay's scholarship and service may not have been radical, but it was relevant. She held a PhD from Harvard but was more invested in theorizing that privileged accessibility over opacity. McKay published her first book with a prestigious university press, but her greatest contributions were not prize-winning monographs but field-defining essays. McKay collaborated with those from elite institutions but was not constrained by academic elitism when identifying collaborators. I make these comparisons not to reinforce specious binaries but to highlight the existence of a middle ground, a liminality, if you will, that McKay occupied as a scholar and teacher. Little did she know that her ability to bridge sides, to execute a vision, and to mediate conflict—skills she refined in the work she undertook to weave Black literary studies into UW-Madison's English Department and to lead the Midwest Consortium for Black Studies—would prepare her to transform the teach-

ing of Black literature worldwide. The result was a "canon blast,"[51] a shot heard 'round the world.

IN 1984, ONE YEAR AFTER NELLIE Y. MCKAY earned tenure and published her Jean Toomer book, Henry Louis Gates Jr., known as "Skip" among those within his inner circle, articulated a vision for advancing a field of study still struggling to break into the disciplinary mainstream. That field was Black literary studies. Gates, who envisioned the "black anthology as canon formation,"[52] aimed to make the literature of Black Americans available worldwide. While at Cornell University in Ithaca, New York, Gates approached his colleague M. H. Abrams to persuade the anthology behemoth to "launch the project."[53] Abrams, a formidable literary scholar who published numerous books of literary criticism, poetry, and prose, was also editor of *The Norton Anthology of English Literature* and a highly respected advising editor of Norton Anthologies. Norton was, and remains, the preeminent publisher of anthologies used for college teaching, and at the time, it offered African American literature a gateway into the mainstream and into a potentially lucrative college textbook market. It was Abrams's relationship with Norton and knowledge of the editorial process governing anthology production that prompted Gates to share his vision for an anthology of Black literature with Abrams before packaging it as a proposal and presenting it to Norton.

The preface to *The Norton Anthology of African American Literature* (*NAAAL*) offered one version of the history of the anthology through the "Principles of Selection" and "Editorial Procedures" sections of the preface, but my alternative take on the history of the anthology, which incorporates information from primary sources and unpublished interviews, reveals how early "gender trouble" rewrote the anthology's origin story, and maps McKay's role in how the *NAAAL* came to be. Following a "two-year gestation period from proposal to approval,"[54] a discussion about what was then called *The Norton Anthology of Black American Literature* (*NABAL*) was held at Cornell on 26 November 1986. Unnamed participants set out to define the scope of the project, establish standards, and set a time line. As logged by an unidentified author of unpublished "Rough Notes," Gates, as leader of the project, was tasked with talking to Mary Helen Washington to "give her her choice of editorial positions."[55] Her options were as follows: take on the role of "Associate General Editor" and be responsible for the "representation of the women writers," or accept the position of general editor of "period 2," 1865–1919, should she decline the associate role.[56]

The unnamed author of these "Rough Notes" rightly expressed uneasiness around the practicalities of the first editorial configuration when they wrote, parenthetically, "(I'm still a little worried how this'll work out in practice)."[57] How would Washington, responsible only for the women, work with each period editor while maintaining the strict limitations of this role? "She is to advise, *not* write,"[58] the notes explained. Washington recalled the conversation she had with Gates about joining the editorial board as one that probably took place at her apartment in Cambridge while she was a faculty member at the University of Massachusetts.[59] Washington published some of her earliest essays in *Black World*—a periodical backed by Chicago's Johnson Publishing that took a diasporic look at the Black experience—and was part of "the small band of scholars who, in 1970, inaugurated the first Black Studies program at the University of Detroit."[60] Washington was at the forefront of "efforts to define and institutionalize the fields of African American literature and Black feminist studies."[61] She was such an important figure that when Ann duCille published "The Occult of True Black Womanhood," she explained how one of her "most precious possessions is a tattered copy of the August 1974 issue"[62] of *Black World* because in it, she found an early piece of Black feminist criticism by Mary Helen Washington.

Excited about the opportunity to participate in such an ambitious project, yet nervous about the responsibility, Washington listened with great anticipation to Gates's proposal. She thought, "This is kind of scary. I'm just a kid from Detroit. I'm not from upper-class and middle-class families."[63] She may not have attended "Harvard and Yale and Princeton,"[64] but she was prepared to meet this challenge. As soon as Gates listed the original editorial board, however, it became clear to Washington that she would not need to summon the courage to accept the offer; she would need to honor her principles and decline. As soon as Washington realized that "there were no other Black women going to be on the *Norton*," she put her foot down, and in a manner that she recalled as not necessarily diplomatic ("given the way I was back in the day") she informed Gates that she was "not going to be the editor of an anthology with no Black women on it except me."[65] According to Washington, Gates responded by saying that decisions had been made, editors already chosen, and therefore no changes were possible.[66]

Washington declined the offer.

It is unclear whether Gates received advice about who else might serve as coeditor of the anthology, but he subsequently reached out to McKay, who agreed under one condition: Black women would be on the editorial board. Washington, who remained friends with Gates well after the editorial board of

the *NAAAL* was decided, was proud of her decision. By maintaining the conviction of her beliefs, she may have made it impossible for Gates to deny McKay's subsequent request for an editorial board with sufficient representation from Black women. The story of Black women and the formation of a new editorial board, then, is as much about Washington's initial rejection as it is about McKay's subsequent acceptance. There is reason to believe that McKay had spoken to Washington about Gates's offer and that McKay was clear on the reasons why Washington could not proceed.[67] Once McKay officially became *NAAAL* coeditor, the new period editors—five men and four Black women—began following a systematic plan to publish the anthology in six years' time.

A methodical sketch guided the editors' efforts. Following the Ithaca meeting on 26 November 1986, period editors created a rough table of contents and the advisory board reviewed their work.[68] By October 1989, due dates were front and center: by January 1991 the manuscript would be due and by January 1992 the book would be published. The "Ithaca meeting," "rough tables of contents," and "advisory board review" of materials were done. From there, they would proceed this way:

WWN re-counting	11/15/89
Editors' votes on major works	11/15/89
Skip and Nellie prepare a "model" author— headnote, text, and footnotes—to be vetted by Mike and John and sent to all editors	12/1/89
After adjustments due to counts, second contents review by advisory board	1/90
Final contents	3/90
Each editor or team prepares a sample author (as above)	3/90
Skip, Nellie, Mike, John vet these samples	5/90
Skip/Nellie prepare rough draft of General introduction, to be vetted by Mike and John, and sent to all editors	6/90
Preparation and completion of all apparatus	6/90–12/90

> Drafts of *everything* to Skip, Nellie, and John; extra copies of period intros and author headnotes to Mike[69]

Together with Mike and John—M. H. (Meyer Howard "Mike") Abrams and in-house Norton editor John Benedict—Gates and McKay mapped out a plan to complete the *NAAL* between 1986 and 1992. The advisory board was tasked with "vet[ting] rough and final Tables of Contents" and "serv[ing] for appeal on special problems."[70] Even though the "Special Consultants" category was framed in the plural, only one such consultant was named: Robert G. O'Meally, the Harvard-educated Zora Neale Hurston Professor of English and Comparative Literature at Columbia University. O'Meally, who founded and once directed Columbia's Center for Jazz Studies, was responsible for "help[ing] everybody out on the oral and vernacular traditions in every period."[71] The anthology was unique in that it included a CD. This aural companion to the text captured the Black vernacular tradition and, through recordings of spirituals, work songs, jazz, and the blues, reflects the places and spaces in Black writing where, in the words of Meta Jones, "the muse is music."[72]

As one of the only times the *NAAL* editors would meet as a group, the 26 November meeting had to handle nuts and bolts and other issues that warranted discussion. The recorded notes, however, documented more than that. They recorded a feeling and philosophy related to the enterprise that honored the uniqueness of the endeavor and participants' pride in being part of history in the making. According to the editors, the *NAAL* was an unapologetic endeavor fixed on formalizing a tradition of Black writing in the foremost teaching tool for literary studies. The *NAAL* would offer ample background information, but it would not justify. For example, when "special problems of *argot*" arose, the editor needed to "annotate for the white student as well—and remember that Afro-American students from one region may not understand the argot of another."[73] When introducing writers, editors were advised to keep in mind that "since this is a volume of literature that doesn't need apology or justification, we won't spend headnote space apologizing or justifying. By the same token, no NALW-type discussion of 'Images of Black People in White Literature'!"[74] The editors behaved as if the respect afforded the established traditions of American and British literature already existed for them.

As McKay guided the process, editors associated with the *NAAL* executed a unique vision that invoked the best of the past while anticipating a space for Black literary futures.[75] The editors felt the pressure to succeed but were also confident that if they presented the tradition of Black literature without qualification, the merits of the tradition would speak for themselves. The nine period editors—William L. Andrews, Houston A. Baker Jr., Barbara T. Chris-

tian, Frances Smith Foster, Deborah E. McDowell, Robert G. O'Meally, Arnold Rampersad, Hortense J. Spillers, and Richard A. Yarborough—were not listed in the original "Rough Notes" but figure prominently on the first edition's masthead and in McKay's previously unpublished but reprinted essay on "The Making of the *Norton Anthology of African American Literature (NAAAL)*."[76] The editors worked "out from the center" and built a list of key writers after first identifying "commonly-agreed essential authors—the Douglasses, Baldwins, Walkers—and works—Douglass's NARRATIVE, CANE, maybe THE BLUEST EYE, if that's taught enough"; additional selections were made based on "what room is left."[77]

The first edition of the *NAAAL* may have taken aim at the canon of American literature, but it was not a cannon blast as far as the long history of Black anthologies was concerned. *NAAAL* editors were unapologetic in their philosophy yet conservative in their approach. Before the *NAAAL* first brought together 120 writers over 2,665 pages, Black anthologies, reaching as far back as the nineteenth century, had asserted the presence and artistry of Black writing. If *Les Cenelles* (1845) was situated "squarely in the French Romantic tradition" in its focus on "love, friendship, and hedonistic pleasure" instead of "slavery and emancipation,"[78] then the idea that anthologies were a high-stakes enterprise for Black people was perhaps initiated as early as 1922 with the publication of James Weldon Johnson's *Book of American Negro Poetry*. Here, Johnson stated that "the final measure of the greatness of all peoples is the amount and the standard of the literature and art they have produced. The world does not know that a people is great until that people produces great literature and art."[79] Other important anthologies followed seeking to do similar work: *The New Negro* (1925) affirmed Johnson's claim in its focus on "the younger generation"; *Caroling Dusk* (1927) proved the prevalence of poetry in anthologizing before the late 1980s; as "a true classic," *The Negro Caravan* (1941) enacted Johnson's vision with its scope, "superior literary intelligence," and "closer knowledge of the field."[80]

The *NAAAL* was rooted in all that came before[81] yet announced, alongside Patricia Liggins Hill's *Call and Response: The Riverside Anthology of the African American Literary Tradition* (1998), a new feature within Black anthologizing: texts that bore the imprint of an unprecedented number of Black scholars and reflected the broadening of the discipline across higher education. In other words, the growing number of African Americanists meant that Black anthologies could be edited by a team of experts instead of by a single editor or a pair of coeditors. The *NAAAL* editors were not

attempting to reshape the tradition according to new or novel voices. Instead, they organized the first edition according to established texts and left space in subsequent periods for an accounting of new directions in Black literature. Publishing such a comprehensive teaching tool certainly had its advantages, but there were, of course, inherent drawbacks. Period editor William L. Andrews pondered one question that pressed on the minds of many: "Does creating an anthology like the Norton open up? Or does it tend to close down? That's debatable. I think that, for me, it was important to be a part of the project because I felt like first you need to open up."[82] The *NAAAL* defined a tradition that would serve as both baseline and touchpoint for future debates about the power and limits of the anthology. It was such a stunning achievement and symbol of the times that Poet Laureate and Pulitzer Prize winner Rita Dove selected the *NAAAL* for inclusion in the national millennium time capsule "to represent America at the end of the 20th century."[83]

McKay made Gates's vision of the *NAAAL* a reality to elevate something bigger than them both. As cogeneral editor, she assumed responsibility over coordinating and calling, cajoling copy from period editors, and keeping in contact with Norton staff. Over the years, McKay shepherded the process by assuming administrative oversight. Gates brought irrepressible vision to the *NAAAL* and leveraged his relationship with Abrams to get it done but was ultimately a "high-concept guy"[84] who did little in the way of managing the day-to-day details to move the *NAAAL* forward. In contrast, McKay was more hands-on in her task management, an approach she had developed over the years in her administrative work at UW-Madison. McKay made things happen. She committed to the *NAAAL* not simply because it was Gates's idea but also because it dovetailed with her investment in broadening access to Black literature. McKay managed period editors as well as her coeditor and facilitated behind-the-scenes work with Norton editor Julia Reidhead. Meeting deadlines was "a heck of a problem,"[85] and McKay had to make sure that period editors adhered to space constraints or revised their work to make it suitable for a Norton audience. Neither was an easy thing to do, since all of the period editors, who worked at institutions across the country, had their own scholarship to advance, their own teaching to do, and their own dissertations to advise. Some were better at managing the deadlines than others. Andrews, McKay's "old faithful,"[86] quickly compiled his table of contents for McKay and Gates; "other people took longer."[87] Difficulty in receiving timely submissions from period editors, however, was only one reason why the anthology took so long to complete.

The anthology, by nature a slow-going enterprise, faced moments of inertia throughout. When Washington declined Gates's offer to join the project, momentum was lost. McKay became the person brought on to "pick up the pieces and try to put the whole project into forward motion again."[88] Gates knew "that he needed somebody, really, to be in charge of the project,"[89] which is perhaps one reason why McKay was able to successfully lobby for the inclusion of Black women editors and Black women's texts. Her impact was noticeable. Because of McKay's involvement, period editors "started seeing more official paperwork, including contracts."[90] Even though the meeting record lists one visit of all involved in November 1986, several period editors recall a subsequent visit to Ithaca, where, it seems, the new team "came together, met each other, drank a lot, talked a lot, ate a lot, and fought a lot because there were all of these things about anthologies, in terms of power and influence, that had to get straight."[91] Work was underway.

Then, in July 1990, barely four years into the project, John Benedict, the "editor and director of W.W. Norton & Company," died of cancer.[92] Benedict was the anthology's "sponsoring editor and champion at Norton," and, until the time of his death, McKay "depended on him to keep our ball rolling."[93] Roughly two years passed before another in-house editor was assigned to the project. It is unclear why. Barry Wade, assigned to replace Benedict, died on 3 March 1993, barely a year after this reassignment.[94] It wasn't until Julia Reidhead, "the tireless intrepid third in-house editor,"[95] came to the project that the *NAAAL* received the editorial push it needed. Gates was especially grateful to Reidhead "for assuming control of our project after her two predecessors died, and giving it the priority that it deserves."[96] This gratitude extended both ways, particularly where McKay was concerned. Reidhead appreciated "McKay's strategic skills in collaboration and mediation," which, in her mind, "were key in bridging differences and bringing the project to completion."[97] McKay "ran it" and "kept us going," recalled Frances Smith Foster, the period editor and colleague whose participation stands out for how it reflects McKay's thoughts about the limits of educational pedigree in determining professional opportunity. At the time, Foster did not teach at an elite institution. And while the high-powered slate of period editors might lead readers to believe that one needed to have an Ivy League education to be included, McKay made sure that skill, not pedigree, was how she identified talent. McKay had developed her unique brand of editorial leadership not only through her previous administrative work but also in her understanding of Black feminist organizing, where an appreciation of the lived experiences of Black women lives at the center.

Upon entering the job market after earning her PhD at the University of California, San Diego, Foster had the opportunity to teach at the University of California, Berkeley, but she declined, opting to stay at home in San Diego instead. Foster was motivated to stay within the state system for two reasons. First, she was married with two children and made the choice to be with her family instead of maintaining a commuter marriage. Second, she was committed to working with "working class and first-generation students," since these constituencies reflected her pedagogical priorities.[98] Even though Foster was at a state school, which, to some, gave her a second-tier status, McKay "was one of the few Ivy League research-one people who was not all snobbish" about where Foster taught. McKay's longtime work in women's studies at the University of Wisconsin–Madison had taught her that there were good reasons not to overlook her colleague from San Diego State College (now University).

As far as West Coast schools were concerned, San Diego State College lacked the reputation of the University of California, Berkeley; California State University, Pomona; or Stanford University, but Foster remarked that it also "had the first women's studies department, and I was part of that project, so [my inclusion in the *Norton*] made sense."[99] Foster had always appreciated McKay for building coalitions founded on mutual interest and expertise: "I always think of [how Nellie chose her collaborators], because I was at what people later told me was a second-tier university."[100] This mattered little to McKay, who, as Foster recalled, "never seemed to consider the status of somebody's university or title."[101] Before Foster became professor of English and women's studies at Emory University in Atlanta, Georgia, McKay included her in the *NAAAL* to make sure that the roster represented the best, and to guarantee that systems that may have once excluded her from opportunities would not exclude a worthy scholar whose personal choices had nothing to do with her professional expertise.

Foster's status as a relative unknown at the time the slate of *NAAAL* editors was composed stood in stark contrast with Gates's celebrity both in the field of Black literary studies and as a public intellectual and cultural critic. Awarded one of the first ever MacArthur Genius Grants in 1981, when he was only thirty-one years old and still an assistant professor of English at Yale University, Gates was dubbed "Black Studies' New Star" by the *New York Times* less than a decade later. The *Times* moniker signaled a sea change in higher education. In the 1990s, the emerging category of the academic superstar, and Gates's standing as an "academic entrepreneur," became new markers of status and prestige in the professoriate.

At the time, Gates was one of the most recognizable Black male academic superstars. He had gained recognition for both his scholarly corpus and his public intellectualism, the latter of which provided a platform for him to dissect issues of the day through public-facing commentary. Gates rose to prominence through his work as a writer for the *New Yorker*, as a stakeholder in the massive *Encyclopedia Encarta*, and as editor of the Schomburg Library of Nineteenth-Century Black Women Writers series. These endeavors went a long way toward making Gates a household name. But his popularity was also the result of what Erica R. Edwards called "charismatic leadership": a practice composed of narrative and performative moves formed after the end of slavery when dispossessed and disenfranchised Black communities promoted patriarchy "in the home, the church and political assembly" to mark their "fitness for freedom."[102] It wasn't enough to be "quiet but effective" like Ida B. Wells-Barnett; Black leaders needed to establish themselves as "a master of voice" to lead the race.[103] For Black people, then, the legacy of charismatic leadership carried with it class imperatives and a "gender hierarchy" in which a well-heeled "singular black male leadership" served as the gold standard for political organizing in the twentieth century.[104] A charismatic academic superstar, Gates spoke with "energy, charm and . . . urgent eloquence . . . to make things happen."[105] In Gates, cultural and institutional power brokers found charisma and much more.

Gates ascended as a superstar within a star system, the embodiment of something altogether new: the academic or intellectual entrepreneur. Entrepreneurship involves initiating moneymaking ventures, sure, but it also requires a keen understanding of the marketplace and an ability to assess opportunity and impact. Gregarious and highly resourced, Gates sold his ideas for an *Encyclopedia Encarta*, Perennial Library's Zora Neale Hurston series, and the *NAAAL*, to name a few, to publishers keen on cashing in on the emerging field of Black literary studies. A support team funded by Harvard's deep pockets made completing these projects possible. With a chief of staff, teams of graduate students, an editorial assistant, a research assistant, and ad hoc "writers and editors to help produce various projects," Gates demonstrated his understanding of what one writer described as "a fundamental maxim of capitalism: Don't do for yourself what you can pay others to do for you."[106] "I'm an intellectual entrepreneur," Gates proffered in an interview; "I love building institutions."[107]

Gates's entrepreneurial spirit and magnetic personality made possible the *NAAAL* and many other projects that were good for Black literary studies. But for some, an individualist ethos could never replace the role of creative

collaborations in the work. Published in 2001, Nellie Y. McKay and Frances Smith Foster's "A Collective Experience: Academics Working and Learning Together" outlined the role "creative collaborations" play as an alternative to the "adversarial academy."[108] It was only after a forum on Black women's studies, hosted by McKay at UW-Madison with Barbara T. Christian and Barbara Smith as participants, that the dialogic essay came to be. Foster's participation in the UW-Madison forum taught her "that I wasn't working in isolation at San Diego State; I had, in fact, the option of belonging to a community joined not by geographic proximity or unanimity of expertise but by the common idea that knowledge production and distribution need not be entrepreneurial."[109]

The *NAAAL* was a collective triumph, the result of coordinated efforts by dedicated scholars bound, across the miles, by a commitment to anthologizing, college teaching, and Black literary studies. Gates's place as the public face of the *NAAAL* in spite of McKay's behind-the-scenes work was also reflective of "the solidification of . . . the very concept of black leadership . . . as a classed and gendered concept" that underscored the maxim that "women organized while men led."[110] Underestimating the importance of McKay's behind-the-scenes persuasive power, however, would be a mistake. At first, as the story goes, Toni Morrison refused to have *Sula* (1973), her second novel, included in the anthology. William L. Andrews encouraged Norton in-house editor Julia Reidhead to tap McKay in the hope that she might get Morrison to reconsider. "Nellie would probably have the strongest powers of persuasion of anyone as far as convincing [Toni Morrison] to change her mind," he recalled.[111] He was right. Because in the end, they got *Sula*.

One can only wonder, however, whether Black women being "equal though invisible partners in black cultural work"[112] is enough. McKay's profound yet hidden influence does not erase what Myisha Priest described as "differences in power and opportunity between the men and their female peers," where the question becomes whether Black men have been actively promoting the work and advancing the careers of their Black woman peers or engaging in a "passive collusion with the institutional neglect of black women."[113] What is certain, however, is how the case of McKay's editorial leadership is evocative of Anna Julia Cooper and Pauline E. Hopkins — prolific nineteenth-century Black women who, in their day, continued to create new worlds for Black women with their writing despite being overshadowed by their more readily recognizable Black male counterparts.

In honor of the hard work that preceded publication, McKay organized a symposium at the University of Wisconsin–Madison to thank the editors and celebrate the *NAAAL*'s release. Between 4 and 5 April 1997, editors and

friends of the project descended on Madison, Wisconsin, and enjoyed sessions that included the following: "an overview of black anthologies," "the Achievement of *The Norton Anthology of African American Literature*," a session on how the *NAAAL* came to be, and a panel that considered the "inheritors of the New Canon: Graduate Students' Voices."[114] The two days of panels concluded with a celebratory dinner at McKay's house on West Lawn Drive. Attendees included a veritable who's who of African American writers and scholars: Michael S. Harper and Wanda Coleman held forth at McKay's dining-room table; Barbara T. Christian sat on the steps to McKay's porch, smoking a cigarette; Deborah E. McDowell regaled colleagues and McKay's graduate students with stories about her intellectual trajectory. Reminders of McKay's dinner parties at 111 Road in Queens were everywhere, especially in the French champagne that flowed freely so that no one would realize that food would be running out soon. The joy of being together would stand as a living example, for her graduate students in attendance especially, of the social value of collective work.

IN 1989, WHILE THE *NAAAL* EDITORS were working hard to meet their deadlines, McKay received unexpected news from Harvard. The opportunity for a full-circle moment had come. Harvard wanted McKay to return and head what was then the W. E. B. Du Bois Institute but has since become the Hutchins Center for African and African American Research. When McKay was mulling over whether to take the job at UW-Madison, one of the deciding factors had been Preston N. Williams's observation that Madison was the type of place institutions such as Stanford and Harvard would go to recruit. He couldn't have been more right. The 13 March 1989, edition of the *Harvard Crimson* announced, "Afro-Am Offers Post to Literary Scholar," outlining the details of the position and the role McKay would play if she accepted. When Harvard made the offer, there were no tenured Black women on the faculty. McKay, then, would have been the "only Black woman with a tenured post" on the Faculty of Arts and Sciences. In addition, accepting the Harvard offer would have made McKay only the second professor on campus to teach African American literature, joining her friend Werner Sollors, who was "Harvard's only specialist in Black literature" at the time.[115]

Harvard's offer came on the heels of other attempts to lure McKay away from Madison. In a single year, between 1988 and 1989, McKay declined "invitations to be considered for appointments" from New York University (NYU), Princeton University, Rice University, and the University of Washington in Seattle.[116] In a June 1989 letter to Carl Grant, Eric Rothstein, and

Gina Sapiro, chairs of Afro-American Studies, English, and Women's Studies at the University of Wisconsin–Madison, respectively, McKay "puts down in writing" information that they can use when discussing McKay's Harvard offer with the dean: "I am taking this opportunity to toot my own horn shamelessly. So here goes."[117] In three pages, McKay discussed her "current high visibility"; her personal connections to Werner Sollors and Nathan Huggins, two members of Harvard's Du Bois Institute; and her work as a "teacher and a citizen" at the University of Wisconsin–Madison to justify the details she would like to see included in a counteroffer.[118] She wanted Madison to "make it hard for Harvard" and invited her colleagues to tell her, too, if "I am not asking for enough!"[119]

Within a month's time, in mid-July, UW-Madison countered. McKay accepted Madison's offer and, in so doing, received a raise that boosted her salary from approximately $44,145 to $67,000—an increase of about 52 percent—over two years' time.[120] In today's dollars and given the rate of inflation, McKay would have seen her salary increase from approximately $102,000 to $142,000 in one fell swoop. In a letter dated 24 August 1989, McKay wrote a lengthy response to A. Michael Spence, the Harvard dean with whom she had been negotiating. In it, she clarified her reasons for declining their offer. "My major reason for not accepting your offer," McKay explained, "is my sense that there is no serious commitment on the part of the College in general to accept Afro-American Studies (not just a handful of individual Afro-Americanists) into full membership within the larger intellectual community."[121] Spence was disappointed but undaunted: "Having met you and having (I now realize) counted on working with you, I hope we may come back in the not-too-distant future with a proposal that is more appealing to you."[122] McKay's diplomacy masked her deeper feelings about the situation. She thought Harvard was racist and said as much to Painter when she forwarded a copy of the rejection letter she sent to Spence with the note: "How does one tell people they run a racist institution," McKay wondered, "in a way that conveys that but does not sound shrill?"[123]

Harvard went back to the drawing board. After "ponder[ing] McKay's thoughtful letter last summer for many hours,"[124] Spence set in motion a process that responded directly to McKay's most pressing concerns. In March 1990, he wrote McKay to renew Harvard's offer "of a Professorship in Afro-American Studies" and to provide an update: he was pursuing visionary leadership for the Du Bois Institute and was now prepared to "provide two additional positions in Afro-American Studies."[125] These structural changes were in addition to a salary raise and a research fund increase that

took the original offer of $25,000 in research funds to a whopping $40,000. "I realize that your greater concerns about Harvard had to do with the difficulties of building Afro-American Studies than with financial matters," Spence admitted, but he "extend[ed] these material conditions as a further measure of [Harvard's] strong desire to have [McKay] with them."[126] McKay's apprehensions ran far too deep for Harvard's sizable coffers to ever fill. The first paragraph of her response read:

> Dear Mike.
> This is not the letter you would like to get from me. I take no pleasure in sending it. But following a careful reconsideration of my earlier decision and your renewed offer to me, again I conclude that coming to Harvard now does not serve my best interests.[127]

In an ironic twist, McKay's decision to decline Harvard's offer made way for someone else: Henry Louis Gates Jr. Harvard offered Gates, then a professor at Duke University, the position of director of the W. E. B. Du Bois Institute. He accepted and, since 1991, has served "as chairman of the Afro-American Studies Department at Harvard" with "a joint appointment as professor of English and Afro-American Studies."[128] In a brief note, Gates thanked McKay for her well-wishes following the announcement of his appointment:

> Dear Nellie:
> I just want you to know how very much your note of support meant to me as I was making my decision about moving to Harvard. I appreciate your generosity of spirit, Nellie, and your friendship. I'll be calling on you, often, for your wise counsel and sound advice.
> See you *soon*.
> Yours, Skip[129]

Some of McKay's colleagues believe she recommended Gates for the post. Others think that she may have declined the offer out of fear that details from her past, those related to her age or the daughter masquerading as sister, would have come to the surface. Whatever her reason for declining, the proof of Gates's fit was evident. "[Skip's reputation] never mattered to me," expressed scholar and biographer Arnold Rampersad. "I always thought he was the cat's pajamas for that world. I wasn't good at building institutions. He obviously was hungry to build institutions. I think what he did at Harvard is unbelievable, astonishing. Yeah."[130]

Now, more than twenty years after the publication of the first edition of the *NAAAL*, it seems almost inconceivable that there was ever a time

when African American literature was not widely available to teachers, to scholars, and to the general public. Since then, "the 2014 publication of a two-volume, third edition of the *Norton Anthology of African American Literature (NAAAL)*, the widespread adoption of *Their Eyes Were Watching God* (1937) in US high school literature courses, and the awards and public notoriety afforded African American writers" have confirmed the institutionalization of Black literary studies.[131] It began as *The Norton Anthology of Afro-American Literature*, became *The Norton Anthology of Black American Literature*, and ended as *The Norton Anthology of African American Literature*. "Never again," McKay wrote, "will anyone anywhere in the world, to whom this volume is accessible, be unaware of what to read, study, or teach in African American literature. Never again will anyone in the United States or our neighbor countries have cause to doubt the existence and/or viability of the literature of black America."[132] The *NAAAL* catapulted McKay's career, bringing her respect, prestige, and financial security. Not long after the *NAAAL* was published, however, McKay's attention would shift from the ivory tower to the public stage as she and other Black studies scholars weighed in on the intraracial tensions and Black sexual tropes on display during the Clarence Thomas confirmation hearings.

THE SAME BLACK-WOMAN-AS-RACE-TRAITOR TROPE that surfaced with the popularization of Black women's literature in the 1980s erupted again in 1991 when the Senate Judiciary Committee undertook proceedings to confirm Clarence Thomas to the United States Supreme Court. During the proceedings, televised live over three days in early October, the committee, composed entirely of white men and with Joe Biden serving as chair, sought to confirm the nominee George H. W. Bush had selected to replace Thurgood Marshall, who had announced his retirement after serving for nearly twenty-five years on the bench.[133] On the third day, 11 October 1991, Anita Hill presented her allegations of Thomas's sexual misconduct, his abuse of power, and his harassment. The live coverage and treatment of Hill in newspapers and other print media horrified McKay. What she saw was the unfolding of timeworn tropes regarding Black women's sexuality and integrity, tropes familiar to those who studied or lived them but invisible to most white people and those in the popular media who painted Hill as an unreliable opportunist engaged in what Thomas himself called the "high-tech lynching" of a Black man.

McKay and Nell Irvin Painter discussed the case in depth through their correspondence, which captured the moment their knowledge of the history of

race and gender relations in the United States collided with the mass media's skewed coverage of Hill and the proceedings. In their letters we find kernels of ideas that would eventually become articles compiled in Toni Morrison's edited collection *Race-ing Justice, En-gendering Power: Essays on Anita Hill, Clarence Thomas, and the Construction of Social Reality* (1992). What began as general ruminations on a racial spectacle that pitted a Black man accused of sexual harassment against stereotypes of Black women's licentiousness became a conversation that drove McKay and Painter to consider not "what took place" but "what happened, how it happened, why it happened; what implications may be drawn, [and] what consequences may follow."[134] In their correspondence, McKay and Painter eked out a space to avow Black women's credibility, affirm their feelings, and refine their analysis of the drama unfolding.

In spite of a late night, Painter rose at her usual 6:50 A.M. and then turned immediately to developments in the saga before starting her day. As reflections on a flashpoint in gender relations and sexual harassment that titillated a public obsessed with the details of Black sexuality, the following excerpts from their correspondence demonstrate how McKay and Painter processed public events privately. The two wrote almost daily for years and spilled plenty of ink discussing their work, their departments, and their lives. Anita Hill's testimony was altogether different because of the way their epistolary exchanges produced work that led to public-facing scholarship. Their letters, typically, were for each other; in this case, their letters would produce material for the world. The thoughts below unfold like a ticker, with the most relevant portions of letters written within days of each other included here:

Dear Nellie: . . . I read every word about Anita Hill and Clarence Thomas and the women on Capitol Hill who had to stand in the hall and wait until the senators were willing to let them in to talk about sexual harassment. Son of a bitch! As one of my Af-Am colleagues said . . . how many lessons can so many people learn all at once!!! . . . Every woman sees herself and understands intuitively every move (and not-move) that Anita Hill made, while the men scratch their heads, unable to fathom why she went with him when he moved to another agency, why she continued to phone him from time to time, why she invited him to her school to speak. They know NOTHING about the power arrangements in this society as they affect women and men, nothing at all.[135]

Dear Nellie, . . . Without rehearsing every bit of the testimony, I will say that I still lean toward believing Anita Hill, because of Clarence

Thomas's unfinished gender business concerning his sister. His analysis of his sister's situation tells me that he has a problem with women and understanding women's roles in this society. . . . I think I heard enough to indicate to me that Thomas was wrapping himself in the race and exiling Anita Thomas [sic] from it. I don't know where she fits in his racial analysis, but evidently it's as not-black. This reminds me of a point that Deborah White and my students make: the quintessential racial crime is [the] lynching of black men, not the rape of black women. By this reasoning, giving Clarence Thomas a rough time is a racial infraction. Harassing Anita Hill is not.[136]

Dear Nell, . . . I think Anita Hill is a supremely brave woman. From the time she talked to the FBI she had to know that CT would not easily back out and that the most powerful patriarchal forces in the country were going to try to rip her to shreds before it's over. Linda Greene was able to get a letter with more than 150 signatures of black women lawyers across the country off to the Judiciary Committee yesterday. I sent Hill a telegram this a.m. in the name of the "Black Women at the University of Wisconsin." Stanlie James is right now writing a letter and she hopes to round up signatures of black women in Madison and elsewhere to also send her. She could come out of this looking like mincemeat, but she needs to know that she has the support of black women in many places.[137]

Dear Nell, . . . I grow increasingly distressed over this spectacle. At [t]his hour, the supporters of Thomas are now singing his praises. This whole bloody thing is too complicated for words. I hate the president and the Senate—him most of all for making this nomination in the first place, the Senate Judiciary for not doing what it ought to have done two weeks ago. So now, this august body of 100 white men can wash their hands of the whole nasty mess as the nation watches two black people destroy each other in the eyes of the whole world. Can things get any worse for relations between middle class black women and men???[138]

In the letters that followed the conclusion of the hearings, McKay and Painter highlighted several key themes: the display of intraracial tensions on national television; truth-telling and the "sides" taken by the Black community; sexual harassment, power, race, and gender; class performance; stereotypes and "legible" Blackness. Then, word came that there was an outlet for their thoughts. Wahneema Lubiano and Toni Morrison had decided to put together an anthology about Clarence Thomas and Anita Hill,

and Painter encouraged McKay to sign on. Even though taking on the project would mean time away from McKay's "black women's autobiographies" research, Painter encouraged McKay to participate because "I'd love to be in the same book with you."[139]

McKay agreed to submit an essay but insisted on a very particular approach. She had just returned from Ohio University, where she gave a paper based on the Thomas-Hill proceedings, and decided that she was invested in writing "a piece addressed to a group of white women."[140] "I would like mine to be a very personal piece addressed to the white feminist community which, I think, did not see how complicated the situation was," McKay continued, "I don't know what you will think of it, but it was therapeutic for me to do it, and now I can go on with my life, feeling somewhat cleansed of anger and helplessness."[141] The embodied foundations of McKay's scholarship and the healing power of Black women's friendships once again found their place.

Included in a collection that features pieces by Leon Higginbotham Jr., Manning Marable, Gayle Pemberton, and Kimberlé Crenshaw, among others, and with a brilliantly crafted and surgical introduction by Toni Morrison, McKay's essay, "Remembering Anita Hill and Clarence Thomas: What Really Happened When One Black Woman Spoke Out," achieved precisely what she had envisioned: it offered a firsthand account of the incident in question and relied on McKay's personal and professional authority, not a litany of secondary sources, to stake its claim. Traces of earlier letters and draft material remain, but the marked difference between the draft copy enclosed in a letter to Painter—a talk given at Ohio University titled "Acknowledging Differences: Can Women Find Unity through Diversity?"—and the published version is the latter's restraint. Raw emotion pervaded the Ohio talk. McKay talked about depression, hurt, and disappointment, eventually moving toward hope, "hope tempered by fears—enormous fears and apprehensions about what lay ahead for Anita Hill."[142] In contrast, McKay's focus on social class, Hill's demeanor and humble roots, her dignity and composure, seem to constrain the essay—so much so that McKay's reference to "angry black women" in the final line seems out of place, an eruption of sorts. Borrowing from Sojourner Truth, McKay wondered: "If one lone woman named Eve could turn the world upside down, then thousands of angry Black women might certainly be able to turn it right side up this time."[143] Hill interrupted what was to be Thomas's smooth transition to the court. McKay and Painter, alongside their contributors to *Race-ing Justice*, refused to allow the implications of that interruption to go unnoticed.

Similarly, Painter wrote her way into her essay for Morrison's collection through a letter to McKay. She wrote freely about the "racial symbolism," its multiple angles, the "trope of sex-and-race, with the cheapness of Black women's bodies," and then, "Well, enough of this," she concluded.[144] "This is the best argument I've had in weeks. Everybody around here agrees with me all the time. Thanks a lot. You've got me started on my essay for Toni and Wahneema's collection."[145] With a graduate classroom as the frame narrative, Painter's "Hill, Thomas, and the Use of Racial Stereotype" fleshed out issues alluded to in her letter to McKay to offer an analysis of the "significance of race in an intraracial drama."[146] Painter's earlier assessment of Thomas's depiction of his sister, at first included in a letter to McKay, showed up again in Painter's published piece. Painter explained how Thomas wielded stereotypes; traced the origins of the "black-woman-as-traitor-to-the-race" trope and pinpointed how Hill's illegibility because of her class, political leanings, et cetera, caused her to virtually disappear. In other words, it was easy for senators, the viewing public, and newspaper writers to describe Hill when facets of her story aligned with stereotypes of the oversexed (and in this case jealous) Black jezebel. But when her class and upbringing collided with this portrayal, she became illegible, impossible to pigeonhole, and out of place, and therefore politicians and the public needed to have her extricated from view. As a whole, *Race-ing Justice* synthesized a vocabulary that distilled how the days' events fit within a history of race relations rooted in stereotype. It also offered a form of public-facing scholarship that anticipated the work of twenty-first-century Black public intellectuals who engage with current events faster than McKay, Painter, and their contemporaries could, at the time, ever imagine.

Black studies and the scholarly groundwork laid by McKay, Painter, and others has afforded today's "black digital intelligentsia"—those writers, scholars, and thinkers who critique and contextualize current events with lightning speed—critical approaches from Black feminism, cultural studies, and critical race theory, for example, with which to dissect current affairs. Their early, formative work, of course, remains relevant. The critical vocabularies that undergird, say, Tarana Burke's invocation of intersectionality in #metoo, and Moya Bailey's acknowledgment that misogynoir exists because #blackstudiesdidthat, prove that Black women's theorizing goes far beyond published books and "elite" spaces. It proliferates (and is unfortunately, but unsurprisingly, also plagiarized)[147] on the internet. The experience of being #blackintheivory, captured in the hashtag created by Shardé M. Davis and Joy Melody Woods,[148] confirms the persistence of the systemic issues McKay, Painter, and their Black women peers decried decades prior.

Black women's theorizing remains indispensable to a genealogy of critical thought in the ivory tower and the public sphere as well.

Through collective action, Black women have consistently voiced their opposition to injustice. In a final example that demonstrates how Black women came together publicly and in solidarity with Hill, the group African American Women in Defense of Ourselves published a full-page ad in the *New York Times*—a $50,000 endeavor that included a statement signed by 1,603 Black women. They wrote: "We speak here because we recognize that the media are now portraying the Black community as prepared to tolerate both the dismantling of affirmative action and the evil of sexual harassment in order to have any Black man on the Supreme Court."[149] For every public display, private organizing took place. By examining the private letters that led to public intellectualism and investigating the McKay-Painter correspondence as a space for intellectual woodshedding, we see the collective process that preceded individual achievement.

MCKAY FELT THE PRESSURE TO ACHIEVE INDIVIDUALLY, as a writer of books, but in truth, this was not her calling. In spite of being crystal clear on Black women's contributions to the academy, she was less confident about the significance of her contributions as critic. McKay expressed her dissatisfaction with her scholarship whenever she berated herself for failing to complete a second book. The yardstick she used to measure her productivity was the scholarly monograph—a standard common within research institutions but a criterion out of sync with her creative gifts. McKay was a supple scholar with diverse interests, and the incredibly wide-ranging collection of essays she produced during her career reveals her as someone particularly adept at deploying her comprehensive knowledge of the broad reach of Black women's writing in analyses that spanned literary genre. McKay was more than *The Norton Anthology of African American Literature* and not just Jean Toomer. Her shorter works challenged traditional systems of academic value and demonstrated her interest in making scholarly expertise available to everyone and in using her academic authority to advance the projects of early-career faculty.

In her introductions, forewords, and afterwords specifically, McKay contextualized, justified, and endorsed the intellectual merits of texts written by Black women (or that featured Black female protagonists) to reclaim Black women's authority over the literature they authored and the characters they embodied. Slave narratives and other early forms of Black writing may have required authentication from abolitionists, white owners, or "white men of

high social and political esteem,"[150] but by raising the profile of texts she deemed important, McKay chose work out of an act of personal power and academic agency, not a reinforcement of white, elite hierarchies of literary value. In her introduction to Ellen Tarry's *The Third Door* (1992), for example, and following a conversation with the "80+ yr old red-head I once talked with in NY,"[151] McKay situated Tarry's autobiography along a continuum of Black women's self-writing and lauded the narrative for its illustration "of the strength and courage of one woman who defined her own mission in life and, in the face of many obstacles, never failed to engage her commitment."[152]

At the request of Florence Howe, founding editor of the Feminist Press, McKay wrote introductions to Ann Petry's *The Narrows*, Marian Anderson's autobiography *My Lord, What a Morning*, and Mary Church Terrell's *A Colored Woman in a White World*, books originally published in 1953, 1956, and 1940 but reprinted with McKay's introductions in 1988, 1993, and 1996, respectively, as part of a book series that introduced "'lost' fiction by women writers . . . to a contemporary audience."[153] The introductions expressed McKay's appreciation for Petry's complex and nuanced portrayals of Black women's subjectivities, her understanding of the motivations behind Anderson's narrative restraint, and how the Black Women's Club Movement collided with Du Boisian notions of the Talented Tenth in Terrell's life story, contextualizing for general readers the significance of these texts beyond the stories they told. McKay's collaborations with Howe, the feminist editor and former chair of the MLA's Division on Women's Studies, yielded essays and first-person accounts that contributed to various facets of the press's "publishing program"[154] and affirmed McKay's commitment to women's studies at large. At Howe's request, McKay wrote three essays "about her intellectual movement into feminism and particularly into black women's studies" in 1990, 1995, and 2000.[155] In addition, the coming-of-age commentary in McKay's afterwords to Jo Sinclair's *The Changelings* (1985) and Louise Meriwether's *Daddy Was a Number Runner* (1986) gave everyday readers access to literary and feminist insights written in language accessible to a broad readership.

This was important work. With "10,000 copies of *The Changelings* and 30,000 copies of *Daddy*" sold, Howe estimated that during the decades these books have been in print—and accounting for the circulation of used copies and library books—McKay's essays have reached over 80,000 readers, combined.[156] Even though McKay was ambivalent about her own scholarly achievements, she appreciated the value of using her scholarly authority to raise the profile of texts that were meaningful to her, even if there was little chance that the writing resulting from these efforts would ever elevate her status within academic

circles. McKay's forewords and introductions to others' scholarly editions, for example—Marcy Knopf's *The Sleeper Wakes: Harlem Renaissance Stories by Women* (1993), John Gruesser's *The Unruly Voice: Rediscovering Pauline Elizabeth Hopkins* (1996), and Sharon Harley and the Black Women's Collective's *Sister Circle: Black Women and Work* (2002)—certainly provided crucial historical and cultural context, but they also allowed McKay to lend her academic bona fides and endorse the work of an up-and-coming generation of literary scholars. McKay, then, labored in both macro and micro contexts. As important as it was for her to shepherd the *NAAAL*, it was equally important for her to do the local work required to advance the careers of others and to make Black litera-ture and Black feminist insights available to readers beyond academe.

McKay was conscious of her legacy, as her correspondence with Painter shows, and her interviews and reflective essays archive her commitment to historiography in field formation. Toward the end of her life, McKay wanted to write an interpretive history of African American literature, "from the Oral Tradition to the Age of Technology."[157] She never completed this com-prehensive history. Instead of writing a history of the field, she recounted her place in it through interviews and other types of first-person accounts. In two interviews, the first, "Charting a Personal Journey: A Road to Women's Studies," published in Howe's *The Politics of Women's Studies: Testimony from Thirty Founding Mothers* (2002), and the second, "A Love for the Life," her interview with Donald E. Hall, McKay spoke to a broad audience—those in literary, cultural, and women's studies—about her early years as a Black woman in the professoriate and how women's studies enlivened her peda-gogy and made her feel at home as a new professor in Madison. Written in an altogether different tone, McKay's commentary in the *PMLA* Forum on "The Inevitability of the Personal" was *not* personal. Here, McKay focused on how her individual beliefs existed as part of a "broad-based and inclu-sive" knowledge system and identified sources of influence through her reading of Henry David Thoreau, Walt Whitman, and Frederick Doug-lass.[158] Notwithstanding the restraint of the latter, published in the more mainstream flagship journal of the Modern Language Association (MLA), these pieces bear the imprint of a woman conscious about leaving her trace and contributing her piece to a collective narrative about the profession and the place of women and Black people in it. When we spoke in 2004, she de-scribed her legacy this way: "What I'd like my legacy to really be," is "in the way you treat students, and in the way you encourage people, and the way you remember what it was like, before you became whatever it is that you become. What do you do to help the next generation?"[159]

McKay's intellectual project was broad in its focus and, remarkably, a place where McKay hid a privately kept personal life in plain sight. McKay published on Black women's autobiography ("Black Women's Autobiographies — Literature, History, and the Politics of Self" and "Nineteenth Century Black Women's Spiritual Autobiographies"); Black theater ("What Were They Saying? Black Women Playwrights of the Harlem Renaissance" and "Black Theatre and Drama in the 1920s: Years of Growing Pains"); Black women writers in general ("Black Women Writers: Revising the Literary Canon" and "Black Women Writers and Critics"); and Zora Neale Hurston ("'Crayon Enlargements of Life'" and "Race, Gender, and Cultural Context in Zora Neale Hurston's *Dust Tracks on a Road*"). These pieces reflect her wide-ranging interests. They also pull back the veil on her thoughts about how race, gender, and age shape how Black women construct the self. Interestingly, when McKay was asked to be forthcoming and offer insight into the personal, say, in her interviews, she could be curiously circumspect; but, when tasked with writing about others, as in the aforementioned essays, she could be incredibly personal. McKay's Hurston essay is a prime example. In it, McKay refuted criticism that cast *Dust Tracks on a Road: An Autobiography* (1942) as a victim of its own "lies" — its "evasions and lack of honest self-disclosure, including Hurston's misrepresentation of the date of her birth" — and proposed that it was more productive to consider, in the words of Barbara Johnson, "Hurston's strategies rather than her truths."[160] We now know that there is reason to believe that when McKay explained, in her *Dust Tracks* essay, that "Hurston was playing the trickster on all her readers,"[161] she was most likely talking about herself and the trick she was playing on us, too.

MCKAY MADE HERSELF INDISPENSABLE TO American and African American literary studies through her scholarship and editorial leadership. She also lived out her mission of removing barriers and expanding access by establishing the Bridge Program between the Afro-American Studies Department and the departments of English and history. This program has two origin stories that, when considered together, suggest the idea had been forming slowly over time but would only be executed when the time was right. An early mention of the Bridge Program was the product of a conversation between McKay and William L. Andrews circa 1988, when Andrews left UW-Madison for the University of Kansas. The two discussed an initiative that would "bond a literature part of Afro-Am studies with the literature of teaching in the English department" and provide a Black studies–centered approach to a PhD in English and history.[162] Susan Stanford Friedman re-

called a conversation four years later, following the April 1992 acquittal of four police officers charged with beating Rodney King, during which she and McKay searched for something concrete to do "instead of feeling so angry and helpless."[163] If the idea began in 1988, it was concretized in 1992, as shown through a series of memos that described how McKay and Friedman, and a "subcommittee of the English Department Ad Hoc Committee on Diversity," proposed a new program to increase cooperation between English and Afro-American Studies.[164] The proposal had three objectives: first, it aimed to increase cooperation between departments; second, it sought to "facilitate the transition to a Ph.D. program in English . . . for those Afro-American Studies M.A. students who wish to go on in literature"; and third, it aimed to "help the English Department recruit students of color into the Ph.D. program."[165] As early as her Harvard application, McKay had made clear that she was invested in building the capacity of young people, and with what would be called the Bridge Program, she made sure no opportunity would be off limits, especially for the Black students to whom she remained committed.

Perhaps surprisingly, given the history of the culture of the English Department, there was less resistance to the idea of a Bridge Program than one might think, but executing the plan required flexibility from both faculty in English and faculty in Afro-American Studies. Issues of graduate student funding, teaching assistantships, and course sequencing needed to be worked out. Advance planning and open communication would be key. But it was also the perfect time for such a proposal. English sought to heal from the conflicts that had fractured the faculty in the previous decade, and the institution itself was in the throes of a campus-wide diversity initiative, former UW-Madison chancellor Donna Shalala's Madison Plan.[166] In addition, there were enough voices within the department, a chorus composed primarily of women, for McKay to have the allies she needed to get English on board. Susanne L. Wofford, former director of graduate studies and now dean of New York University's Gallatin School of Individualized Study, remembered that by the 1990s, a significant shift had taken place within English, so the battles "were not so intense anymore."[167] She continued: "I think part of that was because people like Susan [Friedman] and others became more and more prominent so that the notion that this was a small marginalized group of weird people disappeared compared to the notion that this is actually a major, respectable part of academic life."[168]

McKay's alliances with white women in English, some she had met as members of the women's studies group she joined early in her career at

UW-Madison, proved beneficial in building a bridge between departments. This outspoken cohort of English Department feminists—Susan Stanford Friedman, the new chair of the department; Wofford; Susan Bernstein, who recently left UW-Madison for Boston University after twenty-eight years as a specialist in "Victorian Literature and gender studies";[169] and Deb Brandt, now UW-Madison professor emerita—worked behind the scenes and in casual contexts to garner support for the initiative. Their efforts paid off. The Bridge Program proposal was approved circa 1993, in time for Keisha Watson, who entered the department of Afro-American Studies for graduate study that same year, to become the first official "Bridge" student.[170] In the end, the English Department seemed pleased. "I remember it being a release. I think the English department was relieved that it was happening,"[171] recalled Brandt; Wofford confessed, "I might have very rose-colored glasses, but my memory is that people were pleased with the creation of the Bridge Program, but maybe that's just because I didn't listen to people who didn't like it."[172]

To learn that the Bridge Program languished with McKay's passing should come as no surprise given the fact that, from the time the program was first instituted, it seems that McKay had personally negotiated "the parameters and requirements of the program . . . on an ad-hoc basis" with the director of graduate studies.[173] It is likely that in spite of generational shifts within the English Department, McKay maintained almost singular control of the program because of her distrust of an aging group of faculty that not only were committed to a traditional, Western canon but also were limited in their ability to identify talent and assess potential for graduate study because of selection bias, or the likelihood that they would lean toward applicants who presented most like them. McKay's tight grip saw the program through fragile early years but became a structural liability after her death, when there was no longer a consistent point person to recruit students or oversee the admissions process.

Cherene Sherrard-Johnson stepped in to "continue the bridge program as an important part of Nellie's legacy" and to make sure that "students who might not otherwise pursue a doctoral degree" saw a path from Afro-American Studies to English.[174] Sherrard-Johnson was hired in 2001, more than two decades after McKay joined the Department of Afro-American Studies as a literature specialist. When Sherrard-Johnson was hired, she received the Anna Julia Cooper Postdoctoral Fellowship, which afforded her time to focus on starting out well at UW-Madison by developing her research profile and completing the writing required for tenure. McKay introduced Sherrard-Johnson to her friends in the field, Thadious M. Davis and William L. An-

drews, for example, who read her work, contacted editors "just to say, 'Please give this a serious look,'" chaired conference panels that Sherrard-Johnson was on, and "intervened departmentally with service demands" by saying, on Sherrard-Johnson's behalf, no to service requests so that she "didn't have to be put in the position of having to say no to the chair about a service commitment early on."[175] Even though Sherrard-Johnson was hired through the English department, McKay argued that she "should not have a joint appointment," since early-career faculty often find themselves with "mixed allegiances"[176] when they serve more than one department.

McKay's advice was prescient. Sherrard-Johnson became a tenured member of the English Department in 2007 and stepped in to finish McKay's work with dissertators and to fulfill McKay's vision of the English Department at UW-Madison as a home for Black literary studies. A decade later, in her first year as director of graduate studies, Sherrard-Johnson "updated and then restarted the dormant MA/PhD bridge program . . . by admitting three new students . . . after several years of no new admits."[177] Sherrard-Johnson's procedural adjustments improved Bridge students' funding, the climate in English toward Bridge students, and access to specialists. McKay's personal and professional commitments are inscribed within the Bridge Program, and its longevity is testament both to McKay's vision and to her investment in a pipeline to the PhD for students interested in Black literary studies. Sherrard-Johnson's 2001 hiring brought McKay's vision for the integration of African American literature within departments of English full circle because it marked the moment that the English Department at UW-Madison hired its first African Americanist.[178] In 2019, a department that was once hostile to Black writing as a field, and to McKay as a Black woman scholar, fulfilled its goal of a cluster hire in global black literatures,[179] which brought four scholars of diasporic Black literatures to the English Department. The search, chaired by Sherrard-Johnson, was initiated, in part, to honor "the legacy of professor Nellie McKay."[180] McKay, with a vision, had entered the academy; and it was then and there that she transformed it.

SCENE IV | Home

In this new space one can imagine safety without
 walls, can iterate
difference that is prized but unprivileged, and can
 conceive of a third,
if you will pardon the expression, world "already
 made for me, both snug
and wide open, with a doorway never needing to be
 closed."
Home.

—TONI MORRISON, "Home"

As a faculty member at the University of Wisconsin–Madison, Nellie Y. McKay built me a home. Not one of bricks and mortar, even though she owned a home that brought her joy. She built me a home on the foundational belief that all that she had started, we were prepared to carry on.

My life, it seems, has been an ongoing process of leaving and returning home. Not to New Jersey, where I grew up, but to the South, where I spent my summers, went to college, and reunited with family. My first visits down South were out of necessity. My parents sent me away so my younger brother could learn to talk (apparently, I did all his talking for him). By summer's end, he was speaking in full sentences. As adolescents, he and I spent our summers between my Grandma Means's house in Blair, South Carolina, and with Mommy's older sister, my Aunt Gladys, in Columbia, South Carolina. My mother was the youngest of eight, and my brother and I were the babies of the bunch, but we tried to hang with the big kids as best we could. My older cousins taught me pitty-pat. We played acey-deucey well past my bedtime. But to get to South Carolina, first my mother would drive us from New Jersey to Baltimore so my Aunt Beulah could carry us the rest of the way. At my feet in the back seat were coolers full of fried chicken

between white bread, blocks of cheese, and bologna, all because Aunt Beulah's generation was still "on the bus," as Daddy would say—so accustomed to the impact of Jim Crow segregation on travel that they left before night had turned to morning with enough food and gas to get them to their destination without stopping. South Carolina was Mommy's home, but it was also a place where, in the shade of my family tree, I could see myself as one of many. I could know how it feels to come home.

Years later, I was on the road again, this time traveling from Madison, Wisconsin, to Charlotte, North Carolina, for a new job at my alma mater, Johnson C. Smith University (JCSU), and a new life with my fiancé, Edwin. I had fulfilled my graduate school residency requirement and was more than ready to put Madison in my rearview and head toward the new life I had chosen. Nellie was already nervous about me leaving, and if she had had her druthers, I would have stayed in Madison until the dissertation was complete. What I didn't know then, and what I learned years into my marriage, was that sometime before Ed and I left town, while we were both in the Department of Afro-American Studies but I wasn't around, Nellie cornered him. The department itself is a set of interconnected hallways, a big rectangle, really, so there's no place to hide. One big common area. Nellie, easily a head shorter and 100 pounds lighter, pulled Ed aside, looked him squarely in the eye, and told him, "Make sure she finishes."

I finished and then accepted a tenure-track job at JCSU. I avoided telling Nellie about my job for as long as I could. I knew she respected historically Black colleges and universities (HBCs, as she called them), but I felt something unspoken about the expectations attached to the training I had received. The goal, so I thought, was to get the best job you could—something at an Ivy, a large land-grant Research I, or an elite liberal arts college—someplace highly resourced with a minimal teaching load. And even though teaching at an HBCU was the reason I went to graduate school in the first place, I thought Nellie would be disappointed in me. I told her my plan and without missing a beat she replied, "It's your life."

I reflect, now, on professional choices I've had the privilege to make—the choice to go, to leave, to find and recreate home—because of Nellie. The freedom to choose is a generational wish. One that I link to my inheritance as a Black woman scholar, and one that I heard, albeit implicitly, in the recitation of my family history during family reunions. As I think about my intellectual legacy, then, I think, too, about my great-great-great-great-grandmother, Jomimmie, who was born in Africa and who died in Fairfield County, South Carolina. My enslaved ancestors were subject to *partus sequitur ventrem*,

wherein children followed the condition of the mother, but the computer algorithm that traces my family tree says otherwise. I am listed as a descendant of Colonel David Provence. But what of Jomimmie and her longing for Africa's distant shores? For choice? What would she have wished for me?

The home that Morrison imagines in this epigraph is one based on "a-world-in-which-race-does-*not*-matter," where one can be "both free and situated" within a third space that affords belongingness beyond the binary.[1] When I think of this space and my connection to ancestors familial and intellectual, I imagine routes and roadways, pathways waiting, created in anticipation of my arrival, laid to carry me beyond what I can see. I think of Nellie and the price she paid for me to have privileges both seen and unseen. I am grateful for the space I occupy, the space Nellie and her cohort of Black feminist thinkers bought and paid for with their very lives.

In(to) places that were never mine to begin with, Nellie Y. McKay built me a bridge and made me a home.

Crepuscule with Nellie

For years, Nellie Y. McKay lived alone in a beautiful three-story house at 2114 West Lawn Drive in Madison, Wisconsin. After she purchased the 1909 Prairie-style home with money earned from an advance for *The Norton Anthology of African American Literature* (*NAAAL*), she spent the next several years renovating and decorating it to her liking. Appointed with hardwood floors and rich oak detailing, her house received the same care and attention McKay put into her clothes. Her personal style—expressed in the form of beautiful scarves, mud cloth, and stylish sweaters—reflected her inner elegance and separated her from her white male colleagues, who, she quipped, didn't start paying attention to their appearance, to really *dressing*, until Black women showed up in predominately white academic spaces. McKay's West Lawn Drive home was full of beautiful art and antiques, the latter of which she often found when she and her daughter, Patricia M. Watson, went antiquing in Mount Horeb, Wisconsin, during their regular visits to the National Mustard Museum.

McKay's home represented quintessential Nellie: welcoming and personable with clearly defined limits. She greeted visitors on her screened-in porch and welcomed them into spaces on the first floor: her living and dining rooms, kitchen, powder room, and den. McKay kept the upper floors, floors that housed her bedroom and study, to herself. Self-admittedly "selective about sharing [her] house with others,"[1] she created a home that symbolized the boundaries of her private life and professional self. West Lawn Drive provided McKay with privacy, protection, and a respite from hostile academic spaces. Consequently, she carefully controlled the flow of persons in and out of her doors. McKay treated her home as she treated her life: she maintained strict boundaries and differentiated between public and private areas to clearly define what was generally accessible and what was certainly off limits. Even McKay's house hunting reflected her priorities. She wanted character and enough space for her guests to sleep on another floor: "I no longer wanted to sleep on the same floor as the 'public' areas of my living space."[2] Public and private remained separate.

As much as she would come to enjoy her home—which she called "The Barn" because of the appearance of her detached garage—at an earlier time,

in the mid-1980s, McKay was certain that "home ownership would never lie in her future"[3] because of the upkeep and money homes required. She had deduced, after visiting friends in a home that she was surprised stood upright given its want of repair, that "owning property means investments of time, energy, and financial resources that I don't want to face."[4] McKay changed her tune less than a decade later, explaining to Nell Irvin Painter "that owning a home was the greatest happiness she held outside of her academic career."[5] It may have been "only a house," but "outside of work" it gave McKay "indescribable joy."[6] McKay was highly regarded as a member of the Madison community, but she was also well aware that the professoriate, as a space, was not her own. So, McKay cultivated her home as a place where she could live in peace and with an agency not consistently replicated on campus or in her professional work.

McKay's house was a sanctuary beyond the academy, where not even the sanctity of her office could prevent invasions of her space. In just one example of power and privilege (not to mention bad manners), in the days when McKay was still untenured, a white male colleague barged into her office, ignoring the fact that she was already engaged in conversation with a Black woman colleague. As McKay explained in "A Troubled Peace: Black Women in the Halls of the White Academy," the opening essay to Lois Benjamin's *Black Women in the Academy: Promises and Perils* (1997), the man "stopped at the door and, without apology, pushed his way past my colleague. Before either she or I realized what had happened, he preempted her presence in our space to make a request of me."[7] The intrusion suggests that the communicative space occupied by McKay and her colleague, notably another Black woman, did not automatically warrant the respect of outsiders, in this case a white man. Later in her career, McKay felt more comfortable establishing boundaries, but in this instance she was shocked into silence, gagged by her pretenure status and constrained, perhaps, by respectability. Worse still, in *her* office, no less, she lacked, if only for a moment, the power to reinforce boundaries. In this episode, the "white male colleague's behavior exemplifies academic cultures which deny black women the right to occupy space."[8] This was a climate issue, to be sure, one that encapsulated how Black women were marginalized when attempting to diversify academic spaces never meant for them in the first place.

Published nearly fifteen years after her 1983 essay "Black Woman Professor—White University," McKay's "A Troubled Peace" returned to the tension between how Black women expected to be treated and how white universities responded to their presence, but with a twist. In the first essay

McKay chronicled "the difficulties and discomforts" she and "other black women"[9] experienced as early-career faculty members at historically white institutions. In the second essay, which was published in a collection compiled by Lois Benjamin to extend the work begun during the seminal "Black Women in the Academy: Defending Our Name, 1894–1994" conference at the Massachusetts Institute of Technology (MIT),[10] McKay took on the issue of institutional space in a way that eerily anticipated the cost of a life of the mind, particularly for Black women professors at white universities. In "A Troubled Peace," McKay did more than praise the persistence of Black women professors; she considered the unanticipated costs associated with academic life. In her original conclusion, McKay proffered that "to be a black woman professor in a white university is difficult and challenging, but it is exciting and rewarding, and black women professors like it here. We aim to stay!"; in "A Troubled Peace," she added, "At the time, I did not ask, At what price?"[11]

AS A FACULTY MEMBER AT the University of Wisconsin–Madison, McKay complained of overwork yet gladly made time for her students, who she was happy to let take advantage of her open-door policy. She helped them work through issues both personal and professional and guided Lisa Woolfork as she became, in 2000, the first of McKay's advisees to earn a PhD in English at UW-Madison. McKay also executed two initiatives during this time. The Tom Shick Memorial Fund was instituted in memory of a much-beloved member of the Afro-American Studies Department, and the Bridge Program created PhD pipelines between Afro-American Studies and the departments of English and history. The publication of the NAAAL in 1997 increased McKay's visibility, and subsequently, in 1989, while the NAAAL was in progress, McKay declined an offer to join the faculty at Harvard University. When Harvard made its bid, Congresswoman Donna Shalala, then chancellor at UW-Madison, retained McKay by giving her what was, at the time, the largest raise in the institution's history. For Shalala, this was precisely what one needed to "put together" to "retain a star."[12] The Harvard offer elevated McKay's status, but the retention move came at a cost: rumors of resentment circulated and some Afro-American Studies colleagues took exception to the attention McKay received, especially because the success of the department had always resulted from collective hard work.

By the turn of the twenty-first century, McKay had made her mark on the American academy, mostly from behind the scenes. The majority of McKay's graduate students from the 1990s and before had landed jobs, and she prepared to launch those who entered UW-Madison's graduate programs in the

late 1990s and early 2000s. Requests for letters of recommendation, tenure letters, and promotion letters came pouring in, and, according to colleagues, McKay wrote them all.[13] In April 2003, alongside Craig Werner and with help from her graduate students, especially David LaCroix who managed the enterprise,[14] McKay coordinated a massive symposium on W. E. B. Du Bois, which featured an interdisciplinary slate of participants and a keynote from Pulitzer Prize–winning Du Bois scholar David Levering Lewis.

But by the early part of the twenty-first century, her commitment to building what she called her "project"—which originally included the recovery and publication of Black women's texts, the development of Black feminist methods of analysis, and the codification of Black literary studies, but which now also involved the establishment of Black PhD pipelines and career support for junior faculty—had begun to take a profound toll on her body. A decade older than many knew, McKay wrestled with a physical decline that typically accompanies old age. Just as the seeds she had sown were taking root, just as her efforts to establish PhD pipelines, make Black literature accessible, and contribute Black feminist analytical frameworks were breaking ground, the stress on her body made her increasingly ambivalent about her career choices and their physical costs.

The daily letters McKay once wrote to Nell Irvin Painter slowed to a trickle. For decades, McKay had set aside time at the start of each day to write her friend a letter. With the rise of the internet, email, and reasonably priced long-distance phone calls, the frequency of their correspondence diminished. The advent of electronic communication meant that letters once central to how they communicated with each other, encouraged each other, and challenged each other were sent less and less frequently. In the mornings, there were fewer letters addressed to Painter in the administrative assistant's out-box. Instead, there were "recommendations by the dozen" and "tenure evaluations" for early-career faculty members who needed a senior scholar of McKay's stature to evaluate their scholarship and write in support of their tenure dossiers.[15] The responsibility she felt to the field was a weight her body struggled to bear.

THE LONG HALLWAY STRETCHED OUT before her. Fluorescent lights, disinfectant, and those walls. Those neutral, sterile walls. Slowly, she made her way back to the waiting room. Sleepwalking was more like it. Feet moving, body upright, mind elsewhere. Perhaps her thoughts drifted back to an earlier time, when all she needed to worry about was whether the chef had remembered to keep her entrée salt-free. Perhaps she thought no further

than the examination room, where only moments before, she had learned that her indigestion was not indigestion at all. Perhaps she thought of nothing and instead felt the heaviness of her legs, her slender limbs weighed down by the burden of what was finally an accurate diagnosis. McKay had always been petite and now was particularly so, her already small frame made all the more slight by the food she denied herself to avoid aggravating recent digestive issues. But at a distance, she appeared especially physically ill-equipped to make it the rest of the way to the waiting room, where Susan Friedman waited to hear, for certain, what was ailing her friend. Slowly walking. Head down. Until McKay lifted her gaze, looked her friend in the eye and whispered.

"It's very bad."[16]

Her fatigue had been overwhelming. Sure, McKay was prone to overwork and exhaustion, but this time was different. During the summer of 2004, she found herself bone-tired and experiencing severe digestive issues. In desperate need of relief, she visited her physician, who offered anemia as the diagnosis. A follow-up confirmed that she had suffered a small stroke in November 2003, about a year and a half prior, and an endoscopy revealed abrasions on her stomach. Her symptoms improved slightly after she was placed on two medications: a proton pump inhibitor and an iron supplement. Then, suddenly, the anemia worsened. Alarmed by her ten- to fifteen-pound weight loss, doctors ordered CT scans. The first CT scan, of her abdomen, revealed a tumor on her liver; a biopsy confirmed the cancer in January 2005. Immediately after receiving her diagnosis, McKay reached out to Meg Gaines, the founder of the Center for Patient Partnerships,[17] an advocacy group that amplifies the voices of patients so they have agency when navigating the healthcare system. McKay learned about the center from Susan Bernstein, a faculty colleague from English,[18] and Robin Douthitt, a retired dean of Madison's School of Human Ecology.[19] Gaines's advocacy would prove indispensable, because before long, McKay's exhaustion was accompanied by shortness of breath. A second CT scan, this time of her lungs, revealed that both had spots. Doctors confirmed the worst: her dry cough was a symptom of metastasis. The cancer had already spread. On 21 February 2005, McKay was diagnosed with stage IV colon cancer.[20]

While Gaines coordinated McKay's care by scheduling appointments, securing second opinions, and investigating clinical trials, McKay assembled her students to share news of her cancer diagnosis. She brought them ice cream. She knew receiving the news would be hard for them because sharing it had been hard for her. Their eyes wet with tears. Their hearts heavy

with sadness. Their lungs empty of air. Their throats, already, choked with grief.

A year later, when she was gone, the sadness remained. It wasn't just faculty in the department who mourned; the space mourned, too. "If the walls and the chairs could cry out," imagined former graduate student Eric Pritchard, "I'm sure they would have because she just meant so much. She was the identity of the department. It was her. It was her."[21] And when she was gone, it was never quite the same.

FROM HER EARLY DAYS AT UW-MADISON, McKay experienced a wide array of physical and psychological maladies that seemed to result from the pressures of completing her Jean Toomer book and starting out well as a faculty member. First, there were the dizzy spells. Then depression. And anxiety.[22] Finally, a psychotherapist provided her with documentation that would have secured her a semester-long leave prior to her tenure review. She opted not to take it because it was too risky: "I feel that I have to anticipate everything that can be used against me, especially because I don't feel that I'm dealing with people who really like me—too many middle aged white men who have their own set of hang-ups which I'm sure they'd just as soon get rid of by showing this black woman from Harvard where to get off."[23] Anticipating backlash from her colleagues at the start of her time at UW-Madison, McKay decided not to follow doctor's orders.

Later, she learned to manage her blood pressure by adhering to a strict low-sodium diet. Then, weakness on her right side led doctors to believe that she may have had a stroke.[24] As time went on, she entertained less and less. Aging was certainly a factor, but her work schedule didn't help. She rose daily at 5:20 A.M. and hit the office until the evening, returning home only to eat and to sleep. McKay understood that her field-forming efforts required her constant attention; otherwise, "her life's work" might begin to "crumble around her."[25] As her career progressed, she was working, more and more, to fortify the borders of Black literary studies, investing time and effort by mentoring graduate students and assisting the next generation of Black literature scholars however she could. McKay was building an intellectual home for the next generation just as her body, the foundation, was beginning to give way.

Committing intense effort within so many different domains—research and writing, institution building, teaching and mentoring—made McKay tired and prone to mistakes. In one instance, after running into Herman Beavers at the annual meeting of the Modern Language Association (MLA),

McKay invited the newly tenured faculty member from the University of Pennsylvania to speak to her graduate students. McKay was one of the field-forming faculty members whom Beavers "had come up under in the 80s,"[26] and he was delighted to help in whatever way he could. "Nellie, I'll do anything for you,"[27] he responded when asked by McKay to speak, and she promised to get back to him with details related to his visit before long. They set a date, but a week prior to his planned day of arrival, Beavers had neither plane ticket nor itinerary. "She still hadn't contacted me with any arrangements, so she called me on this Saturday, it was the day before I was supposed to leave to come to Madison."[28] McKay converted an unused ticket for Beavers's travel, and he arrived in plenty of time to give a talk, meet with McKay's graduate students, and enjoy dessert at her home afterward.[29] The graduate students were none the wiser, completely unaware of the last-minute maneuvers executed to correct McKay's original oversight. One can only imagine how many administrative balls she had in the air, given that this one nearly dropped.

McKay would drift off to sleep during talks. Everyone in English and Afro-American Studies knew how overextended she was, so faculty and students responded gracefully to moments when, from her seat in the front row, her eyes would close and her head would bow, as if in prayer, heavy with exhaustion. No one roused Nellie. McKay had already been thinking about the wear and tear on her body, and in reflections published as part of Florence Howe's *The Politics of Women's Studies: Testimony from 30 Founding Mothers* (2000), she noted: "So, while I take joy and satisfaction in my role in the project to which many of us committed ourselves three decades ago, I yearn for less: for my own time to rest from the weariness of continuous overextension—the relentless demands on my time. Like others, I see wonderful achievements but only at the cost of extremely heavy tolls on the well-being of the self, on personal relationships and health."[30] In the early part of the twenty-first century, and after over two decades at UW-Madison, the length of her academic career, McKay thought more and more about the price she had paid to live the life that she wanted.

To what extent McKay's professional commitments and physical maladies impacted her scholarship is anybody's guess. As early as the 1990s, McKay and Painter exchanged several letters that discussed, in part, what the latter saw as the declining quality of McKay's work. One of the recurring themes in the McKay-Painter correspondence was their workload: there were tenure letters to write, theses and dissertations to advise, lessons to prepare, students to mentor, administrative responsibilities to fulfill, and research to undertake. It was this final category that troubled Painter. She

began her 6 May 1990, letter with two paragraphs, one that summarized her concern and another that offered a solution:

> Dear Nellie,
>
> I wanted to say a few last things to you about your working, then I promise to let it alone—at least until I get too alarmed to keep my peace again. I'm deeply worried that the quality of your work is suffering, as you rush about from one chore to another, never stopping to do the background reading you need to keep current or to let your brains rest so they can think creatively. Think about the exciting work you were doing a couple of years ago, particularly when you were at Harvard last time, and what you do now in a rush. My worst fear is that you will get a reputation for superficial thinking because you haven't taken the time to reflect on deeper meanings of the topics you take on. You will say, "ah, I was on leave then, and I can't be on leave all the time." And your public won't know leave years from nothing and will judge you on the quality of your output, from leave years and rushed years, all.
>
> I also realize that you get great satisfaction from being in your office and seeing a lot of people. In the past, when I've suggested that you work at home where you'd have peace and quiet, you said that you'd get lonesome. So how about a compromise next year when you're on leave and want to write seriously? Consider this: working at home in the morning for several hours, say, until noon or two P.M., then coming to the office in the afternoon to pick up mail and see people. This will give you the quiet in which to read and think, plus a daily immersion in the life that nourishes you emotionally.[31]

Painter wanted to help but also understood that the topic might be a touchy one. Early in their correspondence, the two had agreed that nothing was off limits—and that becomes apparent here, where a sensitive issue was fair game. However, Painter's assessment would not be the final word. In her response, McKay differentiated between not producing and producing poor work and proposed the former as a more accurate assessment of her publishing profile at present.

It is hard to read McKay's response to Painter's letter for all that may have been said between the lines. In McKay's reply, she admitted to not writing but rejected Painter's assertion that her writing was superficial. She listed her work thus far and employed a cataloging technique that was typical of how she responded when she felt overextended:

I'm not sure what work of mine you are worried about in terms of quality. As I recollect, I have not been writing much of anything for the past three years, because, as you know, I have not had time to do so. I did the essay on Jarena Lee and Rebecca Jackson while I was at Harvard '86–'87; I did the rape essay, which I think is pretty good, and only one other essay in the last 18 months — the one on Hurston's *Their Eyes* which I did for Michigan. That's an essay I hope to do some revisions on at a later date, but I don't think the Michigan version is bad at all. Otherwise, I am **NOT** writing, and have **Not** been writing for the past year outside of Dictionary entries which require no research. I have not even done book reviews in these three years. I have been afraid of what not writing could mean for my career, but not that I have written anything in the last 3 years that can be called superficial.[32]

This exchange named the sites of joy for McKay — being in community, producing work that brought self-satisfaction — but it also staged the collision between desire and obligation, between institutional pressures and personal values. McKay seems to have been experiencing midcareer malaise, the period following tenure and promotion when faculty are supposed to "feel empowered, energized, and well poised to capitalize on their occupational privilege" but instead experience "misdirection, uncertainty, ambivalence, and even decline."[33] The ambivalence McKay experienced at midcareer resulted from the tension she felt between the work she wanted to do and the type of research expected of those at research-intensive institutions.

Around this time, McKay sketched plans for a second book, but they never took off. Not because she was incapable, but because she made professional choices that prioritized other things. There was the book of interviews inspired by her published conversation with Toni Morrison; a book on autobiography; and, following the publication of the *NAAAL*, "An Interpretive History of African American Literature." These projects stalled indefinitely. What McKay did, and what she was good at, was writing influential essays and project endorsements through introductions, afterwords, and the like. Unfortunately, within research-intensive academic circles, short essays and introductions do not "the big book" make. So, for all of McKay's unflinching assessments regarding the profession and work to help launch careers, this did little to advance her profile within the profession, which framed success in limited and individualistic terms. Her fear of "what not writing could mean for my career" was well-founded, and in this reflection,

published in the *African American Review* memorial issue dedicated to McKay, her longtime friend and colleague William L. Andrews reconsidered McKay's contributions as he explained why monographs mattered and how not having a second may have negatively impacted McKay's endowed chair prospects:

> In our profession, we tend to lionize those whose contribution to knowledge is epitomized by what I've always called "the big book," the single-authored critical volume that changes the way we think or evaluate big issues, major writers, central movements, defining genres of African American literature, and so forth. Nellie never wrote that kind of big book. Few of us do. In the last years of Nellie's life I joined a number of her friends and colleagues in writing recommendation letters in support of Nellie's candidacy for major endowed chairs at Wisconsin. Nellie never won any of those chairs. Why?[34]

McKay's feelings of inadequacy ran so deep that she sometimes found it hard to feel good about her friends' successes. One day, she and Susan Stanford Friedman were "standing in the main office of the English department."[35] Friedman, who had recently published her "second critical book," *Penelope's Web: Gender, Modernity, H. D.'s Fiction* (1990), showed it to McKay.[36] McKay was unable to celebrate with her friend. She responded: "I don't have the same book."[37] At that time, Friedman recalled, "[Nellie] couldn't say, 'How wonderful, Susan. That's great.'"[38] McKay's feelings of failure, brought on by comparing herself with others, ran too deep. Then there was Lawrence L. Langer, McKay's colleague from her early days at Simmons University who "lost touch with her for a while" but who reached out again once he found out she was ill.[39] He remembered the call to her home, while she was battling cancer, proceeding something like this: "'Nellie, this is Larry.' And do you know what she said? She said, 'Larry, I never wrote another book.' I said, 'Nellie, that's not why I called you to yell at you about not writing another book,' but that must have been on her mind."[40] McKay's cancer brought about a strange mix of pride and regret, feelings healthcare advocate Meg Gaines attributed to her terminal diagnosis: "When somebody gets a diagnosis that they think they're going to die from," she explained, "the first thing that comes up for them really are the regrets and things you might have to say you regret."[41]

With her colleagues, McKay expressed regret for not having published a second book, but with Gaines, her regrets were wrapped in the ambivalence she felt about personal sacrifice and her life choices. There was never any one conversation between the two that encompassed all that McKay had to

say, but Gaines remembered the accumulation of moments when McKay talked about "needing to be younger than she was and needing not to have a family and needing to be pretty fleet-footed and unattached and uncomplicated, and wanting to explain to me what the environment was like back then for her, and for African Americans generally, and African American women in particular in academia, and what it would take and this and that."[42] When McKay was sick, Gaines explained, she was "oracular, visionary," and through these winding, circuitous narratives, would link together events from fifty years prior through "these almost free associations."[43] Since Gaines didn't know McKay before the cancer struck, she didn't know whether McKay's nonlinear musings were reflective of who she had always been. Even without this prior knowledge, it was clear to Gaines that during these moments, McKay took advantage of the fact that there was "no danger"[44] in telling Gaines the truth. No judgment. Just the discretion of a lawyer and advocate who would speak only when given permission to do so. Never one to commit to totalizing assessments, even in the face of a terminal diagnosis, regret was not all that McKay thought about when she pondered her life.

McKay also felt overwhelming pride in all she had accomplished. When she talked about the NAAAL, reminiscing on the collaborations and her achievements, it was clear to Gaines that "she was proud of what she had done."[45] McKay conveyed a sense of self-satisfaction when she thought back to being hired as a tenure-track faculty member at UW-Madison. She had broken down barriers, she had "really made it," and although Gaines said she "can't possibly recreate the words [McKay] would use to describe [her accomplishments]," McKay radiated a special energy when she talked about it and how much it meant to her that she had been hired at UW-Madison after "going back to Harvard as, in a sense, an adult student, having had already a life in some way and then getting hired and needing to say that her age was younger."[46] In these moments, McKay shifted her attention away from cancer and any assumption that, in the words of disability scholar Therí Pickens, "the focal point for the patient must be the illness."[47] Instead, McKay reveled in the joy she felt in her exchanges with Gaines, the interpersonal moments when she was more than her diagnosis. For example, there was almost always a coy smile that peeked through whenever McKay mentioned her age, and when Gaines tried to figure out which one of the birth dates on her paperwork was the right one, McKay would "smile at you and she'd say she's certainly not the first person to make herself younger."[48] McKay was clear on her legacy, even if she felt conflicted about the cost of her choices. She was not ambivalent about her community

service, however, and although this labor remained in the shadow of her public accomplishments, a closer look at this work reveals a particularly tender and compassionate side of McKay.

Extensive community service, especially that which never showed up on her curriculum vitae, reminds us that McKay never forgot relevancy as a Black studies core value or what it was like to be young and capable yet resource poor. Her papers overflow with various and sundry requests—to write tenure letters, to review African American and women's studies programs, to give a talk to this or that community organization—and early in her career, McKay responded to requests on an ad hoc basis instead of prioritizing them based on a particular set of guiding principles. For example, in 1979, she volunteered at the Fox Lake Prison, a medium-security men's prison in Fox Lake, Wisconsin.[49] Then, in 1980, Cheryl Peterson, the youth coordinator of Madison's YWCA, asked McKay to consult on a National Endowment for the Humanities (NEH) grant she was writing. If awarded, the funding would support the production of short plays about historical Black women. McKay agreed and, in the reference letter she submitted on behalf of Peterson's application, confirmed her willingness to serve "as a resource person in its implementation."[50]

From time to time, McKay did say no. In 1982 McKay declined Ralph Johnson's request to record her Introduction to Afro-American Literature course for a statewide radio broadcast (she cited her mixed-methods pedagogy and large class size as reasons why broadcasting from her class wouldn't work),[51] but she became a mainstay on Wisconsin Public Radio in 1998, a short time after the *NAAAL* hit bookshelves, and on the radio she shared, with the listening audience, her knowledge of "writers like Toni Morrison, Phillis Wheatley, and Harriet Jacobs."[52] McKay had a gift for radio and enjoyed the medium, contributing "Being Poor" to the Madison radio show *What's the Word?* in 1998.[53] That same year, McKay joined the MLA's Radio Committee, a professional organization that, according to her CV, she served on until her death. By the end of her career, it was clear that she privileged opportunities to interact with adult learners, especially those for whom the ivory tower had previously been just a castle in the air.

The radio democratized her voice among a broader public; teaching in UW-Madison's Odyssey Project and College Days program made McKay's teaching accessible to an audience of curious adults who were probably a lot like she was when she went to college at thirty-six. With Odyssey, McKay taught "humanities classes for adult students facing economic barriers to college" and helped single parents and those who had struggled with "home-

lessness, drug and alcohol addiction, incarceration, depression, and domestic abuse" to be better "advocates for their children" and live better lives for themselves.[54] During the summer, McKay taught in the College Days program, an "education vacation" sponsored by UW-Madison's Extension Division that gave participants the opportunity to "experience college life" by residing in dorms and being taught by faculty.[55] McKay taught classes on autobiography and W. E. B. Du Bois[56] to rave reviews: "Another hit!," "Another well-received seminar!,"[57] wrote Bonnie Hutchins, Extension Program outreach coordinator, in a letter thanking McKay for her participation.

McKay's CV included the requisite teaching, research, and service activities in the form of teaching appointments, books and articles, and advisory boards and professional organizations, but it was incomplete because it omitted the invisible labor that made her intellectual work relevant to surrounding communities and to the public at large. This was not work McKay did to elevate her standing in elite spaces; this was work led by an inner compass that set as her true north the needs of individuals who reminded her of who she had been before Hollis Presbyterian Church, before Queens College, and before Harvard. She worked with these groups because she was sympathetic to where participants had been yet hopeful about where they could go.

The "second book" is a standard measure of productivity at research-intensive institutions such as the University of Wisconsin–Madison, but by focusing solely on McKay's unwritten second "big" book and her despair in not writing one, we risk overlooking the ways she used other types of writing to influence the profession. Her provocative invited *PMLA* essay "Naming the Problem That Led to the Question 'Who Shall Teach African American Literature?'; Or, Are We Ready to Disband the Wheatley Court?" was, at once, a bold statement on the state of the pipeline problem and a deft assessment of the essentialism that drives how institutions understand who should and should not teach Black literature as well as what Black literary scholars are and are not expected to teach. McKay probed "three critical problems": "the insufficiency of the black PhD pipeline, the efforts to discourage white graduate students from exploring black literature, and untrained white scholars' undertaking of scholarship in black literature."[58] With vision, wisdom, and clarity of thought, McKay's *PMLA* article exemplified her ability, as an essayist, to assess and poignantly evaluate the state of the field.

McKay's essay reintroduced issues brought up earlier and elsewhere by Barbara T. Christian, Ann duCille, and Hortense J. Spillers, for example, regarding the elision of Black women from the fields they had taken great risks to form. Together, these women defied the field's tendency to "so

quickly forget the recent past";[59] McKay, like her colleagues, would demand that the profession remember. In *White Scholars/African American Texts* (2005), Lisa Long compiled essays that responded to McKay's *PMLA* call by considering the role of identity politics and embodied diversity in determining the most "authentic" professors of Black literature. Long's book, however, was a stunning achievement in another way. Organizationally, Long foregrounded McKay's "Naming the Problem" essay by reproducing the full text early on and then following with essays that documented, in no uncertain terms, the proliferation of McKay's ideas—specifically, how they generated new ways of thinking about pedagogy, authority, and authenticity. As Long's text grappled with whiteness and a range of other positionalities meeting along "a grid of racialized and sexualized, as well as gendered and nationalized, axes of identification,"[60] McKay's essay was given pride of place both organizationally and conceptually. As the essay from which all others flowed, it was more than "raw material" for others, invoked without citation; in Long's text, it was the primary source, a critical touchpoint to be referenced, cited, and named.

McKay also left behind a "bench by the road"—a commemorative marker to memorialize that which otherwise goes unmarked—in her work with the Toni Morrison Society and through her mentoring of its founder, Carolyn Denard.[61] Denard was one of the young PhDs McKay touched and guided. After graduating from Jackson State University and receiving a master of arts in teaching (MAT) from Indiana University, Denard earned her PhD in English from Emory University. Court-ordered desegregation had forced her to attend the all-white high school in West Point, Mississippi, an experience that returned to Denard's mind when she chose to write her dissertation on Black communities, cultural consciousness, and cultural loss in Morrison's work.[62] Werner Sollors introduced Denard to McKay, and the women, through their commitment to Morrison, became forever connected.[63]

In 1992, Denard attended the American Literature Association (ALA) conference only to find that there was no Morrison Society. "That can't be,"[64] she thought, and took the administrative steps to establish bylaws and tap officers to serve. McKay would be an ideal board member, but Denard was uncertain: "I knew that she was busy and had many other obligations, and as I began to acknowledge as much during the conversation, Nellie stopped me and said, 'If it has to do with Toni, I'll do it.'"[65] For the next twelve years, McKay was a board member of the Toni Morrison Society. Once the Society was established, membership exploded almost overnight. When Morrison won the Nobel Prize in Literature just five months after the Society was

founded,[66] it "quickly grew from a small body of devoted Morrison scholars in the United States to an international literary society of more than 600 members."[67] A "standard-bearer" who served as a role model for newly minted PhDs such as Denard, McKay, "in her quiet way," positioned Denard as a leading Morrison scholar.[68] At McKay's request, Denard contributed to the MLA-sponsored *Approaches to Teaching the Novels of Toni Morrison* (1997). Denard serves as board chair of the Society to this day.

Denard acknowledged McKay's influence on her career, but Black women critics, as a group, are not typically acknowledged for their intellectual impact. Ignoring Black women's intellectual labor not only skews intellectual provenance, or how the proliferation of ideas can be traced on the basis of who cites whom, but the accumulation of constant slights also has a material effect on Black women, their spirits, and their bodies. In "Salvation Is the Issue," Myisha Priest counted the costs of the seemingly unquantifiable impact stress has on Black women in the academy, specifically how the invisibility of Black women's intellectual contributions leads to psychic and physical distress. Nell Irvin Painter, who is cited toward the end of Priest's piece, asked, "How many times have our names not appeared where they should in Scholars' [sic] footnotes? How many times have our books been overlooked—not even considered—for prizes?" Painter continued, Black women "live with a strange kind of invisibility that minimizes us as scholars and allows others to neglect the content of our thought. Living with that kind of marginalization can do bad things to one's health."[69] Case in point: Barbara T. Christian. Toward the end of her life, Christian found words to describe what she felt in her body because of her "disappointment with the direction black cultural work was taking,"[70] specifically the vociferous attacks on affirmative action, the steady decrease in Black student enrollment, and the systematic dismantling of Black studies programs—the original site of Black feminist and Black literary field formation. "When her cancer was still undiagnosed," wrote Priest, "[Christian] walked around with her hand pressed against her heart, where the pain seemed to originate. . . . 'My heart is broken,' she said, months and months before she was diagnosed. 'That is why I'm dying.'"[71]

In the midst of disappointment and heartbreak, such as that expressed by Christian, published scholarship and unpublished ephemera offered "living evidence of a spiraling chain of black women intellectuals whose work," again in the words of Priest, "has been the saving of our spiritual, intellectual, and cultural lives."[72] Black women scholars "made and broke narrative"[73] to make worlds for future generations; and in their day and time, they

were, to one another, that somebody when "you don't have anybody."[74] This fax, sent from McKay to Christian on 19 April, just two months before Christian's death, on 25 June 2000, shows one way they expressed love and support for each other:

> April 19, 2000
> For: Barbara Christian
> From: Nellie McKay
>
> Dearest Barbara,
> A long time ago, before we met and learned each other's faces, I met you in your work that helped me across the finish line toward the life I wanted for myself. For that, I owe you a thanks too large for words.
> In the now, since that long ago, we have loved each other as colleagues, friends, cohorts and fellow travelers along a path that has been full of hard patches but also of great joys. And although most often apart, we have shared the difficult and the good times, each of us always knowing that the other was always there.
> So, in words inadequate to the task at hand, because I know that you will read my heart and understand, I say:
>
>> For all that you have given to me and countless others, I offer gratitude for your life as a warrior and for the blessings of who you are and will always be to and for each of us who know you.
>
> With all my love and many hugs across the miles, absent yet present always,
> Nellie[75]

McKay's commitment to cultivating close and loving interpersonal relationships enacted an ethics of care that allowed her to enrich the lives of others in ways that had nothing to do with the standard metrics used to evaluate professional contributions to the professoriate. She found satisfaction in doing relevant service work and in putting her gifts as a teacher to good use. Since the white academy could never be her home, she built a third home in the academy through Black women's studies and erected a bridge to a new collaborative space where Black women scholars could find comfort and camaraderie, restoration, healing, and joy.

WHEN MCKAY'S CANCER TREATMENT REQUIRED her to accept intimate care in ways she never had before, her home came to symbolize the dissolu-

tion of boundaries between private and public maintained throughout her life. With each visit from a campus colleague or a West Lawn neighbor, the line separating private and public became more fluid. The treatment made McKay weak and tired—not the tired "because you hadn't had a lot of sleep. It was a very different, sick, kind of miserable tiredness"[76]—so she accepted food and company from those who stepped in to care for her whenever her daughter, Patricia M. Watson, was at home in St. Louis. The four or five times a year neighbor and English Department colleague David Zimmerman stepped in to help McKay put "salt in the water softener" or move "something in the house" turned into something more systematic once Susan Stanford Friedman, McKay's longtime colleague from English and Women's Studies, helped to coordinate McKay's care. Zimmerman started visiting on a regular basis, sitting with McKay, asking about her family, and gossiping about colleagues (not the local ones, of course!).[77] He often wondered whether he was really wanted there. One day, he got his answer. "I went down there because it was neighborly, and I cared for Nellie and it was on my own initiative, but I wasn't quite sure what she wanted."[78] Once, when the conversation lagged, McKay, in clarifying candor, turned to him and said, "Okay, you can go now."[79] He wouldn't need to wonder. Within a space where she derived energy and agency, McKay was perfectly capable of defining boundaries on her own.

McKay was not demonstrative in her affections but soon became more comfortable being on the receiving end of her friends' expressions of care. West Lawn Drive had the reputation of being "a very particular Madison neighborhood," a community unto itself, where everybody was in everybody else's business—but in a good way.[80] Because she didn't drive, McKay had for a long time benefited from such an insular community. The West Lawn community went from assisting McKay with periodic trips to Menards, the local home improvement store, to providing communal care when nurse neighbor Lisa Cappelli—who lived across the street, taught nursing at the nearby Madison College School of Nursing, and, most important, "was also a hospice nurse"[81]—stepped in to lend a hand. Cappelli assisted with technical matters: she visited regularly and helped McKay manage the PICC line that had been inserted in her upper arm to administer her treatments without repeatedly inserting needles.

Cappelli and McKay met in early 2005, shortly after McKay's cancer diagnosis. "My friend, Meg, called me," Cappelli recalled, "and asked me, 'Do you know your neighbor across the street, Nellie?' Well, I did *know* her, in a way. I used to observe her from my living room window, getting in and out

of a cab that she often took to campus, or going out in the morning to pick up her New York Times or to look over her garden. But at that time, I did not *know who she was* or what she did. I mainly thought she looked like a quiet and gentle and dignified person. There was always something about Nellie that I felt drawn to."[82] To test the waters and see if McKay would be interested in talking to her "about her illness and care," Cappelli left a "note in the sleeve of Nellie's New York Times" and waited for a reply.[83] McKay called and the two met. After talking for about an hour, during which time Cappelli answered McKay's questions about her "experience as a hospice nurse" and helped her to understand what to expect, McKay accepted Cappelli's help.[84] Their "relationship was very trusting from the start."[85] Cappelli "felt a strong bond with Nellie right away and I believe [McKay] would say the same."[86]

For a year, Cappelli "went to [McKay's] home twice a day to flush her line, change her dressing, and check on her."[87] If Cappelli went in the morning, she would wake McKay and "help her down the stairs"; when she went in the evening, she "helped [McKay] up to her bedroom."[88] During the day, when she let herself into McKay's house, Cappelli would see McKay "sitting in the same chair in her living room, with books and the newspaper on the table next to her."[89] Chemotherapy days were different. Cappelli would "often find [McKay] curled up in her chair sleeping. She looked like a little bird."[90] Some nights, McKay struggled. In the evenings when McKay "was having a difficult time, [Cappelli] went to check on her" and, if McKay "was feeling particularly vulnerable," Cappelli would spend the night: "We developed a tender intimacy over the time we spent together."[91]

Cappelli was the central source of McKay's in-home care, but former colleagues such as College of Letters and Science dean Phillip R. Certain would stop by whenever McKay had the strength to entertain visitors. Certain brought McKay "broths and soups and things like that that she could eat"[92] because the chemotherapy destroyed her taste buds and all but eliminated her appetite. Sometimes, feminist historian and NYU professor Linda Gordon made "yogurt and honey, or something like that."[93] Anything to help McKay, who once took pride in inviting Painter to "eat her heart out" when she weighed in at the physician's office healthy and strong at 110 pounds. Now, she struggled to keep up both her strength and her weight when she had neither to spare. McKay received visitors during the day but typically slept alone at night. After a day of visitors and spoonfuls of a little of this or a little of that, McKay nestled into the home that she loved and that loved her back and, in the quiet of the night, found rest in the place that embraced her.

The ad hoc help McKay received morphed into a more systematic communication plan called the Nellie Tree, in which students, friends, and colleagues in the Madison area rallied together to coordinate care. Simultaneously, former students and colleagues scattered across the country clamored for information. McKay realized that fielding phone calls about her health was not the best use of her time or energy, so the Nellie Tree evolved into an email distribution list that disseminated information about McKay's health to her vast network of colleagues and friends. The Nellie Tree "originated in the conversational spaces between Nellie and [Susan Friedman], and then [Friedman] and Susan Bernstein. Nellie immediately 'got' the idea of the metaphor. . . . And she loved it."[94] The Nellie Tree appealed to McKay because its origins were in the old-school phone tree, a "political tactic" that Friedman and others "used in 'the old days' as we tried to organize and unite people around a particular political action."[95] McKay's former graduate students Kimberly Blockett and Gregory Rutledge, in their guest-edited memorial issue of the *African American Review*, a peer-reviewed journal of Black literature and culture then edited by Joycelyn K. Moody, discussed the Nellie Tree as both metaphor and mechanism: it represented the many "branches" of McKay's influence at the same time it ensured that information flowed from those on the ground—McKay, Susan Stanford Friedman, Stanlie M. James, and others—to those living far away. The Nellie Tree disseminated information among a community of colleagues, students, and friends touched by McKay's influence and linked through a system of relational pathways that routed them to a common source.

The local branch of the Nellie Tree helped McKay run errands she was no longer able to carry out herself and facilitated her transportation to and from appointments. Susan Bernstein, a friend and colleague from the Department of English who recommended that McKay coordinate her care through Meg Gaines and the Center for Patient Partnerships, saw to it that McKay made it to her medical appointments and received her prescriptions in a timely fashion.[96] Others cleaned or helped with food preparation. From trips to the dentist or to the barber, McKay's friends displayed their affection by caring for McKay when it would have been impossible for her to manage many household responsibilities all alone. Notably, Craig Werner and Stanlie M. James were not official parts of the Nellie Tree. Since James "was going to do whatever needed to be done anyway," she and McKay agreed there was no need to add her to the group.[97] James, the colleague McKay mentored by example, would play "clean-up."[98] Should any task fall through the cracks, James made sure it got done. Werner held things down

in the department. He made sure McKay's classes were covered and oversaw other administrative responsibilities as needed "to work with the students, to work with things on this end," he recalled.[99] Carrying on in the face of such grave uncertainty was not easy work, but her colleagues did what was needed out of loyalty to McKay and her intellectual project and so, for once, she wouldn't have to worry about anything or anyone except herself.

In spite of an email in which McKay let members of the Nellie Tree know that she was "down but not out—and still fighting," it soon became clear that recovery was not on the horizon. The "chemotherapy was no longer working," and it was becoming harder and harder for McKay to manage the steps to her bedroom.[100] She wanted to be at home as long as she could, so she had a powered chair installed between the first and second floors so she could access her bedroom. She used it only "a few weeks"[101] before she accepted that sheer will was not enough. "Lisa, I think the gig is up," she told Cappelli, and in late 2005, McKay moved into Agrace hospice in Fitchburg, Wisconsin. It was a beautiful facility with private rooms and patios "overlook[ing] a wooded landscape."[102] Pleased with how well the space was appointed, McKay said, beaming, "Look Lisa, I am ensconced in my beautiful room!"[103]

During the final weeks of 2005 and into January 2006, while she was in hospice, McKay received visits from her dear friends Frances Smith Foster and Thadious M. Davis.[104] They purchased oils in the scents McKay liked. They massaged the oils into her hands and feet, restoring moisture to the dry places and soothing the skin that had become tight and ashy. In the process, Foster realized that despite years of friendship, this was the first time she had ever touched McKay in an intimate way. McKay was not a "hugger," certainly not the touchy-feely type. But the feel of the heat of her friend's hands as they gently kneaded McKay's lower extremities brought McKay incredible joy. Foster recalled: "On the last two or three days of her life, I spent a lot of time massaging oil into her feet and hands and she loved it. It was such an interesting thing. Anyway, that was a very, very magic, special time."[105] Her friends and students were there to go as far as they could to accompany McKay on her journey home.

At this time, McKay's closest colleagues turned away visitors to protect their friend, but several of McKay's Black women students who refused to be denied access met in Madison to visit their mentor and to say farewell to the woman who had helped them cultivate their individual talents. After realizing that she would not receive McKay's permission to visit, Kimberly Blockett, who was among McKay's first Black women graduate students at UW-Madison, a group often referred to as her "daughters," reached out to many of

the Black women who were part of her graduate school cohort—Keisha Watson and Lynn Jennings—and planned a visit to McKay at the hospice center in Fitchburg. The "velvet rope" between Blockett and McKay went up at the same moment an email distributed to a small group of former students indicated that McKay had stage IV cancer. Blockett recalled: "The moment I got the news was also the moment when a barrier went up. It was all one thing. It was like this person who's very dear to you is very sick and you now have no access to this person. It all happened in one fell swoop."[106] Insiders curtailed access to McKay at the very moment community grief swelled.

For Blockett, as one of the first in a line of Black women graduate students specifically recruited to the University of Wisconsin–Madison's English Department by McKay and Susanne L. Wofford in the early 1990s, seeing McKay meant everything. Fifteen years prior, Blockett had arrived at the UW-Madison campus with her two children and formed especially close relationships with McKay and Wofford, the latter serving as the English Department's graduate adviser at the time of Blockett's arrival. Together, McKay and Wofford eliminated night classes in the English Department so parents—Blockett, specifically—would not be at a disadvantage in their studies. Wofford, daughter of Harris Llewellyn Wofford, the United States senator who served as president of Bryn Mawr College and helped found the Peace Corps, championed access in the English Department and advocated for Blockett. As close as Blockett was to Wofford, who helped her negotiate motherhood and graduate study, McKay had always held an extra special place in her heart.

The unique relationship between McKay and Blockett had begun simply enough: with a phone call. As Blockett settled into her new home in Madison, McKay called to introduce herself and to let Blockett know that she had heard there was a new Black woman graduate student but had yet to see her. Blockett had been admitted directly to the PhD program in English, and before the call it had never occurred to her that "that could have been [McKay's] way of saying to me that I was supposed to have come to her."[107] Then McKay became more direct: she explained that "she needed to lay eyes on me," Blockett remembered.[108] "I understood that," she recalled, and asked, "When would you like me to come see you?"[109] The new graduate student immediately made her way to McKay's office—on a Sunday afternoon, I might add—and thus began a tradition of weekly visits that spanned, off and on, the length of Blockett's time in Wisconsin.

Sundays were ideal for one-on-one time with McKay. The department was quiet and McKay was relaxed. Blockett was able to talk about her children

and her marriage, her transition to Madison, and her studies. McKay, with her "listening way,"[110] got to know Blockett during these Sundays, displaying the personalized brand of mentoring McKay had become known for during her career. McKay mentored each of her students differently, according to their individual strengths and needs. Blockett needed to process her life—her responsibilities to family and her commitment to her studies—so Sundays were a key part of what made her relationship with McKay special. When McKay became ill and Blockett was denied access, the mission to see her mentor became personal. "We're on a plane," she recalled.[111] "I'm done with waiting for permission. We flew out."[112] For several days following their arrival, Blockett, Jennings, and Watson went to the hospice and visited with their teacher, mentor, and adviser. Each had time with McKay and made multiple visits daily until Blockett was suddenly stopped by a nurse at the front desk: "Family only."

What Blockett didn't know that day was that a short time before her arrival, Nellie Yvonne McKay had passed. It was 22 January 2006, and Foster and Davis, who were with Nellie until the end, were there to witness the peaceful transition of their friend. The hospice nurses, in their wisdom, "knew that Nellie was probably going to pass that day."[113] Foster and Davis were there when Nellie's breathing became shallow, her breaths more and more irregular until they just stopped. And in the silence, they waited together and felt the magic of it all: the uncanny, surreal gift of being there for their friend at the end and the honor of witnessing her transition. In spite of the sadness, in spite of the grief, they were together on that day and would not be together, at least like that, ever again. The nurse joined in to help them say goodbye. Believing what the hospice nurses said about the spirit lingering in the room for a short time after leaving the body, Foster and Davis paused together and waited for Nellie's spirit to leave. Davis recited a poem Nellie liked. The nurse wished Nellie safe journeys by writing a farewell phrase on the whiteboard. McKay's daughter, Watson, who had left Foster and Davis at the hospice while she made a quick trip to St. Louis, returned to find her mother dead. Some believe sending Watson away was Nellie's doing. It is not uncommon "for people to die when their dearest, closest, loved ones are not present," said McKay's healthcare advocate Meg Gaines.[114] "There may be something to just needing a little bit of empty space to make the transition and not feel as though you have to hang on for people or not die in their presence."[115] Nellie, it seemed, could let go when she wasn't holding on for her daughter. Grief-stricken, no one could have anticipated how drastically things would change following Watson's return to Madison.

During a time prior to hospice, when McKay was still relatively strong and particularly lucid, she and Watson had a conversation about the "secret" that had begun as a joke so many years earlier while they were both students at Harvard. At the time of her death, no one in McKay's academic inner circle was aware of Watson's proper place in the Watson-McKay household. Consequently, in the final months of McKay's life, the question of who should be told when pressed on Watson's mind. Watson knew that the revelation was for others, because immediate family and Watson's circle of friends knew that they were mother and daughter.

This other side of McKay's life, lived out of view of her colleagues, was a life she lived openly as mother and grandmother to Pat and Nicholas, respectively. When the entire family was in St. Louis, everyone assumed their true roles—mother, daughter, grandson—and withheld nothing about the real nature of their relationship with the local community. Madison was quite a different story. Daughter and grandson had very specific roles to play and, with years of experience, were adept at staying in character. Nicholas knew that in Madison, his grandmother was to be called "Aunt Nell": "Nicholas knew, but Nellie instructed him, 'When you're in Madison, I'm Aunt Nell. That's who I am.'"[116] About six months before McKay entered hospice, while she was still living at home, Watson let her know that, once she died, the secret would be out. "When it was our secret against the world," said Watson, "it was one thing. But with you gone," she explained to her mother, "there's no reason to keep the secret any longer."[117] Watson made clear to her mother her intention not to maintain the ruse after she died, and McKay accepted her choice. McKay knew "a lot of people will be hurt or angry."[118] In the final analysis, however, McKay concluded that "it's not going to be my problem."[119] After all, she mused, "I'll be dead."[120] When Watson returned to the hospice facility following her mother's death, she decided that she would no longer bear the load created by her mother's walls.

Foster, Davis, and the hospice staff had supposedly agreed not to notify Watson while she was en route to Madison, but the call somehow got made. The time Watson had alone on the road, heading back to her mother, perhaps prepared her to disclose once and for all the truth of her relationship with McKay. Watson entered the Fitchburg hospice facility and immediately went into the room to be with her mother. The others waited in the lobby. When Watson finally joined her mother's friends, the doctor calmly stated, "Now, with your mother . . ."[121] Before he could finish, Foster interrupted: "Oh, no. She's not her mother. She's her sister."[122] Watson rejoined: "I've got to tell you something that Nellie told me I had to tell you

after she died."[123] Everyone there tried to get her to stop: "We said don't worry about it. Sit down. We're all being very solicitous to her. She's saying, 'No, I gotta do this. I gotta do this now.' We're sitting there, then it's hazy, but I remember her saying, 'Nellie was not my sister. She was my mother.'"[124]

Foster laughed, thinking, "Isn't it just like Nellie, she's always got more about her that we didn't know."[125] McKay's friends had "many, many, many conversations" about why Watson told so quickly.[126] Perhaps Watson understood that it was unlikely for her to have everyone in the room together without her mother present, and decided to divulge immediately while her mother's closest friends were there. There is a chance, too, that deep within, the burden of living as McKay's sister when she wanted to be claimed publicly as her daughter was too great, and Watson simply couldn't wait any longer to regain control of a narrative she had felt bound to uphold. "Honestly, it seemed like a great relief for Pat," remembered Cappelli.[127] "I have wondered over and over the years about what a burden it must have been for Pat to maintain this secret."[128] While Watson's reasons are unknowable (even though I asked her directly about her feelings), Painter, especially, struggled to wrap her mind around why a friend so close would keep this secret for so long.

Multiple accounts, similar in their assessment of Painter's shock, suggest that she felt betrayed by what was depicted by at least one of McKay's former colleagues as McKay's lie. Foster was "surprised that some people felt hurt or angry or whatever" because she knew that, on more than one occasion, McKay had "misled [her]."[129] When Watson recalled the mood in the room after she revealed the truth of her relationship with McKay, she remembered McKay's friends expressing surprise but not shock: "Everyone was surprised, though, when I used the word shocked, that may have been too strong a word."[130] This, she explained, contrasted with Painter's response: "No one took it as a personal affront that they didn't know this, as opposed to Nell Painter, who clearly took it as an affront, and was very, very, very upset. . . . Because I think she thought she was my mother's closest friend, and thought that all of this violated the terms of their friendship, I guess."[131] Joyce Scott, McKay's dear friend from their days in Queens, remembered, quite vividly, a conversation with Painter following the "revelation" in which the depths of Painter's grief and confusion rose to the surface.

Painter tracked down Scott after news of McKay's death circulated via several email list-servs. This particular email thread began when Miriam Petty, who was then the Geraldine R. Dodge Postdoctoral Fellow at the Rutgers Institute on Ethnicity, Culture, and the Modern Experience at Rutgers University–Newark, forwarded "a memorializing paragraph"[132] written by

McKay's Madison colleague Lynn Keller to a Rutgers University email list-serv, perhaps of Black faculty. This message was forwarded to Oberlin alumni. Wendell Russell, the Oberlin- and Harvard-educated attorney who "grew up knowing Nellie," responded with an email notifying the group of his relationship with McKay and revealing information about their time in Queens that, it appears, he had never shared publicly before then: "The word of Nellie McKay's death was very sad news for me. I grew up knowing Nellie; we attended the same church, Hollis Presbyterian Church in Hollis, Queens, New York. When I was a boy, Nellie was a young divorced mother working to support two children, her daughter Pat, and son Harry. . . . Nellie was very bright but she had not finished college at that point. . . . With the encouragement of her friends at church and at work, she started to take college classes at Queens."[133]

Painter received this email and contacted Russell, who, on Painter's behalf, asked Scott if he could share with Painter her contact information. Scott obliged, even though she expressed to Russell that she "did not feel comfortable sharing what [she] knew when Nellie chose not to . . . and had so many opportunities to share."[134] The women spoke, but Scott "did not tell Nell anything, really."[135] Painter, who was, according to Scott, "worked up"[136] following a less than fruitful initial phone call, called back a second time to try again to get her questions answered. For the friend who had maintained a correspondence with McKay for nearly thirty years, for the scholar who had supported McKay throughout her academic career, there were no answers. Given their closeness, why would McKay have withheld this part of her personal life from Painter?

Quite simply, McKay may have feared the loss of Painter's friendship. When Stanlie M. James spoke to Painter after the news broke, she asked, "When was [Nellie] going to tell you? . . . You got to be really great friends and so forth. At what point could she tell you this and you wouldn't be as devastated as you are now? Or think that 'She's not my friend'?"[137] This may have been a case, according to James, when McKay found herself "caught up" in a story that, after being maintained for so long, seemed impossible to get out of.[138] With the scope of their friendship well defined, perhaps there was no space to redefine a relationship solidified after nearly thirty years.

There is also the possibility that withholding her family story, from Painter in particular, was McKay's effort to shield herself from the feelings of inadequacy she experienced as a graduate student at Harvard and that remained even after she became the Evjue-Bascom Professor of American and African American Literature at the University of Wisconsin–Madison. McKay said

repeatedly that "Harvard was very hard for me,"[139] but she didn't see Painter struggle in the same way. The differences between McKay and Painter reflect the diversity of Black women's experiences, even though, as a group, Black women in the academy are often spoken of in homogeneous terms. In McKay's mind, Painter's family, class background and professional pedigree put her on the side of those who "belonged" in the academy, while she was on the side of those who did not. By the time Painter enrolled at Harvard, she had studied abroad at the University of Bordeaux in France, lived and studied in Ghana, and earned an MA in African history from the University of California, Los Angeles. Having earned her master's, Painter completed her PhD at Harvard in five years; McKay took three years longer to complete hers. Joyce Scott was convinced that from early on, beginning with their time together in Cambridge, "Nellie wasn't comfortable given who Nell Painter was. And where she had come from. And what her background was. . . . I think she felt on some level that it would be lost on Nell. So, she never went there."[140]

It is impossible to divorce Painter's response from the complexities of a decades-long friendship. Painter loved McKay. She critiqued her, too. But McKay had her own hobbyhorse, and her presumption about the ease with which Painter worked was just one. McKay had a tendency to imagine Painter as a "superwoman" who was able to do things that she could not. That was a narrative of McKay's making and one that Painter disabused her of whenever the topic arose. Once, in a letter, McKay suggested that Painter would be able to read ten theses in a day while she could not, to which Painter rejoined: "Gimmie a break, won't you? In your quest to prove that you're slower than everyone else in the world about everything, don't try to make me into superwoman. How the hell is *anyone* going to be able to read ten senior theses in one day? Really!! Get serious."[141]

Underlying moments of conflict was a deep love that enabled McKay and Painter to form a connection in spite of the isolation that was part and parcel of being Black women in the academy. The two relied on each other for support both in their careers and in their lives. And, as her final letter to McKay illustrates, much of Painter's sense of her voice in the world was framed in relation to refinements offered when McKay answered back. On 11 May 2005, about eight months before McKay's death, Painter penned her final handwritten letter:

My Dear Nellie,
 How are you doing? Any results from your Catscan? Are you continuing to gain strength? Can you see your next steps?

I think of you so often and wonder about the moments of your day—where and how you are, what you're doing/not doing, thinking and not thinking, fearing and overcoming. For lack of your voice in return, my letters feel terribly self-absorbed to me. I just natter on about me and what I'm doing, unaccompanied, as in so many former years, by your responses.[142]

Painter continued her letter with a discussion of the change in seasons, the swelling of "the tamarack tree in our yard,"[143] and husband Glenn Shafer's trip to England. She discussed a trip to Home Depot, her reading of *The Racial Basis of Civilization: A Critique of Nordic Doctrine* (1926) and the status of *Creating Black Americans*, which Painter published in 2006. She was close to completing a full draft of *The History of White People* (2011) and admitted to loving her neighborhood even though she suspected that one particular neighbor who smiled a little too much and seemed a little too positive might be hiding something. She ended with this postscript: "I received the good news about your good news. WONDERFUL!! Keep getting better!"[144] Painter wrote with candor, good humor, and an attentiveness to McKay's emotional and professional needs. They were close friends who expressed professional success in different ways. Their friendship was the foundation for so much: careers of note, writing of influence, and Black feminist futures. However, it is entirely possible that Painter made McKay feel loved and judged at the same time and that, out of earshot, McKay returned to narratives about Painter's origins—the benefits of class privilege and social capital—that in McKay's mind had given Painter the kind of head start that made it impossible for her to ever catch up.

TRY AS MCKAY MIGHT to define her legacy according to what she failed to achieve, her impact on higher education, her students, the profession, and her colleagues and friends speaks for itself. For all the doors that were closed to her as a child, during her lifetime McKay opened doors for as many as she could.

McKay's mentoring model honored a student-centered ethos practiced by the women of the City University of New York's (CUNY's) Search for Education, Elevation and Knowledge (SEEK) program—Barbara T. Christian, June Jordan, Audre Lorde, and Toni Cade Bambara among them—and used specialized mentoring instead of a one-size-fits-all approach to guiding students, Black students in particular, through the rigors of academic life. After McKay's death, Cherene Sherrard-Johnson finished the work McKay began by advising

Keisha Watson, who was the first student admitted to Madison's Bridge Program in 1993 and who, after raising her family, returned to the University of Wisconsin to finish her dissertation and earn the PhD. McKay's colleagues remained committed to her students because they had been trained to profess the Nellie McKay way.[145] McKay had taught those in her circle that this brand of mentoring "was not an issue, it was not a question. . . . This is what you did. . . . This is it. This is what being a teacher is. This is what being a mentor is."[146] English Department colleague Deborah Brandt remembered that and more of how McKay spoke of her students: "Of course, those students are going to make it. Of course, they're going to go on and make contributions to the field. She would just clear out the negative, whatever doubt there was, the feeling that it wasn't going to work. She just did it, and it was a way of being, and it was just a practice, and I tried that with all of my students. 'You are going to finish. You are going to make your contribution.' I got a lot of that from Nellie."[147] For McKay, there was room for everyone willing to do the work.

McKay's spirit, that commitment to seeing students cross the finish line, was in the room when Keisha Watson defended her PhD in English in 2018. Watson's life "took a detour after [she] had children and moved away from Madison,"[148] and even then, McKay, Werner, Sherrard-Johnson, and Lynn Keller never wavered in their support of Watson or her project. Her dissertation, "'My Song in Bolder Notes Arise': The African American Long Poem Tradition," mapped the long history of the African American long poem and identified deep structures, similarities in craft and substance, that, once revealed, laid bare the commonalities between contemporary long poems and their eighteenth- and nineteenth-century antecedents. "She was there," Watson recalled of the moment during her defense when she talked about McKay, her original adviser, and how she had helped Watson, encouraging her always to "never ever give up."[149] In these lines from our 2004 interview, McKay described how special her early Black women graduate students were in how she thought about the meaning of her life's work:

I have that picture on the wall upstairs in my study of you, and Lynn, and Keisha, and Kim, and Lisa, and my mental description of this photograph—they were the first. They were the first, so I told Lynn, "Listen. You've got to finish. You've got to finish. You can't let me die and you don't finish it. You have to finish it." And the same thing to Keisha, "You've got to finish. You were the first. This is what you can give me now. You can finish." Then it will truly be, "They were the first." . . . Everybody else comes after. Not that everybody else isn't

valuable. . . . But you all, all five of you, are extra special. Extra special. And I am very blessed. Very, very blessed. Didn't do a thing to deserve it. I just . . . life is like that.[150]

The guidance Watson received from Werner and Keller was unwavering, but there was something singular about the support she received from Sherrard-Johnson, a thoughtfulness that had a profound impact on Watson during the final stages of the process. Even though Sherrard-Johnson really "didn't know" Watson, what Watson saw in the mentoring she received was a "legacy of sister support through Cherene . . . there was something about the attentiveness and her understanding of what I was doing that was deeply appreciated."[151] But Sherrard-Johnson knew McKay and understood that "Nellie was very much committed to the University of Wisconsin, but more importantly, she wanted to see Black women bloom in African American and Women's Studies, the fields she so carefully tended,"[152] fields Watson contributed to in her dissertation by shining a spotlight on a poetic tradition that has yet to receive its due.

McKay's mentoring meant the world to various scholars and former students,[153] but one story in particular captures how McKay showed up for them in real time. As a teaching assistant for English 100, Madison's introduction to college composition course, Sherry Johnson, now an associate professor of English at Grand Valley State University, inadvertently transposed the room number of the Writing Center, an alternate location where her class was supposed to meet, in a message to her students. It was the first spring day after a long Madison winter, and the students took advantage of Johnson's oversight and collectively decided to ditch class. After Johnson marked everyone absent, students complained to the director of the English 100 program, who then advised Johnson to "not penalize them in any way because you did put 7142 when you should have put 7124."[154] Feeling unsupported—especially because the students intentionally ignored the fact that the Writing Center was clearly identified as the meeting place—Johnson went to McKay's office for advice. "This is silly," Johnson thought. "I didn't feel like I had the support from the coordinator of the program. I didn't have his support, his concern was with the students."[155] Johnson imagined her students' motivations: did they disregard her instructions because she was young? Because she was a Black woman? Because she was just a teaching assistant? McKay advised her to do what was best.[156]

Still overwrought, Johnson made her way from McKay's office to the restroom and quietly cried in a stall. As she walked out, "there was Dr. McKay

coming into the washroom. She looked at me, and she said 'Sherry, stop it. Stop that right now. Teach them a lesson, you teach them a lesson.'"[157] Johnson admitted, "McKay's statement to me made me stronger. I didn't do what the program chair's recommendation was, which was totally undercutting my authority. I followed my gut, and it worked out fine, but that was because of Dr. McKay, and not the conversation that I had in her office, but when she caught me in the washroom crying. That's the conversation that helped me."[158] McKay's mentoring empowered her students to not yield to institutional equivocating. Others have stories, many of them published in the McKay memorial issue of the *African American Review*, that captured the many sites of McKay's impact. Still more hold inside a sliver of thought, a tiny personal memory kept to themselves, their secret against the world, a landmark of McKay's wisdom to guide them on their way.

McKay's legacy remains felt on the campus of the University of Wisconsin–Madison, the institution she joined in 1978 and the place she remained her entire academic career. McKay's space-making, a central tenet of her work as an institution builder, can be seen through physical spaces named in her honor, intellectual space she afforded through fellowship funding, and disciplinary space in the English Department. In 2011, UW-Madison renamed Frederick Hall after Vel Phillips, "the first black woman to graduate from the University of Wisconsin Law School in 1951."[159] Phillips Hall renamed "houses and floors . . . after influential women for the university," including McKay, historian Gerda Lerner, and others. Housing administrator Jeff Hinz renamed the building as "a way to keep history alive" and to give "students the opportunity to learn about [these influential women] and to hear stories about the struggles that took place."[160] It is appropriate, then, that given the experiences McKay chronicled in "Black Woman Professor—White University," especially those related to the hostility she faced from students, that UW-Madison earmark real estate to honor her institutional history, that it set aside a floor of a residence hall to help students feel at home, and lift up the academic legacy of a woman who made a profound impact on undergraduate life.

On a yearly basis, the Nellie Y. McKay Lecture in the Humanities, initiated with the help of Susanne L. Wofford, former director of UW-Madison's Center for the Humanities, and Susan Stanford Friedman, former director of UW-Madison's Institute for Research in the Humanities, honors McKay in a speaker series that brings to campus McKay's old friends and new voices in the fields of Black studies, critical race studies, and studies of the African diaspora. Since McKay's passing, Frances Smith Foster, Henry Louis Gates Jr.,

Thadious M. Davis, Eddie S. Glaude Jr., Anne A. Cheng, Saidiyah V. Hartman, Earl Lewis, Christine Yano, Christina Sharpe, and Michelle Stephens have presented on a range of topics, from ethics and race and identity politics to Asian American commodity culture and island studies.[161] The breadth of topics covered speaks to the wide reach of McKay's early intellectual investments. These lectures also convey McKay's commitment to making space for a wide array of voices, an investment that grew out of her work on a lifelong project that involved expanding access through community service and graduate school pipelines, codifying the literature of African Americans through anthologizing and teaching, and establishing Black feminist thought as a framework for critical inquiry.

If the space to create new and exciting intellectual work is made possible, in part, through the time faculty have to devote to the reading and writing required to produce scholarship, then two awards—the Nellie Y. McKay Fellowship and the Anna Julia Cooper Postdoctoral Fellowship—afford early-career professors at the University of Wisconsin–Madison, those invested in furthering McKay's groundbreaking efforts to institutionalize African American literature, time away from their teaching duties to write their books. These awards have helped Cherene Sherrard-Johnson publish *Portraits of the New Negro Woman: Visual and Literary Culture in the Harlem Renaissance* (2007); Aida Levy-Hussen finish *How to Read African American Literature: Post–Civil Rights Fiction and the Task of Interpretation* (2016); and Brigitte Fielder write *Relative Races: Genealogies of Interracial Kinship in Nineteenth Century America* (2020). All three monographs enrich the field that was built upon the intellectual foundation laid by McKay as a UW-Madison faculty member.

McKay's legacy is also visible in the English Department at the University of Wisconsin–Madison, which now boasts five faculty members in African American literature and global Black literatures. Sherrard-Johnson, who was hired as the first English Department specialist in African American literature in 2001, over forty years after McKay first joined the faculty, chaired a cluster hire that resulted in the hiring of four new professors to teach in areas related to the "black Atlantic world."[162] In a "year-long search that attracted close to 200 applications," four professors rose to the top, and Laila Amine, Ainehi Edoro, Yanie Fecu, and Kristina Huang joined UW-Madison's English Department.[163] African American literature maintains a presence in McKay's first academic home, the Afro-American Studies Department, and the department's coordination of the April 2006 symposium in McKay's honor and, most recently, the hiring of Brittney Michelle Edmonds, a specialist in

"black critical humor after 1968," continues the legacy of African American literature at UW-Madison.[164]

McKay's disciplinary impact is also legible in the literature—her books and essays, her edited work and anthologies—but also in how those she worked with chose to honor her passing in print. In 2014, the third edition of *The Norton Anthology of African American Literature* was published. The slate of editors was different: Valerie Smith was co-general editor beside Gates; Houston A. Baker Jr. and Arnold Rampersad were editors emeriti; and Kimberly W. Benston and Brent Hayes Edwards joined the masthead. The anthology had expanded: in two volumes instead of one, the editors covered 140 writers—up from the 120 writers included in the first edition—to represent "the most historically important and aesthetically sophisticated works" of Black writing from 1746 to the present.[165] But the third edition is unique in that it includes a dedication page "In Memory of Nellie Y. McKay," which editor Julia Reidhead noted as something that had never been done "in a *Norton Anthology*, but for whom better to set the precedent?"[166] Stanlie M. James, Frances Smith Foster, and Beverly Guy-Sheftall made a similar move in *Still Brave: The Evolution of Black Women's Studies* (2009) with the inscription "For Nellie Y. McKay." These dedications mark McKay's impact on two particular fields of study, African American literature and Black women's studies, but they also conjure something deeper. The dedication page features McKay's name, in black typeface, centered against a stark white background. This island of a name floating in a sea of white space reminds us of the isolation out of which she labored, the singular effort that preceded the collective work signified in the table of contents that follows.

Half in Shadow carries out some of McKay's unfinished business. Her last major project was titled "A Freedom Story to Pass On: An Interpretive History of African American Literature," which, in a 2005–2006 National Endowment for the Humanities proposal, McKay described as a "narrative of African American literary history from its beginning to the end of the 20th century" that "will expand the meaning of freedom in African American literature beyond understanding it purely in reactive terms, as a way of asserting Black agency in a hostile, indifferent or uncompromising white mainstream world. I want to complicate that concept," she wrote, "to make freedom a collective endeavor toward spiritual, intellectual and aesthetic freedom."[167] McKay imagined a future for herself and Black literary studies as a field centered on freedom where, in the face of despair, one finds joy in having one*self*.

Half in Shadow reclaims McKay's story, her past, and her purpose to establish her place in a genealogy that maps Black women's intellectual influ-

ence across generations. McKay exists as part of what Audre Lorde, in *The Cancer Journals* (1980), called "a continuum of women's work" in which the act of "reclaiming this earth and our power" continues beyond death.[168] McKay felt an urgency to accomplish all she could in the life she chose, and out of this frenetic drive to establish a tradition, to forge a space for the furious flowering of a literature wrought by persons of African descent, she reclaimed a personal power that is our inheritance if we do the work. McKay, like Lorde, was aware of her greater purpose. Our responsibility, then, is to find our own.

Acknowledgments

Half in Shadow exists because, for over a decade, I was met with open doors from colleagues and peers. Friends and family members extended their goodwill and hospitality. My cup runneth over.

In the early stages, Nellie's family and closest friends and colleagues helped me to get a foothold into the project. Nellie's children, Patricia "Pat" Watson and Harry McKay, shared their memories of their mother with me. I hope this book allows Pat's son, Nicholas, to see just how much his grandmother meant to others. Pat was especially generous and provided contact information for a host of Nellie's lifelong friends. With Pat's help, I met Donald and Joyce Scott and Robert Plows, who provided indispensable insight into Nellie's life as an adult in Queens, New York. Pat also consulted Thadious M. Davis, Susan Stanford Friedman, Stanlie James, and Nell Irvin Painter on my behalf; their support for this project encouraged me early on. In particular, Nell Painter opened her archived correspondence with Nellie to me, even though it was closed to everyone else. I am overwhelmed with gratitude to her for entrusting me with the stories housed there. Nellie's colleagues Frances Smith Foster and Susan Bernstein asked all the right questions at just the right time; William L. Andrews saw potential in this project and encouraged me to pursue it. And to Nellie, of course, for inspiring me to grow into exactly who I was meant to be.

Nellie's Wisconsin colleagues and my former professors helped me understand "how things were back then." Craig Werner, Susan Stanford Friedman, and Richard Ralston read drafts and answered questions. Thank you for guiding my footsteps all these years. Sandra Adell, I credit you always for my life in Madison, and Freida High W. Tesfagiorgis, our journey back in time was a gift. Lisa Woolfork, Kimberly Blockett, Keisha Watson, Lynn Jennings, Maya Gibson, Heather Hewitt, Amy Feinstein, and David Ikard gave me community in the heartland.

If my longtime Mellon Mays friend and colleague Gene Jarrett planted the seed for this project, then my Grinnell College community, especially my Scholarly Women's Achievement Group (SWAG), nurtured it into existence. Lakesia Johnson, Karla Erickson, Astrid Henry, Angela Onwuachi-Willig, and Michelle Nasser read drafts, provided feedback, and encouraged me when the research seemed overwhelming. Karla is my secret weapon master coach, and Lakesia is my soul sister and endless source of support. Any success I have is yours, too.

My Grinnell College colleagues provided research support at every stage. The members of the English department—Steve Andrews, Timothy Arner, Dean Bakopoulos, George Barlow, Elizabeth Dobbs, Carolyn Jacobson, Shuchi Kapila, Heather Lobban-Viravong, Hai-Dang Phan, Ralph Savarese, Erik Simpson, and Paula Smith—gave me opportunities to present my research on campus. Early on, Richard Cleaver and the late Karen Weise—then later, Susan Ferrari and Laura Nelson Lof—helped

me find grant support for this project. When I became an associate dean, Raynard Kington, Mike Latham, and Angela Voos found me a quiet space (other than my office) to work and insisted that I set aside time, before tackling the day's administrative duties, to move my project forward; Karen Dillon kindly worked out all the details. Terri Phipps and Amber Robson helped with technical and administrative matters, but more than that, they kept me laughing. Lisa Mulholland and DeAnn "De" Dudley pitched in at a moment's notice, and Lisa's careful attention to Mellon Mays matters freed me to think about the book. Maria Tapias, you made the dean's office home and showed me true grace under fire. Our friendship matters so much to me. Vance Byrd, Javier Samper Vendrell, Eiren Shea, Elias Saba, Fredo Rivera, Stephanie Jones, Karla Erickson, Lee Running, and Tina and Caleb Elfenbein, thank you for all of the wonderful distractions during my final months in Grinnell. And to Tina, our letters keep me imagining brighter futures. I am grateful to count you as a friend.

Faculty development funds from Grinnell College and funding for Mentored Advanced Projects (MAPs) supported my extensive work with student researchers. Elena Seeley extended herself to me just when I needed her thoughtfulness, attention to detail, and calm spirit. She swept in during the final stages to get my notes and bibliography in order. Elliott Maya made quick work of Excel spreadsheets. Teresa Fleming, Jermaine Stewart-Webb, Sheva Greenwood, Elliott Maya, our summer MAP, kept me energized. Nicholas Foulon, Imani Noel, and Madison Wardlaw, you put a period on my work with student researchers, and the notebooks you organized saved me hours of time and effort. The students I mentored during my decade as coordinator of Grinnell's Mellon Mays Undergraduate Fellowship (MMUF) program reminded me of the value of undergraduate research and the power of undergraduate researchers. When I think of you, individually and as a group, I'm overwhelmed with pride. The graduate Mellon fellows I have coached—there are too many to name—inspire me still.

My curiosities as a researcher were cultivated in the UNCF/Mellon programs and within Black college contexts. My early mentor at Johnson C. Smith University, Rosalyn Jacobs Jones, taught me the value of taking on challenges before you think you're ready. Dorothy Cowser Yancy, the late Maxine Funderburk Moore, and Mark Reger encouraged me to cultivate my gifts and gave me opportunities to lead. Dawn McNair kept me grounded while encouraging me to seek more. After serving as a Mellon Mays coordinator, I have a new appreciation for Cynthia Spence's visionary leadership, Ada Jackson's good humor, and Donna Akiba Harper's archival memory. Beverly Guy-Sheftall, Bettye Parker-Smith, Vincent Willis, Leroy Davis Jr., Medeva Ghee, Lauren Eldridge Stewart, and Gabrielle Samuel O'Brien reminded me that love and laughter are indispensable to academic work. Cally Waite, you stay looking out. Thank you for making sure I always have what I need.

I have been the recipient of a series of grants and fellowships that helped me fulfill my vision for this project. Beginning in order of receipt, I thank Duke University's John Hope Franklin Research Center and Rubenstein Library travel grant program; the National Endowment for the Humanities' Summer Stipends program; the University of Iowa's Obermann Center for Advanced Studies Fellows-in-Residence pro-

gram; the American Fellowships program of the American Association of University Women (AAUW); Grinnell College's Harris Faculty Fellowship and extensive faculty development funding; the fellowship program of the American Council of Learned Societies (ACLS); the George A. and Eliza Gardner Howard Fellowship program; and Johnson C. Smith University's Inez Moore Parker Fellowship program.

I extend my gratitude to the following archivists, librarians, and researchers, especially Phil Jones of Grinnell College's Burling Library, Elizabeth Dunn of Duke's Rubenstein Library; Alexandra Jean Krensky, Katie Nash, and Catherine H. Phan of the University of Wisconsin–Madison's archives; John Ulrich of Radcliffe's Schlesinger Library; Holly Smith of Spelman College's Archives; Monika Rhue and Brandon Lunsford of Johnson C. Smith University's Inez Moore Parker Archives; and researcher Reginald H. Pitts.

Writing communities and readers buoyed me throughout the process. I worked virtually with Monica White, Ashanté Reece, and Cheryl Hicks, who I reconnected with not a moment too soon. (That conversation in the car saved me.) Kimberly Blockett: thank you for writing with me, for reading for me, and for keeping those memories of Nellie oh, so real. Easton's Nook and kitchen sidebars with Nadine Mattis fed my spirit. At various points, Jacqueline Lazu, Jennifer Wilks, Tshepo Chéry, Claudine O. Taffe, Caleb Elfenbein, and Pier Gabrielle Foreman invited me to present my research, reminding me that there is an audience for this book. These friends and colleagues agreed to read whether requests were timely given or hastily made: Leah Allen, Tamara Beauboeuf-Lafontant, Kimberly Blockett, Stefanie Dunning, Tina Elfenbein, Karla Erickson, Duchess Harris, Candice Jenkins, Lakesia Johnson, Meta Jones, Stephanie Jones, Janaka Lewis, Malin Pereira, Therí Pickens, Howard Rambsy, Ashanté Reece, Kesho Scott, Keisha Watson, Monica White, and Rafia Zafar. Your instructive feedback and rich conversations made this a better book. Howard Rambsy steered me to shore. Therí Pickens encouraged me ever on and helped me to find the poetry in my prose.

Friends beyond the academy gave me love and perspective. Dennis Williams, Jamal Story, and Simone R. Barnett gave me a home away from home in New York City. To Donneka Byrd and Charise Garrett, members of the Black Mommy Brigade: thank you for coming to the rescue just when I needed extra hours of quiet or an afternoon of grownup conversation and Black Girl Magic. I thank my Rutgers '90s women's soccer teammate Karen Turner Light for giving me a chance to say goodbye; I thank my Medford Strikers Magic teammate Sandy Dickson for not letting me quit. The Gamma Lambda chapter of Delta Sigma Theta Sorority, Inc. welcomed me back home in Charlotte with open arms. Sophia Jackson, keep fighting! My Iowa City Bethel AME family anchored me in a community of faith, and I extend my gratitude, especially, to pastor Kimberly Abram-Bryant and former pastor Orlando Dial, Melvin and Cindy Shaw, and professors Michael and Lena Hill. Nina Elcock inspires me to dream big. Alanna Washington and Sherron Hopkins, our closeness carries me further than you know. That computer lab is never far from my mind. Nelta Morgan, you stay in my heart.

I appreciate the work of my editor, Lucas Church, and his assistant Andrew Winters, for shepherding this project from concept to completion and am grateful beyond

measure for the work of three anonymous readers and the University of North Carolina Press. Warmest gratitude to Dino Battista, Kirsten Elmer, Pat Harris, Cate Hodorowicz, Jay Mazzocchi, Margaretta Yarborough, the good folks at Arc Indexing, and anyone I may have missed who performed copyediting, indexing, and proofreading on this manuscript. I appreciate your effort and attention. I extend a collective note of thanks to everyone I interviewed for the book. If I had space to thank each of you individually, I would. This book bears your imprint, and I am honored you opened your memories of Nellie to me.

My family's endless love and encouragement carried me across the finish line. James L. and Shirley M. Greene launched me with good books and remained curious about my interests. James Jr. and Aina, Onaje, and Erica, Aunt Paulette and Aunt Gladys, thank you for loving me, for loving my children, and for giving me a space to get away. Amaria, Jada, and Lauryn, Zuri, Zavier, and Zephen, thank you for always showing your younger cousins a good time. Not all of my family members know what I've been up to, but I'm certain that both immediate and extended members of the Means/Peoples and Greene/Griffin families will be proud. Family stories inspired the genealogical thrust of this book, and I am grateful for all the good ones my immediate and extended relations have given me. I remain covered by the prayers of Mary and Traci Benjamin; thank you, "MomMom," for reminding me that "It is so." To Chloe, who rightly noticed that I've been working on this book as long as she's been alive, and to Spencer, who kept track of my deadlines by counting down day by day, thank you for choosing us. Always remember: writing *is* revision. We're more than twenty years in, Ed, and would you believe it? The last ten involved this book. There's no way I would ever have finished without your patience and love. If I shine, it's because I reflect your glow. Thank you for sharing your life with me.

To God be the glory.

Notes

Abbreviations

BRBML	Beinecke Rare Book Manuscript Library, Yale University, New Haven, CT
DRBML	David M. Rubenstein Rare Book & Manuscript Library, Duke University, Durham, NC
MACNY	Municipal Archives of the City of New York
MOP MIT	Office of the Provost, Massachusetts Institute of Technology, Cambridge, MA
SCA	Spelman College Archives, Spelman College, Atlanta, GA
SL	Schlesinger Library, Radcliffe Institute, Harvard University, Cambridge, MA
QCDSCA	Queens College Department of Special Collections and Archives, Queens College, Queens, NY
UWARM	University of Wisconsin Archives and Records Management, Madison, WI

Prologue

1. Gwendolyn Lewis, email to Shanna G. Benjamin, 4 July 2017, in possession of Shanna G. Benjamin.

2. Hurston, *Their Eyes Were Watching God*, 12.

3. "A Celebration of Life for Mary Elizabeth Griffin Greene: Friday November 4, 2016" (funeral pamphlet) (East Orange, NJ: St. Paul AME Church, 2016), copy in possession of Shanna G. Benjamin.

4. Patricia Watson, letter to Shanna G. Benjamin, 9 November 2009, in possession of Shanna G. Benjamin.

5. Watson, letter to Benjamin, 9 November 2009.

6. Nell Irvin Painter, email to Patricia Watson, Susan Stanford Friedman, Thadious M. Davis, and Stanlie M. James, 7 November 2009, in possession of Shanna G. Benjamin.

7. Susan Stanford Friedman, email to Patricia Watson, Nell Irvin Painter, Thadious M. Davis, and Stanlie M. James, 7 November 2009, in possession of Shanna G. Benjamin.

8. Thadious M. Davis, email to Patricia Watson, Nell Irvin Painter, Susan Stanford Friedman, and Stanlie M. James, 8 November 2009, in possession of Shanna G. Benjamin.

9. Benjamin, "Intimacy and Ephemera," 17.

10. See Benjamin, "Black Women and the Biographical Method."

Introduction

1. Priest, "Salvation Is the Issue," 117.

2. Behind closed doors, all the Black women I knew wondered whether this spate of cancer-related deaths was a symptom of something more sinister and pervasive. Specifically, was "death . . . becoming an occupational hazard of black female intellectual life"? See Priest, "Salvation Is the Issue," 116–117.

3. Friedman, "Nellie's Laughing," 25.

4. Friedman, 25.

5. Richard Ralston, in conversation with Shanna G. Benjamin, 1 April 2006.

6. Benjamin, "Breaking the Whole Thing Open," 1678.

7. Nellie Y. McKay interview.

8. Nellie Y. McKay interview.

9. Young, *The Grey Album*, 33.

10. McKay, "Charting a Personal Journey," 204.

11. Painter, "The Praxis of a Life of Scholarship," 10–11.

12. Painter, 11.

13. McKay, "A Love for the Life."

14. Woolfork, "Academic Mothers and Their Feminist Daughters," 38.

15. Watson, untitled reflection, 52.

16. Watson, 52.

17. McKay understood that "[black literature] was very present in black schools in the South, especially the colleges and universities." She made clear that "before I came to it, those teachers and scholars in black colleges and universities were tirelessly working to preserve it. We seldom give them sufficient thanks for what they did." Nellie Y. McKay, "*The Norton Anthology of African American Literature*: The Promise and the Triumph" (unpublished paper, 14 June 1997), in possession of Shanna G. Benjamin.

18. McKay, "A Troubled Peace," 13.

19. Griffin, "Thirty Years of Black American Literature," 166.

20. Griffin, "That the Mothers May Soar," 491.

21. Griffin, 483.

22. Jackson, *The Indignant Generation*, 6.

23. Bay et al., *Toward an Intellectual History*, 4.

24. Evans, *Black Women in the Ivory Tower*, 36.

25. Waters and Conaway, *Black Women's Intellectual Traditions*, 2.

26. White, *Telling Histories*, 2.

27. Savage, "Professor Merze Tate," 261.

28. Savage, 253.

29. Foreman, "A Riff, a Call, and a Response," 307, 308.

30. "Editorial and Publisher's Announcements," 191.

31. Hopkins, "Famous Women of the Negro Race," 210.

32. Rampersad, "Biography and Afro-American Culture," 195.

33. Rampersad, 195, 196.

34. White, "Mining the Forgotten," 238.

35. Hine, "Rape and the Inner Lives of Black Women," 916.

36. Nellie Y. McKay, letter to Nell Irvin Painter, 6 July 1980, Box 82, Nell Irvin Painter Papers, Nellie Y. McKay Subseries, DRBML.

37. De Veaux, *Warrior Poet*, xiii.

38. Green, "Annotation Tuesday!"

39. Perry, *Looking for Lorraine*, 4.

40. Ransby, *Ella Baker*, 3.

41. Brooks, "kitchenette building," 3.

42. Brooks, 3.

43. Brooks, 3.

44. Morrison, *Sula*, 92.

Scene One

1. Morrison, "The Site of Memory," 85.

2. Washington, *Invented Lives*, xxvi.

3. Alexander, *The Black Interior*, x.

4. Alexander, x.

Chapter One

1. "Marcus Garvey Park."

2. Nellie Y. McKay interview.

3. Nellie Y. McKay interview.

4. Nellie Y. McKay interview.

5. McKay had one biological sister. However, since she introduced her daughter as her sister, McKay consistently used "sisters," plural, when talking about her sibling(s).

6. Nellie Y. McKay interview.

7. Alexander, *The Black Interior*, x.

8. Quashie, *The Sovereignty of Quiet*, 6.

9. McKay, "Response to 'Biography and Afro-American Culture,'" 219.

10. Lorde, *Zami*.

11. Kasinitz, *Caribbean New York*, 24.

12. Birth certificate for Nellie Yvonne Reynolds, 19 May 1930, File No. 15176, Genealogy, MACNY, certified copy in possession of Shanna G. Benjamin. In addition to identifying the countries of birth for her parents, it also identifies their occupations.

13. Marshall, "From the Poets in the Kitchen," 629.

14. "Babies Hospital Historical Collection."

15. Death certificate for Alfreda Reynolds, 23 June 1925, File No. 17069, Genealogy, MACNY, certified copy in possession of Shanna G. Benjamin.

16. Death certificate for unnamed male, 3 May 1926, File No. 14562, Genealogy, MACNY, certified copy in possession of Shanna G. Benjamin.

17. Birth certificate for Nellie Yvonne Reynolds.

18. Jones, *Labor of Love*, 164.

19. See Wilkerson, *The Warmth of Other Suns*, for a masterful study of the great migration as both cultural phenomenon and personal experience.

20. Jones, *Labor of Love*, 164.

21. Jones, 164.

22. Jones, 164–165.

23. Constance E. Reynolds entry, New York Birth Index, 1910–1965, accessed 25 October 2020, Ancestry.com.

24. Hurston, *Their Eyes Were Watching God*, 16.

25. Death certificate for Mrs. Nellie Reynolds, 31 May 1936, File No. 13462, Genealogy, MACNY, certified copy in possession of Shanna G. Benjamin.

26. Scott interview.

27. Scott interview.

28. Death certificate for Mrs. Nellie Reynolds; location of the grave was received from the office of East Ridgelawn Cemetery, 255 Main Avenue, Clifton, NJ 07014.

29. Even though I was unable to secure a marriage license for Joseph and Nellie Yvonne McKay (née Reynolds), an educated guess led me to a Joseph McKay born in 1931 in Saint Elizabeth, Jamaica. He died on 16 May 1979. In the record, Black River, Jamaica, is listed as a "Death Place"; on her Harvard application, McKay listed Black River High School as the place she received her secondary education. While it is impossible to know for sure, this is the only man in the database with that particular name who shared this specific locale with Nellie Yvonne. This, we know, for certain: when Nellie Yvonne left the states, she was a "Reynolds"; when she returned, she was a "McKay." Joseph McKay entry, Jamaica, Civil Registration Birth, Marriage, and Death Records, 1878–1930, accessed 25 October 2020, Ancestry.com.

30. Nellie Y. Reynolds entry, New York, Passenger Lists, 1820–1957, microfilm serial T715, 1897–1957, microfilm roll 8458, line 5, page 284, accessed 12 September 2015, Ancestry.com.

31. Patricia M. Watson interview.

32. Scott interview.

33. Scott interview.

34. Basil J. Prout entry, New York Marriage License Indexes, 1907–2018, spouse Constance E. Reynolds (1977), license number 14024, accessed 25 October 2020, Ancestry.com.

35. Patricia M. Watson interview.

36. Nellie Y. McKay, letter to Joyce Scott, 4 April 1977, in possession of Shanna G. Benjamin.

37. "Bennett Brothers: History."

38. Nellie Y. McKay interview.

39. Nellie Y. McKay interview.

40. Patricia M. Watson interview.

41. Patricia M. Watson interview.

42. Patricia M. Watson interview.

43. Patricia M. Watson interview.

44. Nellie Y. McKay interview.

45. Plows interview.

46. Plows interview.

47. Plows interview.

48. Plows interview.

49. Plows interview.

50. Plows interview.

51. Scott interview.

52. McKay remained grateful to her Hollis Presbyterian family, and in a program printed to commemorate the church's eighty-fifth anniversary, she is recognized under the subheading "A Cultural History of the Hollis Community." After a brief list of her accomplishments, the program cites her inscription in a copy of *The Norton Anthology of African American Literature* donated to the church library: "With my sincere thanks to a community that planted seeds that grew who and what I have become and to young ones whose accomplishments will far exceed my own. All good wishes." See Hollis Presbyterian Church, "A History of the Church and the Community, 1922-2007" (unpublished 85th anniversary program), in possession of Shanna G. Benjamin.

53. Gumbs, "Nobody Mean More," 241.

54. Gumbs, 241.

55. Gumbs, 241.

56. Gumbs, 241.

57. "SEEK Program," Queens College.

58. Watts, "The Remaining 'Gang of Four.'"

59. Martin, "Percy E. Sutton."

60. Martin.

61. Scott interview.

62. Nellie Y. McKay interview.

63. Nellie Y. McKay interview.

64. Nellie Y. McKay interview.

65. Nellie Y. McKay interview.

66. Harry McKay interview.

67. Harry McKay interview.

68. Queens College Students, "The Activist."

69. Peterson, "Historical Note."

70. Peterson, "Descriptive Summary."

71. Arner, "Up against the Great Traditions," 2.

72. Peterson, "Historical Note."

73. "Queens College Dean's Report."

74. Peterson, "Historical Note."

75. McMurray, "Statement."

76. Peterson, "Historical Note."

77. Peterson.

78. Nellie Y. McKay interview.

79. Nellie Y. McKay interview.

80. McKay referred to Michelle Cooper in her interview with me, but in her entry in *Contemporary Black Biography: Profiles from the International Black Community*, McKay credited *Michael* Cooper, a Shakespearean at Queens College, for making an early impact on her life. Gruen, "Nellie Y. McKay," 123.

81. Nellie Y. McKay interview.

82. "John J. McDermott: Distinguished Professor."

83. "Alumnus Funds Million-Dollar Scholarship."

84. Nellie Y. McKay Queens College transcript, in possession of Shanna G. Benjamin.

85. McDermott interview.

86. McDermott interview.

87. McDermott interview.

88. Gumbs, "Nobody Mean More," 244.

89. "Negro Chosen Head of SEEK Program."

90. McDermott interview.

91. Nellie Y. McKay interview.

92. Nellie Y. McKay interview.

93. Nellie Y. McKay interview.

94. Alexis De Veaux, email to Shanna G. Benjamin, 4 January 2012, in possession of Shanna G. Benjamin.

95. Nellie Y. McKay Queens College transcript, in possession of Shanna G. Benjamin.

96. Nellie Y. McKay interview.

97. Rich, *On Lies*, 56.

98. Rich, 56.

99. Savonick, "Insurgent Knowledge," iv.

100. Savonick, v.

101. Freire defined the "banking" concept of education as the belief that "the scope of action allowed to the students extends only as far as receiving, filing, and storing the deposits." Freire, *Pedagogy of the Oppressed*, 72.

102. Jordan, *Soulscript*, xx.

103. Christian, "Being the Subject and the Object," 120.

104. "SEEK Program: An Educational Opportunity."

105. "SEEK Program," City College of New York.

106. Christian, "Being the Subject and the Object," 121.

107. Nellie Y. McKay, letter to Nell Irvin Painter, "Why I Teach This Course" statement enclosed, 31 August 1982, Box 83, Nell Irvin Painter Papers, Nellie Y. McKay Subseries, DRBML. In a handwritten note to Painter, McKay explains how this statement was "handed out with the syllabus of another course in which I am teaching all black women writers this fall."

108. McKay, letter to Painter, 31 August 1982.

109. Nellie Y. McKay interview.

110. Nellie Y. McKay interview.

111. Nellie Y. McKay interview.

112. Nellie Y. McKay interview.

113. Nellie Y. McKay interview.

114. Nellie Y. McKay interview.

115. Nellie Y. McKay interview.

116. "Statement," submitted as part of Nellie Y. McKay's Harvard application, 2 February 1969, in possession of Shanna G. Benjamin.

117. "Statement."

118. "Statement."

119. "Statement."

120. Patricia M. Watson interview.

121. Harry McKay interview.

122. Harry McKay interview.

123. Harry McKay interview.

124. Harry McKay interview.

125. Harry McKay interview.

126. Scott interview.

127. Harry McKay interview.

128. Plows interview.

129. Plows interview.

130. Nellie Y. McKay, letter to Joyce Scott, 12 August 1969, in possession of Shanna G. Benjamin.

131. Patricia M. Watson interview.

132. Nellie Y. McKay interview.

133. Patricia M. Watson interview.

134. Patricia M. Watson interview.

135. Patricia M. Watson interview.

136. Patricia M. Watson interview.

137. Patricia M. Watson interview.

138. Patricia M. Watson interview.

139. Scott interview.

140. Scott interview.

141. Scott interview.

142. "Preston N. Williams."

143. Williams and Williams interview.

144. De los Reyes, "University Hall."

145. Rosenblatt, *Coming Apart*, 213.

146. Serkin, "The Strike, the Bust, the Memory."

147. Robert Kiely, email to Shanna G. Benjamin, 5 June 2014, in possession of Shanna G. Benjamin.

148. Kennedy, "Introduction," xxiii.

149. Southern, "A Pioneer: Black and Female," 499.

150. Southern, 500.

151. Southern, 500.

152. Nellie Y. McKay interview.

153. Rampersad interview.

154. Rampersad interview.

155. Rampersad interview.

156. Painter, "The Praxis of a Life of Scholarship," 9.

157. "Obituary for Dona L. Irvin (1917–2009)."

158. "The Irvin Family."

159. "The Irvin Family."

160. "Frank E. Irvin."

161. Benjamin, "Breaking the Whole Thing Open," 1678.

162. Benjamin, 1678.

163. Benjamin, 1678.

164. Wall interview.

165. Wall interview.

166. Wall interview.

167. Wall interview.

168. Wall interview.

169. Kiely, email to Benjamin, 5 June 2014.

170. Williams and Williams interview.

171. Warner Berthoff, letter to Shanna G. Benjamin, 16 October 2012, in possession of Shanna G. Benjamin.

172. Nellie Y. McKay interview.

173. Nellie Y. McKay interview.

174. Nellie Y. McKay interview.

175. Nellie Y. McKay interview.

176. Nellie Y. McKay interview.

177. "University Designation."

178. Jacobs, *Incidents*, 156.

179. "Our Mission & History."

180. Nellie Y. McKay, "Withdrawal Notice," received and entered into Harvard University File, 22 September 1971, in possession of Shanna G. Benjamin.

181. Since 1974, Simmons College's *Our Little Black Book*, published by the Black Student Organization (BSO), has captured "photographs of and creative work by black students at Simmons."

182. Harris, *Black Feminist Politics*, 4.

183. Harris, 4.

184. Harris, 4.

185. Taylor, *How We Get Free*, 4.

186. "The Combahee Ferry Raid."

187. Taylor, *How We Get Free*, 4

188. Taylor, 4.

189. Smith, foreword, 3.

190. Smith, 3.

191. Smith, "A Press of Our Own," 11.

192. The Combahee River Collective, *The Combahee River Collective Statement*, 9, 11, 14, 17.

193. Washington, foreword, xi.

194. Washington, xi.

195. Nellie Y. McKay interview.

196. Washington, foreword, xi.

197. Benjamin, "Breaking the Whole Thing Open," 1679.

198. Benjamin, 1680.

199. Nellie Y. McKay interview.

200. Benjamin, 1680.

201. Nellie Y. McKay interview.

202. Nellie Y. McKay interview.

203. Washington, foreword, xii.

204. Nellie Y. McKay interview.

205. F. Wylie Sypher, "Letter of Recommendation for Readmission," 16 December 1974, Harvard University file, in possession of Shanna G. Benjamin.

206. Langer interview.

207. Langer interview.

208. Bromberg interview.

209. Bromberg interview.

210. Bromberg interview.

211. Marilyn French's feminist novel *The Women's Room* (1977) captures the climate Bromburg describes. French earned her PhD in English from Harvard; among other things, her novel fictionalizes how gender impacts the educational trajectories and professional aspirations of (white) women.

212. Sypher, "Letter of Recommendation for Readmission."

213. Sypher.

214. Nellie Y. McKay, "Application for Admission, Academic Year 1969–1970, Harvard University," in possession of Shanna G. Benjamin.

215. McKay, "The Girls Who Became the Women," 239.

216. Patricia M. Watson interview.

217. Nellie Y. McKay interview.

218. Nellie Y. McKay interview.

219. Nellie Y. McKay interview.

Scene Two

1. Sreenivasan, Weber, and Kargbo, "The True Story behind the 'Welfare Queen' Stereotype."

2. Williams, *The State of Black America, 1983*, 66.

3. Brooks, "the children of the poor," 53.

Chapter Two

1. Nellie Y. McKay, letter to Nell Irvin Painter, 4 April 1982, Box 83, Nell Irvin Painter Papers, Nellie Y. McKay Subseries, DRBML.

2. McKay, letter to Painter, 4 April 1982.

3. Christian, "The Race for Theory," 51.

4. Nellie Y. McKay, letter to Nell Irvin Painter, 23 December 1982, Box 83, Nell Irvin Painter Papers, Nellie Y. McKay Subseries, DRBML.

5. McKay, letter to Painter, 4 April 1982.

6. Walker, "The Divided Life of Jean Toomer," 60.

7. McKay, *Jean Toomer, Artist*, ix.

8. Walker, "The Divided Life," 62.

9. McKay, *Jean Toomer, Artist*, 59.

10. McKay, 61.

11. McKay, 62.

12. McKay, 67.

13. Marquard, "William J. Holmes."

14. William J. Holmes, Office of the President, letter to Nellie Y. McKay, 14 April 1977, in possession of Shanna G. Benjamin.

15. Bruce Mazlish, letter to Nellie Y. McKay, 10 May 1977, in possession of Shanna G. Benjamin.

16. "Chronicle Data: Submitted Adjunct Salaries per Course."

17. W. E. B. Du Bois Research Institute, memorandum to Joyce Scott, letter from Massachusetts Institute of Technology (MIT) enclosed, May 1977, in possession of Shanna G. Benjamin.

18. Nellie Y. McKay, letter to Financial Aid Office, 24 June 1969, in possession of Shanna G. Benjamin.

19. Richard Ralston, letter to Nellie Y. McKay, 7 July 1977, in possession of Shanna G. Benjamin.

20. "Richard Ralston Collects Culture through Stamps."

21. "Samuel Washington Allen, 1917–2015."

22. Ralston, letter to McKay, 7 July 1977.

23. Nellie Y. McKay, letter to Joyce Scott, 4 August 1977, in possession of Shanna G. Benjamin.

24. Nellie Y. McKay, letter to Richard Ralston, 28 December 1977, in possession of Shanna G. Benjamin.

25. Unable to consult the Du Bois Institute's archived administrative records (1973–1989, inclusive) due to COVID-19 (and current staff have no record of McKay being in residence at the Institute prior to the 1990s), I deduced that McKay was in residence at the Institute from 1977 to 1978 based on her use of Institute letterhead in her correspondences with Richard Ralston, Nell Irvin Painter, and Joyce Scott during this time.

26. McKay, letter to Scott, 4 August 1977.

27. "Preston N. Williams."

28. Williams and Williams interview.

29. Williams and Williams interview.

30. Williams and Williams interview.

31. Williams and Williams interview.

32. Williams and Williams interview.

33. Williams and Williams interview.

34. Wisconsin's Board of Regents approved the establishment of the Department of Afro-American Studies during a time when students demanded cultural relevancy in their college education, a move inspired by the establishment of San Francisco State University's Black Studies Program in 1968, which mirrored Kent State University's Institute for African American Affairs (1969) and African American Studies at the University of California, Berkeley (1970).

35. University of Wisconsin–Madison News, "13 Demands." See "Story."

36. Tesfagiorgis interview.

37. University of Wisconsin–Madison News, "13 Demands." See "Story."

38. University of Wisconsin–Madison News, "13 Demands." See "Story."

39. University of Wisconsin–Madison News, "13 Demands." See "Story."

40. University of Wisconsin–Madison News, "13 Demands." See "Story."

41. Rogers, *The Black Campus Movement*, 1.

42. Rogers, 1.

43. University of Wisconsin–Madison News, "13 Demands." See "Story."

44. Brooks, "H. Edwin Young."

45. Brooks.

46. University of Wisconsin–Madison News, "13 Demands."

47. University of Wisconsin–Madison News, "13 Demands." See "Timeline."

48. Nellie Y. McKay interview.

49. Nellie Y. McKay, letter to Nell Irvin Painter, "Trends and Ideas in Contemporary Black Writing" syllabus and schedule of lecturers enclosed, 4 September 1977, Box 82, Nell Irvin Painter Papers, Nellie Y. McKay Subseries, DRBML. McKay delivered her talk, "Jean Toomer and His Generation," on 4 October 1977.

50. Nellie Y. McKay, letter to Nell Irvin Painter, 25 November 1977, in possession of Shanna G. Benjamin.

51. Werner interview.

52. Day, *Association of Concerned Africa Scholars Bulletin*.

53. Ralston, letter to McKay, 7 July 1977.

54. New, "Panther Teacher," 52.

55. New, 51–52.

56. Rambsy, *The Black Arts Enterprise*, 126.

57. Rambsy, 126.

58. Rambsy, 139.

59. New, "Panther Teacher," 125.

60. Mogaka interview.

61. Mogaka interview.

62. Edris A. Makward, Charles E. Anderson, Fred M. Hayward, and Nellie Y. McKay, "Memorial Resolution of the Faculty of the University of Wisconsin on the Death of Assistant Professor Sarah Webster Fabio," University of Wisconsin–Madison, 3 March 1980, in possession of Shanna G. Benjamin.

63. Griffin, introduction, 3.

64. Griffin, 3.

65. Griffin, 6.

66. Painter, "The Praxis of a Life of Scholarship," 10.

67. Painter, 9.

68. Painter, 10.

69. Painter, 10.

70. Rambsy, *Bad Men*, 170.

71. Rambsy, 9.

72. Graham, "Review of *Jean Toomer, Artist*," 91.

73. Graham, 91.

74. McKay, *Jean Toomer, Artist*, 255–258.

75. Nellie Y. McKay, letter to Nell Irvin Painter, Malcolm L. Call letter to Nellie Y. McKay (18 January 1978); and "Jean Toomer, The Artist: A Portrait in Tragedy" reader's report enclosed, 24 January 1978, Box 82, Nell Irvin Painter papers, Nellie Y. McKay Subseries, DRBML.

76. Readers' reports are procured by university presses, which ask experts to evaluate the merits of a manuscript and to recommend publication or not.

77. Nell Irvin Painter, letter to Nellie Y. McKay, 31 January 1978, Box 82, Nell Irvin Painter papers, Nellie Y. McKay Subseries, DRBML.

78. Painter, letter to McKay, 31 January 1978.

79. McKay, letter to Painter, 24 January 1978.

80. Nellie Y. McKay, letter to Joyce Scott, 26 September 1977, in possession of Shanna G. Benjamin.

81. Painter, letter to McKay, 31 January 1978.

82. Tenure grants faculty permanent employment that can be rescinded only "for cause or under extraordinary circumstances," and it is earned after faculty complete a series of reviews during a six-year probationary period ("Tenure," American Association of University Professors, https://www.aaup.org/issues/tenure).

83. Nellie Y. McKay, letter to Joyce Scott, 29 August 1980, in possession of Shanna G. Benjamin.

84. McKay, letter to Scott, 29 August 1980.

85. McKay, letter to Scott, 29 August 1980.

86. McKay, letter to Scott, 29 August 1980.

87. Nellie Y. McKay, letter to Nell Irvin Painter, 19 August 1980, Box 82, Nell Irvin Painter Papers, Nellie Y. McKay Subseries, DRBML.

88. Walkington, "How Far Have We Really Come?," 58.

89. Nellie Y. McKay, letter to Nell Irvin Painter, 6 September 1983, Box 82, Nell Irvin Painter Papers, Nellie Y. McKay Subseries, DRBML.

90. Nellie Y. McKay, letter to Gerda Lerner, 23 February 1988, Box 31, Papers of Gerda Lerner, SL.

91. Nellie Y. McKay, letter to Gerda Lerner, 13 September 1991, Box 31, Papers of Gerda Lerner, SL.

92. Nellie Y. McKay, letter to Gerda Lerner, 26 November 1991, Box 31, Papers of Gerda Lerner, SL.

93. Spillers interview.

94. Guy-Sheftall interview.

95. Moody interview.

96. Guy-Sheftall interview.

97. McKay, letter to Painter, 19 August 1980.

98. Nellie Y. McKay, letter to Nell Irvin Painter, Richard Ralston letter to Nellie Y. McKay (16 November 1978) enclosed, 19 December 1978, Box 82, Nell Irvin Painter Papers, Nellie Y. McKay Subseries, DRBML.

99. McKay, letter to Painter, 19 December 1978.

100. McKay, letter to Painter, 19 December 1978.

101. McKay, letter to Painter, 19 December 1978.

102. Nellie Y. McKay, letter to Nell Irvin Painter, 14 June 1980, Box 82, Nell Irvin Painter Papers, Nellie Y. McKay Subseries, DRBML.

103. McKay, letter to Painter, 14 June 1980.

104. Nellie Y. McKay, Bascom Chair Curriculum Vitae, 2003, Box 8, Folder 21, Nellie Y. McKay Papers, UWARM.

105. Fontenot interview.

106. Fontenot interview.

107. Fontenot interview.

108. Yarborough interview.

109. Yarborough interview.

110. When COVID-19 travel restrictions prevented me from personally accessing MLA archives, Elizabeth Israel, the Coordinator of Forums with the MLA, confirmed the creation of the discussion group on Black American Literature and Culture in 1977. "In 1983," she wrote, "the group petitioned to become a division and held its first division sessions at the 1984 convention." Elizabeth Israel, email to Shanna G. Benjamin, 1 June 2020, in possession of Shanna G. Benjamin.

111. Yarborough interview.

112. Weixlmann interview.

113. Weixlmann et al., "*African American Review* at 40," 5.

114. Harris interview.

115. Harris interview.

116. Harris interview.

117. Barber, "The Women's Revolt in the MLA," 24.

118. Barber, 24.

119. Smith, "Building Black Women's Studies," 200–201.

120. While Hull does not list a last name, she is most likely referring to Margaret "Margo" Culley, University of Massachusetts at Amherst professor emerita.

121. Akasha Gloria Hull, memorandum to CSW Members and Cheryl, 25 May 1979, Box 10, Folder 6, Nellie Y. McKay Papers, UWARM. This citation regarding the Modern Language Association's (MLA's) Commission on the Status of Women in the Profession mentions "Cheryl" as a recipient but lists no last name in the document itself.

122. Hull, memorandum to CSW Members and Cheryl, 25 May 1979.

123. Hull.

124. Hull.

125. Hull.

126. Hull.

127. The Combahee River Collective, "A Black Feminist Statement," 12.

128. Hull, memorandum to CSW Members and Cheryl, 25 May 1979.

129. Hull.

130. Hull.

131. Erlene Stetson, letter to Nellie Y. McKay, n.d., Box 10, Folder 6, Nellie Y. McKay Papers, UWARM.

132. While Stetson's letter to McKay was undated, McKay's response to Stetson was dated 5 February 1980. Nellie Y. McKay, letter to Erlene Stetson, 5 February 1980, Box 10, Folder 6, Nellie Y. McKay Papers, UWARM.

133. Helene Moglen, letter to Nellie Y. McKay, 14 April 1980, Box 10, Folder 6, Nellie Y. McKay Papers, UWARM.

134. Shirley Nelson Garner, letter to Nellie Y. McKay, 26 November 1980, Box 10, Folder 6, Nellie Y. McKay Papers, UWARM.

135. Barber, "The Women's Revolt in the MLA," 24.

136. Barber, 24.

137. Barber, 24.

138. "Delegate Assembly."

139. Joel Conarroe, letter to Nellie Y. McKay, 12 December 1978, Box 10, Folder 6, Nellie Y. McKay Papers, UWARM.

140. Joel Conarroe, letter to Nellie Y. McKay, 8 December 1980, Box 10, Folder 6, Nellie Y. McKay Papers, UWARM.

141. Howe, "Tribute for Nellie McKay," 12, 16.

142. James, Foster, and Guy-Sheftall, introduction, xv.

143. Nellie Y. McKay, letter to Frances Smith Foster, 2 April 1980, Box 10, Folder 6, Nellie Y. McKay Papers, UWARM; Valerie Smith, letter to Nellie Y. McKay, 13 March 1980, Box 10, Folder 6, Nellie Y. McKay Papers, UWARM.

144. Nellie Y. McKay, letter to Frances Smith Foster, 8 May 1980, Box 10, Nellie Y. McKay Papers, UW-Madison; Nellie Y. McKay, letter to Valerie Smith, 8 May 1980, Box 10, Folder 6, Nellie Y. McKay Papers, UWARM.

145. McKay, letter to Foster, 8 May 1980; McKay, letter to Smith, 8 May 1980.

146. Nellie Y. McKay, letter to Ann Hull, 15 May 1980, Box 10, Folder 6, Nellie Y. McKay Papers, UWARM.

147. McKay, letter to Foster, 2 April 1980.

148. Spillers, "Mama's Baby, Papa's Maybe," 64.

149. Modern Language Association, "Program," 983, 1016, 1024, 1036.

150. Nellie Y. McKay, letter to Nell Irvin Painter, 31 March 1982, Box 83, Nell Irvin Painter Papers, Nellie Y. McKay Subseries, DRBML.

151. Moraga, "Comment on Stetson's Review," 727.

152. Moraga, 727.

153. Nellie Y. McKay, letter to Nell Irvin Painter, 23 July 1980, Box 82, Nell Irvin Painter Papers, Nellie Y. McKay Subseries, DRBML.

154. McKay, letter to Painter, 19 August 1980.

155. Nellie Y. McKay, letter to Nell Irvin Painter, 14 October 1981, Box 83, Nell Irvin Painter Papers, Nellie Y. McKay Subseries, DRBML.

156. Nellie Y. McKay, letter to Nell Irvin Painter, 31 January 1982, Box 82, Nell Irvin Painter Papers, Nellie Y. McKay Subseries, DRBML.

157. Nellie Y. McKay, letter to Nell Irvin Painter, 9 March 1982, Box 82, Nell Irvin Painter Papers, Nellie Y. McKay Subseries, DRBML.

158. McKay, letter to Painter, 4 April 1982.

159. McKay, letter to Painter, 4 April 1982.

160. "Contemporary Literature."

161. See Gray, "An Interview with Nadine Gordimer."

162. McKay, letter to Painter, 4 April 1982.

163. Toni Morrison, letter to Nellie Y. McKay, 23 April 1982, Box 83, Nell Irvin Painter Papers, Nellie Y. McKay Subseries, DRBML. A copy of Morrison's letter to McKay was likely enclosed in one of her letters to Painter between 23 April and 28 May 1982—the day McKay mentioned that she finally "found time today to write a note to Toni Morrison asking her if she'd set a date . . . for her interview." Nellie Y. McKay, letter to Nell Irvin Painter, 28 May 1982, Box 83, Nell Irvin Painter Papers, Nellie Y. McKay Subseries, DRBML.

164. McKay, letter to Painter, 23 December 1982.

165. Nellie Y. McKay, letter to Nell Irvin Painter, letter from Peter Givler to Nellie Y. McKay (24 May 1983) enclosed, 29 June 1983, Box 83, Nell Irvin Painter Papers, Nellie Y. McKay Subseries, DRBML.

166. Nellie Y. McKay, letter to Nell Irvin Painter, article "Conversations With Black Women Writers: An Introduction to Their Works" enclosed, 23 December 1982, Box 83, Nell Irvin Painter Papers, Nellie Y. McKay Subseries, DRBML.

167. Nellie Y. McKay, letter to Nell Irvin Painter, 31 July 1983, Box 83, Nell Irvin Painter Papers, Nellie Y. McKay Subseries, DRBML.

168. McKay, letter to Painter, 31 July 1983.

169. Toni Morrison, "Commencement Speech," 1978, SCA.

170. Nellie Y. McKay, Abstract: Black Women and the Autobiographical Voice: An Affirming Self, n.d., Box 10, Folder 6, Nellie Y. McKay Papers, UWARM.

171. McKay, "Black Woman Professor," 143.

172. McKay and Foster, introduction, x.

173. McKay, "The Girls Who Became the Women," 106.

174. McKay, 106.

175. McKay, 105.

176. Nellie Y. McKay, letter to Nell Irvin Painter, 18 August 1983, Box 83, Nell Irvin Painter Papers, Nellie Y. McKay Subseries, DRBML.

177. Nellie Y. McKay, letter to Nell Irvin Painter, 26 August 1983, Box 83, Nell Irvin Painter Papers, Nellie Y. McKay Subseries, DRBML.

178. McKay, letter to Painter, 18 August 1983.

179. Nellie Y. McKay, letter to Nell Irvin Painter, 25 August 1983, Box 83, Nell Irvin Painter Papers, Nellie Y. McKay Subseries, DRBML.

180. Nellie Y. McKay, letter to Nell Irvin Painter, 18 September 1983, Box 83, Nell Irvin Painter Papers, Nellie Y. McKay Subseries, DRBML.

181. Nellie Y. McKay, letter to Nell Irvin Painter, 8 September 1983, Box 83, Nell Irvin Painter Papers, Nellie Y. McKay Subseries, DRBML.

182. Nellie Y. McKay, letter to Nell Irvin Painter, 20 October 1983, Box 83, Nell Irvin Painter Papers, Nellie Y. McKay Subseries, DRBML.

183. "Tom W. Shick Memorial Scholarship Fund" [inaugural packet], Box 10, Folder 4, Nellie Y. McKay Papers, UWARM.

184. "Kappa Alpha Psi Tom W. Shick Award 2011," 2011, Box 10, Folder 4, Nellie Y. McKay Papers, UWARM.

185. Nellie Y. McKay, letter to Nell Irvin Painter, 27 November 1978, Box 82, Nell Irvin Painter Papers, Nellie Y. McKay Subseries, DRBML.

186. McKay, letter to Painter, 30 August 1978.

187. Nellie Y. McKay, letter to Nell Irvin Painter, 13 August 1982, Box 83, Nell Irvin Painter Papers, Nellie Y. McKay Subseries, DRBML.

188. Nellie Y. McKay, letter to Nell Irvin Painter, 19 December 1982, Box 83, Nell Irvin Painter Papers, Nellie Y. McKay Subseries, DRBML.

189. Nellie Y. McKay, letter to Nell Irvin Painter, 29 January 1983, Box 83, Nell Irvin Painter Papers, Nellie Y. McKay Subseries, DRBML.

190. Nellie Y. McKay, letter to Nell Irvin Painter, 24 April 1983, Box 83, Nell Irvin Painter Papers, Nellie Y. McKay Subseries, DRBML.

191. Nellie Y. McKay, letter to Nell Irvin Painter, 13 February 1984, Box 83, Nell Irvin Painter Papers, Nellie Y. McKay Subseries, DRBML. There are two letters dated 13 February 1984; the letter cited begins "It was good to talk with you yesterday."

192. Nellie Y. McKay, letter to Nell Irvin Painter, 22 January 1985, Box 83, Nell Irvin Painter Papers, Nellie Y. McKay Subseries, DRBML.

193. Nellie Y. McKay, letter to Nell Irvin Painter, 6 June 1984, Box 83, Nell Irvin Painter Papers, Nellie Y. McKay Subseries, DRBML.

194. Nellie Y. McKay, letter to Nell Irvin Painter, 20 August 1985, Box 84, Nell Irvin Painter Papers, Nellie Y. McKay Subseries, DRBML. There are two letters dated 20 August 1985; the letter cited begins "This is just a note."

195. "Professor Reported Missing," *Wisconsin State Journal* (12 November 1986).

196. Nellie Y. McKay, letter to Nell Irvin Painter, 16 November 1986, Box 84, Nell Irvin Painter Papers, Nellie Y. McKay Subseries, DRBML.

197. "Missing Professor's Car Found," *Wisconsin State Journal* (22 November 1986).

198. "Body Found in Wingra Is Missing Prof," *Capital Times* (6 March 1987).

199. Nellie Y. McKay, letter to Nell Irvin Painter, 4 March 1987, Box 85, Nell Irvin Painter Papers, Nellie Y. McKay Subseries, DRBML.

200. Nellie Y. McKay, letter to Nell Irvin Painter, 11 March 1987, Box 85, Nell Irvin Painter Papers, Nellie Y. McKay Subseries, DRBML.

201. McKay, letter to Painter, 11 March 1987.

202. "Dr. Tom W. Shick Memorial Scholarship Fund: Overview," Box 10, Folder 4, Nellie Y. McKay Papers, UWARM.

203. "Kappa Alpha Psi Tom W. Shick Award 2011."

204. Werner interview.

205. Werner interview.

206. Werner interview.

Scene Three

1. Benjamin, "There's Something about Mary," 121.

2. Ellison, "Out of the Hospital and under the Bar," 244.

3. Spillers, "Mama's Baby, Papa's Maybe," 65.

4. Morrison, "Rootedness," 339.

Chapter Three

1. Nellie Y. McKay interview.
2. Nellie Y. McKay interview.
3. Nellie Y. McKay interview.
4. Wofford interview.
5. Brandt interview.
6. Wofford interview.
7. "About the Park."
8. Nellie Y. McKay, letter to Nell Irvin Painter, 4 April 1982, Box 83, Nell Irvin Painter Papers, Nellie Y. McKay Subseries, DRBML.
9. Nellie Y. McKay interview.
10. Nellie Y. McKay interview.
11. "Anna Julia Cooper," 43.
12. Cooper, *Beyond Respectability*, 8.
13. Campbell, *Middle Passages*, 68.
14. Almost one hundred years later, Anna Julia Cooper's words became the organizing framework of Paula Giddings's *When and Where I Enter: The Impact of Black Women on Race and Sex in America* (1984).
15. Cooper, *Beyond Respectability*, 9.
16. Baker, "Presidential Address," 403.
17. Baker, 403.
18. Baker, 403.
19. Baker, 404–405.
20. Spillers et al., "'Whatcha Gonna Do?,'" 300.
21. duCille, "The Occult of True Black Womanhood," 597.
22. See Spillers, "'Whatcha Gonna Do?,'" for a discussion of the "forces of opposition" that "enforce forgetfulness," 301.
23. Watkins, "Sexism, Racism, and Black Women Writers."
24. McDowell, "Black Women Writers."
25. Pemberton, "Black Women Writers."
26. Morrison, review of *To Be a Black Woman*.
27. Jenkins, "Queering Black Patriarchy," 970–971.
28. Traylor, "Re Calling the Black Woman," x.
29. Guy-Sheftall, *Words of Fire*, 25–33, 43–49.
30. Bethel and Smith, introduction, 11.
31. Morrison, review of *To Be a Black Woman*.
32. "Susan Stanford Friedman."
33. Nellie Y. McKay interview.
34. "Bascom Chair Materials," Box 8, Folder 21, Nellie Y. McKay Papers, UWARM.
35. Andrews interview.
36. Susan Stanford Friedman, email to Shanna G. Benjamin, 20 January 2020, in possession of Shanna G. Benjamin.
37. Rooks, *White Money/Black Power*, 29.

38. UW-Madison Afro-American Studies Department, grant proposal to the Ford Foundation, PA# 08900639.

39. Hubbard, preface, xi.

40. James interview.

41. UW-Madison Afro-American Studies Department, grant proposal to the Ford Foundation, PA# 09501520.

42. UW-Madison Afro-American Studies Department, grant proposal to the Ford Foundation, PA# 09901709.

43. Rooks, *White Money/Black Power*, 22.

44. Rooks, 1.

45. Rooks, 23.

46. Rooks, 25.

47. Graham, "Black Is Gold," 55.

48. Graham, 62.

49. Graham, 63.

50. Graham, 64, 65.

51. Davidoff, "Nellie McKay: Canon Blast."

52. Gates, "Canon-Formation," 14.

53. Nellie Y. McKay, "The Making of *The Norton Anthology of African American Literature* (*NAAAL*)" (unpublished paper, 9 December 1996), in possession of Shanna G. Benjamin.

54. Gates and McKay, preface to *The Norton Anthology*, 2nd ed., xxix.

55. "NABAL Talks at Cornell—Rough Notes," 26 November 1986, Julia Reidhead papers, in possession of Shanna G. Benjamin.

56. "NABAL Talks at Cornell—Rough Notes."

57. "NABAL Talks at Cornell—Rough Notes."

58. "NABAL Talks at Cornell—Rough Notes."

59. Mary Helen Washington was a faculty member at the University of Massachusetts from 1980 to 1989.

60. Washington, "Disturbing the Peace," 1.

61. duCille, "The Occult of True Black Womanhood," 595.

62. duCille, 595.

63. Washington interview.

64. Washington interview.

65. Washington interview.

66. Gates agreed to an interview, but scheduling prevented us from confirming a date. Henry Louis Gates Jr., email to Shanna G. Benjamin, 20 January 2016, in possession of Shanna G. Benjamin.

67. Joyce Scott, note to Shanna Benjamin, 7 November 2013, in possession of Shanna G. Benjamin.

68. "Norton Anthology of Afro-American Literature: Projected New Timetable," October 1989, in possession of Shanna G. Benjamin.

69. "Norton Anthology of Afro-American Literature: Projected New Timetable."

70. "NABAL Talks at Cornell—Rough Notes."

71. "NABAL Talks at Cornell—Rough Notes."

72. Jones, *The Muse Is Music*, 209.

73. "NABAL Talks at Cornell—Rough Notes."

74. "NABAL Talks at Cornell—Rough Notes."

75. McKay, "The Making."

76. Benjamin, "Intimacy and Ephemera," 23–27.

77. "NABAL Talks at Cornell—Rough Notes."

78. Kinnamon, "Anthologies of African-American Literature," 461.

79. Johnson, *The Book of American Negro Poetry*, vii.

80. Kinnamon, "Anthologies of African-American Literature," 462, 465.

81. Keneth Kinnamon's outstanding retrospective of the period leading to the *NAAAL* evaluates anthologies dating back to *Les Cenelles* based on organization, text selection, and the strength of contextualizing information (i.e., period introductions, headnotes, and bibliographical information). Importantly, he differentiates between anthologies based on their overall function and purpose. Some anthologies "provide a comprehensive overview of the entire tradition," while others are meant "to capture or even define a particular moment in all its freshness and enthusiasm" or even "codif[y] distinct stages of African-American literary history." See Kinnamon, "Anthologies of African-American Literature," 465–466.

82. Andrews interview.

83. "White House Millennium Council."

84. Andrews interview.

85. Foster interview.

86. Nellie Y. McKay, fax to Julia Reidhead, 21 October 1996, in possession of Shanna G. Benjamin.

87. Andrews interview.

88. Andrews interview.

89. Andrews interview.

90. Andrews interview.

91. Foster interview.

92. "John Benedict."

93. Benjamin, "Intimacy and Ephemera," 25.

94. "Barry K. Wade."

95. Benjamin, "Intimacy and Ephemera," 25.

96. Henry Louis Gates Jr., memorandum to The Editors of The Norton Anthology, 12 May 1995, in possession of Shanna G. Benjamin.

97. Julia Reidhead, letter to Susan Friedman, 14 January 2004, in possession of Shanna G. Benjamin.

98. Foster interview.

99. Foster interview.

100. Foster interview.

101. Foster interview.

102. Edwards, *Charisma*, 6–7.

103. Edwards, 10.

104. Edwards, 10–11.

105. Begley, "Black Studies' New Star."

106. Foer, "Henry Louis Gates Jr."

107. "Dr. Entrepreneur."

108. McKay and Foster, "A Collective Experience," 16.

109. McKay and Foster, 19.

110. Edwards, *Charisma*, 11.

111. William L. Andrews, email to Shanna G. Benjamin, 27 October 2020, in possession of Shanna G. Benjamin.

112. Priest, "Salvation Is the Issue," 120.

113. Priest, 120.

114. VHS tape labeled Norton Anthology African American Literature Symposium, 1997, Video 13, Nellie Y. McKay Papers, UWARM.

115. Palmore, "Afro-Am Offers Post to Literary Scholar," 1, 7.

116. Nellie Y. McKay, letter to Carl Grant, Eric Rothstein, and Gina Sapiro, 8 June 1989, Box 7, Folder 24, Nellie Y. McKay Papers, UWARM.

117. McKay, letter to Grant, Rothstein, and Sapiro, 8 June 1989.

118. McKay, letter to Grant, Rothstein, and Sapiro, 8 June 1989.

119. McKay, letter to Grant, Rothstein, and Sapiro, 8 June 1989.

120. "UW-Madison Gives Prof $20,600."

121. Nellie Y. McKay, letter to A. Michael Spence, 24 August 1989, Box 7, Folder 24, Nellie Y. McKay Papers, UWARM.

122. A. Michael Spence, letter to Nellie Y. McKay, 21 September 1989, Box 7, Folder 24, Nellie Y. McKay Papers, UWARM.

123. Nellie Y. McKay, letter to Nell Irvin Painter, 23 August 1989, Box 86, Nell Irvin Painter Papers, Nellie Y. McKay Subseries, DRBML.

124. A. Michael Spence, letter to Nellie Y. McKay, 2 March 1990, Box 7, Folder 24, Nellie Y. McKay Papers, UWARM.

125. Spence, letter to McKay, 2 March 1990.

126. Spence, letter to McKay, 2 March 1990.

127. Nellie McKay, letter to A. Michael Spence, 9 April 1990, Box 7, Folder 24, Nellie Y. McKay Papers, UWARM.

128. Magner, "Henry Louis Gates Is off to Harvard."

129. Henry Louis Gates Jr., letter to Nellie Y. McKay, 14 March 1991, Box 10, Folder 11, Nellie Y. McKay Papers, UWARM.

130. Rampersad interview.

131. Benjamin, "Intimacy and Ephemera," 1.

132. Benjamin, 11.

133. Thurgood Marshall served as a Supreme Court justice from October 1967 to October 1991.

134. Morrison, introduction, x.

135. Nell Irvin Painter, letter to Nellie Y. McKay, 9 October 1991, Box 88, Nell Irvin Painter Papers, Nellie Y. McKay Subseries, DRBML.

136. Nell Irvin Painter, letter to Nellie Y. McKay, 12 October 1991, Box 88, Nell Irvin Painter Papers, Nellie Y. McKay Subseries, DRBML.

137. Nellie Y. McKay, letter to Nell Irvin Painter, 9 October 1991, Box 88, Nell Irvin Painter Papers, Nellie Y. McKay Subseries, DRBML.

138. Nellie Y. McKay, letter to Nell Irvin Painter, 13 October 1991, Box 88, Nell Irvin Painter Papers, Nellie Y. McKay Subseries, DRBML.

139. Nell Irvin Painter, letter to Nellie Y. McKay, 17 October 1991, Box 88, Nell Irvin Painter Papers, Nellie Y. McKay Subseries, DRBML.

140. Nellie Y. McKay, letter to Nell Irvin Painter, "Acknowledging Differences: Can Women Find Unity Through Diversity?" talk enclosed, 20 October 1991, Box 88, Nell Irvin Painter Papers, Nellie Y. McKay Subseries, DRBML.

141. McKay, letter to Painter, 20 October 1991.

142. McKay, letter to Painter, 20 October 1991.

143. McKay, "Remembering Anita Hill and Clarence Thomas," 289.

144. Nell Irvin Painter, letter to Nellie Y. McKay, 25 October 1991, Box 88, Nell Irvin Painter Papers, Nellie Y. McKay Subseries, DRBML. There are two letters dated 25 October 1991; the letter cited begins "This morning I wrote a long letter to you."

145. Painter, letter to McKay, 25 October 1991.

146. Painter, "Hill, Thomas, and the Use of Racial Stereotype," 201.

147. Bailey and Trudy, "On Misogynoir."

148. Diep, "'I Was Fed Up.'"

149. Hoff, *Law, Gender, and Injustice*, 427.

150. McKay, "Naming the Problem," 360.

151. Nellie Y. McKay, letter to Nell Irvin Painter, 10 August 1992, Box 89, Nell Irvin Painter Papers, Nellie Y. McKay Subseries, DRBML.

152. McKay, introduction, xi.

153. Howe, "Tribute for Nellie McKay," 14.

154. Howe, 12.

155. Howe, 12.

156. Howe, 16.

157. Nellie Y. McKay, email to Nellie Y. McKay, 17 December 2003, Box 8, Folder 21, Nellie Y. McKay Papers, UWARM.

158. McKay et al., "The Inevitability of the Personal," 1155.

159. Nellie Y. McKay interview.

160. McKay, "Race, Gender, and Cultural Context," 179, 180.

161. McKay, 182.

162. Andrews interview.

163. Susan Stanford Friedman, email to Shanna G. Benjamin, 20 January 2020, in possession of Shanna G. Benjamin.

164. Susan Friedman, Nellie McKay, Eric Rothstein, and Don Rowe. "Draft Proposal: Cooperation between the English Department and Afro-American Studies," September 1992, Box 9, Folder 20, Nellie Y. McKay Papers, UWARM.

165. "DRAFT PROPOSAL: Cooperation between the English Department and Afro-American Studies," Box 9, Folder 20, Nellie Y. McKay Papers, UWARM.

166. Wycliff, "Women as Presidents."

167. Wofford interview.

168. Wofford interview.

169. "Emerita: A Fond Farewell to Susan Bernstein."

170. Box 9, folder 20 of Nellie Y. McKay's papers includes several documents related to the establishment of the Bridge Program. In this folder are undated memos, dated letters, and proposal drafts. The dated items begin with "Notes on Meeting about Afro-American Studies Graduate Students" in May 1992 and end with an October 1992 letter from McKay to then-graduate director Donald "Don" Rowe, regarding "Afro-American Studies and the English Department Graduate Program." Lacking is a specific document that confirms the date the program was approved.

171. Brandt interview.

172. Wofford interview.

173. Cherene Sherrard-Johnson, email to Shanna G. Benjamin, 27 November 2019, in possession of Shanna G. Benjamin.

174. Sherrard-Johnson, email to Benjamin, 27 November 2019.

175. Sherrard-Johnson interview.

176. Sherrard-Johnson interview.

177. Sherrard-Johnson, email to Benjamin, 27 November 2019.

178. The English Department's failure to hire an African Americanist wasn't due to lack of trying. In his tribute to McKay, Maurice Wallace described the "shamefulness" he felt from "hurting Nellie very deeply when [he] declined her offer to . . . join her at University of Wisconsin–Madison" (Wallace, "What Nellie Knew," 34).

179. "Professors Embrace Black Literature."

180. "Announcing the Global Black Studies Funding Initiative."

Scene Four

1. Morrison, "Home," 3, 5.

Chapter Four

1. Nellie Y. McKay, letter to Nell Irvin Painter, 11 May 1990, Box 87, Nell Irvin Painter Papers, Nellie Y. McKay Subseries, DRBML.

2. Nellie Y. McKay, letter to Nell Irvin Painter, 18 September 1992, Box 89, Nell Irvin Painter Papers, Nellie Y. McKay Subseries, DRBML.

3. Teresa Fleming, "'Extensions of the Self': Homeownership and Personal Space in the Nellie McKay-Nell Irvin Painter Correspondence" (unpublished paper, 24 July 2015), in possession of Shanna G. Benjamin. The title was inspired by a line from a letter from McKay to Painter in which the former noted that "houses are a big deal. They are extensions of the self." Nellie Y. McKay, letter to Nell Irvin Painter, 3 September 1992, Box 89, Nell Irvin Painter Papers, Nellie Y. McKay Subseries, DRBML.

4. Nellie Y. McKay, letter to Nell Irvin Painter, 24 July 1985, Box 84, Nell Irvin Painter Papers, Nellie Y. McKay Subseries, DRBML.

5. Nellie Y. McKay, letter to Nell Irvin Painter, 6 August 1992, Box 89, Nell Irvin Painter Papers, Nellie Y. McKay Subseries, DRBML.

6. McKay, letter to Painter, 6 August 1992.

7. McKay, "A Troubled Peace," 14.

8. Fleming, "'Extensions of the Self.'"

9. McKay, "A Troubled Peace," 11.

10. "Black Women in the Academy: Defending Our Name, 1894–1994" was a national conference organized by MIT professors Robin W. Kilson and Evelynn M. Hammonds to "address historical and contemporary issues faced by African American women in academia." See "Black Women in the Academy Conference."

11. McKay, "A Troubled Peace," 11.

12. "UW-Madison Gives Prof $20,600."

13. Gordon interview and Werner interview.

14. LaCroix interview.

15. Gordon interview.

16. Friedman interview.

17. "Our Story."

18. Bernstein interview.

19. "Intake Form," Nellie McKay, Center for Patient Partnerships client record, 21 February 2005, in possession of Shanna G. Benjamin.

20. This overview of McKay's illness included in this paragraph cites the following as its source material: "Clinic Note," Nellie McKay, UW Health University Hospital, 21 February 2005, in possession of Shanna G. Benjamin; and "Clinic Note," Nellie McKay, UW Health University Hospital, 24 February 2005, in possession of Shanna G. Benjamin.

21. Pritchard interview.

22. Nellie Y. McKay, letter to Nell Irvin Painter, 19 August 1980, Box 82, Nell Irvin Painter Papers, Nellie Y. McKay Subseries, DRBML.

23. Nellie Y. McKay, letter to Nell Irvin Painter, 14 September 1980, Box 82, Nell Irvin Painter Papers, Nellie Y. McKay Subseries, DRBML.

24. "Radiologic Study Report," Nellie McKay, UW Health University Hospital, 18 November 2002, in possession of Shanna G. Benjamin.

25. Priest, "Salvation Is the Issue," 117.

26. Beavers interview.

27. Beavers interview.

28. Beavers interview.

29. Beavers interview.

30. Howe, *The Politics of Women's Studies*, 204.

31. Nell Irvin Painter, letter to Nellie Y. McKay, 6 May 1990, Box 87, Nell Irvin Painter Papers, Nellie Y. McKay Subseries, DRBML.

32. Nellie Y. McKay, letter to Nell Irvin Painter, 13 May 1990, Box 87, Nell Irvin Painter Papers, Nellie Y. McKay Subseries, DRBML.

33. Beauboeuf-Lafontant, Erickson and Thomas, "Rethinking Post-Tenure Malaise," 644–645.

34. Andrews, "The Debt I Owe Nellie," 24.

35. Friedman interview.

36. Friedman interview.

37. Friedman interview.

38. Friedman interview.

39. Langer interview.

40. Langer interview.

41. Gaines interview.

42. Gaines interview.

43. Gaines interview.

44. Gaines interview.

45. Gaines interview.

46. Gaines interview.

47. Pickens, "Feeling Embodied and Being Displaced," 69.

48. Gaines interview.

49. Nellie Y. McKay, memo to H. Bucher, 1 March 1979, Box 10, Folder 6, Nellie Y. McKay Papers, UWARM.

50. Nellie Y. McKay, letter to Office of Youth Programs, National Endowment for the Humanities, 14 April 1980, Box 10, Folder 6, Nellie Y. McKay Papers, UWARM.

51. Nellie Y. McKay, letter to Ralph W. Johnson, 26 October 1982, Box 10, Folder 6, Nellie Y. McKay Papers, UWARM.

52. Auerbach, untitled essay, 30.

53. Blanche H. Gelfant, Florence Howe, and Nellie Y. McKay, "Being Poor," *What's the Word?*, 1998, Box 1, Folder 9, Nellie Y. McKay Papers, UWARM.

54. UW Odyssey Project, "About."

55. "College Days 2003 Brochure," Box 8, Folder 1, Nellie Y. McKay Papers, UWARM.

56. "College Days: 6/7/01," Box 7, Folder 26, Nellie Y. McKay Papers, UW-Madison; "College Days: June 4, 2003," Box 7, Folder 26, Nellie Y. McKay Papers, UWARM.

57. Bonnie Hutchins, letter to Nellie Y. McKay, 18 June 2003, Box 8, Folder 1, Nellie Y. McKay Papers, UWARM.

58. McKay, "Naming the Problem," 363.

59. Christian, "But What Do We Think We're Doing Anyway," 59.

60. Meyer, "Faulty Analogies," 124.

61. See the Toni Morrison Society's description of its Bench by the Road Project, https://www.tonimorrisonsociety.org/bench.html.

62. Denard interview.

63. Denard interview.

64. Denard interview.

65. Denard, untitled essay, 62.

66. Toni Morrison Society, "Society History."

67. "Society History."

68. Denard interview.

69. Painter quoted in Priest, "Salvation Is the Issue," 120.

70. Priest, "Salvation Is the Issue," 118.

71. Priest, 117–118.

72. Priest, 116.

73. Gumbs, *Spill*, xii.

74. Spillers, "'Whatcha Gonna Do?,'" 308.

75. Nellie Y. McKay, fax to Percy Hintzen for Barbara T. Christian, 19 April 2000, Box 8, Folder 17, Nellie Y. McKay Papers, UWARM.

76. Gordon interview.

77. Zimmerman interview.

78. Zimmerman interview.

79. Zimmerman interview.

80. Johnson interview.

81. Lisa Cappelli, email to Shanna G. Benjamin, 2 July 2020, in possession of Shanna G. Benjamin.

82. Cappelli, email to Benjamin, 2 July 2020.

83. Cappelli, email to Benjamin, 2 July 2020.

84. Cappelli, email to Benjamin, 2 July 2020.

85. Cappelli, email to Benjamin, 2 July 2020.

86. Cappelli, email to Benjamin, 2 July 2020.

87. Cappelli, email to Benjamin, 2 July 2020.

88. Cappelli, email to Benjamin, 2 July 2020.

89. Cappelli, email to Benjamin, 2 July 2020.

90. Cappelli, email to Benjamin, 2 July 2020.

91. Cappelli, email to Benjamin, 2 July 2020.

92. Certain interview.

93. Gordon interview.

94. As cited in Blockett and Rutledge, introduction, 39.

95. Blockett and Rutledge, 39.

96. Bernstein interview.

97. James interview.

98. James interview.

99. Werner interview.

100. Cappelli, email to Benjamin, 2 July 2020.

101. Cappelli, email to Benjamin, 2 July 2020.

102. Cappelli, email to Benjamin, 2 July 2020.

103. Cappelli, email to Benjamin, 2 July 2020.

104. Foster interview.

105. Foster interview.

106. Blockett interview.

107. Blockett interview.

108. Blockett interview.

109. Blockett interview.

110. Blockett interview.

111. Blockett interview.

112. Blockett interview.

113. Blockett interview.

114. Gaines interview.

115. Gaines interview.

116. Bernstein interview.

117. Patricia M. Watson interview.

118. Bernstein interview.

119. Bernstein interview.

120. Patricia M. Watson in discussion with Shanna G. Benjamin, 9 January 2010.

121. Foster interview.

122. Foster interview.

123. Foster interview.

124. Foster interview.

125. Foster interview.

126. Gordon interview.

127. Cappelli, email to Benjamin, 2 July 2020.

128. Cappelli, email to Benjamin, 2 July 2020.

129. Foster interview.

130. Patricia M. Watson interview.

131. Patricia M. Watson interview.

132. Miriam J. Petty-Adams, email to undisclosed recipients, 23 January 2006, in possession of Shanna G. Benjamin.

133. Wendell P. Russell Jr., email to Rutgers Business School and "black_list" listserve, 24 January 2006, in possession of Shanna G. Benjamin.

134. Scott interview.

135. Scott interview.

136. Scott interview.

137. James interview.

138. James interview.

139. Benjamin, "Breaking the Whole Thing Open," 1678.

140. Scott interview.

141. Nell Irvin Painter, letter to Nellie Y. McKay, 11 May 1990, Box 87, Nell Irvin Painter Papers, Nellie Y. McKay Subseries, DRBML.

142. Nell Irvin Painter, letter to Nellie Y. McKay, 11 May 2005, Box 89, Nell Irvin Painter Papers, Nellie Y. McKay Subseries, DRBML.

143. Painter, letter to McKay, 11 May 2005.

144. Painter, letter to McKay, 11 May 2005.

145. Foster, "Professing the McKay Way," 9.

146. Brandt interview.

147. Brandt interview.

148. Keisha Watson interview.

149. Keisha Watson interview.

150. McKay interview.

151. Keisha Watson interview.

152. Sherrard-Johnson, untitled essay, 55.

153. In the *African American Review*'s memorial tribute to McKay, thirty-three colleagues and former students wrote reflections on what McKay's mentoring meant to them.

154. Johnson interview.

155. Johnson interview.

156. Johnson interview.

157. Johnson interview.

158. Johnson interview.

159. Krueger, "Lakeshore Dorm Kicks Off Year with Fresh Name."

160. Krueger, "Lakeshore Dorm Kicks Off Year with Fresh Name."

161. "Nellie Y. McKay Lecture in the Humanities."

162. "Global Black Literatures at UW."

163. "Global Black Literatures at UW."

164. Department of Afro-American Studies, "Brittney Edmonds."

165. Gates and Smith, *Norton Anthology of African American Literature*, xxix.

166. Julia Reidhead, email to Shanna G. Benjamin, 4 April 2014, in possession of Shanna G. Benjamin.

167. Narrative draft for "An Interpretive History of African American Literature," Box 8, Folder 21, Nellie Y. McKay Papers, UWARM.

168. Lorde, *The Cancer Journals*, 17.

Bibliography

Manuscript and Archival Collections

Atlanta, GA
 Spelman College Archives, Spelman College
 Speeches: Ms. Toni Morrison, Commencement 1978
Cambridge, MA
 MIT Office of the Provost, Massachusetts Institute of Technology
 MIT Black History Project, https://www.blackhistory.mit.edu/archive
 Schlesinger Library, Radcliffe Institute, Harvard University
 Papers of Gerda Lerner, 1924–2006
Durham, NC
 David M. Rubenstein Rare Book & Manuscript Library, Duke University
 Nell Irvin Painter Papers, 1793–2016
 Correspondence Series, 1862–2008, Nellie Y. McKay Subseries
Lehi, UT
 Ancestry.com
Madison, WI
 UW Archives and Records Management, University of Wisconsin–Madison
 Nellie Y. McKay Papers, 1975–2004
New Haven, CT
 Beinecke Rare Book and Manuscript Library, Yale University
 James Weldon Johnson Memorial Collection
 Digital Collections
New York, NY
 Municipal Archives of the City of New York
 Genealogy
Queens, NY
 Department of Special Collections & Archives, Queens College
 Campus Unrest Collection, 1969–1970 https://archives.qc.cuny.edu/civilrights/

Books, Articles, and Dissertations

"About the Park." The Friends of Hoyt Park, Inc. Accessed 2 July 2020. http://www
 .hoytpark.org/park.html.
Alexander, Elizabeth. *The Black Interior*. Minneapolis: Graywolf Press, 2004.
"Alumnus Funds Million-Dollar Scholarship in Honor of Beloved Professor." *Queens:
 The Magazine of Queens College* (Fall 2013). http://digital.qc.cuny.edu/i/191277-queens
 -magazine-fall2013/9?m4=.

Andrews, William L. "The Debt I Owe Nellie." In "In Memoriam: Professor Nellie Y. McKay (1930–2006)." *African American Review* 40, no. 1 (Spring 2006): 22–24.

"Anna Julia Cooper." In *Words of Fire: An Anthology of African-American Feminist Thought,* edited by Beverly Guy-Sheftall, 43. New York: New Press, 1995.

"Announcing the Global Black Studies Funding Initiative." University of Wisconsin–Madison, 5 December 2017. https://english.wisc.edu/2017/12/05/announcing-the-global-black-studies-fundraising-initiative/.

Arner, Lynn. "Up against the Great Traditions: The Career of Sheila Delany." *Exemplaria* 19, no. 1 (13 July 2007): 1–15. doi:10.1179/175330707x203165.

Auerbach, Emily. Untitled essay. In "In Memoriam: Professor Nellie Y. McKay (1930–2006)." *African American Review* 40, no. 1 (Spring 2006): 30.

"Babies Hospital Historical Collection, 1887–1994: Biographical Note." Columbia University Libraries Archival Collections. Accessed 10 December 2019. http://www.columbia.edu/cu/lweb/archival/collections/ldpd_6455637/.

Bailey, Moya, and Trudy. "On Misogynoir: Citation, Erasure, and Plagiarism." *Feminist Media Studies* 18, no. 4 (2018): 762–768. doi:10.1080/14680777.2018.1447395.

Baker, Houston A., Jr. "Presidential Address 1992: Local Pedagogy; Or, How I Redeemed My Spring Semester." *PMLA* 108, no. 3 (May 1993): 400–409. doi:10.2307/462610.

Barber, Virginia. "The Women's Revolt in the MLA." *Change* 4, no. 3 (April 1972): 24–27. doi:10.1080/00091383.1972.10568129.

"Barry K. Wade, Editor, 41." *New York Times,* 11 March 1993. http://www.nytimes.com/1993/03/11/obituaries/barry-k-wade-editor-41.html.

Bay, Mia E., Farah J. Griffin, Martha S. Jones, and Barbara D. Savage. *Toward an Intellectual History of Black Women.* Chapel Hill: University of North Carolina Press, 2015.

Beauboeuf-Lafontant, Tamara, Karla A. Erickson, and Jan E. Thomas. "Rethinking Post-Tenure Malaise: An Interactional, Pathways Approach to Understanding the Post-Tenure Period." *Journal of Higher Education* 90, no. 4 (2019): 644–664. doi:10.1080/00221546.2018.1554397.

Begley, Adam. "Black Studies' New Star: Henry Louis Gates Jr." *New York Times,* 1 April 1990. https://www.nytimes.com/1990/04/01/magazine/black-studies-new-star-henry-louis-gates-jr.html.

Benjamin, Shanna Greene. "Black Women and the Biographical Method: Undergraduate Research and Life Writing." *a/b: Auto/Biography Studies* 32, no. 1 (2017): 15–26. doi:10.1080/08989575.2017.1240397.

———. "Breaking the Whole Thing Open: An Interview with Nellie Y. McKay." *PMLA* 121, no. 5 (October 2006): 1678–1681. doi:10.1632/pmla.2006.121.5.1678.

———. "Intimacy and Ephemera: In Search of Our Mother's Letters." *MELUS: Multi-Ethnic Literature of the U.S.* 40, no. 3 (Fall 2015): 16–27. https://muse.jhu.edu/article/593050.

———. "There's Something about Mary: Female Wisdom and the Folk Presence in Ralph Ellison's *Invisible Man.*" *Meridians* 12, no. 1 (2014): 121–148. doi:10.2979/meridians.12.1.121.

"Bennett Brothers: History." Bennett Brothers, Inc. Accessed 5 June 2008. http:// www.bennettbrothers.com/aboutus/history.aspx (site discontinued).

Bethel, Lorraine, and Barbara Smith. Introduction to *Conditions: Five, The Black Women's Issue* (November 1979): 11–15.

"Black Women in the Academy Conference: Panel with Angela Davis, 1994." MIT Black History. Accessed 23 June 2020. https://www.blackhistory.mit.edu/archive/ black-women-academy-conference-panel-angela-davis-1994.

Blockett, Kimberly, and Gregory Rutledge. Introduction to "'The Nellie Tree,' or, Disbanding the Wheatley Court." In "In Memoriam: Professor Nellie Y. McKay (1930–2006)." *African American Review* 40, no. 1 (Spring 2006): 39–66.

Brooks, Gwendolyn. "the children of the poor." In *Selected Poems* (1963), 53. New York: Harper Perennial/Modern Classics, 2006.

———. "kitchenette building." In *Selected Poems* (1963), 3. New York: Harper Perennial/Modern Classics, 2006.

Brooks, Susannah. "H. Edwin Young, Former Chancellor, Dies at 94." *University of Wisconsin News*, 3 January 2012. https://news.wisc.edu/h-edwin-young-former -chancellor-dies-at-94/.

Campbell, James T. *Middle Passages: African American Journeys to Africa, 1787–2005*. New York: Penguin, 2006.

Christian, Barbara T. "Being the Subject and the Object: Reading African-American Women's Novels" (1993). In *New Black Feminist Criticism, 1985–2000*, edited by Gloria Bowles, M. Giulia Fabi, and Arlene R. Keizer, 120–126. Urbana: University of Illinois Press, 2007.

———. "But What Do We Think We're Doing Anyway: The State of Black Feminist Criticism(s) or My Version of a Little Bit of History." In *Changing Our Own Words: Essays on Criticism, Theory, and Writing by Black Women*, edited by Cheryl A. Wall, 58–74. New Brunswick, NJ: Rutgers University Press, 1989.

———. "The Race for Theory." *Cultural Critique*, no. 6 (Spring 1987): 51–63. https://www.jstor.org/stable/1354255.

"Chronicle Data: Submitted Adjunct Salaries per Course." Chronicle Data. Accessed 16 June 2018. https://data.chronicle.com/category/ccbasic/21/adjunct -salaries/.

"The Combahee Ferry Raid." National Museum of African American History & Culture. Accessed 9 September 2020. https://nmaahc.si.edu/blog/combahee -ferry-raid.

The Combahee River Collective. *The Combahee River Collective Statement: Black Feminist Organizing in the Seventies and Eighties*. Albany, NY: Kitchen Table: Women of Color Press, 1986.

"Contemporary Literature." University of Wisconsin Press, Journals Division. Accessed 13 December 2019. https://uwpress.wisc.edu/journals/journals/cl.html.

Cooper, Brittney C. *Beyond Respectability: The Intellectual Thought of Race Women*. Urbana: University of Illinois Press, 2017.

Davidoff, Judith. "Nellie McKay: Canon Blast." *Isthmus: The Weekly Newspaper of Madison*, 31 January 1997. https://isthmus.com/archive/from-the-archives/nellie -mckay-canon-blast/.

Day, Warren, ed. *Association of Concerned Africa Scholars Bulletin* 21 (Fall 1987): 33.
kora.matrix.msu.edu/files/50/304/32-130-1EAA-84-ACAS%20Bulletin%20Fall%20
87%20opt.pdf.

"Delegate Assembly." Modern Language Association. Accessed 2 July 2020. https://
www.mla.org/About-Us/Governance/Delegate-Assembly.

De los Reyes, Gastón. "University Hall, 1969, Is Revisited." *Harvard Crimson*,
4 September 1999. https://www.thecrimson.com/article/1999/9/4/university
-hall-1969-is-revisited-ptwenty-five.

Denard, Carolyn. Untitled essay in "'The Nellie Tree,' or, Disbanding the Wheatley
Court." In "In Memoriam: Professor Nellie Y. McKay (1930–2006)." *African
American Review* 40, no. 1 (2006): 62–63.

Department of Afro-American Studies. "Brittney Edmonds." College of Letters &
Science. Accessed 22 October 2020. https://afroamericanstudies.wisc.edu/staff
/edmonds-brittney/.

De Veaux, Alexis. *Warrior Poet: A Biography of Audre Lorde*. New York: Norton, 2004.

Diep, Francie. "'I Was Fed Up': How #BlackInTheIvory Got Started, and What Its
Founders Want to See Next." *Chronicle of Higher Education*. 9 June 2020. https://
www.chronicle.com/article/I-Was-Fed-Up-How/248955.

"Dr. Entrepreneur." *Black Issues in Higher Education* 15, no. 25 (February 4, 1999).
https://diverseeducation.com/article/52/.

duCille, Ann. "The Occult of True Black Womanhood: Critical Demeanor and Black
Feminist Studies." *Signs* 19, no. 3 (Spring 1994): 591–629. https://www.jstor.org
/stable/3174771.

"Editorial and Publisher's Announcements." *Colored American Magazine* 1, no. 3
(August 1900). James Weldon Johnson Memorial Collection in the Yale Collection
of American Literature, Beinecke Rare Book and Manuscript Library. http://
coloredamerican.org/?page_id=687.

Edwards, Erica R. *Charisma and the Fictions of Black Leadership*. Minneapolis:
University of Minnesota Press, 2012.

Ellison, Ralph. "Out of the Hospital and under the Bar." In *Soon, One Morning:
New Writing by American Negroes*, edited by Herbert Hill, 242–290. New York:
Knopf, 1963.

"Emerita: A Fond Farewell to Susan Bernstein." University of Wisconsin–Madison.
5 December 2017. https://english.wisc.edu/2017/12/05/emerita-a-fond-farewell
-to-susan-bernstein/.

Evans, Stephanie Y. *Black Women in the Ivory Tower, 1850–1954: An Intellectual
History*. Gainesville: University Press of Florida, 2007.

Foer, Franklin. "Henry Louis Gates Jr." *Slate*, 12 April 1998. https://slate.com/news
-and-politics/1998/04/henry-louis-gates-jr.html.

Foreman, P. Gabrielle. "A Riff, a Call, and a Response: Reframing the Problem That
Led to Our Being Tokens in Ethnic and Gender Studies; or, Where Are We Going
Anyway and with Whom Will We Travel?" *Legacy* 30, no. 2 (2013): 306–322.
doi:10.5250/legacy.30.2.0306.

Foster, Frances Smith. "Professing the McKay Way." In "In Memoriam: Professor
Nellie Y. McKay (1930–2006)." *African American Review* 40, no. 1 (Spring 2006): 6–9.

"Frank E. Irvin." Nell Irvin Painter. Accessed 4 June 2018. https://www.nellpainter
.com/assests/pdfs/frank2004.pdf.

Freire, Paulo. *Pedagogy of the Oppressed: 30th Anniversary Edition* (1968). New York:
Bloomsbury, 2000.

Friedman, Susan Stanford. "Nellie's Laughing." In "In Memoriam: Professor
Nellie Y. McKay (1930–2006)." *African American Review* 40, no. 1 (Spring 2006):
25–28.

Gates, Henry Louis, Jr. "Canon-Formation and the Afro-American Tradition." In
Afro-American Literary Study in the 1990s, edited by Houston A. Baker Jr. and
Patricia Redmond, 14–50. Chicago: University of Chicago Press, 1989.

Gates, Henry Louis, Jr., and Nellie Y. McKay. Preface to *The Norton Anthology of
African American Literature*, 1st ed., edited by Henry Louis Gates Jr. and Nellie Y.
McKay, xxvii–xli. New York: Norton, 1997.

———. Preface to *The Norton Anthology of African American Literature*, 2nd ed., edited
by Henry Louis Gates Jr. and Nellie Y. McKay, xxix–xxxiii. New York: Norton, 2004.

Gates, Henry Louis, Jr., and Valerie Smith, eds. *The Norton Anthology of African
American Literature*, 3rd ed. New York: Norton, 2014.

"Global Black Literatures at UW." University of Wisconsin–Madison, 17 May 2019.
https://english.wisc.edu/2019/05/17/global-black-literatures-at-uw/.

Graham, Maryemma. "Black Is Gold: African American Literature, Critical Literacy,
and Twenty-First Century Pedagogies." In *Contemporary African American
Literature: The Living Canon*, edited by Lovalerie King and Shirley Moody-Turner,
55–90. Bloomington: Indiana University Press, 2013.

———. "Review of *Jean Toomer, Artist: A Study of His Literary Life and Work, 1894–1936*."
Black American Literature Forum 19, no. 2 (Summer 1985): 91–93.

Gray, Stephen. "An Interview with Nadine Gordimer." *Contemporary Literature* 22,
no. 3 (Summer 1981): 263–271.

Green, Elon. "Annotation Tuesday! Rachel Kaadzi Ghansah and 'If He Hollers Let Him
Go.'" Nieman Storyboard (7 October 2014). https://niemanstoryboard.org/stories
/annotation-tuesday-rachel-kaadzi-ghansah-and-if-he-hollers-let-him-go/.

Griffin, Farah Jasmine. Introduction to *Beloved Sisters and Loving Friends: Letters from
Rebecca Primus of Royal Oak, Maryland, and Addie Brown of Hartford, Connecticut,
1854–1868*, edited by Farrah Jasmine Griffin, 3–7. New York: Knopf, 1999.

———. "That the Mothers May Soar and the Daughters May Know Their Names:
A Retrospective of Black Feminist Criticism." *Signs* 32, no. 2 (2007): 483–507.

———. "Thirty Years of Black American Literature and Literary Studies: A Review."
Journal of Black Studies 35, no. 2 (November 2004): 165–174. doi:10.1177/002193
4704266722.

Gruen, Dietrich. "Nellie Y. McKay." In *Contemporary Black Biography: Profiles from the
International Black Community* Vol. 17, edited by Shirelle Phelps, 123–125. Detroit,
MI: Gale, 1998.

Gumbs, Alexis Pauline. "Nobody Mean More: Black Feminist Pedagogy and
Solidarity." In *The Imperial University: Academic Repression and Scholarly Dissent*,
edited by Piya Chatterjee and Sunaina Maira, 237–260. Minneapolis: University of
Minnesota Press, 2014.

———. *Spill: Scenes of Black Feminist Fugitivity*. Durham, NC: Duke University Press, 2016.

Guy-Sheftall, Beverly. ed. *Words of Fire: An Anthology of African-American Feminist Thought*. New York: New Press, 1995.

Harris, Duchess. *Black Feminist Politics from Kennedy to Trump*. Minneapolis: Palgrave Macmillan, 2019.

Hine, Darlene Clark. "Rape and the Inner Lives of Black Women in the Middle West." *Signs* 14, no. 4 (Summer 1989): 912–920. https://www.jstor.org/stable/3174692.

Hoff, Joan. *Law, Gender, and Injustice: A Legal History of U.S. Women*. New York: New York University Press, 1991.

Hollis Presbyterian Church. "1922–2007: A History of the Church and the Community." Pamphlet. Hollis, NY: Hollis Presbyterian Church, 2007.

Hopkins, Pauline. "Famous Women of the Negro Race: III. Harriet Tubman ('Moses')." *Colored American Magazine* 4, no. 3 (January–February 1902). James Weldon Johnson Memorial Collection in the Yale Collection of American Literature, Beinecke Rare Book and Manuscript Library. http://coloredamerican .org/wp-content/uploads/2017/07/CAM_4.3_1902.0102.pdf.

Howe, Florence, ed. *The Politics of Women's Studies: Testimony from 30 Founding Mothers*. New York: Feminist Press, 2000.

———. "Tribute for Nellie McKay." In "In Memoriam: Professor Nellie Y. McKay (1930–2006)." *African American Review* 40, no. 1 (Spring 2006): 12–17.

Hubbard, Dolan. Preface to *Praisesong of Survival: Lectures and Essays, 1957–89*, by Richard K. Barksdale, ix–xiii. Urbana: University of Illinois Press, 1992.

Hurston, Zora Neale. *Their Eyes Were Watching God* (1937). New York: Perennial Classics, 1998.

"The Irvin Family." Nell Irvin Painter. Accessed 4 June 2018. https://www.nellpainter .com/family.html.

Jackson, Lawrence P. *The Indignant Generation: A Narrative History of African American Writers and Critics, 1934–1960*. Princeton, NJ: Princeton University Press, 2011.

Jacobs, Harriet. *Incidents in the Life of a Slave Girl*. Edited by Nellie Y. McKay and Frances Smith Foster. Norton Critical Edition, 1st ed. New York: Norton, 2001.

James, Stanlie M., Frances Smith Foster, and Beverly Guy-Sheftall. Introduction to *Still Brave: The Evolution of Black Women's Studies*, edited by Stanlie M. James, Frances Smith Foster, and Beverly Guy-Sheftall, xi–xxvii. New York: Feminist Press, 2009.

Jenkins, Candice M. "Queering Black Patriarchy: The Salvific Wish and Masculine Possibility in Alice Walker's 'The Color Purple.'" *Modern Fiction Studies* 48, no. 4 (Winter 2002): 969–1000. https://www.jstor.org/stable/26286256.

"John Benedict, 57, an Editor of Poetry and of Anthologies." *New York Times*, 25 July 1990. https://www.nytimes.com/1990/07/25/obituaries/john-benedict-57-an -editor-of-poetry-and-of-anthologies.html.

"John J. McDermott: Distinguished Professor." Texas A&M University. Accessed 6 June 2018. https://philosophy.tamu.edu/people/john-j-mcdermott.

Johnson, James Weldon. *The Book of American Negro Poetry*. New York: Harcourt, Brace and Company, 1922.

Jones, Jacqueline. *Labor of Love, Labor of Sorrow: Black Women, Work, and the Family, from Slavery to the Present* (1985). New York: Basic Books, 2010.

Jones, Meta. *The Muse Is Music: Jazz Poetry from the Harlem Renaissance to Spoken Word*. Urbana: University of Illinois Press, 2011.

Jordan, June. *Soulscript: A Collection of Classic African American Poetry*. New York: Doubleday, 1970.

Kasinitz, Philip. *Caribbean New York: Black Immigrants and the Politics of Race*. Ithaca: Cornell University Press, 1992.

Kennedy, Randall. "Introduction: Blacks and the Race Question at Harvard." In *Blacks at Harvard: A Documentary History of African-American Experience at Harvard and Radcliffe*, edited by Werner Sollors, Caldwell Titcomb, and Thomas A. Underwood, xvii–xxxiv. New York: New York University Press, 1993.

Kinnamon, Keneth. "Anthologies of African-American Literature from 1845 to 1994." *Callaloo* 20, no. 2 (Spring 1997): 461–481. https://www.jstor.org/stable/3299277.

Krueger, Katherine. "Lakeshore Dorm Kicks Off Year with Fresh Name." *Badger Herald* (Madison, WI), 30 August 2011. https://badgerherald.com/news/2011/08/30/lakeshore-dorm-kicks/.

Lorde, Audre. *The Cancer Journals*. San Francisco: Spinsters/Aunt Lute Books, 1980.

———. *Zami: A New Spelling of My Name: A Biomythography*. Berkeley: Crossing Press, 1982.

Magner, Denise K. "Henry Louis Gates Is off to Harvard a Year after Joining Duke's Faculty." *Chronicle of Higher Education*, 13 February 1991. https://www.chronicle.com/article/Henry-Louis-Gates-Is-Off-to/89235.

"Marcus Garvey Park." New York City Department of Parks & Recreation. Accessed 30 October 2019. https://www.nycgovparks.org/parks/marcus-garvey-park/history.

Marquard, Bryan. "William J. Holmes, 86; Former College President." *Boston Globe*, 21 February 2014. https://www.bostonglobe.com/metro/2014/02/21/william-holmes-duxbury-his-year-tenure-simmons-college-president-was-second-longest-school-history/z1cdhXfnQyUvhn2eezEjbL/story.html.

Marshall, Paule. "From the Poets in the Kitchen." *Callaloo* 24, no. 2 (Spring 2001): 627–633. https://www.jstor.org/stable/3300541.

Martin, Douglas. "Percy E. Sutton, Political Trailblazer, Dies at 89." *New York Times*, 27 December 2009. http://www.nytimes.com/2009/12/28/nyregion/28sutton.html?pagewanted=all&_r=0.

McDowell, Deborah E. "Black Women Writers." *New York Times*, 20 July 1986. https://timesmachine.nytimes.com/timesmachine/1986/07/20/839986.html?pageNumber=70.

McKay, Nellie Y. "Black Woman Professor—White University." *Women's Studies International Forum* 6, no. 2 (1983): 143–147. doi:10.1016/0277-5395(83)90004-3.

———. "Charting a Personal Journey: A Road to Women's Studies." In *The Politics of Women's Studies: Testimony from 30 Founding Mothers*, edited by Florence Howe, 204–215. New York: Feminist Press, 2000.

———. "The Girls Who Became the Women: Childhood Memories in the Autobiographies of Harriet Jacobs, Mary Church Terrell, and Anne Moody." In

Tradition and the Talents of Women, edited by Florence Howe, 105–124. Urbana: University of Illinois Press, 1991.

———. Introduction to *The Third Door*, by Ellen Tarry, ix–xxvi. Tuscaloosa: University of Alabama Press, 1992.

———. *Jean Toomer, Artist: A Study of His Literary Life and Work, 1894–1936*. Chapel Hill: University of North Carolina Press, 1984.

———. "A Love for the Life: An Interview with Nellie McKay." Interview by Donald E. Hall. In *Professions: Conversations on the Future of Literary and Cultural Studies*, edited by Donald E. Hall, 264–276. Urbana: University of Illinois Press, 2001.

———. "Naming the Problem That Led to the Question 'Who Shall Teach African American Literature?'; Or, Are We Ready to Disband the Wheatley Court?" *PMLA* 113, no. 3 (1998): 359–369. https://www.jstor.org/stable/463345.

———. "Race, Gender, and Cultural Context in Zora Neale Hurston's Dust Tracks on a Road." In *Life/Lines: Theorizing Women's Autobiography*, edited by Bella Brodzki and Celeste Schenck, 175–188. Ithaca, NY: Cornell University Press, 1988.

———. "Remembering Anita Hill and Clarence Thomas: What Really Happened When One Black Woman Spoke Out." In *Race-ing Justice, En-gendering Power: Essays on Anita Hill, Clarence Thomas, and the Construction of Social Reality*, edited by Toni Morrison, 269–289. New York: Pantheon Books, 1992.

———. "Response to 'Biography and Afro-American Culture.'" In *Afro-American Literary Study in the 1990s*, edited by Houston A. Baker Jr. and Patricia Redmond, 214–219. Chicago: University of Chicago Press, 1989.

———. "A Troubled Peace: Black Women in the Halls of the White Academy." In *Black Women in the Academy: Promises and Perils*, edited by Lois Benjamin, 11–22. Gainesville: University Press of Florida, 1997.

McKay, Nellie Y., and Frances Smith Foster. "A Collective Experience: Academics Working and Learning Together." *Profession* (2001): 16–23. https://www.jstor.org/stable/25607179.

———. Introduction to *Incidents in the Life of a Slave Girl*, by Harriet Jacobs, ix–xxiii. Edited by Nellie Y. McKay and Frances Smith Foster. New York: Norton, 2001.

McKay, Nellie Y., Norman N. Holland, Arthur Ramirez, Axel Nissen, Jane Gallop, Angelika Bammer, Deborah Tannen, et al. "The Inevitability of the Personal." *PMLA* 111, no. 5 (October 1996): 1146–1160. https://www.jstor.org/stable/463156.

McMurray, Joseph P. "Statement by President Joseph P. McMurray." 1 April 1969. Campus Unrest Collection, QCDSCA. https://archives.qc.cuny.edu/civilrights/items/show/312.

Meyer, Sabine. "Faulty Analogies: Queer White Critics Teaching African American Texts." In *White Scholars/African American Texts*, edited by Lisa A. Long, 123–133. New Brunswick, NJ: Rutgers University Press, 2005.

Modern Language Association. "Program of the Ninety-Fifth Annual Convention of the Modern Language Association of America." *PMLA* 95, no. 6 (1980): 939–1056. https://www.jstor.org/stable/461742.

Moraga, Cherríe. "Comment on Stetson's Review of 'The Black Women's Issue, Conditions: 5.'" *Signs* 7, no. 3 (Spring 1982): 727–729. https://www.jstor.org/stable/3173870.

Morrison, Toni. "Home." In *The House That Race Built: Original Essays by Toni Morrison, Angela Y. Davis, Cornel West, and others on Black Americans and Politics in America Today*, edited by Wahneema Lubiano, 3–12. New York: Vintage Books, 1998.

———. Introduction to *Race-ing Justice, En-gendering Power: Essays on Anita Hill, Clarence Thomas, and the Construction of Social Reality*, edited by Toni Morrison, vii–xxx. New York: Pantheon Books, 1992.

———. Review of *To Be a Black Woman: Portraits in Fact and Fiction*, edited by Mel Watkins and Jay David (New York: Morrow, 1971). *New York Times*, 28 March 1971. https://timesmachine.nytimes.com/timesmachine/1971/03/28/91277118.html ?pageNumber=132.

———. "Rootedness: The Ancestor as Foundation." In *Black Women Writers, 1950–1980: A Critical Evaluation*, edited by Mari Evans, 339–345. New York: Doubleday, 1984.

———. "The Site of Memory." In *Inventing the Truth: The Art and Craft of Memoir*, 2nd ed., edited by William Zinsser, 83–102. New York: Houghton Mifflin, 1995.

———. *Sula*. 1973. New York: Vintage Books, 2004.

———. "What the Black Woman Thinks about Women's Lib." *New York Times*, 22 August 1971. https://www.nytimes.com/1971/08/22/archives/what-the-black -woman-thinks-about-womens-lib-the-black-woman-and.html.

"Negro Chosen Head of SEEK Program at Queens College." *New York Times*, 4 September 1969. https://www.nytimes.com/1969/09/04/archives/negro-chosen -head-of-seek-program-at-queens-college.html.

"Nellie Y. McKay Lecture in the Humanities." University of Wisconsin–Madison Institute for Research in the Humanities. Accessed 18 December 2019. https://irh .wisc.edu/nellie-y-mckay-lecture-in-the-humanities/.

New, Michael J. "Panther Teacher: Sarah Webster Fabio's Black Power," *Meridians* 17, no. 1 (September 2018): 51–81. https://muse.jhu.edu/article/706742.

"Obituary for Dona L. Irvin (1917–2009): Celebrating the Years, Redefining Older Age!" Accessed 4 June 2018. https://www.donairvin.com/dona/obituary.html.

"Our Mission & History." Simmons University. Accessed 23 November 2019. https://www.simmons.edu/about/our-mission-history.

"Our Story." Center for Patient Partnerships. Accessed 13 June 2020. https:// patientpartnerships.wisc.edu/about/.

Painter, Nell Irvin. "Hill, Thomas, and the Use of Racial Stereotype." In *Race-ing Justice, En-gendering Power: Essays on Anita Hill, Clarence Thomas, and the Construction of Social Reality*, edited by Toni Morrison, 200–214. New York: Pantheon Books, 1992.

———. "The Praxis of a Life of Scholarship: Three Nellie McKay Letters from 1995." In "In Memoriam: Professor Nellie Y. McKay (1930–2006)." *African American Review* 40, no. 1 (Spring 2006): 9–12.

Palmore, Joseph R. "Afro-Am Offers Post to Literary Scholar." *Harvard Crimson*, 13 March 1989.

Pemberton, Gayle. "Black Women Writers." *New York Times*, 27 July 1986. https:// timesmachine.nytimes.com/timesmachine/1986/07/27/375486.html ?pageNumber=64.

Perry, Imani. *Looking for Lorraine: The Radiant and Radical Life of Lorraine Hansberry*. Boston: Beacon Press, 2018.

Peterson, Jon. "Descriptive Summary." Campus Unrest Collection, QCDSCA. Accessed 27 January 2016. http://archives.qc.cuny.edu/finding_aids /CampusUnrest.

———. "Historical Note." Campus Unrest Collection, QCDSCA. Accessed 27 January 2016. http://archives.qc.cuny.edu/finding_aids/CampusUnrest.

Pickens, Therí. "Feeling Embodied and Being Displaced: A Phenomenological Exploration of Hospital Scenes in Rabih Alameddine's Fiction." *MELUS: Multi-Ethnic Literature of the U.S.* 38, no. 3 (Fall 2013): 67–85. https://muse.jhu.edu /article/520524.

"Preston N. Williams." Harvard Divinity School Faculty Directory, Harvard Divinity School. Accessed 8 June 2018. https://hds.harvard.edu/people/preston -n-williams.

Priest, Myisha. "Salvation Is the Issue." *Meridians* 8, no. 2 (2008): 116–122. https:// www.jstor.org/stable/40338754.

"Professors Embrace Black Literature." University of Wisconsin Alumni Association. 18 October 2018. https://www.uwalumni.com/news/english-professors/.

Quashie, Kevin. *The Sovereignty of Quiet: Beyond Resistance in Black Culture*. New Brunswick, NJ: Rutgers University Press, 2012.

"Queens College Dean's Report." 31 March 1969. Campus Unrest Collection, QCDSCA. https://archives.qc.cuny.edu/civilrights/items/show/310.

Queens College Students for a Democratic Society. "The Activist, Vol. 1, No. 1." 14 April 1966. Campus Unrest Collection, QCDSCA. https://archives.qc.cuny.edu /civilrights/items/show/85.

Rambsy, Howard, II. *Bad Men: Creative Touchstones of Black Writers*. Charlottesville: University of Virginia Press, 2020.

———. *The Black Arts Enterprise and the Production of African American Poetry*. Ann Arbor: University of Michigan Press, 2013.

Rampersad, Arnold. "Biography and Afro-American Culture." In *Afro-American Literary Study in the 1990s*, edited by Houston A. Baker Jr. and Patricia Redmond, 194–208. Chicago: University of Chicago Press, 1989.

Ransby, Barbara. *Ella Baker and the Black Freedom Movement: A Radical Democratic Vision*. Chapel Hill: University of North Carolina Press, 2003.

Rich, Adrienne. *On Lies, Secrets, and Silence: Selected Prose*. New York: Norton, 1979.

"Richard Ralston Collects Culture through Stamps." University of Wisconsin–Madison News, 28 April 1997. https://www.news.wisc.edu/richard-ralston -collects-culture-through-stamps/.

Rogers, Ibram H. *The Black Campus Movement: Black Students and the Racial Reconstruction of Higher Education, 1965–1972*. New York: Palgrave MacMillan, 2012.

Rooks, Noliwe M. *White Money/Black Power: The Surprising History of African American Studies and the Crisis of Race in Higher Education*. Boston: Beacon Press, 2006.

Rosenblatt, Roger. *Coming Apart: A Memoir of the Harvard Wars of 1969*. New York: Little, Brown, 1997.

"Samuel Washington Allen, 1917–2015." *Boston Globe*, 4 October 2015. https://www
.legacy.com/obituaries/bostonglobe/obituary.aspx?pid=176004278.

Savage, Barbara D. "Professor Merze Tate: Diplomatic Historian, Cosmopolitan
Woman." In *Toward an Intellectual History of Black Women*, edited by Mia E. Bay,
Farah J. Griffin, Martha S. Jones, and Barbara D. Savage, 252–269. Chapel Hill:
University of North Carolina Press, 2015.

Savonick, Danica. "Insurgent Knowledge: The Poetics and Pedagogy of Toni Cade
Bambara, June Jordan, Audre Lorde, and Adrienne Rich in the Era of Open
Admissions." PhD diss., City University of New York, 2018.

"SEEK Program." City College of New York. Accessed 17 January 2018. https://www
.ccny.cuny.edu/financialaid/seek.

"SEEK Program." Queens College. Accessed 25 January 2016. https://www.qc.cuny
.edu/Academics/SupportPrograms/Seek/Pages/default.aspx.

"SEEK Program: An Educational Opportunity." Campus Unrest Collection, QCDSCA.
Accessed 17 January 2018. https://archives.qc.cuny.edu/civilrights/items/
show/291.

Serkin, Tova A. "The Strike, the Bust, the Memory: Memory of Takeover Still Haunts
Those Students, Faculty Who Saw It Happen." *Harvard Crimson*, 8 June 1999.
https://www.thecrimson.com/article/1999/6/8/the-strike-the-bust-the-memory/.

Sherrard-Johnson, Cherene. Untitled essay in "'The Nellie Tree,' or, Disbanding the
Wheatley Court." In "In Memoriam: Professor Nellie Y. McKay
(1930–2006)."*African American Review* 40, no. 1 (Spring 2006): 55.

Smith, Barbara. "Building Black Women's Studies." In *The Politics of Women's Studies:
Testimony from 30 Founding Mothers*, edited by Florence Howe, 194–203. New York:
Feminist Press, 2000.

———. Foreword to *The Combahee River Collective Statement: Black Feminist
Organizing in the Seventies and Eighties*, by The Combahee River Collective, 3–7.
Albany, NY: Kitchen Table: Women of Color Press, 1986.

———. "A Press of Our Own, Kitchen Table: Women of Color Press." *Frontiers* 10,
no. 3 (1989): 11–13. https://www.jstor.org/stable/3346433.

Southern, Eileen. "A Pioneer: Black and Female." In *Blacks at Harvard: A Documentary
History of African-American Experience at Harvard and Radcliffe*, edited by Werner
Sollors, Caldwell Titcomb, and Thomas A. Underwood, 499–503. New York:
New York University Press, 1993.

Spillers, Hortense J. "Mama's Baby, Papa's Maybe: An American Grammar Book."
Diacritics 17, no. 2 (Summer 1987): 64–81. doi:10.2307/464747.

Spillers, Hortense J., Saidiya V. Hartman, Farah Jasmine Griffin, Shelley Eversley,
and Jennifer L. Morgan. "'Whatcha Gonna Do?': Revisiting 'Mama's Baby, Papa's
Maybe: An American Grammar Book': A Conversation with Hortense Spillers,
Saidiya Hartman, Farah Jasmine Griffin, Shelly Eversley, & Jennifer L. Morgan."
Women's Studies Quarterly 35, no. 1/2 (Spring–Summer 2007): 299–309. https://
www.jstor.org/stable/27649677.

Sreenivasan, Hari, Sam Weber, and Connie Kargbo. "The True Story behind the
'Welfare Queen' Stereotype." *PBS News Hour Weekend*, 1 June 2019. https://www
.pbs.org/newshour/show/the-true-story-behind-the-welfare-queen-stereotype.

"Susan Stanford Friedman." University of Wisconsin–Madison. Accessed 1 July 2020. https://english.wisc.edu/staff/friedman-susan-stanford/.

Taylor, Keeanga-Yamahtta, ed. *How We Get Free: Black Feminism and the Combahee River Collective*. Chicago: Haymarket Books, 2017.

Toni Morrison Society. "Society History." Accessed 25 November 2019. https://www.tonimorrisonsociety.org/society.html.

Traylor, Eleanor W. "Re Calling the Black Woman." In *The Black Woman: An Anthology*, 2nd ed., edited by Toni Cade, ix–xviii. New York: Washington Square Press, 2005.

"University Designation." Simmons University. Accessed 23 November 2019. https://www.simmons.edu/about/our-future/university-designation.

University of Wisconsin–Madison News. "13 Demands: The Black Student Strike of 1969." Accessed 24 November 2019. https://news.wisc.edu/black-student-strike.

"UW-Madison Gives Prof $20,600." *Journal Times* (Racine, WI), 2 September 1990. https://journaltimes.com/news/national/uw-madison-gives-prof-20-600/article_21cd2fa0-2a27-5d66-b348-5ea2c7ff6dea.html.

UW Odyssey Project. "About." University of Wisconsin–Madison. Accessed 12 June 2020. https://odyssey.wisc.edu/about/.

Walker, Alice. "The Divided Life of Jean Toomer." In *In Search of Our Mothers' Gardens*, by Alice Walker, 60–65. New York: Harcourt Brace Jovanovich, 1984.

Walkington, Lori. "How Far Have We Really Come? Black Women Faculty and Graduate Students' Experiences in Higher Education." *Humboldt Journal of Social Relations* 39 (2017): 51–65. https://www.jstor.org/stable/90007871.

Wallace, Maurice. "What Nellie Knew." In "In Memoriam: Professor Nellie Y. McKay (1930–2006)." *African American Review* 40, no. 1 (Spring 2006): 33–35.

Washington, Mary Helen. "'Disturbing the Peace: What Happens to American Studies if You Put African American Studies at the Center?': Presidential Address to the American Studies Association, October 29, 1997." *American Quarterly* 50, no. 1 (March 1998): 1–23. doi:10.1353/aq.1998.0005.

———. Foreword to *Their Eyes Were Watching God*, by Zora Neale Hurston, ix–xvii. New York: Perennial Classics, 1998.

———. *Invented Lives: Narratives of Black Women, 1860–1960*. New York: Anchor Books, 1987.

Waters, Kristin, and Carol B. Conaway, eds. *Black Women's Intellectual Traditions: Speaking Their Minds*. Burlington: University of Vermont Press, 2007.

Watkins, Mel. "Sexism, Racism, and Black Women Writers." *New York Times*, 15 June 1986. https://www.nytimes.com/1986/06/15/books/sexism-racism-and-black-women-writers.html.

Watson, Keisha. Untitled reflection in "In Memoriam: Professor Nellie Y. McKay (1930–2006)." *African American Review* 40, no. 1 (Spring 2006): 52.

Watts, Jenisha. "The Remaining 'Gang of Four' Remember Percy Sutton." *Essence*, 27 December 2009. https://www.essence.com/news/percy-ellis-sutton-gang-of-four-david-paterson-charles-rangel-harlem-basil-paterson/.

Weixlmann, Joe, Houston A. Baker Jr., William L. Andrews, Trudier Harris, Thadious M. Davis, and Jerry W. Ward Jr. "*African American Review* at 40:

A Retrospective." *African American Review* 40, no. 1 (Spring 2007): 5–15. https://www.jstor.org/stable/40033761.

White, Deborah Gray. "Mining the Forgotten: Manuscript Sources for Black Women's History." *Journal of American History* 74, no. 1 (June 1987): 237–242. doi:10.2307/1908622.

———, ed. *Telling Histories: Black Women Historians in the Ivory Tower.* Chapel Hill: University of North Carolina Press, 2008.

"White House Millennium Council: National Medal Winner, Rita Dove." Clinton White House Archives. Accessed 12 October 2020. https://clintonwhitehouse5 .archives.gov/Initiatives/Millennium/capsule/dove.html.

Wilkerson, Isabel. *The Warmth of Other Suns: The Epic Story of America's Great Migration.* New York: Random House, 2010.

Williams, James D. *The State of Black America, 1983.* New York: National Urban League, 1983.

Woolfork, Lisa. "Academic Mothers and Their Feminist Daughters: A Remix." In "In Memoriam: Professor Nellie Y. McKay (1930–2006)." *African American Review* 40, no. 1 (Spring 2006): 35–38.

Wycliff, Don. "Women as Presidents: Shalala Takes Charge At U. of Wisconsin." *New York Times*, 15 August 1990. https://timesmachine.nytimes.com/timesmachine /1990/08/15/095090.html?pageNumber=34.

Young, Kevin. *The Grey Album: On the Blackness of Blackness.* Minneapolis: Graywolf Press, 2012.

Interviews

Andrews, William L. Personal interview by Shanna G. Benjamin. Telephone, 2 May 2013.

Beavers, Herman. Personal interview by Shanna G. Benjamin. Telephone, 12 December 2014.

Bernstein, Susan. Personal interview by Shanna G. Benjamin. Madison, WI, 27 March 2014.

Blockett, Kimberly. Personal interview by Shanna G. Benjamin. Telephone, 23 October 2014.

Brandt, Deborah. Personal interview by Shanna G. Benjamin. Telephone, 5 August 2014.

Bromberg, Pamela. Personal interview by Shanna G. Benjamin. Telephone, 26 June 2015.

Certain, Phillip. Personal interview by Shanna G. Benjamin. Telephone, 4 August 2015.

Denard, Carolyn. Personal interview by Shanna G. Benjamin. Telephone, 8 November 2019.

Fontenot, Chester J. Personal interview by Shanna G. Benjamin. Telephone, 9 October 2019.

Foster, Frances Smith. Personal interview by Shanna G. Benjamin. Telephone, 13 March 2014.

Friedman, Susan Stanford. Personal interview by Shanna G. Benjamin. Telephone, 3 April 2014.

Gaines, Meg. Personal interview by Shanna G. Benjamin. Telephone, 23 January 2020.

Gordon, Linda. Personal interview by Shanna G. Benjamin. Telephone, 16 June 2014.

Guy-Sheftall, Beverly. Personal interview by Shanna G. Benjamin. Washington, DC, 19 October 2019.

Harris, Trudier. Personal interview by Shanna G. Benjamin. Telephone, 21 October 2019.

James, Stanlie M. Personal interview by Shanna G. Benjamin. Telephone, 23 June 2014.

Johnson, Sherry. Personal interview by Shanna G. Benjamin. Telephone, 22 November 2014.

LaCroix, David. Personal interview by Shanna G. Benjamin. Telephone, 6 February 2015.

Langer, Lawrence L. Personal interview by Shanna G. Benjamin. Telephone, 22 June 2015.

McDermott, John J. Personal interview by Shanna G. Benjamin. Telephone, 23 January 2016.

McKay, Harry. Personal interview by Shanna G. Benjamin. Telephone, 18 February 2014.

McKay, Nellie Y. Personal interview by Shanna G. Benjamin. Madison, WI, July 2004.

Mogaka, Fabu. Personal interview by Shanna G. Benjamin. Telephone, 31 October 2014.

Moody, Joycelyn. Personal interview by Shanna G. Benjamin. Telephone, 6 August 2015.

Plows, Robert. Personal interview by Shanna G. Benjamin. Telephone, 18 June 2020.

Pritchard, Erik. Personal interview by Shanna G. Benjamin. Telephone, 23 October 2014.

Rampersad, Arnold. Personal interview by Shanna G. Benjamin. Telephone, 6 November 2014.

Scott, Joyce. Personal interview by Shanna G. Benjamin. Sparta, NJ, 22 March 2013.

Sherrard-Johnson, Cherene. Personal interview by Shanna G. Benjamin. Telephone, 22 October 2014.

Spillers, Hortense J. Personal interview by Shanna G. Benjamin. Telephone, 15 June 2020.

Tesfagiorgis, Freida High W. Personal interview by Shanna G. Benjamin. Telephone, 19 June 2019.

Wall, Cheryl A. Personal interview by Shanna G. Benjamin. Telephone, 12 May 2014.

Washington, Mary Helen. Personal interview by Shanna G. Benjamin. Telephone, 2 June 2014.

Watson, Keisha. Personal interview by Shanna G. Benjamin. Telephone, 22 November 2019.

Watson, Patricia M. Personal interview by Shanna G. Benjamin. St. Louis, MO, 27 October 2012.

Weixlmann, Joe. Personal interview by Shanna G. Benjamin. Telephone, 23 October 2019.

Werner, Craig. Personal interview by Shanna G. Benjamin. Madison, WI, 20 March 2014.

Williams, Constance W., and Preston N. Williams. Personal interview by Shanna G. Benjamin. Chilmark, MA, 9 July 2014.

Wofford, Susanne L. Personal interview by Shanna G. Benjamin. Telephone, 2 December 2014.

Yarborough, Richard A. Personal interview by Shanna G. Benjamin. Telephone, 9 July 2015.

Zimmerman, David. Personal interview by Shanna G. Benjamin. Telephone, 8 June 2015.

Index

Note: Page numbers in *italics* refer to photographs.

salary, 146, 147

"Salvation Is the Issue" (Priest), 181

San Diego State College, women's studies program at, 82, 142

Savonick, Danica, 37–38

scholars: Black literary, 85, 87–88; Black women, 1, 9–10, 15, 126, 181–182, 206n2; women's literature, 81–82

Scott, Donald "Don," 30, 110

Scott, Joyce, 12, 43, 108, 190–91; letter to, 44–45

SDS. See Students for a Democratic Society (SDS)

second book, of McKay, N., 153, 175, 176, 179

"The Second Sex in Academia" (panel), 90

secret personal life, 2–5, 58, 155, 189–191

SEEK instructors, 37

SEEK program, 31–32, 37–38

Senate Judiciary Committee, U.S., 148

service, community, 178

"Sexism, Racism and Black Women Writers" (Watkins), 127

sexual harassment, 149, 150, 153

sexuality, of Black women, 148–149

sexual tropes, Black, 148

Shakespeare class, 36

Shalala, Donna, 169

Sherrard-Johnson, Cherene, 158–159, 197

Shick, Tom W., 101; death of, 102–103

shorter works, of McKay, N., 153–155

Simmons College, 53, 58; McKay, N., leaving, 70–71; McKay, N., teaching position at, 54, 57

Simone, Nina, 46

sister, Watson as, 46, 207n5

"The Site of Memory" (Morrison), 21

sit-in, as Queens College, 34

Skip. See Gates, Henry Louis, Jr. ("Skip")

slavery, 27, 164–165

Smith, Barbara, 55, 56–57, 88–89

Smith, Beverly, 55, 56

Smith, Valerie, 91–92

soccer, 64

social justice, 15, 38, 41, 54; feminism and, 81

Sollors, Werner, 145

South, 163–164

Southern, Eileen, 48–49

Spelman College, 83; Morrison commencement speech at, 96–97

Spence, A. Michael, 146; letter to, 147

Spillers, Hortense J., 126

"star" of faculty, 99

stereotypes, racial, 127, 152

Stetson, Erlene, 90

struggles, at Harvard University, 52–53

student protests, 48

students: Black, 38, 47, 48–49; Puerto Rican, 31, 32, 33

Students for a Democratic Society (SDS), 33–34

study group, women's, 56–57

Sula (Morrison), 144

support, from friends, 84

Supreme Court, U.S., 148

Sutton, Percy Ellis, 32

symposium: for NAAAL, 144–145; on W. E. B. Du Bois, 170

Sypher, F. Wylie, 57–58

Tarry, Ellen, 154

Taylor, Keeanga-Yamahtta, 55

teaching, inclusive, 37

teaching career, of McKay, N., 39

teaching position, at Simmons College, 54

Telling Histories (White), 8

tensions, intraracial, 150

tenure position, 216n82; Black women and, 99; McKay, N., at UW-Madison, 67, 74, 84, 93, 99–100

texts, Black women's, 129–130

"That the Mothers May Soar and the Daughters May Know Their Names" (Griffin), 7